JOHN JOHNSON

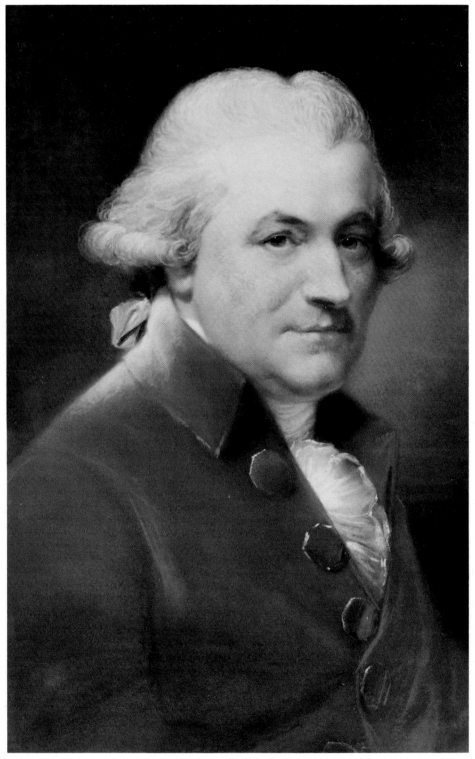

John Johnson, by John Russell, 1786

JOHN JOHNSON

1732–1814

GEORGIAN ARCHITECT
AND
COUNTY SURVEYOR
OF ESSEX

BY NANCY BRIGGS

Nancy Briggs

FOREWORD BY
HOWARD COLVIN

CHELMSFORD
1991

Published by the

ESSEX RECORD OFFICE

County Hall, Chelmsford CM1 1LX

© ESSEX COUNTY COUNCIL 1991

*A catalogue record of this book is
available from the British Library*

ISBN 0-900360-82-8

Essex Record Office Publication No 112

*Set in 10/13pt Baskerville
Designed by Keith Mirams MCSD
Typeset by Dalton Origination Ltd
Printed by The Lavenham Press Ltd*

CONTENTS

LIST OF ILLUSTRATIONS

FOREWORD

THE ELEGANT AND sophisticated architecture of Georgian England was the product of a society in which taste was largely determined by the patronage of a ruling aristocracy of landed gentry. This aristocracy was served by an architectural profession in which there was as yet no clear distinction between architect and builder. At the top were the architects of national repute, men such as Adam, Chambers, Mylne and Wyatt, who had studied abroad and were the source of innovatory ideas in design. They ranked as gentlemen and were often Royal Academicians, but they did not see anything wrong in making money by speculative building or contracting, as well as by providing designs to be carried out by others. Then there were the provincial architects who often dominated a locality, offering their own versions of the current style. These men were almost invariably building contractors as well as architects, and often masons or carpenters by training. Carr of York was the most celebrated: others were Haycock of Shrewsbury, Pickford of Derby, Newton of Newcastle, Wilkins of Norwich. At the bottom were the skilled building craftsmen, masons, carpenters, bricklayers and joiners, who not only worked for the architects but who themselves designed houses, churches and minor public buildings in a vernacular version of the prevailing Palladian or neo-classical style.

John Johnson was a representative of the second class. Although he lived in London and had had some experience as a speculative builder there, his professional base was the county of Essex, from which his practice extended further afield, notably to Northamptonshire and his native Leicestershire. The dependence of his architectural ideas on men such as Chambers and Wyatt is evident, but there are personal elements in his work which give it a certain individuality. His *oeuvre* is well documented, partly because Nichols, in his *History of Leicestershire*, printed a list of his principal works, and partly because County Record Offices such as that of Essex (always a model of its kind) can provide the archival evidence for many of the buildings he designed. It is therefore entirely appropriate that this careful study of Johnson's career and works, written by a professional archivist well known for her interest in architectural history, should be published by the Essex Record Office.

Howard Colvin

vii

ACKNOWLEDGMENTS

THE STUDY OF an architect who left no family or professional papers has necessitated visits to, and correspondence with, a number of county record offices and other repositories. I must acknowledge the help received from many quarters over the years; the location of material is listed under Manuscript Sources. Above all, I am grateful to all my former colleagues in the Essex Record Office, especially to the County Archivist, Vic Gray, for his encouragement of such a wide-ranging architectural study, which may also be regarded as a contribution to the history of Essex local government and society, to Janet Smith, Principal Archivist, for reading the manuscript and seeing the book through the press, and to Nelson Hammond for his patience and photographic skills; he has taken all the photographs not acknowledged separately. I have also received much kindness and hospitality from the owners and occupiers of surviving buildings designed or altered by Johnson; it should be stressed that most of these are not open to the public.

Information on specific points has been kindly provided by: Anne Acland (Killerton); John Booker (Lloyds Bank Archives); James Boutwood (architectural terms); the late Col. John Busby (Thomas Collins); Janet Cooper (Colchester Castle); Godfrey Davis (Wimbledon); Robert Dunning (Halswell); Hilda Grieve (Chelmsford); the late Sir Gyles Isham (Northamptonshire houses); David Jones (Naiad); Alison Kelly (Coade stone); Frank Kelsall (Stucco); Mercia Langstone (Terling Place); Anne Lutyens-Humfrey (Johnson's portrait); Peter McKay (Castle Ashby); Norman Scarfe (Suffolk); Caroline Sholl (Terling Place); Colin Shrimpton (Du Cane family); the late Hon. Charles Strutt and the Hon. Guy Strutt (Terling Place); Peter Walne (Greenhill Grove); John Williams (William Ivory).

Special thanks are due to Howard Colvin, who has been unfailingly generous in his supply of information and suggestions over the years, has read the manuscript and contributed the foreword. My husband, A. C. Edwards, has lived with Johnson for an unconscionable time and has always been ready to supply support and criticism in equal measure. Muriel Eakins has happily typed unfamiliar terms, and John Fulbeck has not only produced impeccable maps and plans from intractable source material, but also provided support in other ways.

Nancy Briggs

EDITORIAL NOTES

Abbreviations

Arch. Hist.	*Architectural History*
Briggs, *County Surveyor*	N. Briggs, 'The evolution of the office of county surveyor in Essex, 1700–1816'
Briggs, *Woolverstone*	N. Briggs, 'Woolverstone Hall'
Ch. Ch.	*Chelmsford Chronicle*
Colvin	H. Colvin, *A biographical dictionary of British Architects, 1600–1840*
C.L.	*Country Life*
E.A.T.	*Transactions Essex Archaeological Society*
E.J.	*Essex Journal*
E.R.	*Essex Review*
Gent. Mag.	*Gentleman's Magazine*
Graves	A. Graves, *The Society of Artists of Great Britain and the Free Society of Artists*
G.L.R.O.	Greater London Record Office
Marylebone Lib.	Westminster City Archives, Marylebone Library
N.M.R.	National Monuments Record
Nichols	J. Nichols, *History of Leicestershire*
P.R.O.	Public Record Office
R.C.H.M.	Royal Commission on Historical Monuments
Simmons	J. Simmons, *Parish and Empire*
V.C.H.	*Victoria County History*
Victoria Lib.	Westminster City Archives, Victoria Library

Places and Sources

Unless otherwise stated and with obvious exceptions, places mentioned in the text are in Essex and the manuscript sources cited in footnotes are in the custody of the Essex Record Office (E.R.O.).

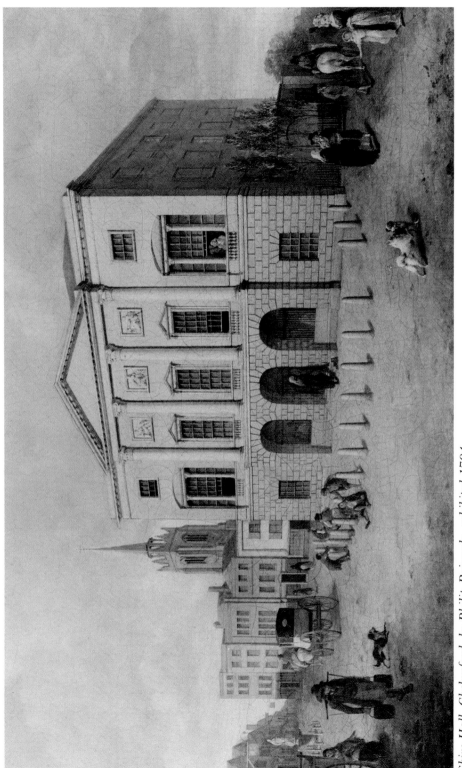

Shire Hall, Chelmsford, by Philip Reinagle, exhibited 1794

CHAPTER ONE

EARLY CAREER IN LONDON

LITTLE IS KNOWN of the first thirty years of the life of John Johnson. He was born in Southgate Street, Leicester, on 22 April 1732 and baptised on 23 July at St. Martin's church.[1] His parents were John Johnson, who had been baptised at St. Martin's on 20 November 1707 and Frances, daughter of Thomas Knight, baptised at All Saints', Leicester, on 6 April 1708. They were married at Peatling Parva church, Leicestershire, in December 1726. The father, described as the eldest son of the late John Johnson of Leicester, carpenter, was admitted a freeman on 26 July 1727. The family also included William, baptised at St. Martin's on 6 October 1741, and Susannah, who married Joseph Springthorpe at St. Mary, Leicester, on 29 April 1766.[2] The architect erected a monument in the south chapel of St. Martin's church, executed by John Bacon, R.A. (1740–99), to the memory of his parents: John Johnson died on 25 January 1780, aged 72, and Frances on 19 October 1776, aged 69. An inscription was added recording the architect's death on 27 August 1814, at the age of 82, and that of his brother, William, on 1 November 1810, at the age of 68[3] (*Illus. page 156*).

The architect is to be identified with the John Johnson, described as the eldest son of John Johnson, joiner, who was admitted a freeman of Leicester on 22 April 1754. His obituary in the *Gentleman's Magazine* stated that he left Leicester 'in early life, possessing little more than strong natural abilities, which soon found their way in the Metropolis.'[4] By 1760 he was married and living in London. The entry in the St. Marylebone baptismal register on 25 January 1761 for John, son of John and Elizabeth Johnson, born on 18 January, almost certainly relates to the architect's eldest son, who worked closely with his father from 1780.[5] By 1762 Johnson was living in the neighbouring parish of St. James, Piccadilly, and is known to have built a house on the north side of Paddington Street, St. Marylebone, on land originally leased to Jacob Leroux. Four years later he had begun his association with William Berners, who was developing the small Berners estate which fronted Oxford Street from Wells Street to Rathbone Place and extended as far north as the Middlesex Hospital. Articles of agreement dated 15 February and 8 April 1766 relate to Johnson's development of a block of land at the north end of the west side of Newman Street (49–66), the east side of Berners Street (32–36) and that part of Charles (later Mortimer) Street (31–35) lying between Berners and Newman Streets, opposite the Hospital.[6] By July 1766 work on Newman Street was sufficiently advanced for Berners to lease individual properties to Johnson, 'of King's Street, St. James, Westminster, carpenter', for 99 years, of which the first two were at a

peppercorn rent. During July and August Johnson sub-leased some of the sites, mainly to other members of the building trade, for example the painters Christopher and William Hill.[7] Larger sums of money to finance building development were raised from Herbert Mackworth of Cavendish Square, who paid £478 16s. in August 1767 for Johnson's interest in 50–57 Newman Street, with a further £464 2s. in August 1768 for 49, 64–66 Newman Street.[8]

Whilst working on the development of Newman Street, which continued into 1768, Johnson was also employed by William Chambers as a carpenter on the German Lutheran church in the Savoy, the first payment to him being made in October 1766 and the final payment in April 1767 (*see Chapter 8*).[9] By November 1767 Johnson had moved into Berners Street, probably taking up residence at no. 32, where he lived until 1786, appearing in the rate book first in 1769, although the street was not numbered until 1771. His second son, Charles, was born on 1 February 1768 and baptised at St. Marylebone parish church on 8 February.[10] Johnson entered into further articles of agreement with Berners on 13 July 1768 relating to 28–31 Berners Street.[11] In August he leased back from Mackworth a piece of ground with a workshop in Berners Mews at the back of Newman Street.[12] As in Newman Street, Berners Street leases were assigned to other members of the building trades, John Utterton, plasterer, taking over 30 Berners Street on 10 December 1769.[13] In a letter to John Strutt of Terling Place three days later, Johnson refers to 'his present hurry in Business'.[14] Early the following year his third son, Joseph, was born on 3 February.[15] As well as working on his own development Johnson found time in March 1770 to search for a house in Berners Street for John Martin Leake, Chester Herald, a friend of Strutt.[16] In the summer of 1770 Johnson was ambitious enough to submit a design for a new church for St. Marylebone, intended to seat 1,200–1,500 persons. The trustees, meeting on 23 June 1770, included Herbert Mackworth and William Chambers, who both served on the committee appointed to consider the plans; not surprisingly, Chambers was appointed as surveyor.[17]

The Charles Street block was the last part of the Berners estate to be developed by Johnson, beginning late in 1769. A district surveyor's affidavit, dated 9 January 1771, refers to 'five houses built by Mr. John Johnson in Charles Street lying contiguous to each other and running in a line from the North East corner of Berner Street to Berner's Mews.'[18] By 1772 these properties (nos. 31–35) were rated as Johnson's property, 'covered in'.[19] The character of these developments is revealed by Tallis' *London Street Views*. By c.1840 nos. 31–33 Charles Street are shown with two bays and three storeys above shop fronts; nos. 34 and 35 appear to have been altered, with the front of no. 35 extending over the entrance to Berners Street Mews. The same publication shows similar frontages for 49–51 Newman Street.[20]

It is possible that Johnson may have done work for the sculptor, John Bacon, when he moved into 17 Newman Street in the summer of 1774. There may be some truth in Cunningham's story that the premises were prepared for Bacon by

a builder called Johnson, who may not have charged for his services. A schedule of repairs to be made to the house in 1841 suggests that the living quarters were not elaborately decorated, but the passage running the length of the house to the garden and workshops had stucco work and niches for the exhibition of figures and other pieces of sculpture.[21]

By 1773 Johnson was sufficiently well known to be employed by the Middlesex justices to survey the old Clerkenwell Bridewell and 'the quakers Poor Houses' in Corporation Row, for a valuation.[22]

At this period, Johnson was building up his country house practice (*see Chapter 2*). Before 1775 he was also designing town houses. He exhibited a design for two houses in Cavendish Street, Cavendish Square, at the Society of Artists in 1775; Howard Colvin has suggested that these could be the pair now known as 61 and 63 New Cavendish Street (*see below*).[23] Two houses in Harley Street were designed by Johnson on land originally leased by the Portland trustees to John White, carpenter, of St. Marylebone, who later became surveyor to the Portland estate. No. 27 (later no. 68) on the east side was leased by the trustees to Mackworth's brother-in-law, the Revd. John Hotham, archdeacon of Middlesex, on 1 December 1773; he was occupying the house by 1775 and became Bishop of Ossory in 1779. No. 43 (later no. 63) on the west side was leased to John Pybus (d. 1789) on 20 December 1773 and also occupied by 1775.[24] Both houses have been demolished without any record of their appearance being preserved, but Johnson may well have used Coade stone doorways of the Bedford Square type in conformity with other houses in Harley Street.[25] Johnson was also involved in the development of at least three other properties in Harley Street. In October 1773 John Utterton mortgaged to Johnson a site on the west side of the street, probably adjoining the house built for Pybus, for £2,000; the mortgage was assigned to the Revd. Jeremiah Milles, Dean of Exeter, in April 1777.[20] The site on the east side (no. 29), originally leased by Thomas Martin in September 1772, was assigned by Johnson to John Cholwell, esq., in May 1775.[27] John White's plan of 1797–99 assigns another site on the west side, probably no. 56, to Johnson.[28]

After his accession to the earldom in 1773 the 7th Earl of Galloway obtained the renewal of the Crown lease of two adjoining houses on the south side of Charles Street. A new house with a frontage of 63 feet was built by Johnson in 1775–76, occupying the site of the present 29 Charles II Street; it was demolished in 1912 without being recorded. Johnson exhibited a design for a chimney piece in 'the Drawing Parlour' at the Society of Artists in 1778.[29]

One of Johnson's three surviving town houses is concealed behind Thomas Cundy's façade of 1854–55 at 38 Grosvenor Square, now the Indonesian Embassy. This account is based on that given by the *Survey of London*, unless otherwise stated.[30] There is no documentary evidence for the execution of this commission, which is not listed by Nichols, presumably because most of the work consisted of interior redecoration. Johnson rendered the exterior with compo-

sition and added the rearward wing building with windows to the side. The front room on the ground floor, possibly used as a dining-room, has a stucco panel on the chimney wall depicting Bacchus and the sleeping Ariadne; this has been enlarged to an oval shape, but was originally identical with that at 63 New Cavendish Street. The rear wing room with its segmental bow has been subdivided, but retains a Doric frieze and four circular wall paintings in reeded frames of sacrifices to Apollo and Diana and a pair of Bacchantes.[31] The staircase has wall-hung stone treads, elegantly chamfered underneath, with Johnson's characteristic iron balustrade of honeysuckle scroll pattern (*Illus. page 5*). A survey by George Shakespear in 1781 criticised the plasterwork being directly on the brickwork, instead of on lath on battens, with the result that the ornaments were affected by mildew. He also considered that a charge of £60 for the ornaments in the 'Great Stair Case' to be 'very extraordinary'.[32] These comments suggest that there was ornamental plasterwork on the staircase wall, although this would not be characteristic of Johnson's work. The plaster dome above the staircase has a sparse radiating pattern of thin husks, with medallions in the spandrels, comparable to the treatment of 63 New Cavendish Street.

The first floor of 38 Grosvenor Square has elaborate stuccoed ceilings with inset paintings and white marble chimney pieces of high quality. The chimney piece in the front room is identical with one at Woolverstone Hall (*see Chapter 2*); a central tablet is flanked by large figures emblematic of Music and Drama, on pedestals (*Illus. page 6*). The design, inspired by Piranesi, could possibly be the work of John Bacon, although the work is bolder than either the chimney piece supplied by him for Burton Constable, co. Yorks, c.1775–76, or that designed by Adam for 20 St. James's Square, 1772–74.[33] The ceiling of this room has a circular painting of Jupiter and Juno in the centre, from which radiate compartments filled with delicate scrolls and oak leaves and containing small vesica-shaped panels of the Dancing Hours (*Illus. page 7*). The treatment is very similar to that at 63 New Cavendish Street (first floor front) and Woolverstone Hall (dining-room)[34] (*Illus. page 37*). There are fans in the corners and roundels of Day and Night at either end of the ceiling. The rear room on this floor has a ceiling with a central painted medallion depicting a sacrifice, bordered by scrolls, urns and anthemion, with corner medallions of the Four Seasons.[35] The bow room in the rear wing has a ceiling with an oblong inset painting of Apollo and the nine Muses, and roundels of the Arts. Semi-circular stucco panels contain a favourite dolphin and pillar motif suggesting a lyre, flanked by mermaid-like figures, above a bold acanthus cornice (*Illus. page 6*).[36] To quote the *Survey*, 'the total ensemble is an accomplished piece of decoration, for all that it lacks the originality and intellectual rigour of James Wyatt's or Adam's work. The ceiling designs, if rather loose and lacking in overall unity, are beautifully executed, and although the flatness and thinness of the designs generally mark them as the work of an architect not of the very first rank, they have the fluent grace of their period.'[37]

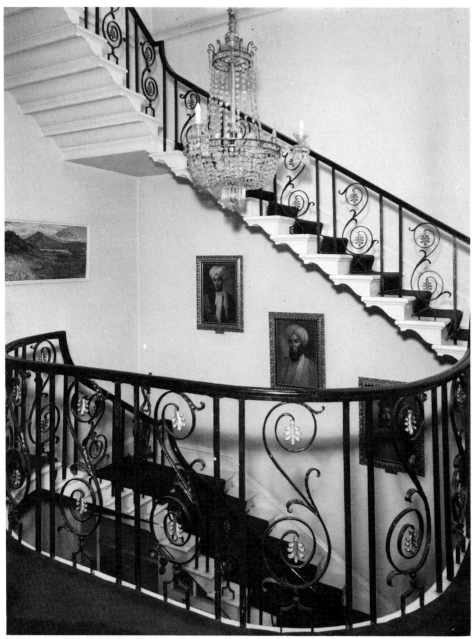

38 Grosvenor Square (Indonesian Embassy), staircase

Johnson's other surviving town houses, now numbered 61–63 New Cavendish Street, terminate the vista at the end of the Adam development of Mansfield Street (1770–75), which was intended to have been filled by the entrance screen wall of a great house for the Duke of Portland. By the end of September 1775 the leases of this site had been transferred from the Adam brothers to Johnson. Only one house in New Cavendish Street was rated in 1776, but the following

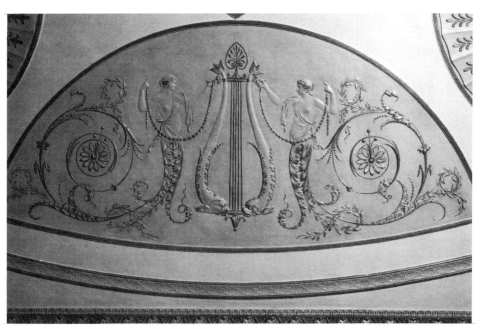

38 Grosvenor Square, ceiling (detail), first floor bowed room

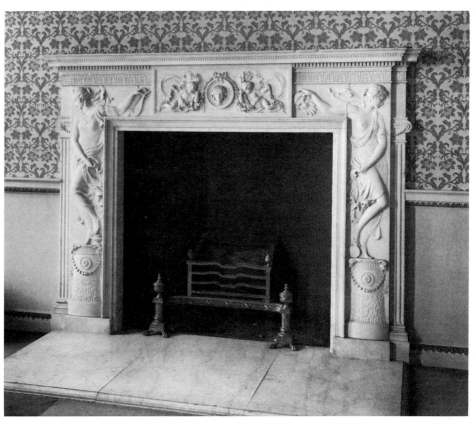

38 Grosvenor Square, chimney piece, first floor front room

year Johnson was paying rates for nos. 21 (£30) and 22 (covered in). Johnson's clients, Sir Charles Bampfylde, Bt., and John Udney, were rated in 1778 for nos. 9 and 10. This renumbering misled A. T. Bolton and Dorothy Stroud into associating the sites with a builder named James Hilson, who was rated in 1777 for nos. 7–9 (covered in). The map of the Portland estate, drawn up by John

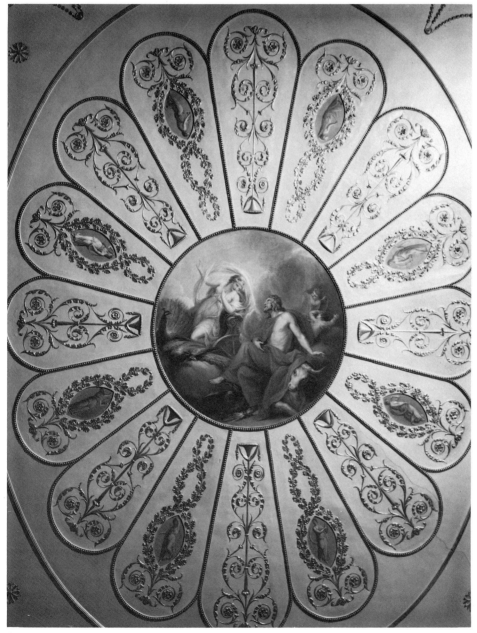

38 Grosvenor Square, ceiling, first floor front room

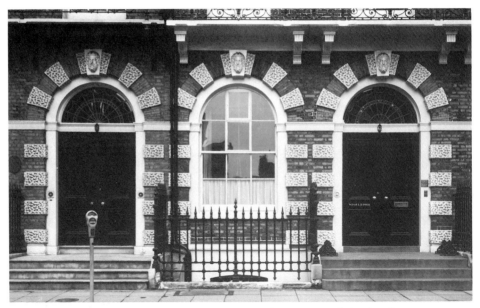

61 and 63 New Cavendish Street, door and window surrounds in Coade stone

White in 1797–99, correctly assigns the sites to Johnson.[38] Both houses have been fully described by Arthur Bolton in 1917 and by John Milnes-Smith of the L.C.C. Historic Buildings Division at the public enquiry into proposed demolition in 1964.[39] Descriptions have also been published of the individual houses: no. 61 by Margaret Jourdain and no. 63 by Dorothy Stroud.[40]

These houses were designed as a pair with a pediment above the central bay; this was removed when a third storey was added together with first floor verandas and balconies in 1865. On the ground floor, Johnson used Coade stone to unify the design by putting a window (lighting the hall of no. 63) between the two doorways, all with blocks and voussoirs of vermiculated rustication and an ornamental keystone, identical with the design used in Bedford Square (*Illus. page 8*).[41] The ground floor front room (Council Chamber) of the smaller house (no. 61), now occupied by the Institute of Petroleum, has a wooden screen with unusual Corinthian capitals and pilasters incorporating female figures and swans (*Illus. page 9*).[42] The rear room (now the Waterhouse room) has a rear ellipse plan. Four inset grisaille panels of children in reeded frames are set at high level, in the spaces between the cornice, a band of paterae and small enriched Corinthian pilasters.[43] The staircase has a simple S-scroll balustrade with foliated bars. The stair compartment was altered c.1865 by the insertion of an extra flight surmounted by a dome.[44] The secondary staircase has been replaced by a lift.

The first floor rooms have painted ceilings. The front room, used as the Library, has inset figure paintings, surrounded by an elliptical band modelled with animals and winged figures, and circular painted insets on the diagonals. Bolton suggested that the arrangement of the centre may have been altered, as

the placing of the painted panels is not at all happy. The room has been refitted with 19th century door surrounds and a copy chimney piece.[45] The elliptical ceiling of the rear (Information) room is in the Etruscan manner, although Bolton felt that the decorative treatment may have been modified at a later date; the centre medallion shows Apollo and Diana and the outer medallions represent the Arts.[46] The former bedroom in the rear wing has a semi-dome to the back and pendentives supporting a flat ellipse.

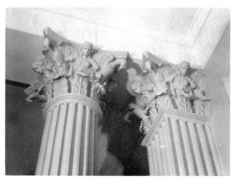

61 New Cavendish Street, capitals, ground floor front room

Margaret Jourdain suggested that the unusually boldly painted female figures in the centre rectangle were of Italian type; they are framed by a band modelled with lions and scroll work. Relief figure medallions characteristic of Johnson's work occupy the corners of the main part of the ceiling (*Illus. page 9*).[47] It is clear from a survey by Alfred Waterhouse, who occupied the property from 1864 to 1901, that there is no question of the ceiling paintings being later in date than 1865.

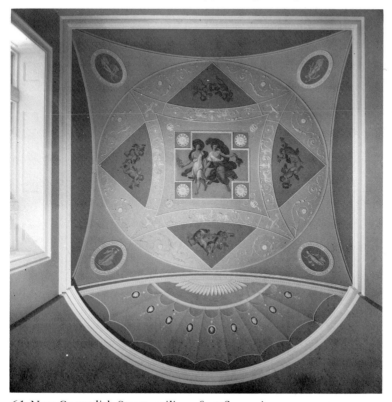

61 New Cavendish Street, ceiling, first floor wing

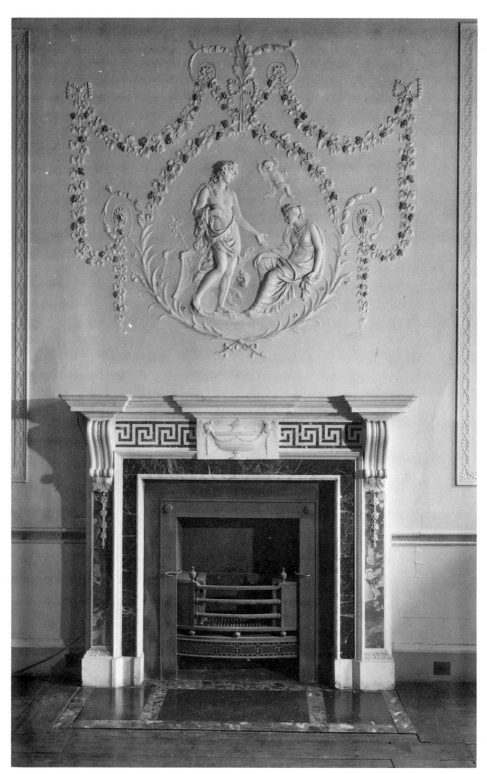

63 New Cavendish Street, Bacchus and Ariadne, ground floor front room

The large entrance hall of no. 63 (now occupied by the Institute of Psycho-Analysis) was divided and altered between 1917 and 1964 but retains part of an enriched cornice and frieze with bucrania, which also occurs at no. 61. The front room (now the Library) was designed with the same screen as in the smaller house, but the rear space had been cut off by 1964. An imported chimney piece is surmounted by a plaster relief of Bacchus and Ariadne, framed by foliage and scrollwork (*Illus. page 10*). Dorothy Stroud has identified this as the 'inrich'd stucco ornament over chimney' repainted by Richard Clarke, who also painted four balconies on the south front as part of John Soane's alterations for Philip Yorke in 1781. The staircase has Johnson's characteristic honeysuckle scroll balustrade.[48] The curved first floor landing is surmounted by a dome with a frieze of flutes, cables and paterae; circular medallions with flying figures occupy the pendentives, but the treatment of the plasterwork of the dome itself is rather thin (*Illus. page 11*). All the first floor ceilings were restored in 1988 under the supervision of English Heritage. The front (Ernest Jones) room ceiling is typical of Johnson's plasterwork; a large central motif of Venus and Cupid is surrounded by radiating petals, identical in treatment with those at 38 Grosvenor Square (*Illus. page 7*) and Woolverstone Hall (*Illus. page 37*).[49] At either end are medallions of classical figures framed by arabesques and husk festoons. The chimney piece is a variant of those at 38 Grosvenor Square (*Illus. page 6*) and Woolverstone Hall; the large female figures on bases hold musical instruments and a pitcher (*Illus. page 12*). The ceiling in the rear (Rickman) room

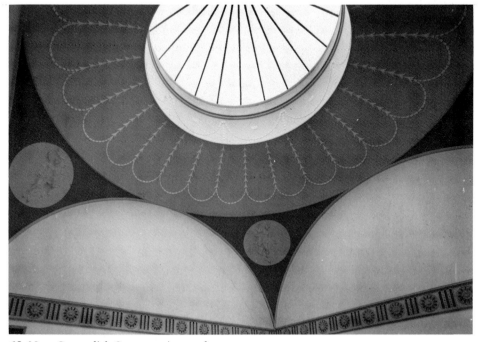

63 New Cavendish Street, staircase dome

is flat, but gives the illusion of a curved section with its five large vesica shaped compartments, each with an inset painting, including Apollo and the Muses; the main plasterwork motifs alternate between urns and dolphins and pillar. The design is probably that exhibited in 1778 as the music room ceiling (*Illus. page 13*).[50] The chimney piece has Corinthian pilasters and carved foliage decoration incorporating lyres. The boardroom in the wing is approached by a groin vaulted lobby; an arched ante-space reduces the plan of the room to a near square. There is a flat elliptical ceiling on small pendentives, without a cornice. The ceiling has a central inset painting representing the marriage of Psyche, with a surrounding painted band of grotesques. The outer frame of the ellipse has Johnson's characteristic bold acanthus frieze. There are circular paintings of high quality in the pendentives, two of them based on the Roman Marriage fresco from the Aldobrandini Palace in Rome. The soffit of the ante-space and its arch have plaster relief decoration.[51]

As with Harley Street and New Cavendish Street, the site of two houses (nos. 9, 10) on the north side of Portman Square, designed by Johnson, formed part of a block of land originally assigned to another developer. On 24 December 1772 the Baker family entered into articles of agreement with James and Samuel Wyatt for the development of land lying west of Baker Street. Johnson was a party with the Wyatts to the leases to his clients, the Hon. Henry Willoughby, later 5th Lord Middleton, 1 May 1777 (no. 10) and the Hon. Charles Greville, 23 July 1778 (no. 9).[52] A comparison of Ackermann's engraving of 1813 with John Claude Nattes' pencil sketch of the same date suggests that Greville's house (no.

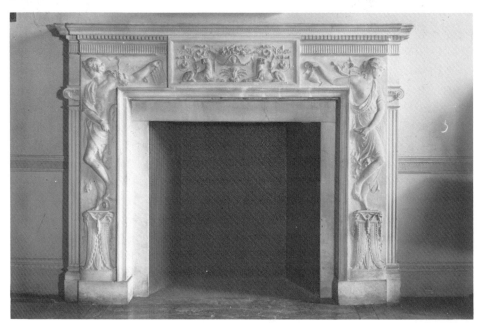

63 New Cavendish Street, chimney piece, first floor front room

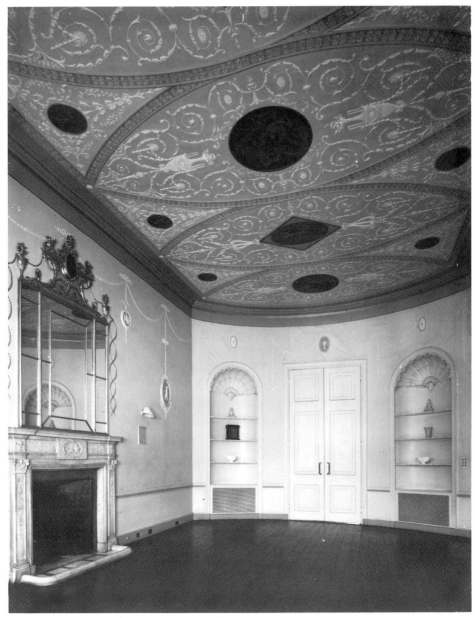

63 New Cavendish Street, first floor rear room

9, later no. 12) was larger and more elaborate, with channelled masonry on the ground floor, and four Ionic pilasters below a frieze and balustraded parapet. This elevation would fit Johnson's admission that he had used stucco on the exterior. An extra storey above the frieze was added to this house before c.1910. The elevation of Willoughby's house (no. 10, later no. 13), with an arcaded ground floor, appears similar to the adjoining property, occupied by 1781 and presumably designed by the Wyatts. An attic storey with balustrading was later

added to both these houses and the facade of Willoughby's house was given an elaborate frieze, with pediments over the windows on the ground and first floors.[53] Both houses are said to have been completed by October 1777 and were first rated in 1778; they were demolished c.1965.[54] The interiors were recorded prior to demolition, but it has not been possible to identify the drawing room ceiling for which a design was exhibited in 1778. The interior of Greville's house (no. 12) included a staircase dome with a frieze identical to that at 63 New Cavendish Street and characteristic female flying figures (*Illus. page 15*).[55]

Johnson, in partnership with Thomas Collins (1735–1830), an associate of Sir William Chambers in the development of Berners Street, and John White, also took part in the development of Portland Place. The Adam brothers had assigned a lease of a block on the corner of Duchess Street (later no. 22) to Thomas Nicholl of St. Marylebone, carver, in November 1774. When Nicholl became bankrupt in 1779, the lease was assigned to Josias Dupre, the occupier of no. 20; his executors assigned it in December 1780 to the partners, who took out a mortgage of £1,500 from the sellers. The lease and mortgage were assigned in May 1781 to Sir Patrick Blake, Bt., who died there in July 1784. The house, with a rusticated ground floor, may possibly have been designed by Johnson; it was demolished for the extension of Broadcasting House.[56]

Johnson reconstructed a house for Sir Hugh Palliser, Bt., on the north side of Pall Mall, after it had been gutted by a mob in 1778, provoked by his insubordinate conduct towards Admiral Keppel. As there was no change in the rate assessment during Palliser's occupancy, 1777–80, it seems likely that the house was repaired rather than rebuilt, although the evidence of Coney's drawing of 1814 suggests a facade of two bays consistent with Johnson's work; there was an arcaded ground storey with the western arch forming the doorway, a bandcourse at first floor level and a moulded cornice below the fifth or attic storey. The house was demolished in 1866 to make way for the Junior Carlton Club.[57]

By 1780 Johnson was well enough established in St. Marylebone to be considered one of its principal inhabitants. At a meeting on 15 June, with Sir Herbert Mackworth in the chair, Johnson was elected a member of the committee of the St. Marylebone Association to strengthen the civil power in response to the Gordon Riots at the beginning of the month. He was present at a committee meeting on 17 June, when it was agreed that members of the Association should provide themselves with a good musket and bayonet and pay a subscription of 5s. Johnson, who was also a member of the committee for the Berners Street district, subscribed 5s. 3d. for self or son on 28 June.[58]

Johnson moved to 27 Charles Street in 1786 and remained there until 1792, whilst continuing to run his business from 32 Berners Street, which was occupied by his eldest son and assistant, John. The house in Charles Street was three bays wide and four storeys high, with a dentilled cornice beneath the attic storey; by 1838–40 it was occupied by a coach builder.[59] The next move was to 53 High

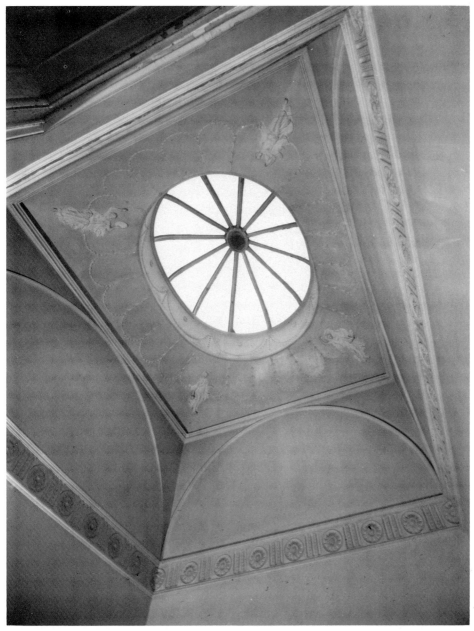

12 Portman Square, staircase dome (demolished)

Street, St. Marylebone, where he remained until 1804. This large house, with a large walled garden, was renumbered several times: 1792 (no. 49), 1794 (no. 47B), 1795 (no. 53). It was occupied and refurbished by Charles Dickens, 1839–50, being then known as no. 1 Devonshire Terrace, and finally demolished c.1959. The original features appear to include a Coade stone doorway of Bedford Square type and two large three-storeyed bows at the side (marked on Horwood's map of 1799) (*Illus. page 16*).

53 High Street (1 Devonshire Terrace), St. Marylebone, occupied by John Johnson, 1792–1804, and by Charles Dickens, 1839–50 (demolished)

Interior features, which may perhaps be associated with Johnson's work, included pillars and pilasters forming a screen in the rooms with bows.[60] A projecting porch was added in 1851 and extended up to the first floor after 1889.[61]

There is no direct documentary evidence linking Johnson with the development of Bedford Square between 1775 and 1783, but it is possible that he may have had a hand in the design of some interiors. However, many of the craftsmen working in the square came from St. Marylebone and may have worked elsewhere for Johnson, like John Utterton, plasterer, who was the lessee of nos. 16, 17, 31 and 47.[62] In 1776 Robert Phillips, plasterer, was paying rates for 35 Charles Street, St. Marylebone; in 1777 he leased no. 9, where the plasterwork has many features of Johnson's style. The three plaster medallions on the ground floor include Eros, used at Castle Ashby, Northamptonshire, and Holcombe House, Hendon; the treatment of the scroll work surrounding the medallions on the chimney breasts is comparable with Holcombe House, in contrast to the more naturalistic treatment of the over door plaque, similar to that at 63 New Cavendish Street. The designs of the ceilings on the first floor are also related to that of the dining room at Holcombe House, the front room having the same motifs in the end compartments (*Illus. page 17*). The rear ceiling uses the same semi-circular panels with mermaid, dolphin and pillar; this motif is echoed in the front room frieze. However, the staircase balusters are of

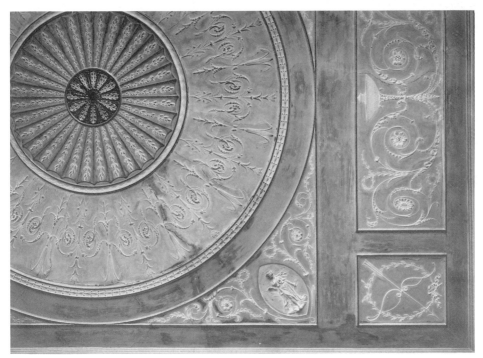

9 Bedford Square, ceiling, first floor front room

unusual design.[63] The ceiling in the front first floor room of no. 30, leased to Charles Jacks, carpenter, of St. Anne's, Soho, 1776, raises a problem of attribution. The main design of concentric circles with urn cornerpieces is identical with that on the first floor of Woolverstone Hall (B), except that the latter has ovals with bow and arrow and quiver and torch motifs, instead of female medallions. However, Andrew Byrne has pointed out that the ceiling at no. 30 has details which are identical with those in the rear room on the ground floor of no. 1, where the interior was designed by Thomas Leverton (1743–1824), although it is possible that the ceiling there is a reproduction.[64] There are four examples in the Square of the use of Johnson's favourite honeysuckle scroll balusters, nos. 3, 5, 18 and 19; all, except no. 18, are associated with a bold acanthus frieze on the second floor landing. At no. 19, there is an interesting rear building, with a stuccoed elevation using Coade stone for the impost, tympanum decoration, keystone and string course. The other surviving rear building in the Square, at no. 21, also leased to William Scott in 1782, is brick; it has flat-headed ground floor windows recessed within semi-circular arches, whose imposts continue as a string course linking the openings in a way characteristic of Johnson's work, particularly on wings or outbuildings.[65]

A certain amount of information about the organisation of Johnson's business from c.1773 can be derived from building accounts for country houses and from the Liardet v. Johnson case of 1778 (*see Chapter 3*). By 1773, he was employing a clerk, who would accompany him on journeys, prepare accounts and conduct correspondence; Joseph Andrews was acting in this capacity in 1780 and 1781, and almost certainly earlier; Johnson had more than one clerk by 1780. John Adams was with him at 53 High Street in 1802.[66] His main foreman, from c.1776 or earlier until 1785, was William Horsfall, who was working closely with him over the use and analysis of stucco. Horsfall sent James Downes, who was employed by Johnson to make composition, out of the way while he added lead.[67] As Johnson's foreman in September 1780, Horsfall replied to an enquiry about the price of mahogany frames for sash windows.[68] Foremen were also despatched to jobs in different parts of the country. Henry Willby was sent to Castle Ashby, Northamptonshire, in the summer of 1771, but died shortly afterwards; William Ivory acted as foreman there from August 1772 to February 1774.[69] At Carlton Hall, Northamptonshire, John Sidway, a carpenter, was succeeded as foreman in March 1778 by William Ivory, who remained in charge until August 1780.[70] When discussing alterations at Springfield Place during July, Johnson first suggested sending Ivory after he had finished work in Northamptonshire and then sent Pearse, who had not acted before in this capacity although he had 'been a long time at work at different places under the direction of Mr. Johnson', at the rate of 18s. a week. Johnson's clerk suggested that a workman in a position of responsibility would normally receive at least a guinea a week, plus travelling expenses. Pearse had overall direction of the work and workmen, kept accounts and sent for materials without consulting the client,

although Johnson considered that he and other workmen were 'as independant of me as if I had not procured some of them from London'. However, Starkey, who was probably in charge of the bricklayers at Springfield Place, received 22d. a week, part of which was paid 'in our office' to his wife during his absence in Essex.[71]

Other workmen might be hired for specific jobs, although carpenters were most likely to have been permanent employees. The workmen at Castle Ashby, 1772–73, probably included carpenters, carvers, gilders, plasterers and, certainly, painters from London.[72] The building accounts for Sadborow, Dorset, 1773–75, distinguish between London and country carpenters.[73] Watkins, the lad sent down to Springfield Place in 1780, is described as only Johnson's apprentice. The sashes for this commission were made in Johnson's own yard and collected by the client's wagon, rather than delivered to an inn for transmission by carrier.[74] Johnson's yard, where Downes made the first batch of composition in the summer of 1776, was near Goodge Street, but he may also have used the workshop in Berners Street Mews, which passed to his son in 1790.

Johnson used a number of London plasterers. Thomas Hackstall worked on 'the ornament ceiling' and 'basso relievos' at Terling Place in 1773 and seems also to have been involved at Kingsthorpe, near Northampton, in 1774, where John Utterton of St. Marylebone was also working. [76] Utterton's man, Banyard, also worked at Carlton Hall, 1777–81, probably in conjunction with Edward Bellman from 1778 to 1780, who was also applying composition there and had frequently been employed by Johnson as a plasterer.[77] The painters Christopher and William Hill, tenants of 56 Newman Street since 1766, who had been involved in Johnson's development in Charles Street in 1769, worked at Kingsthorpe in 1775.[78] The thirteen chimney pieces supplied for Carlton Hall were 'set up' by Hoile, a mason sent from London.[79]

CHAPTER TWO

COUNTRY HOUSES I

TERLING PLACE

I do now think I have done your business in the architect way. One Johnson in Berners Street, Oxford Road. I intend he shall be my man, and from the account I have had of him I was half inclined to send him down to Terling at a venture, but more of this when we meet; only one word now: he is exceedingly honest, cheap and ingenious – what would you more?

In these words, probably written during 1769, Thomas Berney Bramston of Skreens, Roxwell, recommended John Johnson to his friend, John Strutt of Terling. Strutt had bought the manor of Terling Place and about 850 acres from Sir Matthew Featherstonhaugh, Bt., in January 1761 and moved with his family to Terling the following year, spending the next decade 'trying to make up his mind where and how to build himself a permanent home.'[1]

Bamber Gascoyne's letters during 1767 are full of advice on the subject. Surviving sketch plans, showing a breakfast room with a bay window, may have been provided by Gascoyne or Steers, his bricklayer from Ilford. William Chambers also produced plans at this period, which have not survived and did not meet with Gascoyne's approval, although the identity of his 'better planner . . . than Mr. Chambers' is not clear. Although Strutt was in touch with Johnson by late in 1769, the site had not been selected by the autumn of 1770, despite Gascoyne and Bramston calling in the landscape gardener, Mr. Richmond, for this purpose in February.[2] However, work on brickmaking had begun by August 1770, when payments to John Raby for carting brick earth commenced. Bramston's letter of 15 April 1771 suggests that this may have been white brick earth, which Raby was offering to Bramston for Skreens at 10s. 6d. per waggon load. Strutt's ledger includes payments from early 1772 for red and white bricks, some of which were for the cornice and for pavements.[3] By the end of May 1771 Johnson was offering to 'make out Clear Drawings and Sections &c. of the rooms with their Cornices and other Ornaments at Large', so that Strutt could 'see the mode of finishing' before the final estimate was submitted.[4]

Johnson probably visited Terling before producing his undated estimate:

Dwelling House	£4043
Stables &c.	£ 809 11s.
Kitchen &c.	£ 869 17s.
Total	£5722 8s.

The plans, which arrived by the end of July 1771, may not have been the final version. A surviving set, with the main frontage measuring 68 feet, does not correspond to Johnson's elevation with a frontage of about 76 feet, or a copy

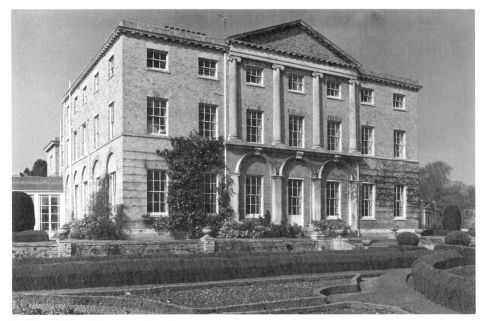

Terling Place, Essex, garden front

made in 1926 of his perspective view. A drainage plan of 1811, showing the west side of the buildings, and Johnson's sketch design for the vestibule can be related to a plan reconstructed from the recollections of Olivia Drummond (1798–1897). The original entrance, with a simple door case, was on the south-east (now garden) front; the three bays in the centre under a pediment had round arches on the ground floor, originally of the same design as the five corresponding recessed arches on the south-west and north-west fronts (*Illus. page 21*). The kitchen wing behind the three-storeyed main block was two storeys high with a pediment; the stables lay across the yard behind the kitchen.[5]

The site finally chosen for the new house, Terling Place, lay several hundred feet south of the old one. The first brick was laid by Joseph Strutt, father of John Strutt, on 30 March 1772.[6] The main contractor was Matthew Hall, the Maldon carpenter (d. 1780), to whom payments totalling £1,382 8s. 5½d. were made between April 1772 and August 1774. Other craftsmen included George Wray, the Chelmsford mason, who received £133 8s. 1d. for work, including the cornice, between 1772 and November 1773. The bricklayer, William Evans, was paid £398 1s. 8½d. between April 1772 and March 1774, including £1 1s. 6d. for sorting white brick per agreement. Sarah Fenton, slater, received £139 3s. 1d. between August 1772 and January 1773; rag slates, of which only the visible parts are trimmed and squared, were used. John Strutt and his wife had a picnic dinner in the house on 25 December 1772. They moved into temporary quarters in the house-keeper's room and some attic bedrooms on 26 November 1773, when Strutt noted that the offices were nearly finished, although Sarah Fenton was not paid for slating this part of the building until March 1777.[7]

Subsequent alterations, carried out to the designs of Thomas Hopper (*see below*), make it difficult to reconstruct fully Johnson's interior scheme. The payment to Thomas Hackstall, plasterer, who was at Terling in December 1773, of £36 15s. for 'Ornament ceiling in the drawing room together with the Basso relievo's in the Hall' relates in part to the existing drawing room ceiling (*Illus. page 23*). This plasterwork is characteristic of Johnson's style with a centre ornament similar to that in the first floor room at 9 Bedford Square; draped female figures occupy the four ovals suspended from ribbon ties. The 'Basso relievo's in the Hall' may refer to an existing sketch design for the vestibule; two large roundels with figures are shown above the doors leading to the rooms on the entrance front on either side of the archway; this design has affinities with the published section of the hall and vestibule at Woolverstone Hall, Suffolk. Another plasterer, Solomon Gunston, received £246 19s. 1½d. for measured work between February 1773 and January 1774. The staircase hall occupied the area of the present two-storey Neo-Greek saloon, but Johnson's wrought iron balusters of identical S-scroll design to those at Kingsthorpe, Northamptonshire, were re-used for a simple dog-leg stair outside the saloon. The original staircase, possibly of imperial type, had a skylight. Three chimneypieces were supplied by William Story for £139 8s.; two are probably to be identified with the white marble chimney pieces in the west room and present dining-room.[8] In 1781 Strutt estimated the total expenses of building Terling Place at £6045 10s. 5¼d.; this included expenditure of £663 6s. 3d. on furniture between 1773 and 1779. The payment of a commission of £275 to Johnson suggests that the building cost about £5,500, a saving of about £200 on the original estimate.[9] In 1778 Johnson exhibited a 'View of Terling Place, the seat of John Strutt, Esq.', perhaps to be identified with that now at Terling Place.[10] Alterations under the direction of Thomas Hopper (1776–1856) began in 1818 with the construction of wings, involving the demolition of Johnson's offices and stables.[11] The work on the main block involved two-storey extensions to the north-west front, converting it into the present entrance. Details of the scheme were still being discussed in December 1819, but progress may have been made the following year.[12] Interior alterations involved the destruction of Johnson's staircase hall as a result of the creation of the saloon, and throwing two rooms together to provide a new dining-room in place of the one which was enlarged to form the library.[13] The striking frieze of plaster casts from the Elgin marbles, made by Westmacott, was inserted in the saloon in 1823, although the late Rupert Gunnis pointed out the close affinities to the frieze of 1838 by John Henning, sen. (1771–1851) in the staircase hall of the Royal College of Surgeons, Lincoln's Inn Fields.[14] The treatment of the original entrance front was not finalised until after September 1821 when Col. Joseph Holden Strutt (1756–1845) suggested 'Three Quarter Columns' would be preferable to pilasters, querying whether 'the Capitals to the Columns [could] be bought Cheap as probably they may be of the same size as some that are made for the Regent Street.'[15] When Hopper placed the four

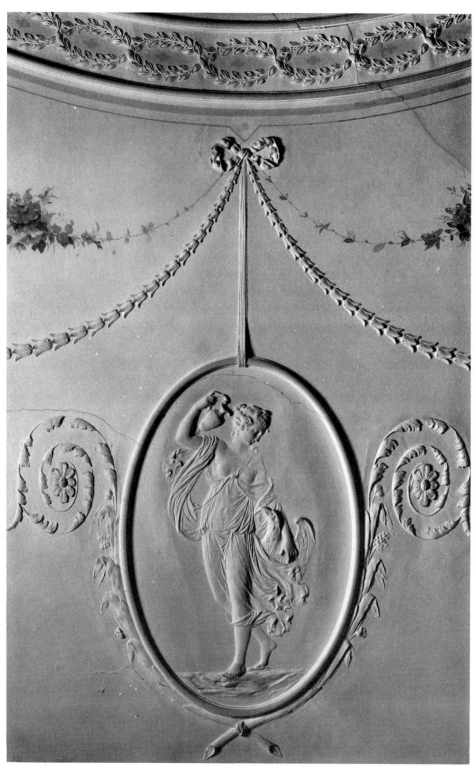

Terling Place, ceiling (detail), drawing room

Ionic attached columns on the first floor, he raised the pediment to the level of the parapet and inserted a cornice above the capitals. The existing round arches were faced with stone and given moulded keystones, and the original central door altered to a window.[16] (*Illus. page 21*).

SKREENS, ROXWELL

Johnson's work for Thomas Berney Bramston at Skreens is less well-documented. Alterations may have been made to the fenestration of the garden front of the early Georgian house, especially the removal of the Palladian windows under the pediment; an entrance porch was added before 1837. Correspondence between Bramston and Strutt, c.1769–71, suggests that the building work included new stables and offices. Materials were also discussed; in April 1771 Bramston was thinking of mixing one 'waggon load of the white earth . . . with my *common* earth' to 'make 2000 good white bricks'; a small quantity of cornice bricks was also required for Skreens. Strutt's accounts also record the sale of surplus stone to Bramston for £26 19s.[17] The house was enlarged and the interior remodelled for W. O. N. Shaw c.1910; it was demolished c.1920.[18]

CASTLE ASHBY, NORTHAMPTONSHIRE

The rebuilding of the two-storeyed Elizabethan Great Hall at Castle Ashby, after its collapse in the spring of 1771, provided Johnson with his first commission in Northamptonshire. The client was the 8th Earl of Northampton. Johnson visited Castle Ashby for two days in May 'to Survey the House' and again in mid-June 'to Order the Great Hall down'. The design has not survived, but from photographic evidence appears to have been deliberately simple. The ceiling decoration consisted of a frieze of olive leaves surrounding oblong panels with festoons and square panels with a circular motif and fans in the corners. The wall treatment was confined to pilaster strips and anthemion friezes at first-floor level and below the galleries at each end, which were supported by wooden columns painted to resemble green marble. The white marble fireplace, with its pairs of Ionic columns with green inlay, was moved to the long gallery during the redecoration of the hall in 1884. Local masons, headed by William White, carried out the work of demolition and completed the rebuilding of the walls in traditional style in the summer of 1772, when new rainwater heads were erected. John Riddey, a plasterer who was paid £51 18s. 1d., came from the adjoining parish of Yardley Hastings. Johnson also provided workmen from London. His first foreman, Henry Willby, died during the summer of 1771; a foreman in charge of the carpenters was paid 13s. 4d. on 15 August 1772, when William Ivory took over, remaining until 18 February 1774. Payments were made in 1772 and 1773 to carvers and gilders (£61 19s.), Mr. Maycock (£49 5s. 6d.) and other London painters (£21). Johnson was also responsible for the design of the octagonal 'tribuna', approached by a staircase from the Hall, later converted to a

billiard room. There are four niches for sculpture, two of which are occupied by Francis Harwood's copies of the Medici Venus and of 'Mars', commissioned by the 7th Earl (d. 1763) and known to have been in the 'Figures Room' in 1774. Four plaster medallions, below a contemporary Doric triglyph frieze and above the panelling of 1892, are characteristic of Johnson's style; the only male subject, Eros, also occurs at Holcombe House (*see below*). The medallions are suspended from ribbon bows, similar to the treatment suggested at Terling Place and at Carlton Hall, where there is a reference to 'large ribbon tyes'.[19]

SADBOROW, DORSET

Sadborow in the parish of Thorncombe, Dorset (originally Devon), designed by Johnson for John Bragge, 1773–75, has been less altered than Terling Place. The house has been described by the Royal Commission on Historical Monuments and by Arthur Oswald.[20] Surviving drawings examined by the Royal Commission show alternative plans and elevations, but reflect the general character of the existing building. The entrance front has the ground floor windows set in blank arcading. A porch was added during the first half of the 19th century when the surround of the original entrance doorway was moved to the north front to form part of a four bay single storey addition; the stone surround has side pilasters, a fluted frieze with discs over the pilasters, and cornice. The south front has a full-height bow of three bays in the centre. In 1843 a two-storey wing was added on the west; the pedimented stone centrepiece in front of this wing is the only surviving part of a greenhouse connecting the house to the offices round three sides of a court, including a drying ground for which levelling was carried out in October 1775.[21] The entrance hall leads into a domed stairhall, approached through a wide elliptical arch springing from entablatures with fluted frieze carried on columns and pilasters with fluted caps.[22] The well-contrived staircase is semi-circular in plan; the stair has plain S-scroll balusters; at first floor level there are two arched openings, one with a balustrade, and a recess. The landing is divided by an open screen of columns. The staircase dome has a circular skylight above plasterwork decorated with panels containing urns and trophies of musical instruments, swags and rosettes (*Illus. page 26*). The north-east room on the ground floor has a screen of two Ionic columns; the frieze is enriched with urns and wreaths. The plaster ceiling in the south-east room, with festoons and roundels containing figure subjects, was altered in the mid 19th century.

Work on taking down the old house and preparing the new foundations began in June 1773, the first stone being laid on 14 July.[23] Johnson visited Dorset in October 1773 and July 1774. Payments to him include £310 14s. for timber, deals and lead in November 1773, just before the new building was thatched for the winter. Total payments of over £1,100 include £200 in August 1775 consisting of bank notes cut in half and sent by post in two instalments, instead of the usual bankers' drafts.[24] The house was faced with Ham Hill stone, obtained

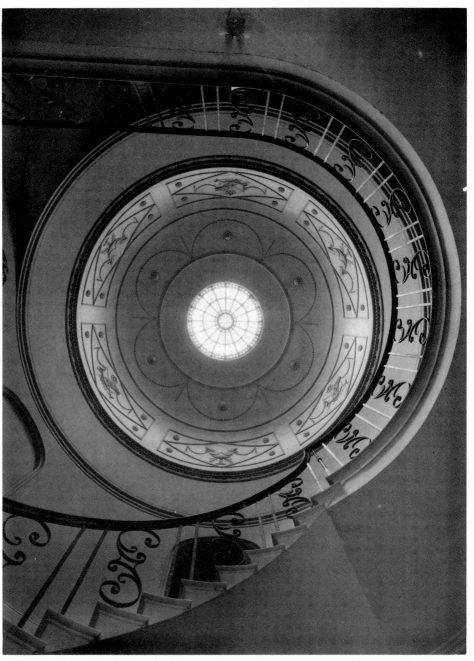

Sadborow, Dorset, staircase dome

by the clerk of works, Jonathan Willis; masons from Ham Hill were paid £45 11s. 1d.[25] Both local (£192 15s. 7½d.) and London (£223 6s. 5d.) carpenters were employed, the latter, presumably provided through Johnson, being employed on cutting and altering mouldings and making 'rules for Doom' of the skylight. The total cost amounted to £2,589 2s. 4½d.[26]

KINGSTHORPE HALL, NORTHAMPTONSHIRE

Kingsthorpe Hall was built for James Fremeaux.[27] Johnson began making journeys to Kingsthorpe in March 1773, but work on the foundations appears to have begun in July.[28] The site lay slightly to the south of the old house, which was not demolished until April 1774. The house is faced in ashlar supplied by William Boswell from the Kingsthorpe quarry, open c.1760–80, and worked by William Hefford and John Abbott.[29] Slates for the roof were purchased from Henry Hind and Richard Lewis, who supplied 'Sweedland slate' at 10s. per square foot. By November 1773 the plumber was 'laying hipps and ridges.'[30]

The ground floor windows are recessed under arches, characteristic of Johnson's elevations. The entrance doorway has an architrave surround under a cornice, shown in George Clarke's drawing, c.1840, before the addition of a modern glazed porch (*Illus. page 27*).[31] The groined entrance hall is well documented (*Illus. page 28*). Johnson's main account, for £331 9s. 9½d., includes the shafts of the columns (£3 3s. 9d.), the bases (£1 9s. 2d.) and the 'fancy caps' to the columns (£2) and refers to the pilasters for the hall having been sent down from London earlier.[32] The carpenters, Benjamin Cuffley and

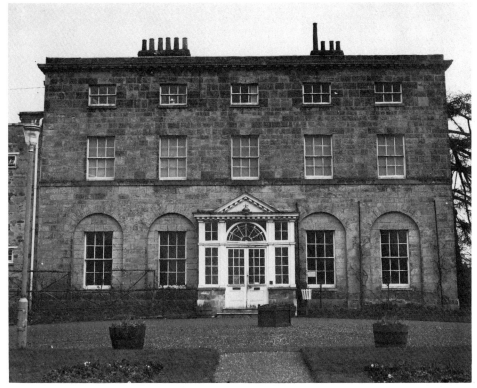

Kingsthorpe Hall, Northamptonshire, entrance front

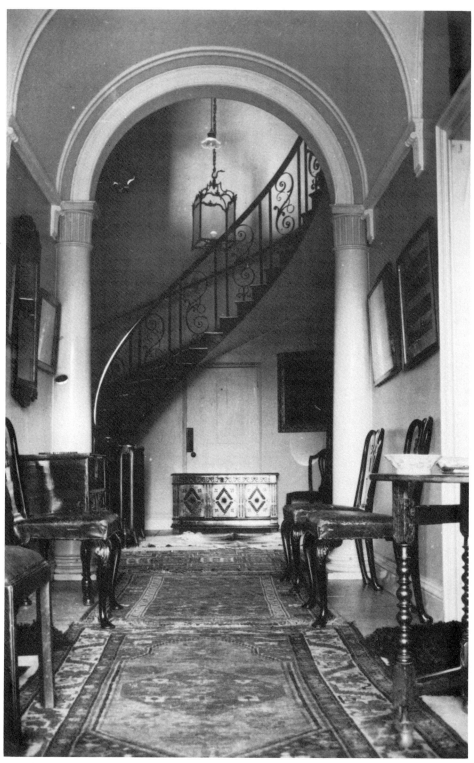

Kingsthorpe Hall, entrance hall and staircase, before 1937

Benjamin Mason, were working on the groins in June 1774.[33] The plasterer, John Utterton of St. Marylebone, who was at Kingsthorpe between April and August 1774, charged 10s. 6d. for a 'Raffle leaf Contreflower very rich 16 ins. Diamr'.[34] The fine stone staircase, leading to a dome with skylight, has iron balusters of the same design as at Terling Place. Johnson's account, however, charges £86 10s. for 'a Clean deal Geometricall Staircase two Storys with a Circular Mohogany handrail, Iron scrole pannels & Iron standards wood Barrs . . . Compleat except Fixing', which cost extra, together with 'getting out and fixing the torus skirting to Do.'[35] The carpenters were altering the landing in June 1774, at the same time as they were getting up the 'Iron Skylight Oak Kirb etc. complete', which had been supplied by Johnson for £6 7s. 6d.[36] The frieze under the dome, similar to that at 63 New Cavendish Street (*cf. Illus. page 11*), may be that described as 'cornice Upper Member dentil and pines frieze of flutes patts [paterae] and wheat in spaces', for which Utterton charged £6 15s. The plasterwork accounts do not include any references to ceilings, although a charge of £1 4s. was made for eight trusses of flutes, husks and bells.[37] Some of the walls were intended to take paper with borders, supplied by Rendall, paper stainer of Castle Street, near Leicester Square, and put up by George Fox.[38] In July 1774 it was decided to take up the floor boards in the breakfast parlour to insert a cold bath; plunge-baths inside the house at this period were usually in the basement or ground floor.[39] Work on the offices and stables took place between April and June 1774.[40] The stables of ashlar with a stone slated roof are of two storeys; the three bay projecting pedimented centre has arches on the ground floor similar to those on the entrance front; there is a Diocletian window in one end wall. Johnson made his final visit to Kingsthorpe in May 1775 and closed the accounts in October. He received commission of £174 9s. on £3,489 11s., which should be compared with James Fremeaux's note in 1791: 'The building of My House out Houses Garden walls orchards planting etc. Cost me full four thousand five hundred pounds'.[41] At his death in 1799, the estate passed to his grand-daughter Susannah, wife of Thomas Reeve Thornton. After the death in 1937 of their descendant, F. H. Thornton, the house became the property of the Borough of Northampton.[42]

CARLTON HALL, NORTHAMPTONSHIRE

Carlton Hall in East Carlton, near the Leicestershire border, is the best documented of Johnson's country houses; it was rebuilt in 1870. It is evident from the accounts, which form the basis of this description unless otherwise stated, that Johnson supplied craftsmen, materials and fittings on a large scale. He was visiting the site with his clerk and making alternative designs for Sir John Palmer, Bt., from 1774, charging for 'making Extra Drawings for Several Designs, before the present were fix'd upon.'[43] Work began in March 1776. William Mayo and Robert Randall accounted for £99 19s. 8d. spent between March and October on payments to 'ground-digers' and labourers, supplied by

Palmer, 'diging out the foundations of his house' and for pulling down and clearing away the 'rubage of his old house at Carlton.'[44] Accounts for repairing plasterwork in the old staircase, old bedrooms and the passage leading to them suggest that part of the old house was retained. Randall remained in charge until at least 30 December 1776 and probably until the end of April 1777, when John Sidway took over, both men coming down from London by coach. Sidway stayed until 23 March 1778, but was allowed time off by Palmer on account 'of my misfortune' in December 1777 and January 1778. William Ivory, Sidway's successor as foreman, is possibly to be identified with the Saffron Walden carpenter and builder, who first appears at Audley End in January 1784 and supervised the second phase of building there.[45] London craftsmen employed at Carlton Hall included Thomas Goodworth, bricklayer, Charles Tomkinson, John Allison and William Moore, all carpenters, Thomas Calvert and Henry Lee, masons, Edward Bellman, plasterer, and the painter, Inkersoll. Local workmen included John Brown and partners, sawyers from Market Harborough, just over the Leicestershire border.[46]

The exterior was recorded in engravings by William Skelton and John Preston Neale, and in George Clarke's watercolour (*Illus. page 30*).[47] The main front had nine bays, the centre five being emphasised by a portico of six Corinthian columns, with two Doric pilasters at each end of the front. An attic storey is visible behind the cornice. Ketton stone was used with a slate roof. Randall had been busy during April 1777 supervising work on the plinth and the bases of the columns and pilasters; the accounts also mention the end bow, which appears to

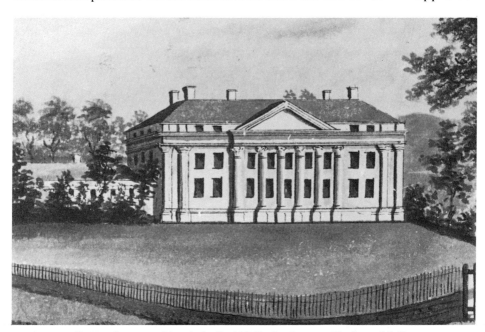

Carlton Hall, Northamptonshire (rebuilt 1870), by George Clarke, c.1840

be visible in Skelton's engraving. 'The Portico Compleat', sent down at the end of April 1778 and erected in May, cost £29 2s. 10¼d. The capitals of the columns of the portico and the pilasters were painted and could perhaps have been Coade stone, like the 'Artificial stone ornament in the Pediment', which cost 12 guineas; no indication of its design is given in the accounts.[48] The use of old stone and of the client's rough stone 'in the basement storey' is mentioned in the accounts and correspondence.[49] Probably only the main elevation was faced with stone. In May–June 1779 Timothy Langley, the smith, was making rakers 'to Rake the Mortar out of Brick Joints for Stucco.'[50] There are references to 'Barrow Lime Stucco' during May–September 1779 and April–June 1780.

The entrance hall had six columns and two pilasters 'with Enriched Capitals' sent 'compleat' in April 1778 at a cost of £41; the ceiling was probably groined. The geometric staircase, lit from a dome, must have been characteristic of Johnson's work. The bill for ironmongery sent down to Carlton in March 1779 included 63 iron staircase bars, one 'Knewill bar with brass base to do', 26 'Scroll Honeysuckle Pannels' and five more 'curved on plan'; all 31 honeysuckle scroll panels were painted. The attic stairs were deal on a 'geometrical plan with moulded nosings'. Three 'Circular Iron Skylights with the Glass cut for Do. and painted' cost £28 18s. 5d., suggesting that the secondary staircases were also top-lit.[51] The plumber's accounts give dimensions of the three lights broken in carriage and of a further three blown out in an 'Extraordinary High Wind.'[52] The main dome probably had a cornice of flutes and paterae as at 63 New Cavendish Street (cf. Illus. page 11).

By 1820 pictures were displayed in rooms on either side of the hall as well as in the library and little drawing room. The principal dining room and drawing room were well proportioned and of large dimensions.[53] The drawing room had a 'rich ornamented ceiling', costing £35, and may also have had a recess with columns and pilasters with 'large richly ornamented capitals'. The 'Statuary Marble Chimney Piece with fluted Frize Roman Pot Tablett Enrichd Oval Pateras over plain pilasters & Moulded Architrave Including black Marble Covings & vein Slab', which cost £46, was probably in this room. The dining room cornice had 'flutes' and 'tongues' and a 'facia' in green. The chimneypiece, costing £56, is described as

> Statuary Marble Ionick Pilasters, fluted with Siana Blockings carved with a Vase & inlaid with Siana; 5 Carved Patera's in frize & the interspace fluted with Siana; Cornice enrich'd with a Carved Bead & Dentils inlaid with Siana; Architrave dotted with Siana; Statuary Slab, black marble Covings &c.

The painter's bills contain references to the colour schemes in both these principal rooms. The ceiling 'pick'd in fine Sky Colar' may be the elaborate one in the drawing room. Cinnamon, sometimes finished with lake, was used with white mouldings. Elsewhere, stone colour or green was favoured in conjunction with white. The study, perhaps identical with the library of c.1820, had an elaborate picture frame painted in green and '3 busto's Painted & Varnish'd'.

The bookcase, described as having an entablature with 'Frize ornamented with Flutes and Tongues' and an open pediment, was probably in this room.

The plasterer's bill, totalling £622 8s. 10d., gives considerable detail of the decoration, without specifying individual rooms.[54] The 'Four Medallions enclosed in frames', possibly associated with '8 Large Ribbon Tyes', may have decorated the walls of the dining room, as at 63 New Cavendish Street and 38 Grosvenor Square, although the documented examples of this type at Hatfield Place, Hatfield Peverel, are described as 'large Medallions' (*see Chapter 9*).[55] Friezes included flutes, cables and paterae, 'richly ornamented Vase Foliage Thyris [thyrsus]', perhaps intended for the dining room and similar to that at Holcombe House, grotesque figures, dolphin and lyre. Fittings, apart from 14 chimneypieces including those for the hall (£8 8s.) and Sir John's dressing room (£14 11s.), varied from doors, some folding, shutters, various mouldings, window sashes and frames to 'a Marble Bason with Brass work Compleat for the Water Closett' (8 guineas).[56]

Johnson exhibited an elevation of the lawn front, which may have had a Venetian window, in 1778.[57] The Palmer family probably moved into Carlton Hall in May 1780, when household goods were unloaded from London.[58] Johnson visited the house to close the accounts in September 1781, the final payment being made in October 1782. The total cost was £7,400, on which Johnson received £370 commission. His clerk explained that the total cost included 'the Nominal Charges of Brick, Lime, Sand and Oak Timber', allowing the client 'the Nominal Value for the Lime & Sand used by the Plasterer', 'exclusive of the Rough Stone of your own used in the Basement Story; and of the amount of the Stuccoing the outside of the Building for which articles Mr. Johnson ordered me to make out no Commission'. The instructions about the stucco may be connected with the patent case (*see Chapter 3*), or, more probably, because he was supplying it himself. Johnson took ten pictures, valued at £50 10s., as part of his remuneration.[59] Two or three rooms were added to the north wing c.1820.[60] The house was rebuilt in Italianate style with French pavilion roofs in 1870 to the designs of E. F. Law.[61]

PITSFORD HALL, NORTHAMPTONSHIRE
Pitsford Hall is listed by Nichols as designed for Colonel James Money (d. June 1785). Not far from Kingsthorpe, it may well have been built c.1775. Baker's description of 'a handsome house with detached offices' corresponds to George Clarke's drawing of c.1840 (*Illus. page 33*).[62] During the ownership of the Money family, the house was occupied by tenants.[63] It was purchased by Henry Lloyd, c.1886. A plan made in March 1887 suggests that the house was probably then in its original state, consisting of five three-storeyed bays above a basement on the south front, with two-storeyed canted bays on the east and west fronts. From the existing front door, a groined vestibule led to a geometric stair on the right hand side of the rear hall; a service stair was placed to the left of the vestibule. Clarke's

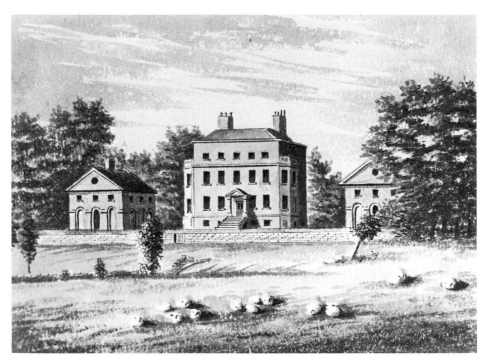

Pitsford Hall, Northamptonshire, by George Clarke, c.1840

drawing shows no windows under the typical recessed arches of the ground floor of the detached service blocks. Lloyd consulted the Northampton architects, Law and Harris, who added a two-storeyed staircase bay on the north front; the original staircase was re-used with new oak panelled spandrels. Between 1887 and c.1895 a two-storeyed addition was made at each end of the south front, but Lloyd remained anxious to obtain larger rooms. This was achieved in 1898 by the extension of the basement, first and second storeys at the rear of the building to form a new dining room on the west and a new drawing room on the east, with bedrooms and a dressing room above. There was an emphasis on conformity with existing work, including the re-use of old windows. Connecting walls were built between the house and the service blocks, into which windows were inserted before c.1910.[64] Further work was carried out before 1913, when the house is described as 'recently done up and altered'. A bay was added at each end of the south front; the ground floor then comprised a lounge hall in addition to four reception rooms. The windows of the rear staircase were altered to a tripartite design, so the main staircase may have been moved to its present position as early as c.1910.[65] Major alterations were made in the 1920s for George Henry Drummond, who had purchased the property; the ends of the north front were raised to three storeys and a two-storey wing added at the north west end. The opening up of the three centre bays of the top floor of the garden front may belong to this period. The interior was redesigned in early Georgian style.[66] After World War II the house was used until 1985 as a school by the Polish order of the Holy Family of Nazareth, who erected a dormitory block in 1966, entailing

the demolition of the original west service block.[67] Northamptonshire Grammar School, an independent boys' school, was opened in Pitsford Hall in September 1989.[68] The centre five bays of the south front, with its contemporary doorcase and the east service block, are all that remain of Johnson's original design. The wrought-iron balustrade, of S-scroll type, may possibly have been re-used in the present wooden staircase, but the balusters appear to have been designed to be bolted to wooden treads, rather than to be sunk in stone.[69]

WOOLVERSTONE HALL, SUFFOLK

William Berners (1709–83), with whose London development Johnson had been associated since 1766 (*see Chapter 1*), purchased the Woolverstone Hall estate c.1773. A new house, designed by Johnson, was erected in 1776; stucco is known to have been used on the building early in August (*see Chapter 3*).[70] The house is not otherwise documented, apart from the unsigned and undated plans at the house in 1977. Johnson exhibited a drawing of Woolverstone Park at the Society of Artists in 1777.[71]

The design of Woolverstone Hall is more ambitious than most of Johnson's exteriors; it consists of a pedimented seven-bay centre block of Woolpit brick with Coade ornaments, faced with Portland stone on the ground floor, and one-and-a-half-storey wings. These wings are shown on the plan (*Illus. page 35*), but were almost certainly refaced and provided with attached Roman Doric porticoes by Thomas Hopper in 1823. Hopper was also probably responsible for the one-storey ranges on the garden front linking the house to the wings. Single bay two-storey blocks, not shown on early photographs (*Illus. page 34*) were added to the centre range early in the 20th century. The garden front has a central bow window (B on plan), but the bow windows of the study (A) and dining room (C), shown on the plan, were probably not executed. Johnson's quadrangular brick stable block, probably on the site of the earlier house, has an entrance archway faced in Portland stone with Coade keystone and paterae, surmounted by a Victorian watertower.

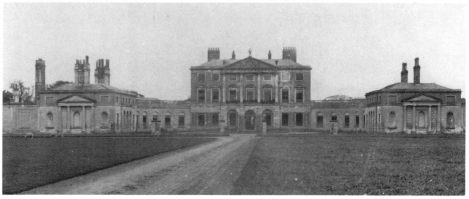

Woolverstone Hall, Suffolk, entrance front

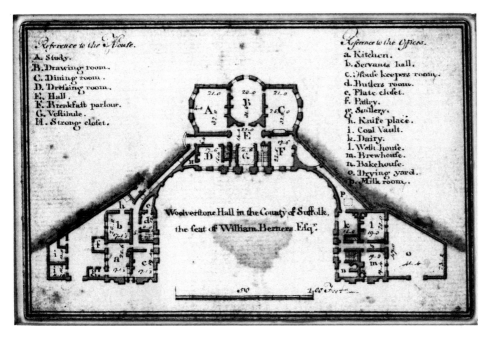

Woolverstone Hall, ground floor plan

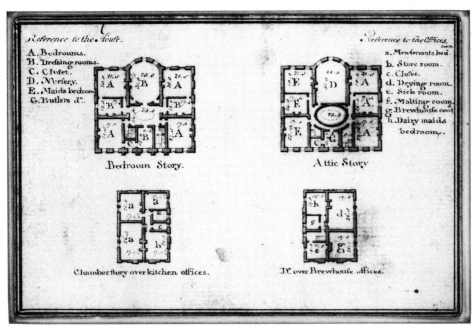

Woolverstone Hall, plan of upper floors of house and offices

The plan, with staircases on either side of the vestibule (G), placed the dome in the centre of the attic storey, in the position occupied by the hall (E) on the ground floor. The lower part of the dome has alternate oval and rectangular plaster panels, below a characteristic bold acanthus frieze. For the main staircase, Johnson used his favourite honeysuckle scroll balusters. The coved vestibule and hall are decorated with oval medallions of female figures. The laid-out plan of the hall and vestibule shows these medallions and also indicates that the niches flanking the door to the drawing room (B) originally contained statues.[72]

Two of the ceilings on the ground floor (B, C) were designed by Johnson; in the dining room (C) the treatment of the panels radiating from the central motif (*Illus. page 37*) is comparable with the first floor ceilings at 38 Grosvenor Square (*cf. Illus. page 7*) and 63 New Cavendish Street. Upstairs, in the dressing room (B), the bow and arrow and quiver and torch motifs, also used at Holcombe House and Langford Grove, are echoed in the painted Pompeian chimney-piece.[73] The treatment of the niche in the dining room (C) is reminiscent of that at 63 New Cavendish Street. The white marble chimneypiece in the dining room is virtually identical with that at 38 Grosvenor Square (*cf. Illus. page 6*). The chimneypiece in the study (A) has the same tablet, frieze and surround as that in the first floor room in the same house.

The Woolverstone estate remained in the Berners family until 1937, when it was sold to Oxford University. In 1947 London County Council established the London Nautical School there. The school was reorganised as a secondary boarding school in 1951, the Hall being purchased by the London County Council in 1958. Woolverstone Hall School closed in 1990, and will be occupied by Ipswich High School for Girls from September 1992.

HOUSES IN WALES

Johnson designed two houses in Glamorgan for copper magnates. Clasmont, near Morriston, was built for John Morris, probably in 1775 after his marriage the previous year, while Gnoll Castle, near Neath, was remodelled for Herbert Mackworth after the creation of his baronetcy in 1776. Since Mackworth had been associated with Johnson since 1767, he may well have been responsible for the architect's introduction to Morris.[74] A visit by Johnson to Wales in early November 1780 cannot yet be related to a specific building.[75] Johnson's reference to the architect, William Edwards (1719–89), informing him that he had never 'received any instructions respecting his profession, except in Common Masonry' before he built the bridge over the River Taff at Pont-y-Pridd, Glamorgan, in 1756, indicates that the two men must have met, probably when Johnson was working at Clasmont.[76]

De Cort's watercolour of Clasmont, 1792 (*Illus. page 38*), shows a three-storeyed symmetrically fenestrated house with low flanking pavilions linked by screen walls. The ground-floor fenestration is typical of Johnson's style.[77] As a result of pollution from the copper works, Morris abandoned Clasmont and

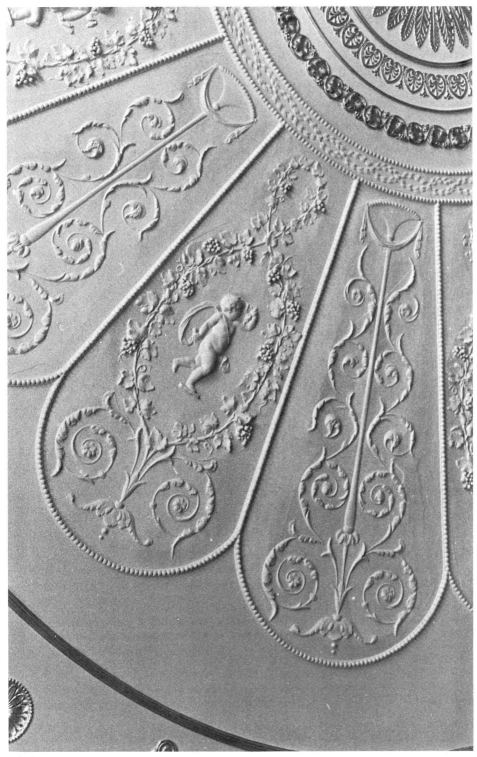

Woolverstone Hall, ceiling (detail), dining room

Clasmont, Glamorganshire (demolished), by H. de Cort

moved to Sketty Park House, near Swansea, in 1806; the shell was demolished in 1819. The new house, built by William Jernegan (c.1751–1836) is said to have been constructed with the materials of Clasmont, but the interior does not seem to have been recorded prior to demolition in 1975; the blind arcading on the entrance front is reminiscent of Johnson's work.[78]

The remodelling of Gnoll Castle was completed by 1778, when Johnson exhibited a view of the lawn fronts.[78] He added a castellated west wing containing a 'commodious suite' of reception rooms to the older north wing, which became the entrance front; he also retained an older service wing. The new wing had typical ground-floor windows set in recessed semi-circular panels in the centre block, between round corner towers (*Illus. page 38*). Copper glazing bars were doubtless supplied by Mackworth's Gnoll Copper Company. The interior has not been well recorded, although a newspaper article of 1911 refers to 'Adam' decoration, especially in the drawing room, and to a central top-lit staircase with mahogany rail.[80] Johnson's son's firm supplied for the Gnoll 'a neat fram'd Altar Piece', painted grey and white 'with Etruscan Tablet compleat' for eleven guineas in August 1786.[81] An inventory of May 1853 does not list a chapel; the reference to an organ loft could relate to the saloon or music hall. The inventory also includes a Gothic room, lobby and drawing room, which may perhaps be contemporary with Johnson's castellated facade.[82] After Sir Herbert's death in 1791 the house was not occupied by his widow, whose second

Gnoll Castle, Glamorganshire (demolished), from an estate map of 1812

husband, Capel Hanbury Leigh, sold the estate to Henry Grant. After Grant's death in 1831 his eldest son, H. J. Grant, may have been responsible for the recent modernisation mentioned in 1847; this may have included the 'noble Grecian colonnade' on the entrance front and the removal of the castellation, which took place prior to the demolition of half of Johnson's west front in 1881, in order to reduce the rateable value. The house was demolished c.1956, but the castellated entrance with twin lodges has been preserved.[83]

A design for a gentleman's seat in Carmarthenshire, exhibited in 1783, may not have been executed. There does not seem to be any evidence for the attribution of Dolforgan Hall, Montgomeryshire, c.1800, to Johnson.[84]

HOLCOMBE HOUSE, HENDON, MIDDLESEX

In 1778 Johnson exhibited the plan and elevation of a villa on Mill Hill belonging to J. W. Anderson, which has been identified as Holcombe House, The Ridgeway, Hendon, probably built in 1775. Anderson (d. 1813) was created a baronet on becoming Lord Mayor of London in 1798. The house became part of St. Mary's Abbey in 1881 and was used as a convent school; it was purchased by the Missionary Institute London in 1977.[85] The two-storeyed entrance front has a rusticated ground floor with a central semi-circular porch between windows with Coade keystones set in recessed arches. The stuccoed first floor has pairs of fluted pilasters at either end and between the three windows; there is a modillioned cornice and balustraded parapet. The elliptical staircase hall has a geometric stair with honeysuckle scroll balusters.[86] The groined lobby has small plaster medallions.[87] It leads to a room on the right with three fine plaster panels: Eros, over the chimneypiece (*Illus. page 39*); a female figure, possibly a muse, holding a mask and trumpet, accompanied by a boy with a wreath; another female figure pouring liquid into a lamp or urn on an altar (*cf. Illus. page 145*).[88] The frieze has an urn and thyrsus motif. The ceiling of simple design has radiating petals round a central motif.

The present dining room has a more elaborate frieze with sphinx and urn and dolphin and pillar motifs (*Illus. page 40*), echoing the semi-circular ceiling panels with dolphin and pillar between mermaids, almost identical with those at 38 Grosvenor Square, which alternate with oval painted panels of the muses. The ceiling design is completed by three plaster panels containing a Neo-classical urn with arabesques, a quiver and torch, and a bow and arrow, similar to the treatment of the dome and the dressing-room ceiling at Woolverstone Hall.[89]

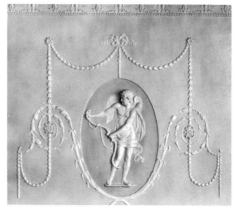

Holcombe House, Hendon, Eros, ground floor rear room

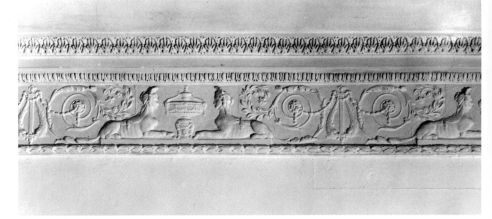

Holcombe House, frieze, dining room

BURLEY-ON-THE-HILL, RUTLAND

The dozen designs exhibited by Johnson in 1778 include a 'Capital, for a Dining-Parlour, for a nobleman in Rutland'. George Finch, 4th Earl of Nottingham and 9th Earl of Winchelsea, inherited Burley-on-the-Hill in 1769 and carried out alterations to the interior, c.1770–74. The work probably included the present dining room, which was certainly executed before 1788. The decoration of the whole room, said to have been restored to the original state after the fire of 1908, is characteristic of Johnson's style[90] (*Illus. page 41*). The plaster figures of Bacchus and Ariadne over the chimneypiece are almost identical with those at 63 New Cavendish Street (*cf. Illus. page 10*), although the surrounding scrolling foliage is more elaborate and carried up higher. The chimneypiece is similar to the less elaborate examples at Woolverstone Hall and 38 Grosvenor Square. A screen of two fluted columns and two pilasters has Composite capitals with the Ionic volute composed of corn husks with a central patera above acanthus leaves, for which the design could well have been considered worth exhibiting. The capitals support a frieze of cables and paterae, used by Johnson at 63 New Cavendish Street (*cf. Illus. page 11*) and elsewhere. The ceiling design is virtually identical to that in the first floor front room in the same house, with a central medallion of Venus and Cupid, although the latter is standing at Burley; the radiating petals have small cupids, as at Woolverstone Hall (*cf. Illus. page 37*). The small cherubs' heads incorporated in the design are not typical of Johnson's ceilings and may be the result of restoration work.

KILLERTON, DEVON

In 1775 Sir Thomas Dyke Acland, 7th Bt., of Killerton in Broadclyst, had commissioned from James Wyatt a design for a grand mansion in a prominent position on the top of a hill in the park. Although revised contract drawings were dated April 1778, Acland proceeded to employ Johnson to design a temporary building on the site of the old house on lower ground. Johnson may well have been recommended by Sir Charles Bampfylde. By July 1778 the local builder,

Spring, was taking measurements on the site. The work was expedited by the use of some old foundations and materials and by the ability of the builder's son to provide additional plans, without calling for Johnson's assistance. By April 1779 the carpenters 'were putting in the skylights in the [upstairs] passage' and 'finishing the Great Parlour'. After the completion of the house in June 1779, work began on the stables, which were finished by the beginning of 1780. While the work was in progress, Sir Thomas' heir died in November 1778 as the result of a duel, which may explain the abandonment of the expensive Wyatt scheme and the retention of Johnson's house as the main family residence until 1939. The estate was given to the National Trust in 1944 by Sir Richard Acland.

The original entrance at Killerton was on the south front; a fine recessed stone doorway, with pediment and columns, led into a corridor with shallow domes on pendentives, which continues into the domestic quarters at the rear. The drawing room on the right was altered in Adam style in 1900, when the main entrance was moved to the east and a single-storey wing added. At this date

Burley-on-the-Hill, Rutland, dining room

Johnson's plain ceilings in the reception rooms were altered and his chimney pieces were replaced. The library (originally the Little Parlour) is opposite the drawing room; original mahogany double doors lead into the dining room (Great Parlour) (*Illus. page 42*). This room retains Johnson's frieze of urns and anthemion with a running scroll, executed by a plasterer named Greenwood, and wooden columns with Composite capitals, carved by 'Mr. Stone of Exeter'. The music room opposite, originally the dining room, was altered c.1830 by the addition of scagliola columns and a bay window. An Edwardian staircase, on the site of Johnson's, leads to his domed upper corridor with its characteristic frieze. The stone stables are on a quadrangular plan; a blind arcade with lunettes flanks a pedimented archway, topped by a cupola. 'This delightful building is Johnson's best memorial at Killerton'; it is now (1991) used as a reception area, shop, tea room, estate museum and garden centre (*Illus. page 43*).[91]

MINOR WORKS AND ATTRIBUTIONS
Johnson must have often been asked to carry out alterations or repairs to existing houses. His work at Finedon, an Elizabethan mansion in Northamptonshire, for Sir William Dolben, Bt., may have been the result of Dolben being Mackworth's first cousin.[92] On 8 April 1780 John English Dolben wrote, from 19 Berners Street, to his father with the results of a discussion with Johnson. Paper

Killerton, Devon, great parlour (present dining room)

Killerton, stables

was to be pasted directly on to the walls of the Velvet room and drawing room; work was evidently in progress on the cellar windows and the Orange room. 'Mr J. says that the cornice in my Aunts room is as significant as any he has put in Sir J. Palmer's new *bedchambers* and therefore he recommends no better for ours'. A recess was to be fitted up in the anteroom to the Velvet room. Johnson had also made provision for a powdering closet within J. E. Dolben's morning room.[93]

Dolben was probably also in touch with Sir John Palmer, since Johnson arranged for 40 bundles of laths, surplus to requirements at Carlton Hall, to be sent over to Finedon in the autumn of 1780. Work was still going on a year later, when Johnson announced his intention of calling at Carlton after a visit to Finedon.[94] Johnson's work probably did not survive the alterations carried out in Tudor Gothic style after 1835; the house was demolished in 1980.[95]

Johnson's relations with his clients were not always happy, as is evident from Thomas Brograve's saga of the alterations to Springfield Place, an early Georgian house he was negotiating to buy, in the summer and autumn of 1780.[96] On Johnson's first visit on 23 July, he was rather surprisingly accompanied by his wife, but 'was so little prepared for business that he had not his rule with him'. The main alterations were to be made to the windows on the ground and first floors; Brograve agreed that the work should be carried out by London workmen and the new sashes made in Johnson's yard. Suggestions for other improvements made by T. B. Bramston were passed on to Johnson, 'who appeared not to approve them, and seem'd displeased that any body but him self should be consulted'. Work began early in August on the windows and doors at the side, but in September Johnson's London foreman gave the Brograves an estimate for sashes in mahogany instead of wainscot, which another London carpenter considered excessive. When Brograve pointed this out, Johnson took offence. By 22 November Brograve was complaining that after four months' work the job appeared only half done; he had given the foreman notice and was

inclined to call for Johnson's account. Johnson retorted that the client had given him the impression that he wanted 'very little of my assistance with respect to direction . . . I have the Vanity to think that others who have placed a confidence in me, . . . (*some* of which are in your Neighbourhood) have not been disappointed in the Event'. Brograve annotated this with the comment that 'Mr. Harris of Baddow as well as Dr. Pugh think as ill of him if possible as Mr. B.' and then complained that there were so many breaches in the house that 'it resembled Ld. Mansfield's house after the late [Gordon] riots' and that he was afraid to stop work due to the lateness of the season. His lack of confidence in the foreman was due to his denying that some of the new sashes were of inferior glass. Johnson submitted his account, including a charge for surveying and making a plan of the house and a design for altering the drawing room, which Brograve claimed he had not ordered. He continued to demand an assurance that the sashes, which were also ill-fitting, contained London crown glass. In replying on 28 December, Johnson agreed that all except six ovolo sashes had been glazed with the best Newcastle crown glass, generally considered to be superior to average quality London glass. Johnson's offer to join Bramston and Strutt, 'your particular friends and Neighbours', with a professional surveyor in an arbitration was eventually accepted by Brograve. The result of the arbitration has not survived, but the evidence reveals something of Johnson's character and of the extent of his domestic work in Essex before his appointment as county surveyor.

Johnson's correspondence with Brograve includes a reference to his absence in Hampshire early in December 1780. Neither this nor a subsequent visit in August 1787 can be definitely related to any known commissions, although there is an isolated example of the use of honeysuckle scroll balusters on a stone staircase inserted into West Green House, Hartley Wintney, possibly for Colonel William Henry Toovey Hawley.[97] Some evidence is available for other unidentified or unexecuted designs by Johnson. Sir Justinian Isham, who succeeded to Lamport Hall, Northamptonshire, in December 1772, commissioned a plan for making a drawing room in the south wing, later remodelled by Henry Hakewill.[98] In 1778 Johnson exhibited a design for the lawn front of a house for a gentleman in Surrey.[99] This has not been identified; it seems unlikely to have been Belvedere House, Wimbledon (*see Chapter 9*). Undated designs for alterations to Mamhead in Devon for Lord Lisburne are in the Victoria and Albert Museum. Lisburne employed Adam to make alterations c.1777, so the designs must relate to this period or earlier. One scheme provided for the extension of rooms on either side of the hall to convert the existing nine-bay front into eleven bays.[100] The larger scheme retained the eleven-bay front and entailed the creation of a new north front with a central three-bay bow. The elevation, with quoin pilasters at each end, urn finials, and ground-floor windows resting on brackets, does not seem characteristic of Johnson's work.[101] The ground-floor plan shows a geometric stair and a domed passage. Upstairs, there

was a vaulted corridor and the new bow was used as a lady's dressing room. On the attic storey, the servants' bedrooms were lit by 'skylights from the back of the roof'.[102]

East Haddon Hall, near Kingsthorpe Hall and Pitsford Hall, was attributed to Johnson by the late Sir Gyles Isham, who printed the contract between Henry Sawbridge and the builder, John Wagstaff of Daventry, 11 March 1780, which does not mention the name of any architect.[103] The facade is not entirely characteristic of Johnson's work, although features such as the handling of the voussoirs of the ground-floor windows and the adjoining channelled masonry, the detail of the central tripartite window, and the similarity of the original doorway, inside the later porch, to that formerly at Kingsthorpe Hall, may support the attribution. The panels with 'festoons of laurels', specified in the contract, now round the three main elevations, do not appear on Johnson's other country houses, although the engraving of his houses in Southgate Street, Leicester, shows garlands over the end windows and similar fluted string courses (cf. Illus. page 135). The interior, especially the entrance hall and drawing room, was redecorated after 1890. The contract refers to chimneypieces in the drawing room and dining room 'agreeable to designs to be deliver'd by J. Wagstaff', who may well have designed the house. The 'Geomatrical Stone Stair case' is of fine quality, but the pattern of the balustrading does not correspond to that used by Johnson elsewhere in Northamptonshire, although it is similar to that used later at the Shire Hall, Chelmsford (1789–91) and at Broomfield Lodge (1808). The plaster decoration of the staircase walls is to be associated with the work of c.1890, although the treatment of the arches on the first floor is possibly original. The elliptical dome had to be reconstructed during the restoration of 1989.[104]

GARDEN BUILDINGS

Johnson exhibited two designs for garden buildings in 1778.[105] Gervase Jackson-Stops has suggested that the Temple of Pan in the grounds of Sir Charles Kemeys Tynte at Halswell in Somerset may be identified with the bailiff's house at Patcombe in the south-west corner of the estate, near a statue of Pan. This house was erected in 1771, according to the brief memoranda made by the steward, Richard Escott. The building could well have been designed by Johnson; it has a semi-circular Doric porch and characteristic recessed arches, which also occur on the riding school on one side of the stableyard; he may also have designed the three-bay coach house.[106] The grotesque temple for a nobleman in Rutland is not documented, but may be associated with Johnson's work at Burley-on-the-Hill. As at Halswell, Johnson's work at Gnoll, where he remodelled the Ivy Tower on a high bluff at the extreme north of the park, formed part of a larger landscaping scheme carried out over a number of years. The castellated tower, which has Gothic copper glazing bars, used to be occupied as a house, but is now a shell (Illus. page 46).[107] Johnson probably designed the domed Grecian temple in the grounds of Holcombe House, demolished soon

after World War II.[108] His last exhibited design in 1783, the plan and elevation of a hermitage in the gardens of Sir Patrick Blake, Bt., is also undocumented. Johnson had been involved in the development of Blake's town house in Portland Place (*see Chapter 1*); Blake was also associated with Mackworth, who was appointed a co-trustee of his West Indian estates in his will.[109] Recent research on Langham Hall, Blake's Suffolk estate, has not revealed the existence of the hermitage, but the footings of a large stable block of 1770 survive.[110] The pedimented temple in the grounds of Langford Grove, c.1782, and the summer house at Whatton House, Leicestershire, c.1802, may also be Johnson's work (*see Chapter 9*).

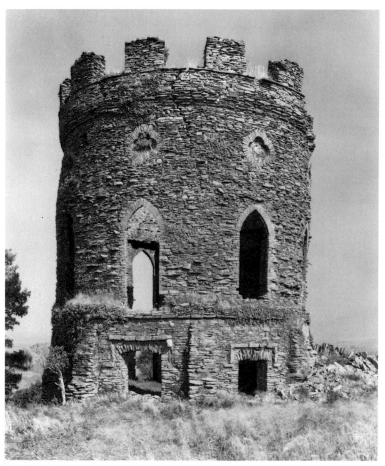

Gnoll Castle, Ivy Tower

CHAPTER THREE

COADE AND STUCCO

J OHNSON SHARED THE contemporary interest in technological innovation, particularly in his extensive use of Coade stone. Besides his patent for composition, dated March 1777 and discussed more fully below, he also took out a patent in October 1779 for securing buildings from damage by fire by laying down thin tiles or slates on the rafters.[1]

COADE STONE

As Alison Kelly has pointed out in her definitive studies of Coade stone and its use by numerous Georgian architects, Johnson had a 'special fondness for Coade stone', using it for the greater part of his career, from 1774 to 1810.[2] Eleanor Coade established herself in Lambeth in 1769. The factory's product has been shown by the British Museum Research Laboratory to have been a form of stoneware manufactured from a ball clay, to which ten per cent of grog (pre-fired clay ground to powder), and up to ten per cent each of flint and fine sand were added, with ten per cent crushed glass as a vitrifying agent; it was fired in kilns at temperatures of $1100°-1150°C$. for up to four days. 'It is the highly vitrified nature which is responsible for the hardness of Coade stone and this in turn is responsible for its resistance to weathering.' The use of moulds for multiple copies of finely-modelled architectural components, although expensive to prepare, made Coade considerably cheaper than natural stone.[3] These qualities would have appealed to Johnson.

In 1774 Eleanor Coade exhibited at the Society of Artists 'a chimneypiece in artificial stone for a nobleman's hall from a design of Mr. Johnson's.'[4] He had just completed remodelling the Great Hall at Castle Ashby, Northamptonshire, for the 8th Earl of Northampton, but the fireplace there was marble (*see Chapter 2*). Alison Kelly has plausibly suggested that this could have been for the Earl of Galloway's house (*see Chapter 1*), although Johnson himself did not exhibit his design for a chimneypiece in the 'drawing-parlour' of the same house until 1778; the design has not been traced in the Coade etchings.[5] The next two examples of Johnson's use of Coade stone are on extant buildings. Woolverstone Hall (1776) shows a full range of architectural details: vases on the pediment, one ingeniously used as a chimney pot, modillions, a large circular medallion of Diana the Huntress, with bow and hound, between festoons in the pediment, frieze, paterae and balusters. The four capitals of the columns under the frieze have been identified by Alison Kelly as no. 162 in the Coade etchings (Ancient Ionic), with the volutes crossways fluted with a single line of beading and a small flower in the centre of each volute. There is also decoration in the blind arches

over the three centre windows consisting of sphinxes and an urn (*Illus. page 34*).[6] Johnson also provided a bearded head Coade keystone and round and oval paterae on the stables.[7] At 61–63 New Cavendish Street, he used an interesting variant on the Bedford Square doorways; three arches, with bearded head keystones, are set side by side, the centre one forming a window (*Illus. page 8*). Johnson may have seen another variant used in Stratford Place (1773), where a doorway to the right of two windows, similarly linked with rusticated blocks, is recorded in the Coade etchings (no. 476).[8] Carlton Hall, like Woolverstone Hall, had an 'Artificial Stone Ornament in the Pediment', costing £12 12s. in April 1778.[9] Holcombe House, exhibited in 1778, has the popular keystones with the draped lady's head (no. 450 in the Coade etchings). At Bradwell Lodge (1781–86) two elaborate Coade urns on pedestals were placed in niches on either side of the Venetian window in the main block; vertical oval paterae were used above the entrance (*Illus. page 139*).[10] Johnson used another variant of the Bedford Square doorway at Langford Grove (1782). There is a bearded head keystone and guilloche impost blocks, but the voussoirs and main blocks are not rusticated and may not have been Coade. Alison Kelly has not traced any other examples of this type of doorway being used for country houses. As the house was demolished in 1952 it is no longer possible to determine whether features such as the paterae and capitals on the centre tripartite windows of the garden front and the urns on the link buildings were also Coade.[11] Johnson may have himself worked in Bedford Square (*see Chapter 1*). The little building built c.1782 at the rear of no. 19 makes extensive use of Coade on the elevation for imposts, tympanum decoration, keystone (no. 460 in the Coade etchings) and string course.[12] The best-documented examples of Johnson's use of Coade belong to his work as county surveyor. For Moulsham bridge, E. Coade, Artificial Stone Manufacturer, supplied in March 1786 '4 Oval Patera with River Gods Head in Centre' at £3 10s. each and in August '72 Ballust' at 7s. each and '24 Halves do.' at 3s. 6d; they were packed in nine crates, the cost of which with lighterage and shipping amounted to £3 12s. (*Illus. page 49*).[13] As at Woolverstone Hall, Johnson made extensive use of Coade features on the facade of the Shire Hall, pointing this out in the introduction to his *Plans*, published in 1808 (*see Chapter 6*). The bill, dated March 1790, from the Ornamental Stone Manufactory, Lambeth, for £105 10s. gives details of the work entailed, and can be related to features shown in Plate XIII of Johnson's *Plans* (*Illus. page 99*). A charge of £2 2s. was made for 'modelling & moulding 3 large Corinthian Modillions'; 68 of these at 5s. each and 28 'Raking Do.' at 6s. 6d. were supplied for the cornice and pediment. Four 'Ionic Cap. for Column for the [tripartite] Windows' at 45s. each and four for the pilasters at 14s. must have been stock items, but the large Ionic capitals appear to have been a variant on no. 162, with specially modelled necking of acanthus leaves, since a charge of £29 8s. was made for 'Modelling & moulding . . . Fan in the Volute, Beads round Necking wth Leaves' and making four capitals, 2'6" in diameter and 2'10" high (*cf. Illus. page 99*). Forty balusters at

Moulsham bridge, Chelmsford, Essex

Moulsham bridge, Coade patera with river god

Moulsham bridge, keystone

4s. 6d. and ten halves at 2s. 6d. were used below all windows on the first floor. The three centre windows had trusses at 16s. each, which are to be identified with no. 507 in the Coade etchings. There were also '20 Pateras for Windows 5¼ modelled' at 2s. 6d. each.[14] The fine Coade plaques of Mercy, Wisdom and Justice were modelled by John Bacon, R.A., who had been closely associated with the factory since 1775. The design is a variant on the Coade reclining lady theme, but this set of plaques is the only one specifically associated with Bacon's name and is modelled in much higher relief than usual; the figures lean forward a little so as to correct the perspective for the viewer on the ground (*cf. Illus. page 99*). The first account included a charge of £21 for 'modelling large Emblematical Pannell of Wisdom consisting of 2 figures in alto rel', measuring 5 feet 6 inches by 4 feet 6 inches. Johnson reduced this charge to £17 10s., which was the price for modelling the panels of Mercy and Justice in August/September 1790, plus a charge of a guinea, also rejected by Johnson, for modelling the sword and beam scale for Justice.[15] The commission for the panels caused problems both for Mrs. Coade and the contractors. In August 1790 the masons spent ten days 'unloading getting up and setting centre figure of Artificial Stone and Capitals to front of Building', with a further four and three quarter days on the other two figures. The panels must have been returned to the factory at some stage, since a further eight days in September was spent on 'unloading preparing and setting up Artificial stone figures in front.'[16] The total cost of the plaques is not extant, but can be estimated by adding the cost of modelling to the charge of £94 10s. for three identical plaques for County Hall, Lewes, Sussex in 1809 (*see below and Chapter 6*). The firm received compensation of £10 from the Essex justices in July 1792 'for the extra Expenses incurred in executing the 3 Pannells'; this was acknowledged by John Sealy, on behalf of Mrs. Coade.[17] The pair of royal arms supplied for the courts, which cost £27 6s., do not appear to have survived Victorian alterations to the interior[18] (*Illus. page 102*).

Johnson's rebuilding of Wimbledon church, Surrey, 1787–88 (*see Chapter 8*), incorporated 'Gothic pinnacles of artificial stone' on top of the square wooden tower at the west end.[19] According to Croggon's day book, a replacement pinnacle was supplied in September 1818.[20] Coade was also used for the conduit at Chelmsford, c.1792 (*see Chapter 6*); the firm charged £108 12s. for a large statue of a standing naiad (*Illus. page 110*). The high price, comparable with that of 100 guineas in the Coade catalogue for a nine-foot figure of a River God, is not surprising in view of the size of the conduit, measuring approximately 13 feet overall, the naiad herself being nearly 6 feet tall; Coade girls were usually 4 feet 6 inches. The factory made a reclining water-nymph intended for a fountain, but the standing naiad was a special commission.[21] The use of Coade on the facade at Hatfield Place, Hatfield Peverel, 1791, is not documented by surviving bills from the factory, although Johnson's account refers to keystones of Pomona and Flora; these are marked COADE 1791. There are also four pairs of Coade pilasters with defective foliate capitals and a Coade frieze with paterae

(*cf. Illus. page 143*).[22] The closely-related unexecuted design for refronting Thorpe Hall, Thorpe-le-Soken, 1782, has the same foliate capitals and frieze with paterae; the cornice is surmounted by four handsome urns with finials (*Illus. page 141*).[23] Johnson's own house at 53 High Street, St. Marylebone, had a Bedford Square doorway with Jupiter keystone, probably erected when he moved there in 1792; the keystone is now in the Dickens Museum, Doughty Street (*see Chapter 1 and Illus. page 16*).[24]

The County Rooms, Johnson's most important work in Leicester (1799–1800) has a facade resembling his other public buildings (*cf. Illus. page 137; see Chapter 8*). Two plaques of the Borghese Dancers, one of Coade's most popular designs, are placed above the first-floor niches. The three tripartite windows have small paterae in the frieze and small Ionic capitals, with balusters below. The aedicules of the niches have friezes with paterae and trusses with squeezed female faces.[25]

The disastrous collapse of the nave of Chelmsford church on 17 January 1800 provided Johnson with an opportunity for the structural use of Coade stone (*see Chapter 8*).[26] He decided to deal with the collapse of the south arcade by using Coade pillars, matching the mouldings of the original 15th century columns. The order for the three Gothic columns was placed in May 1801 and completed by 13 July.[27] In response to the trustees' concern about an anonymous letter, John Sealy wrote to Johnson on 31 August, pointing out that the Gothic screen at St. George's chapel, Windsor, had proved its load-bearing capacity since 1790.

With regard to those at Chelmsford, if properly set and filled in, I have not the least shadow of a doubt but they will stand for ever – a Core, of some sort, of course, is carried through them, either rough pieces of Stone or Brick work – and that grouted in properly, and there is not the least Danger of their bearing any weight.

Sealy charged twelve guineas each for the columns, and £1 for his mason assisting to reset the columns for four and a half days.[28]

The clerestory windows were also replaced in Coade at a cost of nine guineas each; they were ready at the same time as the columns, the total order weighing about eight tons.[29] There were also two 'large Gothic Windows with bold Architraves and Sills' at 55 guineas each, a reduction from the original price of 60 guineas. The trustees had decided that two original windows taken out of the south wall should be reused in the north wall; two new Coade windows were 'to be made on a similar construction' and placed in the south wall; one of the old windows was sent to Lambeth as a model. Two further Gothic windows costing ten guineas each were supplied in 1803, probably for the north chancel aisle.[30]

The restoration included a Coade stone font. Johnson showed the trustees a print of a font, probably that surviving at Debden, and also mentioned seeing one at Coade's Gallery, where it was priced at £30. The trustees only intended to pay £6 or £7, 'but on the recommendation of Mr. Johnson if you will engage to furnish them with one at *Twenty five pounds* agreeable to the one in your Gallery leaving out the figures . . . they will be induced to go to that price.'[31] The font

arrived without a top; when this was sent in May 1803, the trustees objected to an additional charge of five guineas.[32]

Almost all of the Coade used in Johnson's work has survived subsequent restorations. The junction of the Coade pillars in the south aisle with the original stone bases can be clearly seen, together with the clerestory windows and the two in the south aisle, on the right of the porch. The font was replaced in 1869; it languished in a builder's yard until presented by the architect, Frederic Chancellor, to St. Peter's church, Primrose Hill, in 1892. On the demolition of St. Peter's, the font was transferred to the Chelmsford and Essex Museum, where it is on display. There are Tudor roses on the cusped panels of the bowl; it is inscribed COADE & SEALY LAMBETH 1803 (cf. Illus. page 130). The Coade cover has not survived; it is not shown in an engraving of the church in 1850; a terracotta cover, later replaced by a wooden one, was made for St. Peter's.[33]

Johnson's use of Coade entailed visits to Lambeth and discussions with Sealy. On 13 April 1805, as county surveyor, he went to the 'Lambeth Stone Factory re County Arms.' This had been ordered for the house of correction at Chelmsford; eighteen guineas was charged for 'modelling large Coat of Arms on a Shield Bearings 3 sabres etc.'[34]

County Hall, Lewes, Sussex (1808–1812), Johnson's last public building, repeats a number of Coade motifs from the design of the Shire Hall (see Chapter 6; Illus. pages 99, 111). 60 modillions, identical with those at Chelmsford, were supplied for the cornice at 2s. each. During repairs in 1958 one had to be replaced in Portland stone.[35] The plaques, invoiced as 'Wisdom and Boy, Justice and Boy, Mercy and Boy', cost £94 10s. and had to be fixed by Coade and Sealy's man.[36] When repairs were carried out, the central figure of Wisdom was found to be insecure, revealing the honeycomb construction of the back; one of the ribs forming an anchor for the top cramp was completely broken. A new Portland stone arm had to be provided for the left hand figure of Mercy.[37] The ten impost trusses, at one guinea each, and the 40 balusters are identical with those at Chelmsford, but the treatment of the first floor windows was varied by the use of the squeezed 'female head blocks' under the trusses; these are marked COADE & SEALY LONDON 1808 and are identical with those at the County Rooms, Leicester. The '12 oval Pateras Apollos Hd. in Centre Enriched ovolo Moulding Leaves etc. Moulded for plaster cast' at a charge of twelve guineas, may have been intended for the architraves of the windows or for use inside the building.[38] It seems to have been intended to erect the arms of the county on the entablature of the County Hall. The committee decided on 3 March 1810 to consult Johnson about the propriety of this proposal; should he be in favour, he was instructed to order the arms to be executed in composition or any other material he thought suitable; the work does not appear to have been carried out.[39]

During the restoration of Chelmsford church, Johnson's youngest son, Dr. Joseph Johnson, died at his house in Paddington on 13 February 1802 at the age

of 32. His father chose a Coade monument, which is placed in a niche on the south elevation of St. Mary's church, Paddington Green (*cf. Illus. page 150*). The design is a variant of a popular monument based on Coade's best-selling Vestal; she is shown on the left of a large urn, bearing the inscription:

> *Underneath this Monument*
> *are deposited the Remains of*
> *JOSEPH JOHNSON M.B.*
> *Who died 13 February 1802*
> *Aged 32 years*

The base of the urn is inscribed: COADE & SEALY LAMBETH 1802.[40]

THE STUCCO PATENT CASE

The history of the use of stucco on 18th century exteriors and the background to the case of Liardet v. Johnson, 1778, have been discussed by Frank Kelsall.[41] The role of the case in patent law has been analysed by John Adams and Gwen Averley.[42]

John Liardet, a Swiss clergyman, took out in 1773 a patent for 'a composition or cement for all the branches concerning buildings to which the same is applicable'; this composition was oil-based, in contrast to the simple lime-sand stucco in common use. It was developed commercially in association with the Adam brothers. In 1777 Johnson, describing himself as an architect of Berners Street, patented a 'composition for covering the fronts and tops of houses and for ornamenting the same'.[43] He claimed to have improved on Liardet's composition by adding serum of ox blood; this ingredient was normally used to produce apparent ageing in cement. Since Liardet's composition included lead compounds to act as drying agents, unlike Johnson's specification, it has been suggested that the serum of blood was in fact red lead or potassium permanganate; Johnson, being well aware of their drying properties, could have been trying to deceive the opposition.[44] On 27 May 1777 Liardet and the Adam brothers filed a complaint against Johnson and two workmen in his employ, James Downes and Edward Bellman. Johnson was alleged to have procured copies of Liardet's patent specification, and to have prepared a similar composition, on whose use he had made a profit. He was further accused of offering their workmen rewards for information about the composition. In his reply, dated 2 September, Johnson claimed that Liardet's invention was not original, citing dictionaries of 1751 and 1764 and the patent obtained by Charles Rawlinson in 1772 and claiming that contact with Rawlinson then first gave him the idea of using the ingredients listed in those publications to make cement for covering houses. His early experiments resulted in a defective composition, hence the decision to add serum of blood, which he claimed caused an essential difference. Johnson categorically denied using drying oil, as specified by Liardet, or intending to make a similar composition.[45] The case was tried twice before

Lord Mansfield on 21 February 1778 and 18 July 1778, the verdict being given in favour of the plaintiff on both occasions.

Johnson's reply and that of James Downes, together with the three pamphlets published after the second trial, provide interesting evidence of his use of stucco and of his business associates and employees at this stage in his career.[46] In August 1776 he used the composition, prior to the addition of serum of blood, at Woolverstone Hall. Johnson stated that he had used a composition of serum of blood, linseed oil, sand and lime, and no other ingredient, for the houses of the Duke of Dorset (38 Grosvenor Square), the Hon. Charles Greville (12 Portman Square) and on a small part of the house of John Pybus at Greenhill Grove in East Barnet, Herts. (not Middlesex as stated by Johnson).[47] John Raffield, who was an assistant in the Adam office, gave evidence that Liardet's cement had been used at Greville's house; this was the only instance of its use cited at the trial.[48] Downes gave evidence that composition was despatched to unspecified places in the country.[49]

Johnson's association with Charles Rawlinson (1729–86), a builder of Lostwithiel, Cornwall, is interesting. He claimed to have been consulted by Rawlinson in 1772 after the latter had obtained a patent for covering the roofs of buildings with slate, using composition, and published *The Directory for Patent Slating*. Johnson admitted that Rawlinson would expect some recompense for the use of his patent cement, 'but no positive terms have been agreed upon'. During the second trial, Rawlinson gave evidence that the garden front of his house had been stuccoed before 1773 with a composition consisting of whiting, white lead, red lead, boiled oil with litharge, raw oil and sand, but later confessed he had not used sand until after Liardet had taken out his patent. The pro-Adam pamphlet cast doubts on Rawlinson's impartiality as a witness, since he was staying in Johnson's house during the trial and used his servant to bring a specimen of cement to the court for analysis.[49] James Downes claimed that he ought to be treated as an independent witness, rather than as a party to the case. He had been employed by Johnson to make a considerable, but unspecified, quantity of a composition of lime, sand and linseed oil; the first batch had been made at Johnson's yard near Goodge Street in June or July 1776. Downes denied using the composition, apart from a small quantity on the slating of Johnson's stable. Edward Bellman, a plasterer frequently employed by Johnson (*see Chapter 1*), seems to have been successful in his attempt to be removed from the case.[50]

William Horsfall, Johnson's foreman, seems to have been fully in his confidence. He sent Downes away while he put lead into the composition, and attested in court that Johnson's cement 'stands, though Mr. Adams's falls.' Horsfall took a specimen of stucco, probably David Wark's cement, for analysis off a house in York Buildings, where it had been used c.1765.[51] John Utterton, a plasterer who had worked for Johnson at Kingsthorpe Hall, gave evidence that a capital executed in Liardet's cement had fallen off a house in Bedford Square, probably no. 47, which Utterton had sub-leased on 1 December 1777.[52]

Johnson had been accused of suborning Adam's workmen, although no evidence to this effect was produced at the trial. Frank Kelsall was mistaken in suggesting that Johnson had acted as clerk of works to the Adam brothers, although the terms of the transfer of the site of 61–63 New Cavendish Street are unknown. If Johnson used stucco on these two houses, 'it is difficult to see where'.[53]

The trials of Liardet v. Johnson determined 'that no man in England shall stucco the outside of a house without leave of the proprietors of Liardet's patent . . . for unless the plasterer will coat the walls with *porridge* (to use the Chief Justice's elegant expression)' it was impossible to make a lasting cement without using the same materials as Liardet.[54] As the court had found that Johnson's cement did not differ from Liardet's, a perpetual injunction was issued against him on 5 July 1780; this may explain why his clerk was instructed in September not to charge the client for the use of 'barrow lime stucco' on the extension of Carlton Hall.[55] As Frank Kelsall has pointed out, the issues debated at such length in the case soon became academic. 'Oil-based stuccos began to fall off buildings with increasing regularity.'[56] Johnson's involvement, however, was not forgotten, at least in Leicester, where William Gardiner (1770–1853) referred to 'our townsman Johnson' as having the reputation of introducing 'the art of stuccoing.'[57]

CHAPTER FOUR

COUNTY SURVEYOR

O
N 15 JANUARY 1782 John Johnson of Berners Street, St. Marylebone, was
appointed by Essex Quarter Sessions to 'succeed Mr. William Hillyer
deceased as Surveyor of the Gaol, Houses of Correction, Bridges and
other Buildings . . . upon the same Terms as the said William Hillyer lately held
the said Office or Employment.' Johnson's appointment signified the permanent
nature of the surveyor's post in Essex. Since Hillyer does not appear to have ever
been formally appointed and had died in office, the terms of Johnson's
appointment were not specified until July 1783:

> For every Journey after the rate of 1s. 3d. a mile out . . .
> For surveying and drawing of Plans Estimates and other Works at and after the rate of
> five pounds Per Cent upon the money expended therein and for his Attendance at every
> . . . Quarter Session . . . the sum of two guineas.[1]

In appointing Johnson, the magistrates had chosen a man well known to at least
two of their leading members. T. B. Bramston probably decided to employ him
at Skreens, Roxwell, during the course of 1769, when he recommended him to
John Strutt, who was in the process of deciding how and where to build his house
at Terling; Johnson produced plans for Terling Place by July 1771.[2]

The main work of the county surveyor consisted of the maintenance of county
bridges, the gaol and houses of correction, and the sessions house or shire hall;
these aspects merit separate treatment (*see Chapters 5–7*). The work also entailed
attention to a number of miscellaneous tasks, such as the purchase of a large
engine for driving bridge piles in 1785.[3] When it was decided at Midsummer
1789 to use the surviving part of a house purchased for the widening of
Moulsham bridge as an office for the clerk of the peace and for the storage of
county records, the surveyor was ordered to strengthen and secure the building.
Twenty years later, he had to make a survey of the premises, suggesting that
security could be improved by raising the roof to make space for bedrooms and
building a record repository over the yard, but this scheme was not executed.[4]

Arrangements for the execution of criminals involved the county surveyor.
The gallows on the outskirts of Chelmsford had been demolished before 1781,
when Hillyer had been ordered to construct 'another Gallows . . . to be fixed up
from time to time as Occasion may require'.[5] Hillyer's scheme was either not
carried out or may have proved unsatisfactory, since in July 1784 Johnson was
ordered 'to prepare a Stage . . . to be erected occasionally . . . in the Court of the
County Gaol between the Gaol and the River according to a plan now
produced.'[6] In November 1799 he was ordered to improve the arrangements for
executions in the prison yard, recommending a palisade between the wall of the

gaol and the river, about twelve feet from the place of execution.[7] When the court was considering methods of employing the prisoners, Johnson was sent to Clerkenwell Prison in May 1799 'to Examine the Manner of preparing the Okum for Prisoners to pick the same'. His report resulted in a visit to the county gaol in November to select a suitable site for the work; a rope shop was placed in the angle next to the river.[8]

The administration of justice necessitated the provision of suitable accommodation for assize judges. The High Sheriff complained in October 1806 that 'the Representatives of the Crown delegated to exercise its Judical Powers amongst us, . . . have been consigned, during their stay here, to such an abode as has not protected them from the Inclemency of the Seasons, and has been inferior to the Apartments provided for the Keepers of our Prisons'. He pointed out that the Ipswich Arms in Chelmsford high street used as the judges' lodgings was due for demolition and that the old house of correction, 'situated in a very convenient part of the Town, offers a desirable Scite for the Erection of any Building which might be judged expedient to supply the deficiency'. The clerk of the peace replied that the matter had been taken into consideration in a very full court, which did 'not conceive that they have any power or that it is competent to provide such Accommodation at the Expense of the County'.[9] Johnson was not immediately involved in any scheme to provide accommodation for the judges at the old house of correction. When the property was put on the market in the summer of 1807, he had to make all necessary arrangements for the auction on 1 June. Problems with the county's title made it difficult to sell the building.[10] In 1809 the scheme was revived, with T. B. Bramston's support, necessitating an attempt to obtain an act of parliament. Johnson had to prepare a plan of the building with an estimate of the cost (£350) of necessary alterations, including the erection of a dining room. The bill was lost on the motion for the second reading on 25 May.[11] A second scheme proposed by Johnson in the autumn of 1809 would have cost £1,200 to £1,300, but a new bill was lost on the second reading and the scheme finally abandoned in May 1810. As county surveyor, Johnson was again involved in the auction of the premises, which took place on 12 December 1811.[12]

As a result of increased road traffic during the French Wars, Quarter Sessions set up a committee to enquire into the propriety of erecting an engine in or near Chelmsford 'for the purpose of Weighing Waggons and other Carriages which shall be pressed to carry Troops or Baggage or otherwise for the Public Service.' At the first committee meeting on 12 October 1804 the county surveyor was directed to find a suitable site and make an estimate. In December he suggested a site about six yards in front of the Shire Hall and was following up an estimate from Mr. Bass of the Commercial Company. However, detailed negotiations took place with Joshua Ringrose of Naseby, Northants, who agreed to provide for £90 'a Weighing Engine . . . similar to that which was erected by the said Mr. Ringrose' at Shenfield turnpike gate. The estimate, which excluded the brick

and stone work and the weighing shed, was accepted in May 1805, although the size of the machine was reduced at Ringrose's suggestion, especially 'as this is to be fixed in a large Town'.[13] The erection was carried out by John Kemshead, who set out the ground with Ringrose on 31 August and was busy in October adjusting the bedding plates and fitting them to the kerb.[14] When the machine went wrong late in 1809, Johnson was ordered to examine it and arrange for it to be put in order.[15] A petition in 1806 from farmers and other inhabitants of South Essex 'stating that they have long laboured under a very heavy grievance owing to Baggage Waggons passing and repassing from Kent to Essex and Hertfordshire being loaded above the Statute Weight', and requesting a weighing machine near Tilbury Fort was accepted by Quarter Sessions.[16] Johnson had to visit Tilbury Fort in July with a local magistrate to select the site for the engine and again in August to examine the work. Ringrose charged £67 16s. for fixing the engine; the weighbridge cost £45 17s. 9d.[17]

In Essex, as elsewhere, the workload of the county surveyor increased during the last quarter of the eighteenth century, as is evidenced by statistics on public works compiled in September 1791. Over £41,000 had been spent on public buildings since 1773, including the erection of the gaol (£22,520), houses of correction at Halstead (£2,349 3s. 8d.) and Newport (£1,454 3s. 9d.) and the shire hall, at an estimated cost of £14,150. Expenditure on county bridges since 1785 amounted to over £7,000, which should be compared with an average annual expenditure of £350 at the beginning of the century. A competent and energetic surveyor would keep a close eye on estimates for public works; Johnson reduced that for Battlesbridge in 1793 from £55 to £25.[18] From 1789 separate accounts were being kept for each county bridge.[19] At Midsummer 1797 the county surveyor was ordered to keep a separate account for each work; after examination at Quarter Sessions, these were to be entered by the clerk of the peace in a book kept for the purpose.[20] The volumes of quarterly accounts begin in 1796, Johnson having handed over vouchers from that date in July 1799, when his accounts were 'for the first time copied into the Book provided.'[21] From 1808 a quarterly statement was attached to each bundle of vouchers, having previously been entered in Johnson's book.[22] The vouchers sometimes included detailed tradesmen's accounts, such as those for Dedham bridge and for the new house of correction at Chelmsford.[23] It was ordered at Michaelmas 1798 that the surveyor's accounts should be printed with the county accounts, but these have not survived before 1843. A single printed balance sheet, covering Easter 1797 to Epiphany 1799, gives a total expenditure of £1,981 7s. 2½d., with separate totals for each work.[24] A year later, 'in order to give due time to the County Surveyor to examine the Bills which shall . . . be delivered in by workmen', the system was changed so that bills delivered at one session should not be paid until the next, unless the surveyor reported in writing in favour of immediate payment.[25] The examination of bills on completion of various works often entailed long journeys. On 16 October 1797 Johnson went

55 miles from London to Colchester to examine the works at the house of correction in the castle, make out bills and adjust the accounts, taking the opportunity at the same time of examining the roof in the keeper's dwelling.[26] Later in the month he had to attend a committee of magistrates at Epping to settle the bills for Chipping Ongar bridge.[27]

From April 1796 the surveyor's accounts provide details of his journeys on county business, in addition to routine attendances at sessions. A visit to Dedham bridge, 63 miles from London, on 1 April was followed by one to Battlesbridge. At the end of April he was again at Dedham, giving directions to workmen, with a further journey of six miles to examine the state of the abutment at Cattawade bridge. On 18 May he was at Chelmsford giving orders for work on the south wall of the gaol and at the shire hall, before meeting the committee at Battlesbridge, then back to Chelmsford before setting out again to examine the works at Dedham and giving directions for securing the arch at Nayland bridge. Johnson was again in Essex between 9 and 13 July, visiting Half Mile bridge at Ingatestone on the way from London to Dedham. He then returned to Chelmsford, paying a visit to Battlesbridge, attending Midsummer sessions and giving evidence at Assizes, and visiting Langford and Chipping Ongar bridges on the way home. Woodford bridge was examined on 1 August and again on 5 September, when the masons' and carpenters' work had been completed. After attending Michaelmas sessions, Johnson accompanied Henry Sperling, J.P., to Ballingdon bridge on 6 October. He was at Chelmsford and Colchester on 21 October to meet the committee on Colchester house of correction. Whenever possible, visits were combined to make lengthy round trips. On 6 June 1797 he set out on a journey of 76 miles, visiting Passingford and Chipping Ongar bridges, Chelmsford, Colchester and Ramsey bridge. In October 1797 he visited three houses of correction, travelling to Colchester (55 miles) to make out bills, on to Halstead (14 miles) to give directions and then to Newport (30 miles). A visit to Halstead house of correction on 22 May 1799 was followed by a journey to Blue Mills and Wickham Mill bridges on 24 May, returning via Chelmsford.[28] A round trip of over 120 miles took place between 25 and 28 August 1803, involving giving directions at Halstead house of correction, examining Ballingdon bridge and discussing it with the town clerk of Sudbury, examining Rod bridge and 'thence across the country to Peat bridge to give directions for the rebuilding of it', with a visit to Chelmsford gaol on the return journey. A similar journey in September 1802 involved expenditure on post chaise and coach, as well as 2s. 6d. for boat hire on the Stour.[29] At an earlier period, when mileage is normally indicated in the surveyor's bills, Johnson may have used his own phaeton.[30] Visits to Small Lea bridge to meet the Hertfordshire surveyor in December 1809 and April 1810 necessitated coach and chaise hire. On 29 April 1810 Johnson set out for Mr. Strutt's by Baddow Coach; after spending the night at Terling Place, he shared the cost of a post chaise to Langford near Maldon to examine the bridge.[31]

The accounts also give details of expenditure on county business in London. Johnson spent 7s. on coach hire when visiting the Lambeth Stone factory in April 1805 to examine the Coade county arms intended for the new house of correction at Chelmsford.[32] In May 1809 and February 1810 he had to visit the county solicitor at Bedford Row in connection with the Judges' Lodgings bills and attend the House of Commons committee on two occasions in May and June 1809.[33] The county surveyor's commission of five per cent on the cost of work included the provision of plans and drawings, but information on unexecuted designs is sometimes available from the accounts. A charge could also be made for duplicate plans, presumably made by a draughtsman; extra drawings of White's bridge, Great Burstead, for the committee cost £2 12s. 6d. in July 1812.[34] Johnson produced designs in July 1800 for the Chelmsford house of correction 'intended to be Erected in the Garden behind the Gaol', for which he charged three guineas. In September he attended a committee meeting in connection with a revised plan; this necessitated taking a plan of the two houses and garden ground adjoining the gaol and making a design for this site at a cost of four guineas; he also charged two guineas for 'Making Another Plan of the Scite of the Gaol and Garden together with the Adjoining Garden Grounds to lay before the Magistrates at the October Sessions.' When the final plan had been produced, Johnson had to advertise in the *Morning Herald* for a brick maker.[35] After the completion of the new building, the first attempt to sell the old house of correction necessitated 'Measuring, Laying down a plan and valuing the land and premises' at £2,000 and 'Drawing out descriptive Advertizement for Sale of Do.', prior to the auction on 1 June 1807, which he had to attend.[36] He also attended the successful auction on 12 December 1811 and almost certainly drew up the description in the printed sale particulars.[37] Although the clerk of the peace was responsible for drawing up contracts, the county surveyor would have been involved at all stages. On 9 May 1805 Johnson made a journey to Ballingdon bridge 'to Contract with Sparrow and Jefferies for Rebuilding the Same' and paying 16s. for stamping the agreement.[38] He made a similar payment in June 1812, when he travelled to White's bridge, Great Burstead, to set it out with the contractors.[39]

As was the practice in other counties, e.g. Surrey, Johnson was formally reappointed 'Surveyor of all the Bridges and other Public Works', at Midsummer 1803 under 43 George III c. 59.[40] At Midsummer 1803 he was paid £50 'as a Present or Gratuity from the County for the Attention which he has paid to the Business and Concerns of the said County and the satisfactory manner in which he has conducted the same'. His allowances were raised at the same sessions: five guineas for attendance at Quarter Sessions; 1s. 6d. per mile (out and home) for all other journeys on county business; the rate of commission was unchanged.[41]

The Essex justices do not appear to have objected to Johnson employing his own workmen or his son's firm on county business. He was, however, subject to

some criticism during his later years, mainly from an outspoken justice, Montagu Burgoyne. In 1806 Burgoyne took up the cause of the bricklayer, John Harvey, who complained of the delay in settling his accounts for the new Chelmsford house of correction. Johnson was defended by Lewis Majendie, a leading justice, who wrote on 21 July to the clerk of the peace, pointing out that Johnson's son had paid £150 to Harvey on account and assured Majendie that Harvey's 'accounts should be examined and liquidated by the next Sessions . . . I never knew that Mr. Johnson had been *usually* dilatory in settling his accounts . . . nothing is more likely to lay him open to censure than this'. Majendie had written to Johnson with his opinion on Harvey's bills and the accounts in general, but defended him on general principles, considering 'him to have generally acquitted himself faithfully to the County, and therefore that it was harsh in Mr. Burgoyne to prosecute an old Servant of the County', whilst admitting that Johnson was at fault in the case of Widford bridge.[42] Burgoyne's main criticism related to the general standard of work at the house of correction; in March 1806 he had employed Francis Aldhouse of Titchfield Street, described by him as 'an Eminent Surveyor', to examine the building. Johnson defended himself in a letter to the New House of Correction Committee dated 6 April 1807. He pointed out, in reply to Burgoyne's charge relating to the thickness of the walls, 'that had I looked to my own Emolument I might have directed the Walls to have been a much greater thickness'. In conclusion, Johnson claimed to 'have faithfully served the County for more than Twenty five Years, with Integrity, assiduity and with every Attention to Aeconomy'. The court regarded Johnson's dignified defence of his professional character as satisfactory.[44]

Johnson also had the support of Majendie and other leading justices, such as Thomas Ruggles, in his work in connection with bridges, especially those on county boundaries.[44] Apart from assistance given by his son, John Johnson junior, mainly during his declining years (*see Chapter 10*), Johnson valued the help of responsible workmen. By 1807 he was referring to William Jeffries as 'a workman employed', probably since 1796, 'to look over or inspect the County Bridges within the Divisions of Tendring and Colchester'. At a later period, he was using Charles Murrell as an 'Assistant to the County Surveyor in the care of' Widford bridge; in November 1810 the court ordered temporary repairs to be carried out to this bridge under the direction of the county surveyor or his assistant, Murrell.[46] Charles Murrell, described as a road surveyor, was paid £34 3s. 3d. at Epiphany sessions, 1812.[47]

Johnson retired from the office of county surveyor in 1812 at the age of eighty. His letter of resignation, dated 14 July, is similar in phrasing to his reply to Burgoyne's accusations:

> *I have served the office of Surveyor to this County with Assiduity and Integrity upwards of Thirty Years, my late Illness and great Age obliges me to say, that it is my intention at the next Quarter Sessions to resign my situation.*

At Michaelmas sessions, it was unanimously resolved:

> *that the thanks of this Court be given to the said John Johnson Esquire for his long, active, faithful and meritorious services to this county during the space of more than thirty years, and doth order that such resolution be entered into the records of this county and that a copy thereof, signed by the Clerk of the Peace, be transmitted to Mr. Johnson and inserted three times in the Chelmsford Chronicle and the Essex Herald and also in the County Chronicle.*[48]

CHAPTER FIVE

COUNTY BRIDGES

Throughout the 18th century the maintenance of county bridges formed the main work of the county surveyor.[1] Under the Statute of Bridges, 1531, the county was liable for the repair of a bridge for which no responsibility could be laid elsewhere.[2] After the Glasburne decision against the West Riding Sessions in 1780, the county became increasingly responsible for the maintenance of bridges built by individuals which had become 'useful to the county in general'.[3] Under the Act of 43 George III c. 59, s. 5, bridges could not be accepted as county bridges unless 'erected in a substantial and commodious manner under the direction or to the satisfaction of the county surveyor'. The earliest list of county bridges dates from a year after Johnson's surveyorship, but he is known to have been involved in the rebuilding, repair or survey of nearly fifty bridges.[4] Few of these bridges have attracted the attention of local historians despite G. Montagu Benton's comment of 1931 that 'the subject is certainly one that merits historical research'.[5]

During the period of Johnson's surveyorship the county assumed additional responsibilities both for new bridges and existing bridges built by private individuals, parishes or subscription. The brick bridge at Sutton Ford over an arm of the Roach was built as the result of a petition presented by Jerehemiah Kersteman and other principal inhabitants of the Rochford Hundred to Quarter Sessions on 20 April 1784. The road through the ford was 'highly inconvenient and disagreeable'; there had been several recent instances of danger to life as a result of 200 yards of road being overflowed at every tide, preventing the passage of carriages, cattle and sheep; the water sometimes rose to seven feet deep at spring tide. The surveyor estimated that a brick bridge of one arch would cost £136, plus £101 for fencing the road near the ford. The court ordered the additional cost of £112 for raising, ballasting and making good the road to and from the bridge to be borne by the petitioners.[6] At Easter 1786 the county surveyor reported that the bridge, railing and road on each side had been completed in a very good manner 'at an expence much beyond what was allowed by the county, which has been defrayed by a subscription made by the gentlemen in the neighbourhood'.[7] Twenty years later, Johnson pointed out that the bridge had been built to his design, but not under his direction, and appears 'not to have had any attention paid to it since'.[8] The bridge at Wickham Mill over the dangerous ford of the Blackwater had been built in 1774–76 with grants totalling £290 'as a free gift from the county'; it was to be maintained by the parish.[9] When in 1799 the road on the Maldon side of the bridge was torn up by floods, Johnson recommended two flood tunnels of the same diameter as those at Blue

Mills, at a cost not exceeding £50.[10] After the execution of this work, Wickham Mill appears to have been accepted as a county bridge.[11] A petition for a county bridge over an arm of the Blackwater at Langford in 1795 was not immediately successful, although Johnson pointed out that the existing horse bridge was below the level of the adjoining land and recommended raising the road and erecting a timber bridge 25 feet long and 12 feet wide at a cost of £150. After a flood in the winter of 1809, which endangered the lives of travellers and led to the loss of several horses, Johnson visited the Wescomb family at Langford Grove to examine the horse bridge and prepare a plan, section and elevation for a new carriage bridge at an estimated cost of £300. John Wescomb offered to contribute £150, equivalent to the cost of repair of the horse bridge. Counsel's opinion, dated 9 May 1809, drew the county's attention to the implications of the act of 1803; the county was not empowered to pay the difference between Wescomb's offer and the actual cost of a new carriage bridge. The Wescomb family would have to bear the full cost of a bridge erected under the direction of the county surveyor; it would then be accepted as a county bridge. By July the family had accepted the situation, advised by John Strutt, J.P., who accompanied Johnson on his visits to the site on 29 August 1809 and 30 April 1810, in the latter case to examine the completed bridge.[12]

Two bridges were taken over from Lord Petre. At Midsummer 1791 a committee was appointed to enquire into the condition and liability to repair Chain bridge, Mountnessing, on the turnpike road. Their report found that the bridge was erected by Lord Petre's ancestor, but that he was 'not bound either by prescription or otherwise to repair the said bridge'. The court resolved at Michaelmas 1791 'that the . . . bridge being useful to the county in general, the inhabitants . . . are bound to repair it'. Lord Petre's steward, William Roberton, greeted the resolution with acclamation, but the matter was referred back to the committee. Thomas Berney Bramston and John Bullock interviewed Lord Petre, who then made an offer of £63 10s. (half the original estimate for rebuilding) 'upon his being exonerated from all future expense . . . on account of the said bridge'. The plan and estimate (£320) for the new bridge was altered to increase the width to 24 feet.[13] In the case of Half Mile bridge, Ingatestone, on the same road, Roberton took the initiative by writing to the clerk of the peace in January 1796 to point out that the wooden bridge was not originally intended for public use, having insufficient breadth for two carriages to pass and the timbers only of one fourth the scantling necessary to support very heavily loaded waggons which passed over it daily. He maintained that 'the expense of erecting a proper bridge, of so small a span', would not be 'a matter of any consequence to the county'. After a further interview with Bramston, Lord Petre offered £40 towards the cost of a brick bridge of the same width as Chain bridge, on the same conditions as before. The bridge was completed in July at a cost of £72; in 1858 it was described merely as 'a brick culvert'.[14] Bramston himself had built a small bridge over an arm of the Can near Roxwell church at his own expense about

1779; in April 1796 the court ruled that as it 'has ever since been used by the Publick and thereby become a County Bridge', it should 'be immediately repaired at the charge of the said county'. Further repairs were done at the county's expense in 1800 under Bramston's direction.[15] In 1810 a small brick bridge spanning Cripsey brook in High Laver and Moreton was found to have been erected at private expense, 'in a place where there was no bridge before', prior to the act of 43 George III. The county was, therefore, liable to maintain it and the surveyor was instructed to order repairs up to a limit of £20.[16] The subscription bridge at Shonks Mill in Navestock and Stanford Rivers was also adopted by the county in 1810. Johnson met a committee of both parishes on 2 April and prepared a plan and elevation with two flood tunnels. At the end of May a committee of local justices reported that there had been a horse bridge on the site c.1770, when a carriage bridge was built by public subscription. As the bridge was situated in a 'very public road and of great public utility', the committee recommended rebuilding it at or near the present site and widening it, 'which is particularly necessary on account of the great quantity and weight of timber' frequently carried over the bridge. After Johnson had visited the site to meet Patman, the carpenter, he recommended rebuilding a timber bridge on the same site with extended wings; the cheaper design, without flood tunnels, appears to have been executed.[17]

The county's expenditure on bridges inevitably rose between 1700 and 1815, in Essex as elsewhere, as a result of the increase in road traffic, the acceptance of additional bridges, the widening of existing structures and the incidence of inflation; over £7,000 was spent on bridges between 1785 and 1791. The employment of a permanent surveyor enabled costs to be controlled to some extent. Under the County Rate Act, 1739, bridges could not be repaired or rebuilt until the defect had been presented by the Grand Jury at Sessions or Assizes; in Johnson's time it was usually the county surveyor's duty to provide the necessary information.[18] An order of Easter Sessions, 1767, cited at Michaelmas 1799, limited the value of minor work ordered by local justices, without reference to Sessions, to £3.[19] At Michaelmas 1793 Johnson pointed out that the 'very extraordinary estimate' for repairs to Battlesbridge included a large proportion of work to be done on private property; an estimate of £55 was accordingly reduced to £25.[20] The use of tenders for bridges does not seem to have been adopted before the early 19th century, although Johnson's clerk pointed out to John Macro, a Foxearth carpenter, in August 1789, that unless his price for timber at Rod bridge was reduced by 3d. a cubic foot, it would be the county surveyor's duty to seek alternative estimates.[21] Right at the end of his career, in May 1812, Johnson was ordered by a committee of justices to prepare a plan and tender document for White's bridge, Great Burstead; on 15 June the committee accepted a tender from William Curtis and Richard Wingfield for £142 18s.[22]

Only two of Johnson's bridges cost over £1,000. Moulsham bridge (1787), the

only example in stone, cost over £1,740, perhaps as much as £3,000.[23] The Essex part of the first bridge at Dedham (1786), described as 'a very handsome Brick Bridge with Stone Piers', replacing a timber bridge, was estimated to have cost about £1,500.[24] Other brick bridges were erected for less than £500. At Stifford (1800) a brick bridge of three arches was rebuilt in one arch at a cost of £485 5s. 9½d.[25] In 1797 the justices for Ongar Division wanted the new three arch bridge at Chipping Ongar to be 20 feet wide; the brick walls were to be coped with stone. The estimated cost was about £450 'owing to the high cost of bricks (40s. per thousand) and the great length and depth of the wings'.[26] The single arch bridge at High Ongar (1787) also had stone coping and involved an expenditure of about £450.[27] Occasionally it was possible to effect economies by decreasing the length of a bridge and using wooden fencing. At Peet bridge (c.1803–1805) over the Pyefleet Channel, the waterway of nineteen feet was halved, with the posts and a single rail continued for 40 to 50 feet; the result, described in 1857 as a 'brick culvert', cost £134 2s.[28]

A number of timber bridges cost over £500. The four Essex bays of Ballingdon bridge (1805) cost £820 14s. 3½d., including £12 for the county's share of the temporary bridge.[29] The same type of construction was employed at Rod bridge in Foxearth (1809), with three piles to a truss instead of four; the work came to £550.[30] An estimate of £600 for a bridge of oak timber with iron braces and brick abutments coped with stone at Battlesbridge (1795) appears to have been exceeded by £50.[31] At Cattawade bridge (1790), the eight bays of the Essex part measured 94 feet long, exclusive of the new brick abutments coped with stone, and the roadway was increased from eight to twelve feet, at an estimated cost of £500.[32] The completion of the second Dedham bridge (1795–96) for only £448 10s. was considered to be due to the diligence of the labourer in trust, William Jeffries.[33]

Other timber bridges were built for between £200 and £400. The cost of £400 for Langford bridge in Kelvedon Hatch (1808–1809) was probably to be accounted for by its length of 45 feet and the widening of the carriage way to twelve feet.[34] Shellow bridge in Beauchamp Roothing and Willingale Doe (1812) cost £276, including £30 to raise the road at the east end of the bridge to prevent flooding.[35] At Ramsey bridge (1808), it was possible to reduce the waterway from 66 feet to ten feet, as the result of a sea wall having been built; Jeffries was able to re-use piles from the old bridge, so his detailed bill for £275 12s. 7d. was £56 7s. 5d. less than the original estimate.[36] Ackingford bridge in Chipping Ongar and Bobbingworth (1806) was 25 feet long; it would have cost £100 to rebuild with the existing roadway of nine feet; an estimate of £230 for a roadway of fourteen feet was accepted.[37] Blackwater bridge, near Bradwell-juxta-Coggeshall, was rebuilt in 1788 at an estimated cost of £200.[38]

Increasing road traffic resulted in the need for major repairs as an alternative to complete rebuilding. Heybridge, on the Mountnessing–Ingatestone boundary, was widened by eight feet to twenty feet in 1788, which necessitated

rebuilding the south parapet and coping it with stone, as at High Ongar; the work cost about £50.[39] The narrowness of the roadway at Two Mile bridge, Writtle, a small brick bridge with three arches, resulted in the north wall being out of upright and the centre and one side arch and both piers being considerably crushed, in 1793; the roadway was to be widened to at least thirteen feet six inches and repairs effected, for an estimated cost of £40.[40] Damage to parapet walls could also be costly, as at Blue Mills bridge in 1795, when the expense of rebuilding, coping with Portland and inserting 'land tyes' was estimated at £130.[41] The arches of stone and brick bridges were prone to sinking as a result of poor foundations or flood damage. At Baythorn in 1795, the surveyor had been informed that the brick bridge had sunk nearly two feet out of upright as a result of a severe flood; repairs cost £120, including £78 for bricklayer's work by Boanerges Boast.[42] Repair to the sunken large stone arch at Dagenham Beam bridge in 1804 was simplified by the shallowness of the Beam river, so that repairs, at a cost of £98, could be carried out without interrupting traffic.[43] Brick bridges with several narrow arches were not always able to take flood water in rainy seasons, so Johnson sometimes recommended the insertion of flood tunnels in the abutments. These tunnels were used to replace a wooden bridge leading to the brick bridge at Blue Mills in 1799 at a cost of about £120.[44] The same diameter of six feet was adopted for similar tunnels at Wickham Mill on the Maldon side only, after the road had been torn up by floods in the spring of 1799; the cost was about £40.[45] It was usually found more satisfactory to rebuild timber bridges than to undertake extensive repairs. In 1789 a 'complete repair' of Rod bridge was carried out for £69 11s. 6d., but in 1808 the bridge was found to be beyond repair and had to be rebuilt.[46]

Moulsham bridge, the only bridge designed in stone by Johnson, is still standing; it replaced the three-arch stone bridge of 1372 across the Can at Chelmsford, known variously as the 'Stone Bridge' or the 'Great Bridge'.[47] The state of the bridge was drawn to the attention of Quarter Sessions in 1784. The adjoining footbridge, probably erected in 1761 as a wooden structure cantilevered out on the west side, similar to that recorded at Peg's Hole in West Ham in 1858, was closed in July. A survey, with a plan and estimate for repair and widening or rebuilding, was ordered in October.[48] After rebuilding had been decided upon, a plan was accepted for a brick bridge of two arches 'with such addition of stone as may be thought necessary'; a committee was appointed in April 1785 to examine the plan and estimate, give directions for preparing materials and to arrange for a temporary bridge for the use of traffic on the main London–Colchester route during the demolition and rebuilding of Moulsham bridge.[49] By July expenditure of £105 had been incurred, including £80 paid to Jonathan Bottomley, carpenter. The Court decided that the bridge should be 34 feet wide, including a footway on each side, instead of twenty feet as proposed by the plan produced at the Easter session; it was to be built with stone and brick with one arch of 36 feet, according to the plan now produced

by Johnson.[50] The first stone was laid on 4 October 1785; 'traffic . . . passed by Baddow-lane, crossing the river by a wooden structure, and entering Springfield-lane at the rear of the King's Head'.[51] During October, the bricklayers were working overtime some days, from 3 a.m. until midnight on 4 October, with double time on Sunday. On 29 October the masons had to cover the piers with straw for the winter.[52]

Besides local craftsmen such as Bottomley, Chivens Hollingsworth the bricklayer, Sarah Wray, widow of George Wray, stonemason, and Thomas Merritt, smith, the firm of John Johnson, junior, and Co. was employed at the bridge.[53] Johnson's eldest son, born in 1761, was working in association with William Horsfall, his father's foreman, and possibly with Joseph Andrews, his father's clerk, supplying materials for Moulsham, Weald and Passingford bridges. Quantities of best Dutch tarras, used for hydraulic cement, were supplied on 20 September, 8 and 19 October 1785, together with ten centres for the bridge. The firm worked in October on the temporary bridge, which was in place on the site of the original bridge until the end of April 1786, when the route across the meadow from Baddow lane to Springfield lane came into operation.[54] Johnson's elegant design required nearly 100 tons of Portland and 140 tons of arch stone from Swanage, Dorset. The Portland was mainly supplied by Wallinger and Fletcher, at 26s. per ton, including freight to Maldon; Thomas Smith charged 9s. per ton for carting stone from Maldon to Chelmsford over Danbury Hill.[55] Nicholas Wescomb supplied nineteen and a half tons of Portland stone at a cost of £32 10s., almost certainly surplus from the building of Langford Grove to Johnson's design in 1782; this stone was carted by Sarah Wray, whose firm charged 4d. a foot for sawing.[56] Decorative features for the bridge (*Illus. page 49*) were supplied by Eleanor Coade, Artificial Stone Manufacturer, Lambeth (*see Chapter 3*). One Coade baluster had been lost before 1857, when the existing substitute was ordered; the original was discovered during flood relief work in 1963–1964 and has been deposited in the Chelmsford and Essex Museum.[57] The keystone on the upstream side (*Illus. page 49*) is dated 1787 and the final accounts were submitted during that year, including five guineas compensation to Joseph Howard, a journeyman carpenter 'employed to help build the New Bridge', who 'caught a violent cold, which was attended with an Ague and Fever', preventing his following his business for a considerable time.[58] However, according to Coller, the bridge was not reopened until 14 January 1788.[59] The lamps shown on the corner piers in the painting of the County Gaol (*Illus. page 69*) were erected in the winter of 1790–91, after the Lighting Commissioners had been ordered to take down their lamps from the centre of the bridge.[60]

A succession of heavy floods in the first quarter of the 19th century, with the water at the bridge ranging from five feet higher than usual in 1809 to nine feet higher in June 1824, resulted in complaints about Johnson's design. The width of the river Can at this point was 54 feet, but the waterway under Johnson's

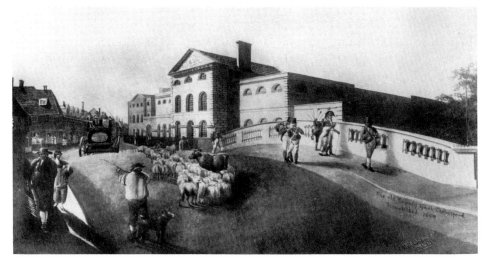

Moulsham bridge, County Gaol and House of Correction, Chelmsford, c.1810 (Gaol demolished)

single arch was only 36 feet. A memorial of the principal inhabitants, dated 18 July 1824, pointed out that 'the present Bridge . . . has Buttresses projecting one third into' the river, 'which not only prevent the passage of the water to the extent of their own space but also has the effect of further impeding the watercourse by causing the water to regurgitate more in the centre of the river and for the support of the foundation of the present Bridge an immense quantity of brickbats and rubbish were thrown around the Buttresses which tended further to reduce the waterway'. It had been pointed out after the inundation of May 1818 'that the [old] Piers which were left in the Arch of the new Bridge must greatly impede the current of the Water in the times of Floods and consequently raise the Water much Higher'. Thomas Hopper, as county surveyor, was fully aware that Johnson would have had difficulty in removing the piers, despite the river being 'dammed back' during construction work. Thomas Telford (1757–1834), president of the Institute of Civil Engineers and responsible for over a thousand bridges, was called in by Quarter Sessions in August 1824; he recommended clearing out the channel and replacing Johnson's bridge with one of cast iron 'of such ample waterway as to remove every possibility of its being an Obstacle'. Only the first part of Telford's advice was accepted by the court, although the problem of flooding was not eliminated until the Essex River Board undertook the flood relief scheme of 1963–64, during which one of the two piers of the medieval bridge was uncovered.[61]

Although the majority of Essex bridges in the 18th century were built of brick, Johnson appears to have designed comparatively few in this material. However, as the county surveyor, he was responsible for the maintenance of about a dozen brick bridges built c.1760–80, including Hillyer's work at Salt bridge (1772), Wickford (1773–75), Nayland (1775–76), Abridge (1777), and the main bridge at

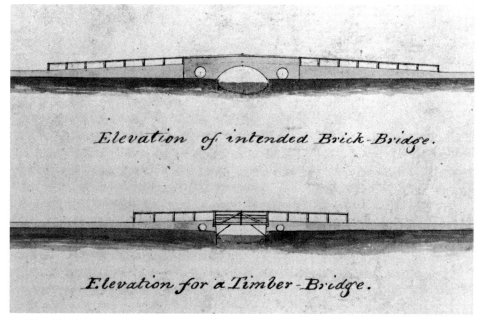

Widford bridge, Essex, alternative designs

Loughton (1781).[62] There are no surviving designs by Johnson for brick bridges, apart from the unexecuted simple design for Widford, 1803, which took the form of a single arch with flood tunnels; the brick abutments had post and rail fencing (*Illus. page 70*).[63]

The surviving bridge at North Weald (1785–86) across the Cripsey Brook is probably characteristic of Johnson's work. It was described in 1857 as having a span of 30 feet in one sequential arch, finished with long abutments ending in quadrant wings.[64] There are three iron tie bars through the brickwork, with tie plates in the form of paterae; these were supplied by John Johnson, junior, and Co., for £1 each.[65] John Booker has suggested that these tie plates 'appear to be the earliest surviving castings in Essex in any context'; Johnson used them also at the contemporary Passingford bridge, demolished c.1968, and at the earlier Baythorn and Great Bardfield bridges.[66]

Passingford and several other brick bridges had parapets coped with stone. At Chipping Ongar in 1797, the divisional Justices specifically requested the widening of the roadway to twenty feet, as at High Ongar, and 'that the Walls may be Cap'd with Stone'.[67]

Despite the absence of any of Johnson's designs, documentary evidence suggests marked similarities between his brick bridges, at least in the Ongar Division. In reporting on the ruinous state of the timber bridge at High Ongar in April 1787, the surveyor recommended a brick 'bridge, similar to those of Moreton [c.1784] or North Weald, with two flood funnels as shown by the sketch, which will give a much better waterway', at a cost of £400. The court ordered that High Ongar bridge should be taken down and 'rebuilt with brick according

to the Plan and Elevation of the Bridge at North Weald Bassett', produced in court.[69]

In at least two cases, existing brick bridges were rebuilt by Johnson to an improved design. At Stifford in October 1799 he recommended replacing the three arches measuring about fifteen feet in the centre and about six feet on either side 'with one Arch equal in waterway with the three present Arches – vizt. Twenty seven feet as being less expensive and of less obstruction to the current – particularly as the Bed of the River is wanted to be sunk much deeper than it now is'. By 1857 the central part of the arch had become depressed; in 1868 it was replaced by an iron bridge, which was rebuilt in concrete c.1925.[69] In the last year of Johnson's surveyorship, the condition of White's bridge, Great Burstead, caused concern. The survey, possibly carried out by Johnson's son, pointed out that an arch of six and a half foot span was too small to carry off the water, leading to the flooding of the roadway, which was itself nearly thirteen feet wide. The committee, appointed in April 1812, agreed that the bridge should be rebuilt with a fourteen foot arch 'at the suggestion of Mr. Johnson'.[70]

Problems with workmen were encountered at both Weald and Passingford bridges. In the absence of detailed surveyor's accounts before 1796, it is not possible to ascertain the number of visits paid by Johnson to these bridges. The court was dissatisfied with his report on them in October 1785. In a further report in April 1786, Johnson stated that Weald bridge had been built higher above the surface of the water than intended in his design, causing extra expense; the change was due to the height of the floods, but would necessitate raising the road. The joints of the brickwork had failed 'owing to the lateness of the season in which the business was done – this Mr. Palmer has agreed to rectify at his own expense'.[71] The court made an order for work to be done on raising the road, but the parishioners were forced to petition Quarter Sessions at Michaelmas 1787, claiming 'that the County Bridge that has been lately rebuilt . . . is carried fully thirty feet above the surface of the ground and the road from the same into the old road thereby almost perpendicular and so dangerous that passengers with their horses, carts and carriages dare not pass and repass with safety'; they estimated that it would take nearly 1,000 loads of earth to slope the road from the bridge down into the old road to provide an easy descent. The court ordered the road to be properly sloped, covered with stones and secured by posts.[72] At Passingford, a committee of local justices visited the bridge on 19 October 1785 and heard the complaint of the miller, James Brown, who was allowed £30 as compensation for loss of water during rebuilding. They found that the bridge had not been completed to Johnson's plan and that 'a considerable quantity of piling and planking and brick work has been done on the wings at each end of the bridge', without orders from Johnson. The brickwork had been set out by Palmer's employee. It was recommended that the county should not pay for the wings, which were to be taken down and rebuilt to Johnson's design. In July 1786 the committee examined the accounts for the

bridge and recommended that £24 6s. 6d. should be deducted for overcharging by John Palmer, carpenter.[73]

A large engine for driving piles, ordered by Sessions in April 1785, was supplied for £40 by John Johnson, junior, and Co. at the same time as materials for Weald and Passingford bridges.[74] The purchase of an engine could be regarded as a good investment for the county, since the contractor for Chertsey bridge, Surrey, in 1766 had charged 10s. a pile plus carriage of the engine to the site.[75] Over the next decade, the engine was used for the brick bridge at Dedham (1786–88) and its timber successor (1795), as well as at other timber bridges, such as Cattawade (1790) and Battlesbridge (1795).[76]

Construction in timber was considered more suitable than brick for bridges with long spans. Langford bridge over the Roding in Kelvedon Hatch was described in Johnson's report of 1808 as 45 feet long and as 'a considerable span' in 1857.[77] At Battlesbridge a span of 100 feet was needed over the Crouch.[78] On the Stour, the Essex waterway at Rod bridge in Foxearth was stated to be 43 feet 9 inches in 1807 and at Cattawade the Essex part was 94 feet long clear of the abutments, being described in 1858 as a large timber bridge, carried on sixteen trusses of oak piles, eight being on the Essex side.[79]

Timber was also better able to withstand flood damage, as evidenced by the second bridge at Dedham (1795).[80] The Small bridge at Loughton with three brick arches, which had been repaired by Hillyer in 1777, blew up in January 1809, cutting off communication between Chigwell and Epping. Johnson visited the site twice in February and reported that the force of the water under the piers had caused the fall of the bridge; he had arranged for a temporary oak plank bridge, 'which will serve the use of a new timber bridge of about twelve feet span, which will not be so liable to be destroyed and the bricks of the late bridge will serve to build the abutments'.[81] Conversely, the use of timber might result in the need for frequent repair and rebuilding. Langford bridge had been rebuilt in 1773, but required repair in 1797–98.[82] By 1808 rebuilding and widening was considered essential; an increase in width would not cause any problems, as 'the principal timbers rest on mud cills, which cills extend much beyond the width of the bridge, so that it may (if required) have the carriageway two or three Feet more than' its present width of nine feet nine inches.[83] The rebuilt bridge was described as in excellent condition in 1857; after restoration in 1878–79 it was replaced in concrete c.1913.[84] Johnson was confident that his design for Battlesbridge (1795), to be built 'with Oak Timber, Iron Braces and Brick Abuttments coped with Stone' would 'last more than twice the time of' timber bridges 'erected in the Common Manner'.[85] His original design for Battlesbridge does not survive, but Hopper's elevation, prior to demolition in 1855, does not appear to show any iron members, although there are diagonal ties between the piles and the girder, with cross braces between the piles on opposite sides of the bridge, as used in the repair of Rod bridge in 1789.[86] In 1807 Johnson reported 'one of the braces under the bridge being considerably

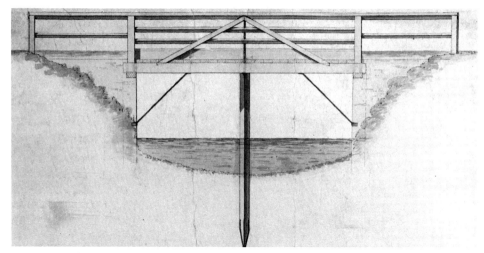

Ackingford bridge, Bobbingworth, Essex, elevation

bent as your Surveyor conceives from barges having lately passed under it'; this episode suggests that iron braces may have been used and later replaced.[87]

Earlier, at Rod bridge in 1789 Johnson had advocated the use of 'iron stay bars . . . as braces from the beams to the railing', instead of timber 'knees', to ensure durability.[88] The surviving designs for Widford bridge (1803), Ackingford bridge (1806), Langford bridge in Kelvedon Hatch (June 1808), Shellow bridge (August 1810), and the unexecuted design for Shonks Mill bridge (April 1810), all include timber inverted 'V' braces from the beam to below the railing in the centre of each bay, with a piece of iron running down from the apex to the beam.[89] At Ackingford the upright iron member is bolted into a central wooden pile. Diagonal iron ties between the abutments and the beam were used at

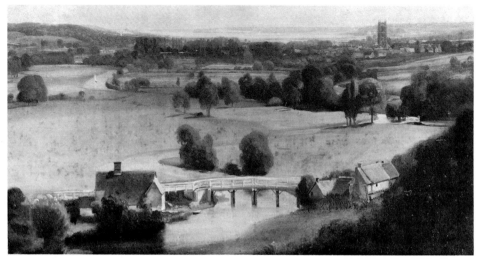

Valley of the Stour (detail showing Dedham bridge from Langham Coombs) by John Constable, c.1805

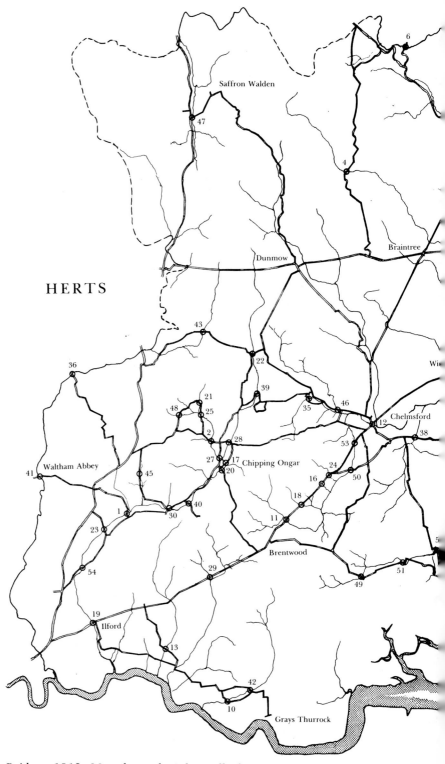

County Bridges, 1813. Map drawn by John Fulbeck

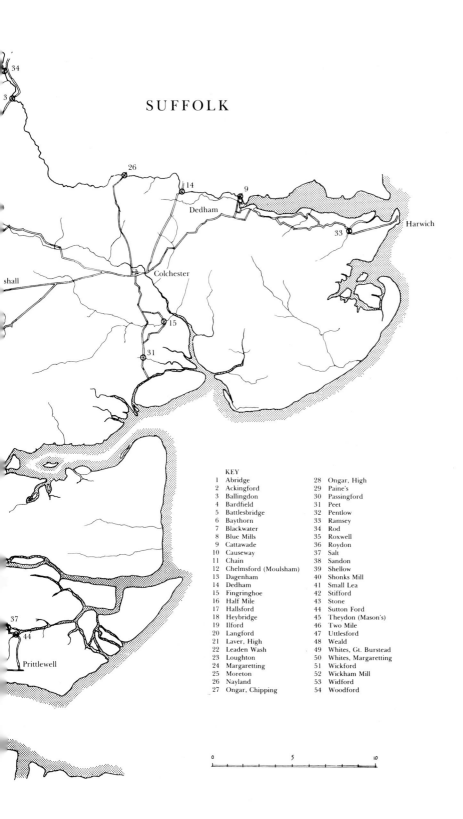

SUFFOLK

Harwich

Dedham

shall Colchester

Prittlewell

KEY

1	Abridge	28	Ongar, High
2	Ackingford	29	Paine's
3	Ballingdon	30	Passingford
4	Bardfield	31	Peet
5	Battlesbridge	32	Pentlow
6	Baythorn	33	Ramsey
7	Blackwater	34	Rod
8	Blue Mills	35	Roxwell
9	Cattawade	36	Roydon
10	Causeway	37	Salt
11	Chain	38	Sandon
12	Chelmsford (Moulsham)	39	Shellow
13	Dagenham	40	Shonks Mill
14	Dedham	41	Small Lea
15	Fingringhoe	42	Stifford
16	Half Mile	43	Stone
17	Hallsford	44	Sutton Ford
18	Heybridge	45	Theydon (Mason's)
19	Ilford	46	Two Mile
20	Langford	47	Uttlesford
21	Laver, High	48	Weald
22	Leaden Wash	49	Whites, Gt. Burstead
23	Loughton	50	Whites, Margaretting
24	Margaretting	51	Wickford
25	Moreton	52	Wickham Mill
26	Nayland	53	Widford
27	Ongar, Chipping	54	Woodford

0 5 10

Widford and Ackingford (*Illus. pages 70, 73*). Constable's painting of Dedham bridge (*Illus. page 73*) appears to show diagonal ties between the piles and the beam, but Dedham, Battlesbridge and Ballingdon (*Illus. page 76*) did not have the braces from the beam to below the railing shown in the surviving designs.

Although far from typical, Widford (1803–1805) is the best documented of Johnson's timber bridges with its surviving design and detailed accounts for the period February to April 1805.[90] As in the case of Dedham, an important brick bridge was eventually replaced in timber.[91] Its condition caused concern early in 1802; Johnson reported a severe fracture in the right hand arch and advised flood tunnels to prevent flooding of the roadway to a depth of two to three feet at the west end of the bridge. In May, after Johnson had pointed out that the brook was choked from half a mile above the bridge down to Writtle bridge, a committee was appointed. Their report in July dealt with the problem of site ownership and the unwillingness of C. H. Kortright of Hylands to clear the river bed. Excavation on each side of the road and under the bridge proved to be necessary before work on the flood tunnels could be started.[92] Johnson visited the site on 7, 16, 28 July and on 16 August 1802, when he checked the fractured arch. In November the new work was damaged by a broad wheel waggon; the committee ordered it to be made safe for carriages in February.[93] Nearly £400 had been spent on the bridge up to January 1803, but in April the committee was ordered to consider rebuilding, to confer with Kortright and the Turnpike Trustees, and to obtain plans and estimates from the county surveyor.[94] By June the bridge was in a dangerous state; Johnson surveyed it on 4 June, met the committee there on 18 June and produced his design at Adjourned Sessions on 24 June.[95] After the court had accepted the design for a new brick bridge and

Ballingdon bridge on the Essex–Suffolk border, c.1892

the diversion of the road, Johnson presented the bridge as out of repair to the Grand Jury on 13 July. The following day, he visited the site to set out the ground for the road and the new bridge, returning to Chelmsford to apply to the court for a timber instead of a brick bridge. At their next meeting, the Turnpike Trustees noted that the county was building a new timber bridge and agreed to the necessary alterations to the road.[96]

Johnson's decision to construct a timber bridge may have thrown too much responsibility on John Funnell, the Springfield carpenter, who had done a great deal of work for the county since acting as clerk of the works for the erection of the Shire Hall.[97] Johnson was also preoccupied with the problem of his own bankruptcy, which resulted in his suffering a stroke, probably early in 1804.[98] He does not appear to have visited the bridge between October 1803 and 22 May 1804, when Bramston and Johnson had a site meeting with the Turnpike Trustees. Johnson paid five visits in June and two in July. On his next visit on 20 August he was dismayed to find the bridge not yet completed despite Funnell's assurances.[99] John Funnell was buried at Springfield on 12 September by coroner's warrant: 'not being of sound mind hanged himself in a saw pit'.[100] A reference by Lewis Majendie in July 1806 to Johnson having been deceived by an employee over Widford bridge 'at a time when his great misfortunes befell him' could well suggest that Funnell was responsible for problems with the first timber bridge, which had to be rebuilt after flood damage early in 1805.[101]

This time Johnson entrusted the work to John Kemshead, one of his own men, who was based at Berners Street and already working on the new House of Correction in Chelmsford.[102] After the flood, he started by making a temporary bridge for foot passengers in the first week of February 1805. Johnson arrived at the bridge to give directions on 12 February. After demolishing the first bridge, Kemshead cleared the ground to lengthen the bridge before preparing and driving piles to form the foundations of the abutments. During March planking was spiked on to the piles and the brick flood tunnels were repaired; the brick abutments were rebuilt and work was begun on the middle tier of piles. The tops of the piles were tenoned before caps were fixed on to them; beams were placed across the caps to form a temporary footpath by the end of March. The rest of the beams were in place with planking affixed by the end of the first week in April. More railing was needed for lengthening the bridge, which was opened during the second week of April 1805. Work still needed to be done on fixing iron braces, driving piles across the river, and repairing the circular walls to the wings. During June weather boarding was fixed over the outside beams. Kemshead charged £269 16s. 11½d., less £40 17s. 7d. for old materials used in the works.[103] Five years later, Montagu Burgoyne seized the opportunity of making political capital during the by-election of January 1810 by tracing the history of the unfortunate bridge 'from the time of its being upraised to the time of its falling in a third time, after it had been rebuilt'.[104]

Bridges on turnpike roads, like Widford, bore the brunt of increasing traffic,

but Quarter Sessions still remained responsible for the maintenance of existing county bridges. There were important bridges at Ilford and Woodford on the two stretches of road under the control of the Middlesex and Essex Trust. The act of 1785 included a clause making the Trustees responsible for maintaining 'such bridges as have been, or ought to be repaired at the common charge of the county'; the Trustees could then demand reimbursement from Quarter Sessions. No advance notice of this clause had been given to the county, which pointed out that in all works relating to bridges 'the county universally employed their own Surveyor and Workmen and the Justices give their own orders . . . respecting the works'. Counsel reluctantly gave his opinion that the Justices were obliged to reimburse the Trustees' expenditure, although the effect of the clause 'is to take out of their care management and control the repairs of the two Bridges and the road at the ends of them'.[105] However, the county surveyor had to examine both bridges on at least three occasions. At Ilford in 1790 he ordered repairs to the brick piers at an estimated cost of £18.[106] In the summer of 1801 a survey was made after the turnpike surveyor certified that the further arch was in a dangerous and shattered state, resulting in work costing over £100.[107] At Midsummer 1807 the court ordered 'stops' to be taken out of the Old River at the upper part of the West bridge and also between the two bridges; chalk was to be placed at the lower part of the east bridge under the direction of the county surveyor. A subsequent order dealt with the raising of copings and railings between the bridges and at the ends.[108] Johnson visited Woodford bridge twice in 1796, on the second occasion to examine the completion of the mason's and carpenter's work.[109] The bridge was again surveyed in October 1796.[110] Johnson examined the bridge in February 1800 at the request of Samuel Bosanquet, J.P., but found 'nothing materially deficient'.[111]

The position is less clear in relation to certain bridges on the roads maintained by the Essex Trust. Heybridge or Tan Office bridge, on the Mountnessing/ Ingatestone boundary, was found by a committee to be a county bridge when it was widened in 1788.[112] By 1845 the family of Mountnessing bricklayers responsible for repairs claimed that 'the Turnpike Trust has always paid for repairs'.[113] The bridge may have been taken over by the Trust after 1788.

In 1799 the Trust took over some bridges which had formerly been maintained by landowners. Both Springfield bridges on the main road to Colchester were taken over on 26 July 1799. Johnson was employed in a private capacity to reconstruct the brick bridge with flood tunnels, shown in Bamford's water colours of 1906 (*Illus. page 79*). The work cost £114 and attracted local criticism; the bridge 'broke down' in October 1800.[114] Robert Lugar, who succeeded Johnson as county surveyor, was paid £17 9s. by the Trustees for superintending the repairs of both bridges between February and July 1813.[115] The wooden bridge, nearer Chelmsford, was replaced in iron by the Trustees in 1819, to the design of Thomas Hopper.[116] In December 1799 the Trustees took over Newland bridge in Witham and decided to pull down the wooden structure

Springfield bridge, by A. B. Bamford, 1906

and rebuild it in brick under Johnson's superintendence, hence his reference in 1802 to flood tunnels also at Witham bridge; it was not adopted by the county until 1861.[117]

The practice of the county surveyor's undertaking work in a private capacity for the Turnpike Trustees had begun in 1798.[118] Johnson and his son, John Johnson, junior, also supervised work at Shenfield and Widford turnpike gates, including the supply and installation of weighbridges in 1798 and 1799.[119] In February 1800, Johnson's son wrote to the clerk with his father's recommendation 'to swear the parties to the quantities charged in their several accounts; this practice is constantly pursued at the Sessions in all business done for the County'.[120]

The repair of bridges on county boundaries created considerable problems for the county surveyor. Working at a distance, particularly in the Stour Valley, he had to rely on close cooperation with local justices and builders. The case of Dedham bridge between 1785 and 1796, in which the Clerk of the Peace (William Bullock) was also heavily involved, illustrates these problems in an acute form. Bullock's involvement probably led to the preservation of a bundle of papers, which provides more detailed information than the Quarter Sessions minutes of either county.[121] On 11 January 1785 the county surveyor was ordered by Quarter Sessions, upon the requisition of the Suffolk justices, to attend them or their surveyor to receive propositions for repairing or rebuilding the bridge.[122] Three days later, Suffolk Quarter Sessions appointed a committee to meet the Essex justices; 'Mr. Thomas Fulcher of Ipswich is desired to attend' committee meetings.[123] It now appears that Fulcher (c.1737–1803) was not a permanent county surveyor, like Johnson, but one of a number of surveyors

employed by the Suffolk justices paid by a fee or percentage for each job of bridge repair or other county building, who sometimes purchased materials or hired labour at the expense of the county, contracted with master-workmen, or carried out the work personally, sometimes, as in Fulcher's case, to his own design.[124] When the Essex committee was appointed in April, Johnson was ordered to attend meetings, the first being fixed for 23 May at 11 a.m. 'upon the premises'.[125] By 12 July the Essex committee was empowered to treat with Mr. Nicholas Freeman for the purchase of the necessary land.[126] The following day, Suffolk Quarter Sessions approved the recommendation to alter the site of the bridge and build a new bridge on the site selected by the committees 'according to the plan now produced by Mr. Thomas Fulcher of Ipswich'; advertisements were to be inserted for tenders for building the Suffolk part under Fulcher's direction.[127] On 6 August, Fulcher in conjunction with Mr. John Johnson, 'the Surveyor on the part of the County of Essex', was to agree with such person or persons 'as they shall judge proper' for building the bridge.[128] The end of the summer bridge-building season was approaching and it was not until 25 April 1786 that Essex Quarter Sessions resolved 'that each County do build their respective proportions of the . . . bridge', starting as soon as possible, the site and plan having already been confirmed by both counties; the necessary land was purchased from Freeman for £105.[129] Three days later, Suffolk Quarter Sessions appointed Fulcher as surveyor of the work, empowering him to contract with builders and purchase materials; as surveyor, he was allowed the customary five per cent 'upon the materials and work for his trouble' and could draw upon the Treasurer for materials up to £300. Both surveyors advised on the purchase of the land needed at either end of the new bridge.[130]

Very little information is available about the bridge during its construction, 1786–88. The Suffolk Quarter Sessions records give the cost of the bridge (£1,400 between April 1787 and May 1788) and Fulcher's fee of £50 for surveying, with further payments totalling £178 13s. 5d. in January 1790, probably in connection with the approach road.[131] Payments by Essex Quarter Sessions between Michaelmas 1786 and Michaelmas 1788 totalled about £1,640, mainly paid out to Palmer Firmin of Dedham, esquire, including a payment of £200 for making good the approach as ordered at Michaelmas Sessions 1787. Brewick timber (200 pieces measuring 2928 feet) was delivered at Manningtree in the autumn of 1786 at a cost of £109 6s.; 160 feet of stone for coping and a further 11 tons were shipped in July and August 1788.[132] Fuller details of the design of the bridge, however, are available from the county surveyor's report made on 14 April 1795, two months after the bridge had been blown up by the pressure of water in the flood of 10 February, supplemented by the case drawn up for counsel's opinion the following June. The original site of the timber bridge was inconvenient, being liable to flood on the Suffolk side and having a steep descent on Gun Hill, with poor visibility, on the Essex side. The new bridge was built about 70 feet to the east (see plan page 81) and a causeway ('New Road'

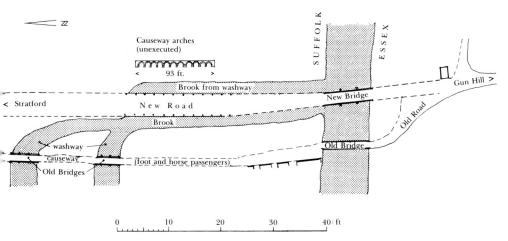

Plan showing positions of old bridge and of new bridge and road over the Stour near Dedham, redrawn by John Fulbeck from John Johnson's plan of 1795

on plan) built on the Suffolk side leading to Stratford St. Mary, extending for 91 feet 'over and across the washway'; arches were to be built under the road 'to carry off the water in times of floods, agreeably to the design or plan of their own surveyor for that purpose'. On the approach to the bridge from Gun Hill, the ground was raised at a cost of £504, thus reducing the descent by between thirteen and fourteen feet perpendicular. The new bridge was described as 'a very handsome Brick Bridge with Stone Piers', stone coping and four arches built to Johnson's design at considerable expense, the Essex proportion being given in the case as about £1,500. After the bridge was erected, Fulcher informed Johnson that the Suffolk magistrates had ordered the road to be carried from the foot of the new bridge to Stratford without building any bridge or archways for the conveyance of flood water. Johnson protested more than once at the impropriety of this scheme and refused to accept liability for any damage to the new bridge. After the Essex magistrates were informed of the situation, several local justices gave their opinion to the Suffolk magistrates; they replied that they had taken advice from an unnamed Norfolk surveyor who thought 'that no injury could take place'. Johnson warned the Suffolk surveyor that, as a result of the road to Stratford being raised, a stream of water (marked 'Brook . . .' on the plan) would be created parallel to the road and nearly at right angles to the river and that this brook was likely to meet 'the small brook which received the water' from the original washway (see plan), now well below the level of the New Road. He thought that the confluence of the two streams above the new bridge would force the water against the abutments and the bank on the Essex side. It was reported to Quarter Sessions after the flood that, in fact, 'the abutment is not destroyed but the bank and trees are washed away into the river'. Johnson conceded that an extraordinary flood might have resulted in damage to the bridge, but he thought 'it very probable it would not have been blown up'. He described the method of building the bridge: 'as the foundation or fordway of

the river was so strong', great difficulty was experienced in driving the iron-shod piles lower than eight or nine feet, using the county pile-driving engine with a hammer weighing seventeen to eighteen hundredweight; planks were pinned down to the piles, presumably as a platform for the stone blocks employed for the piers; the abutments were also stone. The force of the current during the flood was such that the bed of the fordway had been torn up to a considerable depth; Johnson regarded this as the probable cause of the bridge giving way and maintained that this would not have been the case if the arches under the road had been erected to carry off the floodwater.[133]

James Round of Birch Hall, the Essex J.P. who had visited the site with Charles Matthews of Colchester, J.P., on 11 February, also maintained, in his report to Quarter Sessions on 14 April, that the damage 'was occasioned in a great measure in his judgement by means of the causeway on the Suffolk side . . . having been raised to make a road . . . and there being no arches made under the said road to carry off the water in times of flood . . .'. Both Round and Matthews had been members of the committee responsible for building the bridge. This view was stressed in the case for counsel's opinion, when it was maintained that the disaster was 'in a considerable degree to be attributed to the noncompliance of the Suffolk magistrates with their original design and agreement of building archways' under the road.[134]

When Round and Matthews visited the site on 11 February, they 'took every precaution . . . necessary for preventing accidents to travellers, and for securing the materials of the . . . bridge'. Matthews also wrote to some Suffolk justices. Round went to London the following week to meet the clerk of the peace and the county surveyor; T. B. Bramston and Samuel Wegg were also present. To avoid waiting two months for Quarter Sessions to be held, Johnson was ordered to survey the bridge and order such repairs as were necessary for public safety under the direction of the justices for the Colchester division. The Essex justices suggested a site meeting of members of the former committee and their surveyors. When Matthews and Johnson visited the site by appointment, probably on 9 March, none of the Suffolk justices appeared; 'the Surveyor who attended on their behalf being entirely new to the business' asked Johnson to propose a plan. When he suggested a temporary bridge on the site of the old timber bridge, where the river was narrow, where 'some of the old piles remained' and 'the road on each side could be restored or made passable' cheaply, the Suffolk surveyor objected and proposed two or three other plans, 'which appeared both to the Essex magistrate and Mr. Johnson very exceptionable'. The new Suffolk surveyor was John Doughty, who had produced a plan in 1791 of the brick and stone Cattawade bridge for the Suffolk justices and acted as surveyor during its erection, and that of Kersey bridge, 1794.[135] After the non-repair of Dedham bridge had been presented at Assizes for both counties, a meeting took place on 30 March between justices from both counties, Johnson and Doughty. The Essex magistrates, including Round and Matthews, still

wanted to erect a temporary bridge on the site of the old timber bridge, but the Suffolk magistrates wanted a site west of this; no decision was reached at the meeting. The following day, Johnson was informed by the solicitor to the General Post Office that indictments for non-repair of the bridge were being prepared. The Essex magistrates, therefore, ordered Johnson to start work on their part of the temporary bridge, using 'fir and other proper materials'; work was advanced by 14 April and completed on 30 April. At Quarter Sessions on 14 April, the clerk of the peace was ordered to make arrangements for a further meeting with the Suffolk justices to settle a plan for rebuilding or repairing the bridge 'upon the site where it lately stood'.[136] However, on 17 April, Suffolk Quarter Sessions ordered half a permanent wooden bridge to be built to meet the wooden temporary bridge erected by Essex; the road from the foot of the bridge towards Stratford St. Mary was to be repaired and arches made according to Doughty's plan.[137] The Suffolk deputy clerk of the peace did not mention the permanent nature of the bridge when writing to inform Bullock of the court's order, but William Jeffries, who had earlier been present at Johnson's interviews with Fulcher, was keeping Johnson informed about the substantial nature of the Suffolk bridge and the use of oak timbers; Jeffries visited Chelmsford on 18 April. On hearing the news, T. B. Bramston announced his intention of calling on Bullock with Johnson on 27 April and of hoping to shame the Suffolk justices 'out of their shabby intentions'. The intention of the Essex justices to erect a permanent bridge on the site of the destroyed bridge was supported by the General Post Office 'as being more conveniently situated for the public accommodation'; the road was used not only for mail, but also for traffic to the Continent, presumably via Harwich.[138]

A meeting of justices from Essex and Suffolk finally took place on 20 May; only three Suffolk magistrates attended, but the Essex contingent of nine included, besides Round and Matthews, John Strutt and the Revd. Henry Bate Dudley. The Suffolk justices and their deputy clerk maintained that the committee was not 'authorized or at liberty to depart or deviate in any respect' from the terms of the order to erect a permanent bridge on the old site. Strutt proposed that Suffolk should complete their part so as to meet the Essex section of the temporary bridge, and defer the problem of a permanent bridge on the present site until after the holding of both Sessions, but, once again, the Suffolk committee was not empowered to agree. This attitude created difficulties for the Post Office; William Goodchild, the postmaster at Ipswich who was in contact with Doughty, thought that the road could be passable within a month if the temporary Essex bridge could be raised to meet the Suffolk portion, which had been built two feet higher. Goodchild's letter to Parkin was laid before Essex Adjourned Sessions on 28 May, when it was decided to seek the opinions of two counsel, Edward Law of Lincoln's Inn and S. Shepherd of the Temple. Both held that Suffolk could be compelled by indictment to rebuild their half of the bridge on the site chosen in 1786, since this had 'effectually become a Public

Bridge'. Essex had no claim to damages and might fail in bringing an indictment for neglect, since the county might be held to have acquiesced in the mode of making the causeway adopted by Suffolk. Their advice to give Suffolk notice of the intention to rebuild the Essex half, whilst heightening the temporary bridge and notifying the public of its temporary nature, was accepted immediately. Johnson visited the site on 20 June and told the Essex deputy clerk 'that the Gentlemen of Suffolk are taking every measure in their power to oppose this county', by destroying the road leading to the late bridge and aiming 'to erase every vestige of what had been done by them in respect of the late bridge and the approach to it'. He had informed Bramston that Suffolk was making good the road over the Essex half of the temporary bridge and that mail was passing regularly. Bramston, Strutt and Thomas Kynaston, also a member of the committee, met Bullock on 26 June and decided that nothing should be done until after the next sessions.[139]

Suffolk had already spent £400 on what they intended to be a permanent bridge; an order was made on 17 July for payment of this amount to Messrs. Roper and Doughty.[140] At the next Suffolk sessions on 1 August the Suffolk magistrates set out their reasons for building the permanent bridge on the old site, where the river was narrow and the land suitable for foundations; the bridge would cost less, requiring only one arch of 42ft. opening and being built at right angles rather than obliquely. The Suffolk surveyor thought the road on the Essex side could be heightened to improve the descent of Gun Hill at a cost of £200, inclusive of the purchase of the necessary land, and that a timber bridge could be completed for £100. If the plan was rejected, a reference 'to the determination of some eminent Engineer' was proposed. However, the Suffolk committee was ready to meet the Essex committee and to report to the adjourned Sessions on 22 August. There is no record of a meeting having taken place or of any comment by Suffolk on the counsels' opinions, but at the adjourned Sessions it was decided that 'the Suffolk part of the . . . bridge shall be rebuilt according to the intentions of the Essex Magistrates'; there was no need for further committee meetings, but the surveyors were to meet 'to consult upon the best means for carrying this order into execution with all convenient expedition'. Arrangements were made for the surveyors' meeting in the second week of September, Johnson travelling down to Stratford St. Mary by coach, probably on 11 September.[142]

At Essex Sessions on 25 September an order was made for the Essex part of the bridge to be rebuilt according to Johnson's design for a timber bridge which had been approved by Suffolk Quarter Sessions on 22 August.[143] Doughty attended the Essex Sessions and took the opportunity of measuring the width of the river on his return journey; he wrote to Johnson about the problems of narrowing the river, unless 'reduced by each County alike'. He requested a copy of Johnson's plan for production at Suffolk Sessions and pointed out that oak timber could be obtained from Mr. W. Harvey, carpenter, at Stratford. Johnson

went down to the bridge again on 8 October.[144] When Suffolk Sessions met on 9 October, the order for a timber bridge specified that it was to be built 'according to the plan produced by Mr. Johnson to the Essex Magistrates . . . and signed by Mr. Doughty the Suffolk Surveyor without reducing the waterway of the river to 45 feet as then proposed'.[145]

In April 1796 an order was made for a payment of £400 to Johnson towards the cost of the bridge; he had already been examined as a witness at Assizes and proved 'that all necessary steps were taking by the . . . County for putting the same into proper repair'. He visited the site again on 24 April.[146] On 13 July he was able to report that 'Dedham Bridge is completed in a neat substantial manner'. Praise was due to William Jeffries 'as Labourer in trust in faithfully executing the designs and directions given him and keeping the several accounts'; as a result the temporary bridge, rebuilding the present bridge 'with a stone abutment to the top of the parapet' and the necessary roadworks 'has cost the County no more than the sum of £448 10s., he having charged only three shillings a day for his time (the wages of a common workman)'. The gratuity to Jeffries recommended by Johnson was fixed by the court at fifteen guineas.[147] Messrs. Roper and Doughty were paid £500 in April, which may represent the cost of the Suffolk part of the bridge, since a payment to Doughty of £400 in October 1795 may relate to work on the temporary bridge.[148]

None of Johnson's designs for the bridge survive, but the view in Constable's painting of the Valley of the Stour, c.1805, in the Victoria and Albert Museum (*Illus. page 73*), can be related to the county surveyor's report of September 1857. It is described as a 'large wooden bridge crossing the Stour about one mile west of Dedham on trusses composed of piles three in one tier braced together supporting the roadway which is protected with open framed timber fencing. The Essex end of the bridge has a solid brick abutment with high retaining walls coped with stone. A small culvert to increase the waterway in floods pierces this abutment'. The Essex abutment is not shown in the painting, but there is a red brick abutment on the Suffolk side. The piles and white fencing are clearly shown, together with existing buildings including the Talbooth restaurant on the right. A similar, but more distant, view appears in an oil painting formerly in the Fison collection.[149] The bridge was replaced by an iron bridge in 1875 and in turn by the existing concrete structure in 1928.[150]

Essex justices were actively involved in the repair or rebuilding of other bridges on county boundaries, whether as individuals living locally, or as members of committees. Some of the latter might travel from a distance, as in the case of the Revd. Henry Bate Dudley's membership of the Dedham Bridge committee. Thomas Ruggles (1737?–1813) was a magistrate for both Essex and Suffolk. Pentlow bridge came to the attention of the Suffolk justices, who ordered repair in July 1792.[151] After the county surveyor had been ordered to examine the bridge, the setting up of a joint committee was suggested by Essex Quarter Sessions. The committee reported at Easter 1793 that the whole bridge

would have to be rebuilt, since the existing bridge had three bays and was supported by Suffolk to the centre of the middle bay; Ruggles, also acting as a Suffolk justice, had conferred with Thomas Corder of Long Melford, carpenter, who would rebuild the timber bridge according to Johnson's plan.[152] When Suffolk Quarter Sessions was held at Bury on 15 April, an order for rebuilding by Corder to the plan of the Essex surveyor was made and forwarded to the Essex sessions on 26 April by Ruggles.[153]

Lewis Majendie of Hedingham Castle (d. 1833) was another active justice. A letter from him was laid before Easter Sessions 1801, informing the court that Rod bridge in Foxearth, between Long Melford and Sudbury, was in a ruinous state and in need of immediate inspection.[154] Johnson found in May that the wharfing on each side of the abutment was totally decayed and some rails were very defective; repairs to the Essex part of the bridge were completed by October 1802.[155] Both Ruggles and Majendie were involved in negotiations over Ballingdon bridge in 1802–04.[156] Early in 1807, Rod bridge was again causing trouble.[157] When Johnson visited the site in July and found the bridge beyond repair, he 'had the assistance of the Revd. Mr. Herringham', rector of Borley (1805–19), another active justice, who 'promised to see some of the magistrates of Suffolk respecting the part belonging to that County (which is not so bad as that of the Essex part) to know their opinion on the subject'. A magistrate from Babergh Hundred had already been appointed to meet Herringham to inspect the bridge.[148] Herringham wrote to say he had attended the Sessions at Bury on 12 July and enclosed a report from Thomas Blunden of Melford, builder, dated 4 August, pointing out that any necessary repairs and painting to the Suffolk side could be done 'at the time when the county of Essex should rebuild their half'.[159] After two Suffolk magistrates inspected the bridge, repairs were ordered to be carried out under their direction.[160] At Michaelmas 1807 a plan and estimate for rebuilding the Essex half at a cost of £500 was accepted; the work was completed by Michaelmas 1808.[161]

Justices were also active on the Hertfordshire border; James Barwick of Waltham Abbey had been involved with Small Lea bridge, between Waltham Abbey and Waltham Cross, since it was built in 1774.[162] Barwick reported to Quarter Sessions at Michaelmas 1799 that the bridge was in great want of repair, estimated at £25, 'and unless the same is done before the winter sets in may suffer much by the water that comes thro' it in that Season'.[163]

William Palmer (d. 1821), a London merchant originating from a Leicestershire family, who built up the Nazeing Park estate between 1780 and 1820, carried on negotiations with the clerk of the peace for Hertfordshire over the rebuilding and resiting of Roydon bridge in 1802.[164] A committee was set up at Epiphany sessions 1801. The county surveyor visited the site on 23 February with Palmer and a Hertfordshire magistrate and found the bridge required virtual rebuilding at an estimated cost of £45. The magistrates 'suggested . . . that it would be to the advantage of the publick to erect a bridge over the ford-

way', which lay in a straight line with the original course of the river, 'and totally fill up the circuitous part of the . . . river. In this your surveyor entirely concurs, if the matter can be adjusted between the two counties'. On 13 March the court asked Palmer to have a presentment prepared against Hertfordshire; he agreed to do so at the next Hertfordshire sessions, provided that he could have a copy of the county surveyor's report.[165] When the court met on 22 May it was agreed to contribute £50 towards building a new bridge on the site recommended by Palmer on the Hertfordshire side of the boundary, 'such new bridge to be maintained . . . entirely at the expence of the said County of Herts and this County being exonerated from all expences of repairing the old bridge and filling up the ditch'. Palmer was authorised to come to an agreement with the Hertfordshire justices.[166] A committee was not appointed until Midsummer 1802, presumably because of the need to await the result of the case which had been referred by writ of *certiorari* to King's Bench; Hertfordshire was convicted during Easter vacation 1802.[167] Besides Palmer, the committee members included Sir George Duckett, Montagu Burgoyne, John Perry and the Revd. Edward Conyers; they met at Roydon bridge on 2 August, where some magistrates wanted Johnson to produce a sketch of the circuitous line of the river. He produced this on 6 August with a design for a timber bridge over the fordway at an estimated cost of £90.[168] Johnson's plan and report were considered by the clerk of the peace for Hertfordshire, who wrote to Palmer on 7 August, expressing willingness for a joint rebuilding of the bridge on the fordway site in his county. Palmer replied, two days later, stressing the urgency of rebuilding; 'the only matter yet unsettled is in what proportion the expence is to be borne by each county'. Essex had raised the offer of a contribution to £100, being near if not the total cost of the job, which included work on the road and waterway associated with the existing bridge, 'provided that the bridge is entirely in Hertfordshire'. The clerk of the peace replied on 27 August that the magistrates had resolved to build the bridge over the waterway, subject to a minor alteration of the suggested position, and to accept the contribution on the terms on which it was offered. The work was completed to Johnson's plan by 1803, although Hertfordshire did not require payment until February 1804.[169]

Johnson usually seems to have had good relations with the Suffolk and Hertfordshire surveyors, the case of Dedham bridge excepted. He was probably more experienced and of higher standing than his counterparts and usually provided the designs for bridges on county boundaries. This was the case at Pentlow (1793), Roydon (1802) and probably Small Lea (1810).[170] When Rod bridge in Foxearth needed repair in 1789, Johnson surveyed it on 31 July with the Suffolk surveyor, who was willing to defer executing repairs to the Suffolk half until Essex was ready to act.[171] The Suffolk surveyor is not named, but may have been Thomas Fulcher, who was still working at Dedham bridge.[172] Hertfordshire first appointed a county surveyor of buildings, bridges and works in 1798, but the holder, John Best of Hertford, carpenter, died before

Midsummer 1800. Two years later, the court consulted the unnamed 'Carpenter for this County', who confirmed Johnson's estimate for rebuilding Roydon bridge.[173] In 1806 John Simpson of Essendon, carpenter, applied for the post, his salary being raised from £20 to £30 the following year.[174] Simpson surveyed Small Lea bridge before the clerk of the peace was ordered to write to the Essex justices about the state of the bridge at Easter 1807.[175] No further action seems to have been taken for two years, when Hertfordshire wanted a joint survey, but Johnson's reports in May and July do not indicate whether this in fact took place, although he visited the bridge on 12 May and 7 June.[176] A joint survey was, however, carried out on 21 December, when rebuilding was recommended; Simpson agreed to Johnson's suggestions of a brick starling (protective piling round a pier) to be carried up under the centre arch and to the widening of the carriageway from thirteen feet to fourteen feet six inches.[177] The surveyors met again in the spring of 1810 and produced an estimate for two temporary bridges and supporting the original bridge.[178]

It was not, apparently, normally customary for the same craftsmen to have been employed by both counties, although this seems to have been the case at Pentlow bridge, 1793–94. Possibly because the existing timber bridge had three bays, both courts, no doubt at the instigation of Ruggles, agreed that Thomas Corder of Long Melford, carpenter, should rebuild the bridge to the Essex surveyor's plan.[179] At Rod bridge, the Suffolk justices ordered Corder to prepare materials for repair in October 1788, nearly a year before the Essex justices ordered repair to their side in August 1789. Johnson's clerk, John Gittins, wrote to a Foxearth carpenter, John Macro, that the charges in his estimate for timber at 2s. 9d. a cubic foot were higher than the price of 2s. 6d. which Corder had led him to expect, being the rate charged at Halstead house of correction. 'From the very good account he [Johnson] has received of you from Mr. Corder, he is desirous of your being employed in the business, but if you cannot provide the timber at lower charges than you have delivered, he is bound by his duty to the County to apply for estimates from other people . . .'. Macro must have satisfied Johnson since he received a payment of £69 11s. 6d., which slightly exceeded his original estimate of £62 19s. 8½d.[180] From at least 1790 Johnson was fortunate in working closely with William Jeffries, a carpenter, who may also have kept the Cock at Manningtree and the Three Compasses at Dedham.[181] He worked on the first Dedham bridge, but was definitely employed in a responsible position at Cattawade bridge, of which the Essex part, carried on 8 oak trusses, was 94 feet long clear of the abutment. The accounts kept by Jeffries between 7 April and 10 November 1790 have been preserved; he sometimes worked seven days a week, being also responsible for organising supplies of timber and other materials and the sale of old materials at auction.[182] The completion of the bridge in a substantial and workmanlike manner was reported at Epiphany Sessions 1791; the committee pointed out that Jeffries, 'the only carpenter employed', had not charged more than 3s. a day, 'the

customary wages of a common workman' and merited further compensation; the court awarded a payment of £21.[183] Jeffries' accounts for Dedham bridge, 1795–96, are very detailed. Meetings with Johnson are recorded on 9 March, 24 June, 11 September and 8 October 1795, with a final meeting on 24 April 1796. Besides hiring storage for tools and the pile-engine, he had to collect in bills for timber, chalk and cartage, post the accounts and journey to Colchester to swear them before a justice. Old materials were sold by auction and the pile-engine was despatched to Battlesbridge in August 1795. Weekend work was also necessary at Dedham bridge; on Saturday, 2 April Jeffries paid out 2s. for beer for the millers drawing down the water, so that he and four men could draw piles, possibly from the temporary bridge, on the Sunday.[184] Jeffries' role in providing information on the permanent nature of the work carried out for the Suffolk justices in April 1795 has already been mentioned, but he had earlier been keeping Johnson informed as to the amount of water that went over the old road to Stratford St. Mary during heavy floods after the building of the first bridge.[185] When the county surveyor reported the completion of the second bridge at Midsummer Sessions on 13 July 1796, he commended Jeffries' work on the bridge and in keeping the total expenditure down to £448 1s., all for a workman's wage of 3s. per day. The court awarded Jeffries a gratuity of fifteen guineas.[186] By 1807 Johnson referred to Jeffries as 'a workman employed by the said surveyor to look over or inspect the County Bridges within the Divisions of Tendring and Colchester . . .'.[187] He had obviously been acting in this capacity for some time, since in 1796 he paid visits to Nayland bridge in July and September and corresponded with Johnson on the subject. In the same letter, dated 30 October 1796, he informed Johnson that Robert Nunn, High Constable, had laid a great quantity of gravel on Cattawade bridge 'at least six inches higher than the side cills'; he had sent a message to Nunn to reduce the level, 'for you was angry with me for suffering it to be laid on'. He also reported that 'Ramsey bridge is in a very bad state'.[188] When he was later employed on Ramsey bridge in October 1807, he wrote to inform Johnson that poor people were removing timber from the wings for use as fuel; his informant supposed 'all would be gone this winter time if not putt a stop to'. The clerk of the peace replied sending Jeffries notices to be fixed up on and near the bridge and instructing him to take any offenders apprehended before the local justice. Jeffries' accounts for work on Ramsey bridge, March–July 1790, have also been preserved.[189]

The repair or rebuilding of some bridges on county boundaries raised complex issues. Although corporate towns were liable under the Act of 1531 to maintain bridges within their boundaries, this was not at first realised in 1802 when Ballingdon bridge linking this transpontine suburb to Sudbury was found to need rebuilding. In October 1802 Suffolk Quarter Sessions set up a joint committee, which surveyed the bridge on 4 October and found that the bridge would have to be rebuilt in the spring. A further meeting took place on 11

November, when it was suggested that a temporary bridge be built at the joint expense of both counties and the corporation of Sudbury.[190] However, at Suffolk Quarter Sessions on 17 January 1803, the court, having taken into consideration counsel's opinion, decided that the county of Suffolk was not liable for the repair of Ballingdon bridge.[191] Johnson produced alternative designs at Midsummer 1803; the cheaper with wooden railing was selected and justices from the Hinckford division were instructed to confer with the Borough on this basis.[192] Lewis Majendie was already worried in May that 'an uniform and substantial bridge' was not likely to be constructed; he had been informed by Ruggles 'that on consulting several gentlemen on the subject of a subscription he found them so *cold* that he did not venture to propose it under such circumstances'.[193] Johnson went over to examine the bridge and confer with Robert Frost, the town clerk, at the end of August. The clerk reported to Majendie on 4 October 1803 that he had laid Johnson's plan and estimate before the Sudbury magistrates, who 'are decided in their opinion that a sufficient sum of money cannot be raised for the purpose by the usual means'; they could only afford repairs, unless Majendie's suggestion, presumably of a subscription, should be practicable. Frost repeated these arguments in a letter to Bullock on 10 November, pointing out that the town was 'burdened with a numerous and unusually expensive poor'.[194] Early in 1804 the Essex justices considered erecting a temporary bridge, but when Majendie, Edward Walker and the county surveyor visited the site on 19 May 1804 it was decided to accept the suggestion made by Johnson and John Sparrow, 'a respectable carpenter residing near the spot', to make a temporary repair, costing £30, to last until the following spring; a public subscription was again mooted. The deadlock was finally broken in June 1805; the bridge was closed on 18 June, a temporary bridge erected and rebuilding begun on 26 June. The bridge was re-opened on 18 September; the work for the Essex half, consisting of 4 bays, cost £820 14s. 3½d., including £20 13s. 6½d. for repairing the pile-engine and carriage from Chelmsford and £12 for the Essex part of the temporary bridge. The committee (Majendie, Walker and Robert Andrews) reported that 'the Essex part . . . has been ably planned and executed in a solid and substantial manner, very much to the credit of Mr. John Johnson the county surveyor and those whom he has employed in its construction'. After extensive repairs c.1860 the timber bridge (*Illus. page 76*) was rebuilt in reinforced concrete in 1912.[195]

Long drawn out but amicable negotiations were also necessary before Roydon bridge could be rebuilt in 1802. The Hertfordshire justices agreed to change the watercourse so that the new site of the bridge lay entirely in their county; Essex paid £100 to be exempt from its maintenance in future.[196]

CHAPTER SIX

SHIRE HALL

FROM THE EARLY years of the 18th century, the condition of the Sessions House in Chelmsford caused concern to the Essex justices. In 1714 the extension on the west side known as the Little Cross was rebuilt in brick as an enclosed Nisi Prius or civil court, under the direction of Edward Glascock, surveyor of bridges and public works, while the timber-framed old Assize House, where the Crown Court sat in the open, was extensively restored. By 1722 the county records were stored in the new Nisi Prius court.[1]

Between 1767 and 1772 the justices' main preoccupation was the planning and siting of a new gaol at Chelmsford. In October 1770 Quarter Sessions approved plans by William Hillyer the surveyor for a new gaol and for rebuilding the sessions house. Hillyer had surveyed the sessions building on several occasions and considered 'it would be money thrown away to make any material alteration by repairs instead of rebuilding', although this was disputed by Robert Baldwin on behalf of opponents of the scheme. Provision was to be made for public courts of justice, a county room and a room for the records. Hillyer estimated the cost of his design to be £9,704. He disclaimed knowledge of other shire houses, but his engraved plans place the county room above a grandly named piazza, comparable with James Adam's arrangement of the Shire Hall at Hertford (1768–1771), although the topography of the Hertford Market Place may have necessitated placing the corn market at the rear of the building with a separate front entrance to the courts. As the gaol at Chelmsford was rebuilt on the original site beside the river Can, no further progress was made with the scheme to rebuild the sessions house.[2]

On 7 October 1788 Quarter Sessions resolved that the present Shire House was not in a fit condition for transacting the public business of the county. A committee, under the chairmanship of Thomas Berney Bramston, was set up to investigate whether the building should be repaired or rebuilt, with provision for a Grand Jury Room, a room for witnesses 'and a place for depositing the County Records'. The committee's terms of reference included the possible purchase of a site and the need to apply to Parliament for powers to acquire a site, erect the building and to defray other expenses. The county surveyor was ordered to survey the present building before the committee met again on 10 November. He reported that the brickwork of the north and west fronts of the Nisi Prius court was decayed. It would also be necessary to take down and rebuild the east wall between the two courts and to replace the columns supporting the Corn Market. The whole roof would have to be stripped, retiled and releaded. Repairs 'to last some years' would cost £200. The committee resolved 'that the present

Shire House cannot be repaired so as to answer the publick purposes of this County' and that it was expedient and necessary to build a new Shire House. Johnson was accordingly ordered to produce a plan and to survey possible sites, providing ground plans, for the next meeting on 28 November.[3]

Johnson's report to the committee pointed out that he had been unable to make site plans 'owing to the shortness of time allowed him for designing and making drawings for the new County Hall'. He had examined three possible sites: the former Red Lion adjoining the river, which was liable to flood and would necessitate expensive piling; the White Hart and Bell inns, with the adjoining butcher's shop, in Tindal Street; the premises adjoining the churchyard and present shire house, which had been previously surveyed and would provide a rectangular site, unlike the other two.[4] The committee, having agreed that it was proper for the county to purchase land for erecting the Shire House, decided that the best site was the premises adjoining the churchyard and present shire house, with such part of the latter's site 'as may be wanting for the said erections'. The plan for the new building produced by the county surveyor 'is such a one as promises to answer every public purpose'. The plan at this stage appears to have included a county room, since the committee advocated financing the scheme by a county rate levied upon landlord and tenant 'in moities', on the grounds that 'these Buildings may be rendered useful to the County for other public purposes when not wanted for the Administration of Justice'. The surveyor was to prepare estimates in accordance with the plan and elevations produced to the committee, 'stating the difference between carrying up the Front with Stone or partly with Stone and partly with Brick'.[5]

At the meeting on 9 January 1789, the committee recommended the adoption of the elevation 'marked B with a Pediment in the Center and the three Basso Relievos under the same according to the Elevation marked A', at a cost of £8,745. Quarter Sessions amended the recommendation slightly, accepting the elevation 'marked A omitting the Ornaments in the Frieze over the rustick story and over the Ionick Columns and also the Shield in the Pediment'; the building was now estimated to cost £8,918.[6] The surviving elevation (*Illus. page 93*) is duly signed by the clerk of the peace, but is not marked A or B; it includes the features to be omitted from the executed design: the county arms in the pediment; the frieze of bucrania and festoons over the Ionic columns; the fluted and Vitruvian scroll friezes above the rusticated lower storey, which may have represented alternative treatments.[7] The county surveyor was ordered to attend Lord Howard as Lord Lieutenant with the approved plan and elevation.[8]

The acquisition of the Shire Hall site was the responsibility of the clerk of the peace, but his negotiations were based on the valuation of 5 May 1789 made by the county surveyor. Johnson had only made allowance for inconvenience and loss of trade in the case of the Red Cross inn adjoining the churchyard, which was assessed at £420, including 'the value of the trade as the house would not be worth such a sum without'.[9]

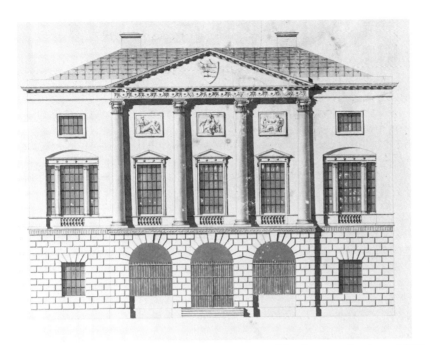

Shire Hall, Chelmsford, Essex, elevation accepted by Quarter Sessions, 1789

The act for building a new shire house, 1789, provided for a Grand Jury room, witnesses' room and for the storage of county records. It was later decided to store the non-current records in the surviving part of a house purchased for the widening of Moulsham bridge. The justices were authorised to take down the old shire house and the dwellings purchased for the purpose, to erect the new shire house and 'to complete, fit up and furnish the same for the convenient carrying on and transacting the public Business of the . . . County'. The Mildmay family, as lords of the manor, retained the right of keeping the market and fairs; a convenient place was to be provided for collecting tolls and depositing stalls. 'Farmers and others resorting to the . . . Market shall be allowed the use of the Piazza or open Part of the . . . new Buildings, for the Purposes only of assembling together to transact their Public Business, and of buying and selling their Corn and Grain . . . on Market and Fair Days'. No buildings, except movable stalls, were to be erected between the new shire house and the street. A sum not exceeding £14,000 could be raised in the same manner as the county rate. Accounts were to be made up annually, any surplus forming part of the county stock.[10]

Preparations for the assembly and storage of building materials began at the end of April 1789. The county surveyor was to procure stone and advertise locally and nationally for sealed tenders for the supply of red and white brick, timber, lime and sand.[11] On 16 May Quarter Sessions decided that £6,742 10s. was to be raised immediately. The surveyor was authorised to contract for red brick, lime, sand and fir timber and for the use of a field for the storage of building materials.[12]

Portland stone for the front elevation of the Shire Hall was supplied by Wallinger and Fletcher, from whom 80 tons had been purchased for Moulsham bridge (*see Chapter 5*). John Arnold Wallinger of Hare Hall, Romford, was in partnership as a cork and stone merchant in London with William Fletcher, who witnessed his will in 1792. The Wallinger family had strong Chelmsford connections, having owned the Brick House in Chelmsford market place since the 15th century; Wallinger himself was to be buried in Chelmsford churchyard. The firm supplied Portland between May 1789 and May 1790; 71 tons of scantling blocks of specified dimensions cost 30s. a ton, with 255 tons of common blocks at 26s.[13] The stone was landed at Maldon and brought to Chelmsford by Thomas Smith of Maldon, carrier, at 8s. per ton.[14] Purbeck stone was supplied by Nathaniel and James Chinchen of Swanage, Dorset, who sent a consignment ready sawn by sea on 18 July 1789 to Mrs. Sarah Wray, the Chelmsford mason. This stone was used for steps and paving; 15 tons of tooled Purbeck for the plinth and quoins cost £16 10s., but a mason had to spend five days squaring and jointing the plinth 'being damaged by the carriage'.[15]

The main suppliers of red bricks were William Brignall of Danbury, brickmaker, and Robert Greenwood of Chelmsford, the Quaker ironmonger. Under the terms of their contracts, Brignall was to supply 300,000 bricks before 1 November 1789 and a further 200,000 by 1 June 1790, at £1 11s. 6d. per thousand, while Greenwood charged £1 9s. per thousand for 200,000 bricks by November 1789 and 150,000 by June 1790.[16] Greenwood also supplied white bricks, but the main supplier was William Gooding of Playford, near Ipswich, Suffolk, who had provided white bricks in March–June 1789 for the reconstruction of Althorp, Northants; between October 1789 and April 1790 Gooding supplied 61,000 bricks at a cost of £170 16s., with a further consignment before June 1790. On 24 December 1789 Robert Mason of Purleigh, farmer, contracted to convey up to 100,000 white bricks from the port of Maldon before Midsummer 1790, at 17s. per thousand. The bricklayers and labourers had been held up 'for want of white brick' before Gooding's first consignment arrived at the end of October 1789.[17]

Contracts have also been preserved for the supply of lime, sand and oak. John Birch and James Davis of Northfleet, Kent, were to deliver best chalk lime at Chelmsford for 12s. per 'Hundred of 25 Bushels'. Local supplies of pit sand were available from Thomas Livermore of Broomfield, farmer, who was to supply it at 10s. for every load of 60 bushels, taken in the first instance from Sandpit Field. George Dench of Roxwell, timber merchant, contracted to supply 57 loads of British oak timber, at £4 9s. per load; 2,437 feet of timber arrived in August 1789.[18] Memel fir timber was obtained from John Thurstan of Colchester.[19]

The site for the new Shire Hall lay between the churchyard and the old Shire House, which remained in use during the erection of the new building, probably being demolished during April 1791. The sale of the materials by auction

realised £52 11s. 4½d., plus £55 10s. for the sale of old lead.[20] It was necessary to store materials for the new building on land behind the White Lion inn, approached from Duke Street by a passage still in existence (1991). A contract was made on 23 June 1789 with the landlord, William Street, for the use of Home Field (four acres) with a sawpit and a carriage way to and from the field, for the purpose of laying in materials and preparing them for use; Street was to receive ten guineas on the completion of the building. In fact, on 14 January 1793 he received fifteen guineas, some of which he expended on surplus building materials.[21] Charles England, who had come down from London to act as 'labourer in trust', began receiving materials on 21 July 1789.[22] The carpenters were busy in January 1790 sawing oak boards and putting up posts and rails in the field to set the boards against.[23]

The main contracts for bricklayers', carpenters' and masons' work were awarded in July 1789 to John Johnson, junior, Joseph Andrews and William Horsfall of Berners Street, St. Marylebone, builders and copartners, 'their proposals being greatly below and in every other respect preferable to those delivered in by any other person for undertaking the same works'. Johnson's son's firm had previously been employed on county bridges (see Chapter 5). The contract specified rates for piece work and day labour, masons, bricklayers and carpenters receiving 3s. per day and labourers 2s. Scaffolding was to be provided by the firm. Payment was to be by instalments equal to two thirds of the value of work done and certified, the balance to be paid on completion of the building. In September 1790 the same firm obtained the contract for plumbing work connected with the roof. The firm's account for piece work also includes plastering (£590 3s. 6d.), painting (£72 2s. 5d.) and slating (£145 6s. 11½d.). They later claimed that the county surveyor insisted that ten per cent should be deducted from estimated prices if they were to undertake completion of the building in addition to the original contract for the carcase of the Shire Hall.[24]

The use of the Johnson firm provided little scope for the employment of local craftsmen. John Funnell, a carpenter who was rated in Springfield from September 1796 and buried there in 1804, may have come with the firm from London; he received an allowance of £21 from Quarter Sessions at Epiphany session 1792 'for his extraordinary trouble and care in superintending the building under the direction of the County Surveyor'.[25] Mary and Thomas Merritt, the Chelmsford whitesmiths, were paid about £170 for goods and smith's work. George Wray received £4 18s. 8d. for unloading stone at Maldon in July 1789, but his mother's firm of stonemasons was not employed until July 1791, after the completion of mason's work by Johnson and Co.[26]

Funnell's gratuity must have had some connection with the difficulties encountered by the main contractors. After the submission of their account for day labour and piece work, totalling £4,006, they petitioned the county surveyor on 4 October 1791, representing 'the heavy loss we had Sustain'd from the Materials being deposited at the distance they have been from the Building. And

the Great Inconvenience that Attended the Execution, on Account of the Old Shire House Remaining during the Erection of the New One . . .'. A committee of justices was set up to consider this petition, and presumably asked for further details of the contractors' estimated loss. A second petition, dated 7 January 1792, stated that until 'after the first Measurement and making out of the Bills in September 1790', the expense of loading and carrying the materials from the field to the site was not allowed for; comparison of these bills with later accounts produced a loss of about £90. 'But the Inconvenience Attending the getting up the Materials on Account of the Shire House being so immediately before and so close As to Admit Nothing but the Scaffolding (which obliged Us to move the heavy Burthens of Stone etc. upon the Scaffold for the Greatest part of the front of the Building) was Attended with a Loss impossible for Us with any precision to Assertain.' Also, 'We were Oblig'd to have different head Workmen to Conduct each Department which Funnell as Clerk of the Works would have been able to have Managed', if the materials had been deposited on site. The second petition also incorporated the contractors' claim that Johnson had insisted upon a reduction of ten per cent on the estimate for completing the building.[27] The firm was awarded £200 in response to the petition.[28]

The cost and progress of the building of the Shire Hall is well documented. Abstracts of accounts, 1789–95, are supported by the vouchers for bills paid by the Treasurers of the East and West Divisions and the contractors' accounts for day labour and piece work, 1789–91. There is also the county surveyor's report on expenditure to the end of September 1790, totalling £5,171 3s. on building and £3,466 8s. 1d. on obtaining the Act of Parliament and purchase of the site; a further sum of £4,762 would be required for completion, plus Johnson's final commission of £238 2s.[29] The work took just under two years. The labourer in trust started work on 21 July 1789. The foundation stone was laid on 21 August by Thomas Berney Bramston and other leading justices, who had attended meetings of both the Shire House committee and of adjourned Quarter Sessions held at the Black Boy. An inscription giving the date was cut in the foundation stone, beneath which was deposited a 'leaden box, soldered up . . ., containing coins of the present reign' and medals struck in commemoration of George III's recovery from insanity. William Caswell, the landlord of the Saracen's Head, charged two guineas for 'entertaining workmen' on the occasion. Quarter Sessions was first held in the Shire Hall on Tuesday, 12 July 1791, the building being described by the *Chelmsford Chronicle* as 'now nearly finished (the painting excepted).' The committee made its final report at Epiphany Sessions 1792, stating that the work had been 'completed in the most perfect and elegant manner, with a saving of near £2,000 under the original estimate'; the services of the surveyor were recommended to the court's consideration. The Revd. Henry Bate Dudley, seconded by Thomas Kynaston, moved 'that the thanks of the county quarter sessions be given by the chairman to John Johnson, esq. and also that a piece of plate' to the value of 100 guineas be purchased out of the surplus

money raised for building the Shire Hall and presented to Johnson 'as a public testimony of his integrity and professional abilities, in the execution of the said Shire House, as architect and surveyor of the County of Essex'. On the motion being unanimously agreed, the chairman thanked Johnson, 'who returned his acknowledgments to the court in the handsomest manner'. T. B. Bramston, Kynaston, Richard Baker and Bate Dudley were to be responsible for purchasing the piece of plate. Messrs. Whipham and North of Fleet Street supplied 'a Rich Chased Cupp and Cover Gilt both sides to contain three quarts with Engraving long Inscription County Arms etc.', with the elevation of the building on the other side, and 'a polished beaded oval waiter Gilt both sides with Engraving', which was presented to Johnson by the chairman of Quarter Sessions in July 1792.[30]

The design of the exterior and interior of the Shire Hall is documented by Johnson's *Plans, sections and perspective elevation of Essex County Hall . . .*, published in 1808. The main change from Johnson's original design was the addition of low wings set back from the main facade. On 21 August 1789 Quarter Sessions resolved 'that it will be adviseable to employ the vacant Ground at each End of the New Shire House . . . for the purpose of erecting a Court Keepers Room and a Repository for the [Market Stalls] . . . and a Guard Room and Repository for Arms and other Stores belonging to the Militia . . .'[31] Johnson's published plan (*Pl. i*) shows the court keeper's kitchen and wash-house in the basement below the court keeper's room and bedroom on the ground floor with the stall repository at the rear of the western annexe (*Pl. ii*). The militia accommodation consisted of a guard room and prison, two armouries and storage for clothes and accoutrements; it was fitted up in August–October 1792 (*Illus. page 98*). Both wings are clearly shown on the obverse of the Chelmsford trade token of 1794 (*Illus. page 97*). The eastern annexe is shown in engravings of 1804 and 1831 and a photograph of 1879 with a simple recessed arch fronting the street, just discernible in Reinagle's painting, now in the Chelmsford and Essex Museum (*colour plate opp. page 1*).[32] The western annexe was raised in 1851, but a

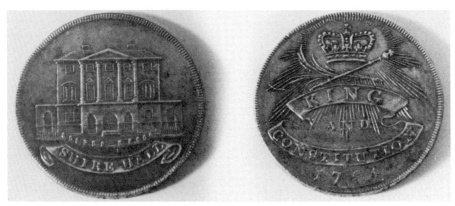

Shire Hall, elevation from Chelmsford trade token, 1794

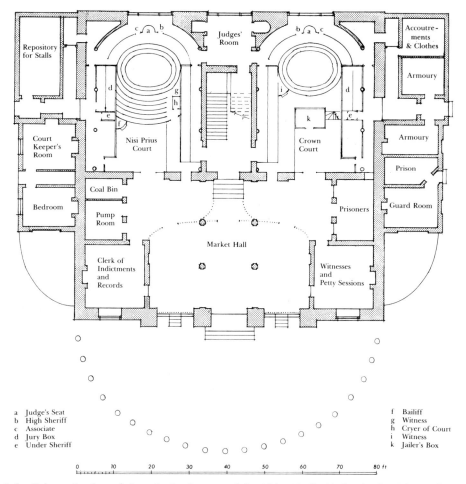

John Johnson's plan of the principal storey of the Shire Hall, Chelmsford, 1808, redrawn by John Fulbeck

photograph of 1876, taken in conjunction with the evidence of the token, suggests that the original designs of the two wings were identical.[33]

Johnson's report of October 1790 also refers to increased expense as a result of the committee's decision to use white bricks and an additional 150 tons of stone in 'returning the two Piers on each End of the Building', so that the Portland facade was continued for a short distance on the east and west elevations, although the surviving original design for the west front appears to show alternative treatments of the return wall.[34]

The main elevation, faced with Portland above a rusticated stone base, has five bays, with the three middle bays projecting slightly under a pediment. The small entrances on either side of the central entrance were only opened during Assizes. In Johnson's words, 'the ornamental parts in the front are all finely executed in artificial stone' (*see Chapter 3*). Eleanor Coade's bill of March 1790

can be related to features in Plate xiii of Johnson's *Plans* (*Illus. page 99*). The most distinctive feature of the Shire Hall facade is the use of Coade plaques in high relief of Mercy, Wisdom and Justice, modelled by John Bacon, R.A. (*Illus. page 99*).[35] Each figure has an attendant boy; the central figure of Wisdom has lost its spear, but Mercy still has her olive branch and Justice her scale, for which the copper beam cost 1s. 9d.[36] The elevation of the Shire Hall was included by Christian Ludwig Stieglitz amongst the fifteen English examples in *Plans et Dessins Tirés de la Belle Architecture* . . ., first published in Leipzig in 1800; the plate is one of the few in the book lacking a plan. Dr. Stieglitz (1756–1836), a well-known German architectural historian, probably visited

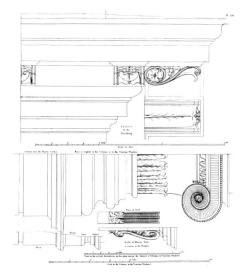

Shire Hall, details of features executed in Coade stone, from John Johnson's Plans . . ., 1808 (pl. xiii)

England about 1798. The engraving shows the main front without the wings; the design of the centre windows is described as elegant, but small windows are shown instead of the Coade plaques.[37]

WISDOM

MERCY

JUSTICE

Shire Hall, Coade plaques, 1808 (Plans, *pl. xiv*)

The arrangement of the interior of the Shire Hall was determined by the justices' requirements, as laid down by court orders and embodied in the act of 1789.[38] The entrance led into the market hall (*Illus. page 100*); the act provided for farmers and others on market days to 'be allowed the use of the Piazza . . ., for the Purposes only of assembling together to transact their Publick Business and of buying and selling their Corn and Grain'. Both Hillyer's plan for the Sessions House and James Adam's for the Shire Hall at Hertford had made similar provision for a corn market (*see above*). At Chelmsford, Johnson placed the Crown and Nisi Prius courts at the rear of the ground floor on either side of the staircase, whereas at Hertford the courts occupied the centre of the ground floor, separated by a passage and approached from either the corn market at the rear or a smaller entrance hall at the front of the building.[39] Johnson placed a room for the judges behind the staircase between the two courts. Inside the courts, the cornice was pierced to provide ventilation, grates being fixed in apertures in the walls.[40] His son's firm supplied 78 iron panels for fixing to the front of the court galleries.[41] In the Crown court, a subterranean passage led from the cells in the basement to the dock, as a result of an order made by the committee on 7 March 1791.[42] In each court, the judge's seat was raised in a niche seven feet eight inches high, to increase audibility; it was placed in front of the

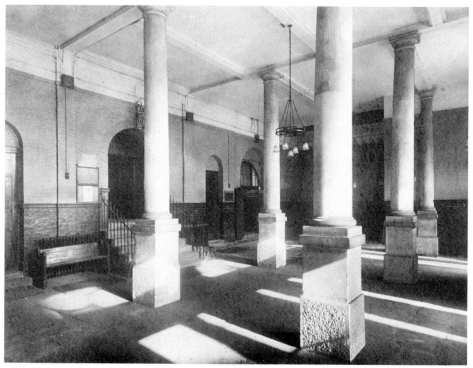

Shire Hall, market hall prior to alteration, 1936

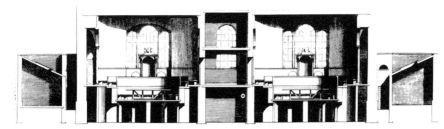

Shire Hall, section across courts facing the entrances, 1808 (Plans, pl. ix)

Venetian windows forming the original fenestration of the rear elevation (*Illus. pages 101, 102*).[47] Edward and Marsh, upholsterers of Mount Street, supplied the seats, upholstered in black leather, for seven guineas the pair; cushions covered with crimson velvet, costing ten guineas, lay on the judges' desks.[43]

Eleanor Coade charged £27 6s. for modelling the King's Arms and making a pair which were placed above the judges' seats on 18 June 1791; the Coade royal arms appear to have been replaced during the Victorian alterations to the courts.[44] Each court had a separate room for jurors.[45] The room for the Grand Jury, specifically mentioned in the act, was placed on the mezzanine floor behind the upper part of the county room; it is now (1991) known as the Picture Room.

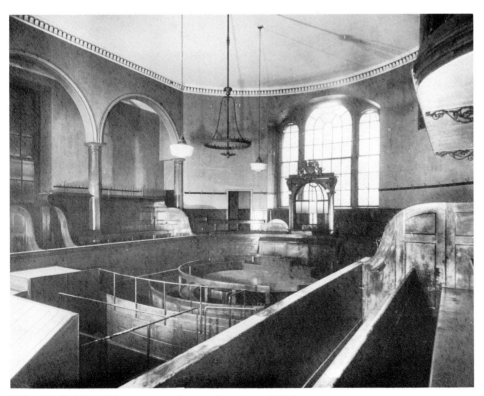

Shire Hall, Nisi Prius court prior to alteration, 1936

The prosecutor and his witnesses were also housed on this floor, together with a small bailiff's room.[46] The room on the left at the front of the ground floor was used for the clerk of indictments and for records, as provided by the act; that on the right, allocated to witnesses, was also used for Petty Sessions.[47]

Johnson's staircase, which remained in its original position until 1936, was lit by a dome (*Illus. page 102*). Johnson and Co., his son's firm, provided a wrought iron skylight, the lower tier and cap glazed with German plate glass and the upper tier with best crown glass. The use of German plate glass at a cost of £21 is mentioned as an additional expense in Johnson's report of October 1790. The plasterer provided four 'large trimd flowers and margins' for the staircase dome. Bennett and Bottomley, Balcony and Skylight Manufactory, No. 8 St. Martin's le Grand, supplied 27 ornamental panels at 5s. each, used for the stairs between the ground floor and the county room.[48]

The county room, measuring 78 by 33 feet, and 30 feet high, occupied the whole of the front of the first floor, a position comparable with that at Hertford (1768–71) and the Middlesex Sessions House at Clerkenwell (1779–82).[49] There are no surviving designs for the room, although Johnson's report of 30 September 1790 refers to 300 guineas extra allowed 'for the finishing of the County Room according to the Design fix'd on by the Committee'. The printed *Plans* include sections showing the entrance side and the west wall, with details of the ceiling design, ornamental panels, cornice, mouldings and pilasters.[50] A music gallery with a stone floor was placed over the entrance from the staircase; a sound board was put up in December 1792 (*Illus. page 103*).[51] Johnson and Co.

Shire Hall, judge's seat, 1808
(Plans, *pl. xi*)

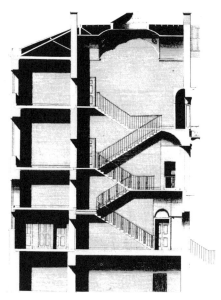

Shire Hall, section showing staircase,
1808 (Plans, *pl. x*)

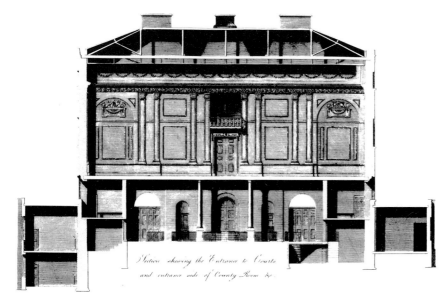

*Shire Hall, section, 1808 (*Plans, *pl. vii)*

charged £56 for the two statuary chimney pieces, one at each end of the room, with tablets carved with 'recumbent figures' by Charles Rossi, for which he was paid £21 in June 1791 (*Illus. page 103*).[52] The execution of the barrel-vaulted ceiling is well documented in Johnson and Co.'s accounts for piece work (*Illus.*

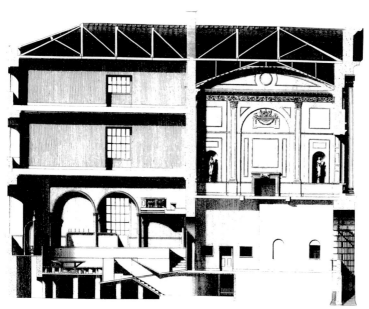

*Shire Hall, section across Crown Court and County Room, 1808 (*Plans, *pl. viii)*

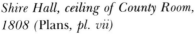

Shire Hall, ceiling of County Room, 1808 (Plans, *pl. vii*)

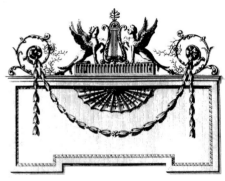

Shire Hall, ornament panels with 'rich Batt wing fanns', County Room, 1808 (Plans, *pl. xi*)

page 104). The plasterer supplied 1020 'Rich Oak leaves and Acorns with stems by hand' for which £89 5s. was charged; it was then painted 'in Oil and Turpentine the Ornaments white and the Ground . . . picked out in french Grey in Distemper' at a cost of £28 16s. ½d. French grey, a pearl grey with pink and blue in it, but no yellow, appears to have become fashionable in the late 1760s.[53] The account for plastering included 221 feet 'Run very large full Enrich'd Modillion Cornice with wide rich foliage Frieze' at £82 17s. 6d. and 20 'Pillaster Capitals consisting of Rich raffle leaves Stems and husks and the 2 returns in the Gallerys' for £15 14s. Six 'Rich Batt wing fanns' were part of the ornamental panels in the arches over the fireplaces and on the side walls (*Illus. page 104*). The modillion cornice, the pilaster capitals and 'the ornament pannels', together with the figures on 'enrich'd pedestals' were all painted by Benjamin Ridley's team of five painters from London after the completion of the main contract.[54]

Early 19th century descriptions refer to the county room as 'a richly decorated assembly room (occasionally used for the county meetings)'.[55] The first Chelmsford assembly for the winter season of 1791 was held in the county room on 10 October.[56] The incorporation of assembly rooms into 18th century public buildings was not unusual, although found more commonly in town halls. The Shire Hall at Stafford (1794) was also to include an assembly room. At Warwick the Court House, rebuilt by the Corporation in 1724 to 1731, was used for monthly winter assemblies, but the larger race-week assemblies were held in the Shire Hall, designed by Sanderson Miller (1754–58), when the hall was converted into a ballroom and the octagonal court rooms used as card rooms.[57] The assembly room in the Shire Hall at Hertford lacks the intended Adam decoration; the Hertfordshire justices stipulated on 28 November 1778 that the sum of £550 to 'be incurred by the addition of the Assembly Room . . . is to be paid out of the subscription for that purpose.'[58]

At Chelmsford on 4 May 1791 'a very numerous meeting of magistrates and gentlemen', assembled for the sessions at the Saracen's Head, decided to raise 'a subscription for the purpose of furnishing the county room'. The subscription

list was headed by Lord Howard as Lord Lieutenant and by Lord Petre with donations of £50 apiece. At least £1,300 was raised by the time the list closed on 1 January 1792. In the absence of a newspaper report of the meeting to decide expenditure held on 12 January, it is not possible to determine how the money was used. Some could have been spent on the four female statues in the niches on either side of the fireplaces; these were possibly by Bacon, who was responsible for those in the County Rooms at Leicester, also designed by Johnson.[59] The statues were painted and each held a rich two-light lustre.[60] The main lighting was provided by 'eight handsome 12 light rich cut glass chandeliers', suspended by chains from the ceiling, supplemented by a pair of two-light lustres on each mantlepiece.[61] The mahogany settees, first mentioned in an inventory of 1808, listing four 8 chair backs, two 5 chair backs, and seven 4 chair backs, were upholstered in green moreen, a woollen material, also used for the white festoon curtains.[62]

The county room and its ceiling were repainted by John Kemshead of Berners Street in 1803; he also relaid the floor. At the same time the other rooms were repainted or repapered and the three Coade 'large outside pannels in Alto relievo 4 times painted in stone colour.'[63] An enquiry the following year into the Shire Hall housekeeper's wages suggests that the county room was used for balls during race week as well as for subscription assemblies.[64]

In 1825 the county surveyor arranged to heat the courts and other rooms with warm air from a stove at a cost not exceeding £120.[65] He was also ordered to examine the house adjoining the gaol, lately occupied by the Keeper of the House of Correction, with a view to converting it into accommodation for the clerk of the peace and for the storage of county records. The work, costing £530, was in progress by Easter 1826.[66]

The design of Johnson's market hall, although successful as an imposing approach to the courts, did not provide sufficient light for farmers and dealers examining corn and seed. A memorial from farmers and others attending the busy Chelmsford market was presented to Quarter Sessions in April 1834, complaining that they had been subject for many years 'to great inconvenience for want of a suitable place in which to hold their corn market', being forced to transact business in the street outside.[67] The court adopted Hopper's plan to provide additional light by enlarging the openings on either side of the three central arches on the entrance front and by the provision of side openings; some interior walls were removed and two additional pillars inserted on the line of the original partition. The plan was to be executed by private subscription; work began in January 1835 with the removal of the magistrates' room from the ground floor, followed by the paving of the entrance hall with stone instead of brick. The work was completed in June 1835 at a cost of £572 13s. 4d., of which £475 17s. 7d. was borne by the subscribers.[68] The alterations do not seem to have been entirely successful; a scheme to provide further accommodation, proposed in 1842, does not seem to have been executed, owing to lack of

funds.[69] The problem remained unsolved until the formation of the Chelmsford Corn Exchange Company in August 1855, resulting in the opening of a purpose-built Corn Exchange in 1858.[70]

Between 1846 and 1852 further work took place on the interior of the main building, with extensive alterations to the wings. The county room was repaired and repainted in 1849 at a cost of £300; it was also decided to remove the music gallery, filling up the space 'so as to preserve the uniform character of the room'.[71] Separate rooms were provided for the use of the judges when they retired from their respective rooms for conferences.[72] The courts were rearranged and lighted with gas. In the Crown court, better provision was made for barristers, solicitors and reporters and the position of the bail dock was altered.[73] As it was considered preferable to house the clerk of the peace and the county records in the 'immediate vicinity of the courts', rather than in Moulsham, the west wing was raised with a hipped roof. After rebuilding, the wing contained an office for the clerk of the peace and storage for hurdles on the ground floor, with the room for the judge of the Nisi Prius court above the clerk's office and a strong room for the county records at the rear of the upper floor. The committee inspected the new building on 21 February 1852.[74]

Four years later, on 22 February 1856, the third flight of stairs leading to the grand jury room collapsed, probably as the result of the failure of the landing at the entrance to the county room. The stone steps had been recently repaired, but James Fenton, surveyor to the Local Board of Health, who gave evidence at the adjourned inquest, pointed out that each step in the original construction ought to have been pinned, not merely rebated together, and that the whole weight of the staircase depended upon the outer corner of the landing.[75] A new staircase of York stone from the ground to the grand jury room was erected and the existing staircase to the upper rooms strengthened.[76] Fenton's verdict contrasts with that given by Johnson, in conjunction with James Wyatt and John White, on the collapse of five central piers at Somerset House as not due 'to any bad construction of the plan or to any Neglect in the execution.'[77]

The Sebastopol cannon, presented to the town in 1858, was placed in front of the Shire Hall. It remained there until 1937, when it was removed to Oaklands Park.[78]

The coldness of the courts caused concern in February 1864, resulting in the entrances to the market area being filled with masonry and glass the following year.[79]

During 1868 the county room was redecorated at a cost of £159; the committee had stipulated that the ceiling was to be painted in plain colours, rather than being picked out in gold. Two gas burners were introduced.[80] By 1872 the county room and grand jury room were allowed to be used for the county and other public and subscription balls, concerts, meetings of the Essex Agricultural and other county societies, societies for the promotion of religion or morality, meetings for scientific and literary purposes, and public dinners.[81]

In 1887 an illuminated clock was presented to the town in commemoration of the Golden Jubilee by Messrs. Sparrow and Co., bankers; it was placed in the pediment of the Shire Hall.[82]

Major alterations took place between 1901 and 1906. The west wing was altered to provide a record room below the office of the clerk of the peace; an additional storey with a flat roof enabled a hall-keeper's flat to be incorporated.[83] The heating of the courts was improved. The Crown court was enlarged in area by 25 per cent, incorporating part of the rebuilt east wing; the gallery was moved to the south side of the court. New cells were provided in the basement, with a subway to the new police station on the other side of New Street.[84] In 1908 a staircase to the churchyard was provided from the new judges' room in the rebuilt east wing.[85]

The county room was painted and redecorated in 1907.[86] In 1911 the three surviving figures in the niches were fitted with electric lamps; the fourth figure may have disappeared as the result of the creation of an emergency exit from the room, first mooted in 1897.[87] The county room was again redecorated in 1927; the Shire Hall sub-committee insisted that the panels were to be redecorated 'as at present', presumably referring to the stencilled decoration, probably added in 1907. Gilding was also to be renewed; the work cost £493.[88]

In May 1934 major alterations to the interior of the Shire Hall, with the exception of the county room, were approved.[89] During 1936 the entrance hall, courts and grand jury room were reconstructed and modernised. The resiting of a new staircase resulted in the refenestration of the rear elevation with Crittall windows (*Illus. pages 107, 108*). The discovery of dry rot during the progress of

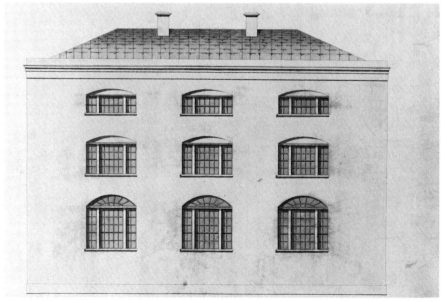

Shire Hall, elevation of north front accepted by Quarter Sessions, 1789

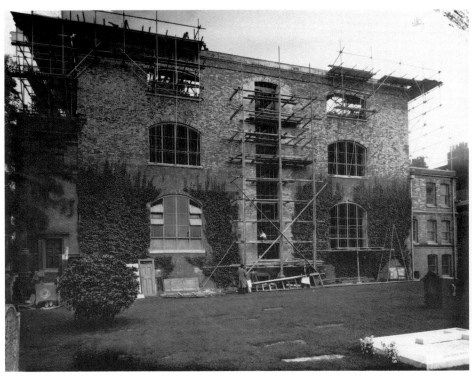

Shire Hall, north front undergoing repair and refenestration, 1936

the work led to the insertion of a steel roof, which was recovered with slates. The dry rot also affected the joists above the ceiling of the county room, which had to be replaced with a replica. A tablet in the entrance hall records the major reconstruction of 1936, carried out at a total cost of £20,000.[90]

In 1952 the county room was redecorated again at a cost of £1,055. Great care was taken by the County Architect to achieve an Adam colour scheme, enhancing 'the architectural features of the County Room'; defective gold leaf ornament was to be renewed.[91] The recent redecoration in 1981 is more successful and nearer Johnson's original colour scheme (*Illus. page 109*).

Reinagle's painting of the Shire Hall in 1794 includes the conduit on the left, at the top of Duke Street (*colour plate opp. page 1*). In June 1791 the *Chelmsford Chronicle* reported that the water supply of the town was to be improved and the existing conduit, 'now in a ruinous condition', was to be rebuilt 'upon a more elegant plan to make it in some measure correspond with the magnificent new Shire House near it'.[92] The trustees of the charity set up under the will of Sir William Mildmay (d. 1771) had consulted Johnson in 1787, when he received two guineas for a plan and attendances. Nothing more may have been done until early in 1791, when Johnson is reported to have made a gift to the town of his commission for designing and superintending the execution of the conduit and also to have subscribed five guineas; the work was nearly completed by the end of the year. In January 1793 the trustees paid him £108 12s. 'for Mr. [sic] Coad's

Bill for the Conduit.'[93] The work was executed by Johnson's son's firm, Johnson and Horsfall, who sued the trustees for payment in June 1796. The trustees brought a surveyor down from London to examine the work, but the jury gave their verdict in favour of Johnson and Horsfall, who were paid £447.[94] However, the design of the conduit was not successful in improving the town's water supply. In 1797 a vestry meeting was called 'to take into consideration the stoppage of the water of the conduit'; a proposal to rebuild the conduit was abandoned in February 1801.[95] A timely legacy enabled the trustees to replace Johnson's conduit by a domed rotunda in 1814; this was resited at the junction of the High Street and Springfield Road in 1852, and moved to Tower Gardens in Roxwell Road in 1940.[96]

Johnson's conduit, constructed of Coade stone, was erected near the site of its predecessor. The figure of a naiad held a shield with an inscription commemorating its erection; she stood on a cylinder with four dolphins and a short Latin inscription, formerly on the old conduit. This cylinder in turn rested upon a cylindrical vermiculated pillar, which stood on a rusticated base with four lions' heads, from which the water issued into a small basin, surrounded by posts. There is no documentary evidence of the modeller of the Coade statue, although Frederick Roberts has suggested that either Bacon or Rossi could have been involved, in view of their associations with both Johnson and the Coade firm. After 1814 the naiad disappeared for many years, but is known to have been in a private garden from 1876 to 1963, when she was presented to the Chelmsford

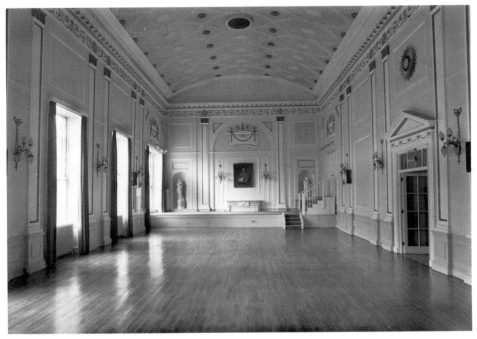

Shire Hall, County Room, 1991

Society, who donated the statue and associated components to the Borough Council on 24 October 1964. The shield with the inscription was missing when the Chelmsford Society discovered the remains of the conduit. The naiad was cleaned and restored at the expense of the Chelmsford Rotary Club, prior to being put on display with its dolphin base in the foyer of the Shire Hall in February 1980 (*Illus. page 110*).[97]

The subscribers to Johnson's *Plans . . . of the Essex County Hall* (1808) included four from Sussex, the Earl of Chichester, Lord Sheffield, W. B. Langridge, Clerk of the Peace, and Mr. John Cowper. All, except Sheffield, were to be concerned in the building of the County Hall at Lewes.[98] Plans for the new County Hall were originally commissioned from Johnson in 1801. He was

Coade Naiad from Chelmsford conduit, in Shire Hall foyer, 1991

appointed surveyor of works, but no further action was taken until 26 February 1808, when Quarter Sessions resolved to apply for an act of Parliament for demolition of the existing Sessions House and the acquisition of a new site for rebuilding. The process of obtaining an act required Johnson's attendance at the House of Lords committee; he was again appointed surveyor on 23 June 1808, John Cowper, a local architect and builder, acting as clerk of works.[99] Johnson came down to Lewes when the building committee viewed the site on 16 July, discovering that the plans had failed to take account of an adjoining property projecting into the land already purchased by the county. It was then decided to adopt an enlarged plan, necessitating the taking up of the foundations and the acquisition of further property.

Johnson's plans have not survived, although the building is otherwise well documented, and has much in common with the Shire Hall. The design did not include giant columns; instead of a triangular pediment, as at Chelmsford, there was a rectangular 'pediment', inscribed 'COUNTY HALL', as at the County Rooms at Leicester (*Illus. pages 111, 137*). The Lewes 'pediment' was

County Hall, Lewes, Sussex, c.1910–1920. The inscribed tablet was removed after 1977.

taken down after 1977. The use of Coade, including the plaques of Mercy, Wisdom and Justice, was almost identical with the treatment of the facade of the Shire Hall (*see Chapter 3*). A recessed open colonnade of five bays led into the market hall, which, as at Chelmsford, was flanked by a clerk's office on the left and a magistrates' room on the right. The Crown and Nisi Prius courts were placed to the left and right of the staircase. Cells were originally located in the backyard. As at Chelmsford, height for the courts was obtained by raising the ceilings above the level of the front rooms. The county room with an adjoining grand jury room occupied the first floor at the front of the building. The ceiling of the county room was 'to be arched in a neat, plain manner'; Johnson supplied patterns of ironwork, including that for the ornamental gallery in this room.[100] He also purchased a marble chimney piece at £55 11s. 6d. for the Supper Room.[101] The county room was also furnished by public subscription, under the direction of the Earl of Chichester.

Despite his age, Johnson managed to pay a few visits to Lewes during the course of the work, although he was in constant touch with Langridge by letter or during the latter's visits to London. Johnson attended Sessions on 13 January 1809.[101] However, the committee's suggestion in February that the courts should be floored with oak, instead of deal, was rejected by letter, but in April Johnson requested a special meeting of the committee to provide final

instructions for the fitting up of the courts, which he then appears to have discussed in town with the Earl of Chichester.[102] There was further correspondence about the lay-out of the courts in October, when Langridge, who had been in touch with the clerks of the peace for Lancashire, Hampshire and Dorset, asking for plans, sent Johnson a sketch of a proposed separate entrance for counsel, attorneys and witnesses. However, on 19 October the committee confirmed Johnson's plans before details of other courts reached Lewes. Forty years later, a barrister described the lay-out of the Lewes courts as 'precisely similar to the courts at Chelmsford'.[103] In December 1809 Johnson came down for a committee meeting at which the Keeper of the House of Correction approved the cells.[104] He paid one more visit to Lewes in July 1812, when the building was completed. The cost at that date amounted to £10,152.[105]

Between 1890 and 1930 extensive alterations in the County Hall were carried out. The courts were altered in 1890, when the two side entrances of the colonnade were filled in to form offices. In 1891 the sash windows on the first floor were reglazed with plate glass. The following year, further office accommodation was obtained by lowering the ceiling of the county room. In 1900, a two bay extension in similar style was added at the east end. A further extension on the west in 1930 was based on the design of Newcastle House, which formerly occupied the site.

CHAPTER SEVEN

COUNTY GAOL AND HOUSES OF CORRECTION

THE COUNTY GAOL at Chelmsford and the houses of correction at Barking, Chelmsford, Colchester, Halstead and Newport together constituted one of the main responsibilities of the county surveyor. The house of correction at Newport had been rebuilt in 1775 and is still in use as a private house, despite complaints made in 1796 of poor workmanship and materials. Johnson's plan of 1791 for building three solitary cells on adjoining land purchased on the initiative of local justices was not accepted by Quarter Sessions, despite local concern about the policy of mixing hardened and dangerous convicts with the lesser offenders for whom houses of correction were originally intended.[1]

HALSTEAD HOUSE OF CORRECTION

At Halstead, the house of correction had been completely destroyed by fire on 29 March 1781.[2] By June the justices had decided to rebuild on a new site in Bridge Street. At the beginning of July Hillyer produced plans; the specifications were completed before his death, his final accounts including a charge of £21 for plans, elevations and estimate.[3] On 9 April 1782 Johnson, as Hillyer's successor, was ordered to survey the new site and to examine the plans and designs, on which he was asked to make observations.[4] In July Quarter Sessions approved 'a Plan and Estimate for building a large and more convenient House of Correction . . . having been before prepared and being now produced'; it was to be built 'according to the said plan and estimate under the care and direction' of the county surveyor. Johnson may have modified Hillyer's design, since the clerk of the peace was instructed to prepare conveyances of the site for the erection of the new house of correction 'agreeable to the Plan prepared and settled by Mr. John Johnson the Surveyor.'[5] The front elevation, comprising the keeper's house, with the ground floor windows set in recessed arches, was not uncharacteristic of Johnson's work. The conversion of the two right hand bays to a steam flour mill by 1866 makes it difficult to reconstruct the original design; the work appears to have entailed the demolition of the pediment and a change in the position of the central doorway.[6]

Work on the Halstead house of correction took about a year. On 15 July 1783 the building was reported to be complete and ready for occupation on 4 August. Isaac Slythe of Colchester, who had contracted to do the bricklayer's and mason's work, had encountered difficulty in securing bricks and lime at a reasonable price, since 'we begann the Jobb so late in the Season that every Body that had a

Days work to do . . . wanted a thousand of Bricks.' Slythe was obliged 'to Ride about and beg of the Brick men to let me have all the Bricks they could', regardless of price. Red bricks were procured from Linnott's kiln at Halstead (23,900), High Garrett (88,000), Earl Nugent at Gosfield (41,000), Coggeshall (8,300) and Middleton Hall (11,300). Grey stocks for the facade came from Linnott (7,100), Higham (3,000) and Copford (1,300). 12,000 better quality tiles were brought from ten miles away. Slythe complained that the prices for brickwork, tiling and lath and plaster in the original contract were too low and that 'the County have broke their agreement with me', entitling him to have the work valued. However, discussion between Slythe and Johnson resulted in the justices agreeing in January 1784 to an extra payment of £40 to Slythe, in consideration of the 'advanced price' of materials.[7] The total cost of the building, which may have included the site, amounted to £2,349 3s. 8d.[8]

In 1789 Johnson was ordered to make a survey with a view to providing solitary cells. He reported that it would be possible to provide ten, two of those being converted from refractory cells. The justices decided to provide four on the men's side. In 1819 the accommodation, separated from the keeper's house by a railing across the courtyards, comprised eight cells and two day rooms.[9]

Alterations by Thomas Hopper as county surveyor in 1823 included subdividing the existing cells, putting treadmills in the central yards and forming a chapel upstairs out of part of the governor's accommodation.[10] The building was sold by the county in 1850, after being used partly as a police station, and demolished in 1973 when the Bridge Street area was redeveloped as a shopping complex.[11]

COUNTY GAOL

The county gaol in Chelmsford had been built on the Moulsham side of the river to the designs of William Hillyer between 1773 and 1777. John Howard, the prison reformer, visited the gaol in 1779, remarking that it exceeded the old gaol 'in strength and convenience as much as in splendour'; he also pointed out that the infirmary consisted of one close unfurnished room and that the interior of the gaol had not been whitewashed since it was first occupied.[12] On being appointed county surveyor in January 1782, Johnson was ordered to examine recent work done at the gaol by the London contractor, William Staines; he was to be assisted by Hillyer's former clerk, Benjamin Garner.[13] Johnson only found it necessary to recommend a few minor works, but the following year he had to deal with an escape attempt, suggesting lining the four felons' cells with York or Scotch paving stones to improve security.[14] In 1783 he also exhibited the 'Principal Front of a quadrangle Prison now building in Essex'.[15]

The act of 1784 introduced the principle of classification: separate accommodation was to be provided for prisoners convicted of, and those charged with, felony, prisoners committed for misdemeanours, and debtors; males of each class were to be separated from females and separate infirmaries provided for

both sexes.[16] The Essex justices appointed a committee to examine the gaol in relation to the provisions of the act in April 1784, but it was not until Michaelmas 1786 that, at the urging of the Chief Justice of the Common Pleas, Johnson was specifically ordered to make a survey 'with a view to the constructing Wards for the separate confinement of Prisoners'. He produced a plan and estimate for £900 in January 1787, but this was referred back to the committee so that a plan could be prepared for converting the present felons' wards and brewhouse 'into Places of solitary confinement'. At Easter 1787 the court adopted Johnson's plan to convert the female wards for this purpose, since this part of the prison was in view of the gaoler's apartment.[17] The roof of the first eight solitary cells was ordered to be covered with patent slate during the summer of 1788; the conversion was completed early in 1789.[18]

During the work the few female prisoners were moved into the men's infirmary. In consequence, at the Assizes on 21 July 1789 the Lord Chief Justice, Lord Loughborough, laid a fine of £500 upon the inhabitants of the county 'for not having in the Common Gaol two Rooms one for the Male and one for the Female Prisoners set apart for the sick', pursuant to the act of 1784.[19] In October the justices ordered that the solitary cells should be set apart as a sick ward for male prisoners and that the disused tap room should be used as a female infirmary.[20] The execution of the order appears to have been delayed by the complex legal situation resulting from the fine on the county, fully discussed by R. E. Negus.[21]

Major changes at the gaol took place as a result of the act of 1791, under which visiting justices were appointed and renewed emphasis was placed on the principle of classification.[22] The first report of the visiting justices at Michaelmas Sessions 1792 drew attention to the poor state of the buildings and the attendant risk of escape. The removal of the buildings in the centre of the prison, including the chapel, to make space for a double row of separate cells was recommended, rendering the gaol 'much more airy, safe and commodious', whilst 'capable of answering every purpose required by Law'. By January 1793 work on the sick wards had been completed. Johnson estimated that it would cost about 2,000 pounds or guineas to demolish the central part of the prison and 'build with Purbeck Stone and Arch with Brick' 30 new solitary rooms and an observation post for the keeper; the debtors' hall was to be converted into a kitchen and the brewhouse into a chapel with a room for prisoners' clothes over it.[23] A revised estimate of £1,555, providing for six fewer rooms and for the walls to be executed wholly in Roman bricks, specially made and larger than those normally used, was accepted in January 1794.[24] Other works at this period included the improvement of the drainage system, the rebuilding of the river wall, with the provision of a bath for the prisoners, and the erection of railings to enclose the courtyard in front of the gaol.[25]

The completion of the work, providing accommodation for 124 prisoners of different classes in addition to 50 debtors, was reported in October 1796.[26]

There are no separate abstracts of accounts for work on the gaol after 1781. John Johnson, junior, supplied and fixed the large thin 'patent' slates, said to have been introduced by James Wyatt, and often employed by Johnson; some of the twenty tons delivered at the gaol in 1787 were available for use in the summer of 1794.[27] The local firms employed at this period had also worked at Moulsham bridge: Jonathan Bottomley, carpenter; George Wray, mason; Thomas Merritt, smith; Chivens Hollingsworth, bricklayer.[28] John Funnell also worked at the gaol as a carpenter, but Johnson reported to Michaelmas Sessions 1797 that, instead of employing a clerk of works, he had 'from time to time sent his Drawings and Directions to . . . Funnell, Whose Attention during the Progress of the Business has taken Up Much of his Time'. The justices ordered him to be paid a gratuity of ten guineas.[29] Montagu Burgoyne later claimed that repairs and alterations to the gaol after 1780 had cost over £7,000.[30]

Hillyer's gaol, as altered by Johnson, can be reconstructed by comparing James Neild's description of 1803 with the plan and detailed report made by Thomas Hopper as county surveyor in 1819.[31] Neild pointed out the defects of Hillyer's original plan with the centre court 'crowded with a large chapel, large tap-room, spacious kitchen and many domestic offices, which prevented free circulation of air'. Johnson's removal of the buildings in the centre made space for eight single cells 'without the least interruption to the free circulation of air'. The main quadrangle measured 103 by 86 feet, with a continuation measuring 38 feet square; it was divided longitudinally into three yards by the two ranges of 'Cage Cells'. The gaol was entered from Moulsham Street through the governor's house. The separate accommodation for debtors lay on the left hand side of the quadrangle; in 1803 it comprised a courtyard and day room, with sleeping rooms, some upstairs in the governor's house, and the common or straw room for those unable to pay for beds. The women's ward for day and night use lay at the end of the debtors' yard in 1819, having been converted from the debtors' day room in 1807. At the same time, the women's infirmary was reduced in size and boarded to cure a problem with damp.[32] The male infirmary, beer house and new chapel lay on the side of the quadrangle furthest from the entrance, with the condemned cells, subdivided in 1802, on the side of the quadrangle nearest the river.[33]

Hopper's report stressed the deficiencies of the gaol, which lacked a porter's lodge, adequate supervision from the governor's house, sufficient separate cells, day and night cells for women, airing yards and work rooms. These criticisms were echoed by a prominent justice, C. C. Western, in his *Remarks on Prison Discipline* (1821), which also referred to the house of correction, erected by Johnson in 1802–1806, although he admitted that both Johnson and the magistrates had the need for economy primarily in mind and that 'the great modern improvements' in the construction and management of prisons postdated the work at Chelmsford.[34] A new gaol, to Hopper's design, was built at Springfield between 1822 and 1828. The old gaol and house of correction

continued in use for female convicts and debtors until alterations to Springfield Gaol were completed in 1848. The West Essex Militia armoury and depot were erected on the site of the old gaol in 1859, thus giving rise to the name of Barrack Square for the area.[35]

CHELMSFORD HOUSE OF CORRECTION

The Chelmsford house of correction occupied a site in the high street opposite Springfield road. The keeper's residence was on the street frontage with the three brick prison buildings, erected in 1753, 1754 and 1766, behind.[36] By Midsummer 1790 it was 'so incomplete and generally in so ruinous a state that nothing short of rebuilding upon an enlarged plan will answer the publick purposes of this County.'[37] The visitors' report at Michaelmas 1792 was more specific, drawing attention to the lack of both separate places of confinement and space to employ the prisoners.[38] The county surveyor pointed out at the next sessions the difficulty of acquiring land adjoining either the house of correction or the gaol. By Easter 1794 he had made a report on a site at the north end of the town, consisting of 15 acres on the south side of the Writtle road known as the Common field, belonging to the Wallinger family, which the county bought for £1,400 the following year, after the state of the house of correction had been presented under 22 Geo. III, c. 64.[39] By 1798 it was agreed that this site was unlikely to be used for the original purpose; after unsuccessful attempts to sell it to the government for barrack purposes, it was leased, after the bricks intended for building the new house of correction had been removed from the site.[40] During 1800 the committee and the county surveyor were considering schemes to extend the existing house or utilise the gaol site. Difficulties over the title to houses at the south-west corner of the gaol were not resolved until the end of 1801.[41]

Johnson's plan, which included provision for all classes of felons and other prisoners, divine service, workrooms and storage, was finally approved at Epiphany 1802.[42] A contract was made with John Harvey of Springfield, bricklayer, for new brickwork at £10 per rod, and for the use of old bricks available at the site; he was to have the use of part of the Common field for making bricks; allowance was to be made for the difference in value between white bricks and common red brick, and for the making of 'guaged Arches.'[43]

The contract for carpenter's work was awarded to John Kemshead of 34 Berners Street, St. Marylebone; proposals were also received from Anthony Shobrook and Richard Early of Chelmsford (jointly) and John Funnell. Kemshead's tender was considerably lower than Funnell's 'except only in the Article of Oak fronts for Bedsteads in which the said John Funnell was lower by two pence per foot Superficial.'[44] Kemshead was already in the employ of Johnson, who owned the house in Berners Street; he later worked for the county at the Shire Hall in 1803 and at Widford bridge in 1805.[45] Kemshead liked to describe himself as an architect, made occasional designs, and in fact applied for

the post of county surveyor in 1816.[46] Detailed accounts for his work at the new house of correction, July 1802 to January 1807, have been preserved.[47] The work began in July 1802 with demolishing the old buildings on the site and tying the new work to the walls of the gaol; elm piling was provided for the foundations, as specified in the contract.[48] Hopper's plan and survey of 1819 describe the governor's house fronting the street, which was set out in June 1804; the eastern yard contained male prisoners and the western female, with an infirmary for each sex and a chapel over the cells; the workrooms were also upstairs, with an adjoining overseer's room to which an iron casement was fitted in February 1806. [49] Changes to the original plan are reflected in the accounts.[50] Scaffolding was erected in March 1805 for masons working on the Portland stone elevation, approved at Michaelmas 1804 (*Illus. page 69*).[51] A packing case was supplied for the county arms in the pediment; these were ordered from the Coade factory in 1805 at a cost of eighteen guineas.[52] Extra land had been purchased in 1805 to provide 'a backside or outlet'.[53] The prisoners were moved into the new house of correction in October 1806; Kemshead had to install a pump in the brewhouse and stocks for both sexes, brought from the old prison.[54] Kemshead was paid £2,179 9s. 10¾d. for carpenter's work, plus £607 5s. 6d. for slating and £131 9s. 9d. for plastering.[55]

The House of Correction Committee reported at Easter 1807 on the total cost of the work, which amounted to £7,390 15s. 11½d.; this represented a net saving of £1,279 10s. 10½d. over the original estimate of £7,297 7s. 6d., plus alterations and additions totalling £1,372 19s. 4d. These savings were attributed to the county surveyor 'being able from the Competition of Workmen and the prompt Payment made by the County to Contract for and procure the Materials and Labor considerably under the Prices usually charged . . .'. The committee's report also dealt with a serious accusation made by Montagu Burgoyne, who produced a letter from Francis Aldhouse, a London surveyor, giving his opinion that the outward walls of the house of correction were 'by no means of sufficient thickness for . . . a place of confinement', with bad quality bricks and poor workmanship.[56] Johnson's dignified reply of 6 April 1807 to these serious 'Charges against my professional Character' pointed out that no attempt had been made to state what this thickness should be. He maintained that no reasonable thickness of brickwork would deter prisoners with iron implements; walls of 'less thickness' in the gaol had proved satisfactory. The reply included a detailed description of the plan and construction of the building, the walls being 'Bonded by the several Cross Walls of the Cells'. The main walls were two bricks in thickness; prisoners attempting to escape were liable to find themselves either in the gaol or in another cell. Johnson also defended the quality of the brickwork, pointing out the problems resulting from 'the very great demand at that time by Government and other Public Works'.[57] The court accepted the committee report and regarded Johnson's reply as satisfactory, although Burgoyne repeated his criticism in a political pamphlet the following year.[58] In

1821 C. C. Western criticised the house of correction even more severely than the county gaol; it was 'of light and flimsy construction, and the work was so hastily and badly executed, that we cannot be surprised to find that it is neither secure, durable, nor commodious'.[59]

BARKING HOUSE OF CORRECTION

Johnson was also responsible for the design of the earlier purpose-built house of correction at Barking. A committee of justices reported to Midsummer Sessions, 1790, that the existing house was too small, with no provision for the separation of felons from other prisoners, workrooms or sickrooms; some prisoners had to be sent to Chelmsford house of correction. It recommended the purchase of a freehold site in the town centre 'on which a more extensive and convenient House of Correction may be erected', which could also take prisoners from Chigwell, Lambourne, Loughton, Navestock, Stapleford and the Theydons, who would otherwise be sent a greater distance to the house at Newport.[60] The site chosen was in North Street, for which Johnson produced a plan, elevation and estimate (£1,250) at Easter 1791; this was approved, subject to the committee reconsidering whether the building should be sunk below ground level.[61] The building was erected between 1791 and 1793, using local craftsmen who were paid partly from the proceeds of the old house and of building materials from both sites.[62] At Easter 1794 the visitors were not entirely satisfied with the new building, complaining that the rooms upstairs were not usable in summer, being immediately under the roof which consisted of single boarding covered with copper. The solution, at a cost of under £20, was to lay a lath and plaster ceiling and put in three casement windows, 'well ironed', at the back of the house; the work was nearly complete by the next sessions.[63]

Johnson's design has not survived, but Hopper's plan and report of 1819 shows that five of the cells were partly underground. It was not possible to ventilate the vaults or workrooms or alter the existing building, but he considered that it would be possible to build additional accommodation.[64] By 1828 it was decided to erect a new house of correction; at Epiphany 1829 the old building was formally presented as inadequate under 4 Geo. IV. c. 64. A new site on the north side of the London road at Ilford was purchased for £750.[65] The prisoners were moved to Ilford in August 1831, but the old house was not sold for demolition until 1834.[66]

COLCHESTER HOUSE OF CORRECTION

Colchester, unlike the other houses of correction, was not purpose-built, consisting of the east part of the ground floor of the Castle. £250 was spent on enlarging and improving the accommodation in 1787–88. The work involved creating a day room north of the original prison in the south-east corner, separated by a yard from the existing keeper's house; the white brick outer wall of this room, with a door and two barred windows, is still standing (1991).

Howard mentioned the lack of decent separation of the sexes in 1780; Johnson dealt with this criticism by inserting a day room for women above the men's day room, described in 1819 as separated only by a wooden floor, and a night room for women in the roof.[67] James Round, J.P., one of the visitors of Colchester huse of correction, pointed out that James Neild, who visited the Castle in 1801, had omitted all mention of the women's wards from his critical account published in *The Gentleman's Magazine* for August 1804.[68]

In 1797 Johnson produced a new design for a more convenient prison, costing £400, on an unspecified site, but the county decided to renew the lease of the Castle from the Round family. The tiled roof erected by Johnson does not seem to have been satisfactory and was replaced by slate at a cost of £125 in 1800, when the local justices complained that Johnson had not sent the slates down from London until the beginning of October, a fortnight before the slater arrived.[69] The steeply sloping roof of large slates survived until 1934, but the roof line is visible on the first floor of the Castle (1991). A new house of correction on the Ipswich road was completed in 1835.[70]

CHAPTER EIGHT

CHURCHES AND OTHER
PUBLIC BUILDINGS

JOHNSON GAINED SOME experience of ecclesiastical architecture by working for Chambers at the German Lutheran Chapel in the Savoy in 1766–67. He submitted a design for the new St. Marylebone church in 1770. The rebuilding of Wimbledon church, Surrey, except the chancel and Cecil chapel (1787–88) and the major restoration of Chelmsford church, now the Cathedral (1800–1803), constituted his most important ecclesiastical undertakings. Throughout his career, he was also concerned with surveys and minor repairs of other parish churches.

Most of his Essex work belongs to the period after his appointment in 1782 as county surveyor. In 1774 John Strutt, as lord of the manor of Woodham Ferrers, may have been responsible for Johnson being called in to the parish to survey the steeple, which had been rebuilt in brick in 1715. Johnson considered 'that it must be wholly taken down and rebuilt'; he produced a plan and estimate for about £400. The vestry appointed Johnson as surveyor, but there is no further mention of him in the minutes. In 1776 the parish accepted a lower estimate of £215 from Matthew Hall of Maldon for building the steeple in wood within the body of the church. No work took place before 1793, when a faculty was obtained to dispose of bells and lead in order to provide a bell suitable for use in the church.[1]

The condition of the chapel at Kentish Town in the parish of St. Pancras had caused concern in March 1773. The building was surveyed by Johnson with John Holt prior to the issue of a brief in January 1780. They considered that rebuilding was necessary and estimated that a larger chapel would cost at least £1,500, exclusive of old materials. The identity of those submitting new designs is not known, but that of James Wyatt was accepted and the work carried out in 1782–84.[2]

WIMBLEDON, SURREY

A vestry meeting was held at Wimbledon on 10 July 1785 to appoint a committee to consider the repair or alteration of the parish church and to appoint a surveyor. The committee, which included Sir Richard Hotham of Merton Grove and William Beaumaris Rush, chose Johnson as surveyor. His plan and estimate was considered by the vestry on 30 April 1786. Repairs to the south wall would cost £124 4s., but at least £500 more would be required 'to enlarge the church and make it more commodious for the inhabitants'. Over £773 had been raised in subscription by August, when Johnson was asked for a detailed estimate, since

it had been discovered that the north wall and steeple were also 'considerably out of repair'. Johnson produced a plan and estimate for £1,087. An offer of an extra £100 subscription was accepted from William Pitt of Chapel Street, Westminster, a member of a local family, provided that a steeple was added according to Johnson's plan. A new committee was appointed, including Hotham, Rush and Moses Isaac Levy of Prospect Place, one of the biggest subscribers. Demolition of the church was deferred until the spring, 'the season being so far advanced'. The committee came into conflict with Johnson on 15 January 1787, when he attended and informed them that, as surveyor, 'he had considered himself empowered to prepare the materials for enlarging and repairing the church . . ., and of course he was to employ his own workmen and could not consent to comply' with the committee's request to employ Wimbledon tradesmen. However, in February an agreement was entered into with Messrs. Mason, Terry and Jennings of Wimbledon to enlarge the church to Johnson's designs at a cost of £1,182. Church services were suspended during March 1787, whilst the medieval chancel was 'to be fitted up suitable for divine service to be performed in it'.[3]

Changes to the original scheme became necessary almost as soon as work started. In May Pitt offered to pay an additional £25 for 'a more ornamental steeple than at first was intended'. Problems with the existing roof led to an endorsement on the original contract with the builders:

> 'Whereas the Roof of the Church was found to be so far decayed that the Contractors chose to take the whole of it down rather than to shore it up in the manner first proposed, in consequence of which Mr. Johnson the Architect produced a Plan of a new Roof to be covered with Patent Slate.'

It was agreed that the work should be done at a cost not exceeding £60. Woodburn's engraving of 1809 shows the low pitch of the roof of the nave, consistent with the use of patent slating.[4] The next problem concerned the raising of the floor level of the nave above that of the chancel. At first, a rise of as much as three feet was suggested 'to make the church more wholesome and free from damps', but it was finally decided to raise the floor by only 21 inches to avoid a step up into the lobby and another down into the church; a porch at the west end would also be necessary as a result of raising the floor. Johnson was empowered to make an agreement with the contractors, the additional cost not to exceed £90.

By December 1787 the committee was turning its attention to the interior arrangement of the church. Johnson produced a plan 'for altering the chancel and Earl Spencer's seat, bringing the communion table to the west end of it and placing the pulpit over it and the minister's desk and the clerk's desk on each side of the same'. Bartlett's description of 1865 makes it clear that this scheme entailed shutting off the chancel from the rest of the church

> by the erection of a semi-circular apse, running in the form of a niche into the chancel. Into this apse were crowded the altar, above which towered the pulpit, the reading-desk

*and the clerk's desk! ! Above the altar were the lights or windows of Lord Spencer's pew
or box, which occupied an upper story formed in the eastern half of the old chancel, the
lower story being used as a robing-room! !*[5]

No illustration is known of Johnson's short-lived arrangement of the apse. New
pews were needed for the nave, together with a new pulpit, reading desk and
clerk's desk, communion table and rail, all to Johnson's design; he reduced the
contractors' original estimate from £241 to £212. By February 1788, £934 4s.
had been raised by subscription; a rate was granted to cover the total cost of
£1,569. The church was reopened on Sunday, 6 July 1788, but Johnson was not
able to report on the satisfactory completion of the work until 25 January 1790.[6]

The restoration was carried out in grey stock brick. Engravings show three
segment-headed windows on the ground floor of the nave with round-headed
windows above. The fenestration was similar on the western apse, above which
rose a one-storeyed tower with Coade stone pinnacles and a steeple (*Illus. page
123*). The nave measured 48 feet by 44 feet. The roofs of the side aisles were
domed 'into three divisions, arched in front, the four corners of each dome
having medallions in *chiaro obscuro*, of Adam, Noah, the Apostles, &c'. The
galleries were supported by Doric pillars, painted to represent Siena marble, the

Wimbledon church, Surrey, 1823

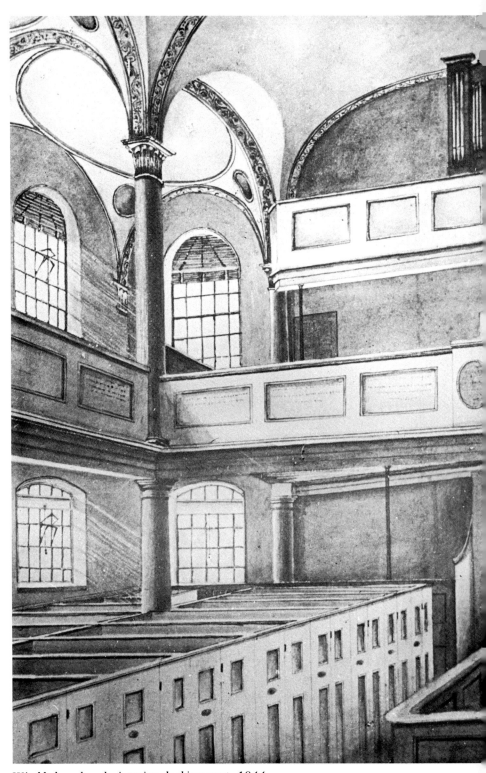

Wimbledon church, interior, looking west, 1844

vaulting springing from gilded Corinthian capitals (*Illus. page 124*). The design may have owed something to Chambers' Lutheran Chapel of the Savoy, whose features included plaster medallions of the Apostles.[7] Wimbledon church appears to be Johnson's only executed ecclesiastical work in the classical style. It stood for just over half a century before falling victim to the pressures of changing taste and population growth. In 1812 the pulpit was removed from its towering position before the altar.[8] Major alterations, at a cost of £456, were made between 1818 and 1820 with the intention of increasing accommodation by the provision of 150 free seats in galleries in the chancel, which was to be thrown open to the church once more. The eastern apse was demolished and the altar, with its ironwork and handrail, was refixed at the extreme east end of the chancel, as shown in a watercolour of 1825 in the possession of the Wimbledon Parochial Church Council. Edward Lapidge (1779–1860) may have been responsible for the design of these alterations, although William Pepper of Kingston was employed as a surveyor by the contractor.[9] The major restoration of 1843 by G. G. Scott and Moffatt destroyed virtually all of Johnson's building. The western wall of the church was taken down and the building extended about 35 feet in that direction. Johnson's north and south walls were cased in flint, but a few traces of his brickwork are visible at the east end of the north and south aisles.[10]

CHELMSFORD

As county surveyor, Johnson was the natural choice of the Chelmsford vestry when problems arose concerning the parish church. In April 1787 he was asked to survey the two windows and door on the south side near the chancel and to make estimates for repair, including inserting two windows similar to the new one already in existence.[11] The vestry resolved in August to accept estimates from George Wray and other local tradesmen to make the two windows and erect a new door and doorcase; the work, carried out under Johnson's supervision, was completed by May 1789.[12] After the erection of the Shire Hall, it was necessary to rebuild the churchyard gates adjoining the new building. Quarter Sessions contributed £20 in May 1792 to the new gates designed by Johnson (*Illus. page 126*).[13]

The major restoration of Chelmsford church (1800–1803) after the collapse of the nave on 17 January 1800, is documented by the minutes and letter-book of the trustees for repairing the church, together with miscellaneous correspondence, bills and vouchers.[14] There are no plans or drawings apart from Johnson's sections of the existing and proposed chancel roofs, dated November 1802.[15] The disaster had been caused by workmen opening a vault, which lay between two of the pillars separating the south aisle from the nave. The foundations of the arcade were undermined; later that evening it collapsed, bringing down the roofs of the nave and both aisles, together with the greater

part of the clerestory (*Illus. page 127*).[16] A parish meeting held in the Shire Hall the following day made arrangements for shoring up the remains and requested Johnson's 'immediate attendance' to make a survey; services were to be held in the Shire Hall. Johnson provided a report by 30 January, when a further survey and estimate was ordered. On 27 February it was decided to apply for an act of Parliament to raise money for repairs.[17] At the first meeting of the trustees under the act, on 28 June, Johnson was appointed surveyor; he was also authorised to agree with workmen and provide materials.[18] The trustees' choice of Johnson as architect did not meet with unanimous approval in the town, as evidenced by an anonymous letter of 6 October 1800. John Oxley Parker, who usually presided at trustees' meetings, was accused of 'Shameful Infatuation' in forcing Johnson 'upon the Inhabitants . . . saying no one is Equal to itt but him'. Johnson was accused of knowing nothing of business 'and has been So Base as to Call the Tradesmen in Chelmsford a Sett of D–m'd Villions.' The writer went so far as to predict that a church rebuilt by Johnson might collapse again.[19] In the event, a number of Chelmsford tradesmen were employed including George Wray, mason, and John Harvey, bricklayer, although Johnson's son's firm supplied carpenters, plasterers, painters and slaters for the later stages of the work.[20] In September 1801, Johnson dismissed William Collier, superintendent of the workmen since May, who may have been a local man, and appointed William Cowper, who had worked for him in this capacity elsewhere and subscribed to *Plans . . . of Essex County Hall* in 1808.[21]

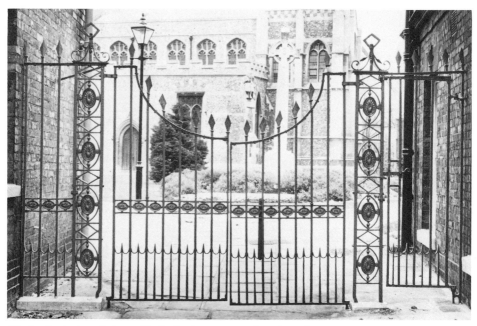

Chelmsford church (now Cathedral), gates to churchyard

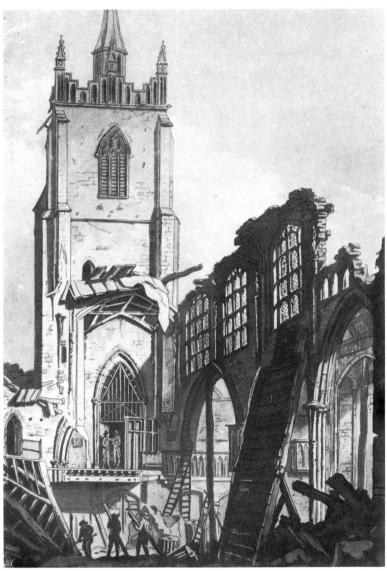

Chelmsford church, Essex, ruins, looking west, January 1800

In mid-November 1800 Johnson ordered the walls to be covered with straw. When the trustees met on 14 January 1801, approval was given to plans, sections of the proposed windows and columns, and estimates; work was to commence 'as early in the ensuing Spring as the Season will in his Judgment admit.'[22] As the result of a further survey in April, it was decided that it was necessary to take down the north and south walls between the tower and the chancel, retaining the south porch; the north wall was to 'be reinstated and faced with white brick', making use of the windows taken out of the south wall, which were replaced in Coade stone. As the three columns of the north aisle were found to be unsafe, they were to be taken down and rebuilt.[23]

The ceiling and clerestory of the nave provide the most distinctive and attractive features of Johnson's restoration (*Illus. page 129*). There appear to have been at least three designs for the ceiling; two were produced on 17 November 1801, 'with Gothic ornaments and figures in a model of the inside of the roof'. Johnson's son's plasterer's account charged £262 10s. for 'the Gothic Tracery Ceiling with the figures between the Upper Windows and the Cherub Corbells that support them', plus £10 for 'the Gothic Flowers in Facia'. Thus, the decoration of the ceiling and clerestory was composed entirely of plasterwork, with the exception of the Coade stone clerestory windows.[24] On the completion of this work in September 1802, Naples or Patent Yellow watercolour appears to have been used for the groundwork of the ceiling, the Gothic cornice and facia being yellow and white.[25] While the work was going on, the townspeople complained about 'the insufficient number of hands employed at the church.' John Johnson, junior, replied from Berners Street on 7 May 1802, pointing out that at least eight or ten carpenters, plasterers and slaters 'have been preparing Various Works here for Months past', including the slates and moulds for the plasterers. Work was also in progress on repewing. On 16 February 1802 John Adams, Johnson's clerk, provided suggested dimensions for the width of the pews. The pulpit, reading and clerk's desks were supplied for £162 17s. 9½d. Later correspondence suggests that Johnson built only the west gallery; in February 1812 he was reluctant to look at other designs for a south gallery, suggesting that accommodation could be increased by returning the existing one to the first column on both aisles.[26] After the completion of work on the nave in the autumn of 1802, it was found necessary to lower the pitch of the chancel roof so that 'the Middle Arch of the Chancel' could 'be Carried Parallel to the Great Arch'. A roof of fir timber was made according to Johnson's sketch and covered with slate in the spring of 1803.[27]

The exterior treatment of the church may be regarded as more controversial. The south wall was faced by Wray in Portland stone during 1801. In July 1802 the trustees accepted Wray's estimate for finishing the parapet of the south aisle with traditional battlements and embrasures of flint and stone. It had been decided in April that 'the New Parapet of the Middle Aisle [clerestory] . . . be finished with a plain Coping of Portland Stone'. This decision was altered in August 1803, when 'Mr. Johnson proposed a Method of painting the parapet of the Middle Aisle in imitation of flint work and warranted that it should stand its Colour at least twenty years without requiring reparation or new Painting'. This method involved the use of 'blacksmith ashes for Masons feinted work' and has resulted in a rather unaesthetic expanse of Portland stone contrasting with the flushwork below. Both the north aisle and the north chancel aisle were faced with white brick.[28]

After three years' work the church was reopened on Sunday, 18 September 1803, at a service for parishioners only. A commemorative Latin inscription, referring to the 'new and elegant decorations', on a white marble tablet was

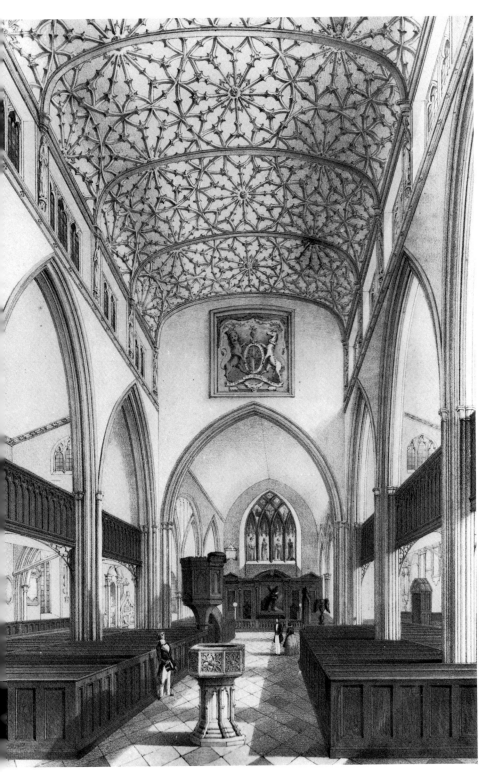

Chelmsford church, interior, 1850

placed inside the church over the new folding doors of the south porch.[29] The total cost of the restoration amounted by December 1804 to £7,258 2s. 8¾d., of which £2,870 was accounted for by work carried out by Johnson's son's firm. There was an additional charge of £440 17s. for Johnson's own services, including four journeys before the commencement of the works, four days' attendance at the Houses of Parliament in connection with the act, six special journeys and 48 visits when in Chelmsford on county business.[30] Johnson's work is shown in the view of the interior in 1850 (*Illus. page 129*). This engraving shows the Coade stone font (*Illus. page 130*). The north and south galleries were

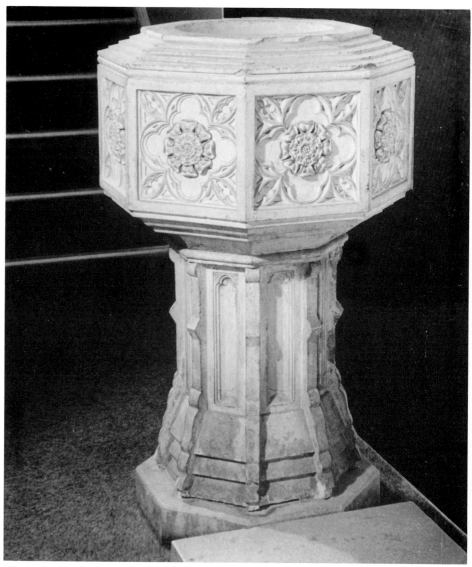

Chelmsford church, Coade font (now in Chelmsford and Essex Museum)

added to the designs of Dent Hepper in 1812 and 1818.[31] The pews had been replaced by open oak benches before 1867, when Johnson's west gallery was removed.[32] An outer north aisle was erected in 1873, necessitating the removal of the white brick north wall.[33] Alterations to the chancel in 1878 included the insertion of a clerestory, replacing Johnson's roof. The plaster ceilings of the north and south aisles were replaced in 1899 by the existing timber roofs, replicas of the original 15th century work.[34] On the exterior, Johnson's Portland facing of the south wall, on the right of the porch, and the clerestory is visible, together with the white brick north and east walls of the clerestory, the two Coade stone windows in the south wall and those in the clerestory. Inside, there is the surviving nave roof and clerestory with the three Coade pillars in the south aisle (*see Chapter 3*).

MISCELLANEOUS CHURCH SURVEYS AND REPAIRS

Shelley church was in such a poor state of repair that after May 1800 baptisms took place in the adjoining parish of High Ongar. Johnson issued a certificate of non-repair in July, estimating that repairs would cost £680. Nothing was done until June 1812, when a faculty was issued for rebuilding at a cost of £475. The work was carried out the following year under the direction of Daniel Miller, churchwarden; there is no evidence that Johnson was consulted again.[35]

The parish church at Hornchurch underwent an extensive, but undocumented, restoration in 1802, costing nearly £2,000. The lead on the spire was replaced by copper. The south aisle was found to be more than a foot out of upright, as a result of damp, and had to be rebuilt or refaced in brick. Johnson also insisted on spouts to carry the water from the eaves well away from the walls. He erected spouts in similar fashion at Danbury.[36]

During 1807 Johnson was involved in minor restoration work at Thaxted and Great Hallingbury. The south-west angle of the Thaxted spire, with three ribs or flying buttresses and one pinnacle, was repaired in Portland stone by a builder named Dorman. The work, costing £348 12s. 6d., was surveyed by Johnson, who recommended the payment of the balance of Dorman's account.[37] The work at Great Hallingbury church, amounting to £64, was carried out for John Archer Houblon, who had married T. B. Bramston's daughter in 1797.[38]

Johnson referred to several restorations in a letter to the *Gentleman's Magazine* dated 3 November 1808. He pointed out the importance of clearing earth from the outside walls and of the correct positioning of rainwater pipes. He acted on these principles in an undocumented restoration, c.1803, at Bishop's Stortford, Hertfordshire, where he laid headstones level with a new gravel walk which had a drain underneath to carry the water down to street level; a pipe was also brought from the roof of the steeple to that of the church.[39] Work at Stilton, Huntingdonshire, was in progress in November 1808, including the rebuilding of the chancel and the lowering of the churchyard, so that an area next to the wall was left open and paved. Daniel Twining, rector, 1806–1853, was the

nephew of the Revd. Thomas Twining, rector of St. Mary's, Colchester, 1788–1804, which may account for Johnson's commission. Sir Stephen Glynne visited Stilton before 1840 and commented on 'much bad modern alteration . . . The Chancel has been modernised in a poor pseudo Gothic style & the E. end has an ugly sloped battlement'. The curious arrangement of the battlement is shown in Suckling's drawing of 1824, above a square headed window with three lights in a blind arch. The drawing also suggests that Johnson removed the spire, shown in *The Itinerant* of 1800. He also reduced the length of the vestry and built an apse inside the square end of the chancel, similar to his treatment of the east end of Wimbledon church. The restoration of 1857, to the designs of Edward Browning of Stamford (1816–1882), included cutting 'out the Circular portions of the East end of the Chancel', inserting new heads and mullions into the existing east window and completing the lowering of the chancel, but the faculty papers and restoration accounts do not appear to include the removal of the crenellation.[40]

JOCKEY CLUB ROOMS, NEWMARKET, SUFFOLK

On 30 May 1771 Johnson wrote excitedly to John Strutt of his intention to call at Terling Place on his way to or from Suffolk:

> *I have made Designs for Stable Buildings for Lord March to be Built at Newmarket and am Appointed by the Jockey Clubb to the Direction of a new Sett of Rooms to be built for them at the same place this Summer (a Considerable Building). I have made the Designs and the work is begun – you will therefore expect to see me make a figure on the Turff very soon —.*[41]

Johnson's patron, Lord March, a prominent member of the Jockey Club, became the 4th Duke of Queensberry in 1778.[42] James Pollard's view of 1825 shows some of Johnson's work on the New Rooms; a round-headed triple arcade, erected in 1772, joins two ranges of buildings. Soon after 1825 the screen was replaced by a wall and the open Betting Court behind covered in to form the existing Arcade Room. In 1773 Johnson had exhibited at the Royal Academy the tablet of the dining room chimneypiece at the Jockey Club Room, showing 'two centaurs running a race and whipping themselves'. The design was described as 'absurd' by Horace Walpole; like most of Johnson's work, it has not survived various alterations and additions to the building, including the major rebuilding of 1932–35.[43]

CHELMSFORD GRAMMAR SCHOOL

During the summer of 1795, T. B. Bramston was corresponding with Richard Benyon, a fellow governor of the school, over the headmaster's wish to erect 'a chamber floor above the dwelling house or the schoolroom', for use by boarders. Bramston was doubtful about the strength of the walls and proposed to consult Johnson about the practicability of adding another storey.[44] Between ·October 1797 and April 1799 Johnson was paid £580 15s. 6d.; in addition to £280 disbursed by Bramston, there were also payments for bricks (£27 12s. 6d.) and

to John Funnell, carpenter (£27 12s.). It seems likely that Johnson was responsible for the addition of a third storey, with a pyramidal roof, to the tall centre block shown in Buckler's engraving between the master's house fronting on Duke Street, also three-storeyed, and the single-storeyed schoolroom. He was paid a further £18 17s. in October 1806.[45]

FELSTED SCHOOL

The rebuilding of the master's house, later known as Ingram's, between 1799 and 1802, is more fully documented than the work at Chelmsford. It was decided at the School Feast, 29 August 1796, 'that it is essential to the Prosperity of this ancient Foundation that the Master's House be completely Repair'd or Rebuilt'. On 1 October 1797 the building committee, including T. B. Bramston, as joint Treasurer, and John Strutt, resolved in no uncertain terms 'that it is advisable to direct Mr. Johnson, the County Surveyor, to go over to Felsted & form a plan and estimate for rebuilding the School house there with Brick in the plainest, and most substantial manner possible'; the house was 'to be capable of lodging commodiously forty boys'. Johnson's estimate amounted to 1,500 guineas, including the use of old materials and the repair of outbuildings; the greater part of this sum was to be raised by subscription. The old master's house was demolished in March 1799. The first brick of the new building was laid on 1 April 1799, the work being completed early in 1802.

The total cost amounted to £1,708. John Funnell, carpenter, received £536 16s., including the cost of timber. John Harvey, the Chelmsford bricklayer, was paid £278 18s., the bricks being supplied by William Hilton of Danbury for £385 10s. The Braintree mason, John Challis, supplied and refurbished chimneypieces and a 'Portland slab in the long Dining Room'. Johnson's son was paid £354 3s. for plastering, painting and glazing, plus patent slating brought by sea from London to Maldon and thence by the newly-opened Chelmer Navigation; two slaters travelled by coach. In May 1801 Johnson, who received £111 5s. as surveyor, wrote to the headmaster pointing out that the discrepancy between the estimate and the statement of accounts was mainly due to the increased cost of materials. 'But it is to be Rememb'red that Commission and Journey Expences are never included in An Estimate.' The existing red brick house, with slate roofs, certainly has the requisite plain character; the facade has five bays, the middle three projecting with a parapet and simple round-headed door.[46]

WORK IN LEICESTER

During the last decade of the 18th century, Johnson was involved in a number of projects in his birthplace. Conditions, including the lack of ventilation, at Leicester Infirmary, opened in 1771, had been criticised by John Howard in 1789. According to John Nichols, Howard's suggestions were put into practice, 'under the judicious direction of John Johnson . . ., an eminent architect in London, and a native of this town'.[47]

In 1792 Johnson drew up ambitious plans for a development known as Brunswick Square on Corporation property at the Horse Fair. Nichols described it in enthusiastic terms:

> *In the area of the Square was to have been St. Margaret's Chapel; on two of the sides beautiful streets, to be named George Street and Charlotte Street, after their present Majesties. A Royal Terrace would have filled the side towards the London Road; and a new Town Hall . . . was to have filled the fourth side. Had this plan taken effect, it would have been creditable to the town; in which no place can be put in competition, either for public convenience, or a display of corporate magnificence and civic grandeur.*

A borough committee, reporting on 7 December, was equally enthusiastic, going into detail on the likely profit to the Corporation from the scheme and accepting Johnson's proposal that there should be a uniform stone elevation. Johnson was to be offered a lease of his choice 'of any part of the Premises'. Despite the committee's observation 'That the great Scheme in Contemplation seems more pregnant with material Advantages to the Corporation & to the Town' than any previously submitted, nothing further was heard of the project or of the actual plan seen by Nichols. In January 1812 Johnson was paid 20 guineas 'in acknowledgement for his plans of buildings made twenty years ago'.

During 1792 to 1794, the borough was involved in the rebuilding and enlargement of the town gaol and house of correction. Although the corporation records do not refer to Johnson as the architect, it is possible that part of the payment in 1812 may have been for the design of the gaol. Nichols, who attributes the building to Johnson, describes it as having courts on either side for different classes of prisoners, with a very small chapel in the centre of the prison, an infirmary and a bath. The three projecting centre bays have a rusticated ground floor, similar to that of the Shire Hall, Chelmsford, heavy string courses

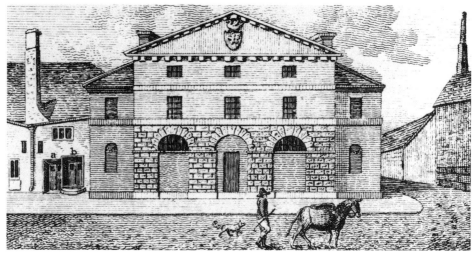

Leicester, Borough Gaol (demolished)

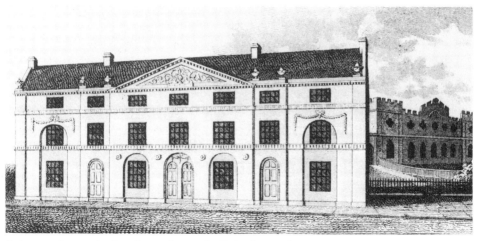

Leicester, houses in Southgate Street, built in front of Consanguinitarium (demolished)

Leicester, Consanguinitarium (demolished)

and a modillioned pediment with the borough arms (*Illus. page 134*). The gaol was demolished in 1837, but some masonry survives between Nos. 21 and 23 Highcross Street.[49]

Johnson turned his attention in 1785 to a more personal scheme (*see Chapter 10*). He provided accommodation, known as the Consanguinitarium, for members of his family. This consisted of five dwellings, each with a room on the ground floor and a bedroom upstairs, in a castellated stone building with stained glass windows in Southgate, 'partly screened by four neat dwelling houses which bound the street, erected . . . on the spot where he was born' (*Illus. page 135*). These houses were built of white brick with a pediment, urns and neo-classical decoration; they had lost their decorative features before 1922 and were demolished c.1965. The Consanguinitarium was rebuilt in Earl Howe Street by R. J. Goodacre, said to be a relative of Johnson, in 1878.[50]

The County Rooms, Johnson's most important and only surviving work in Leicester, was originally undertaken as a hotel, but had to be taken over by a group of gentlemen in 1799. Johnson seems to have been involved at an early stage and was corresponding with Sir Edmund Cradock Hartopp, M.P., in December about the scheme and the adjourned meeting of the subscribers fixed for 6 January 1800. An undated subscription list, probably of this date, headed by the Duke of Rutland, with five shares of £52 10s., includes Sir John Palmer (*see Chapter 2*), Hartopp and Edward Dawson (*see Chapter 9*), as well as Johnson himself and William Oldham, a local architect and builder, who each held one share; £5,302 10s. had been raised. A further £2,000 was to be raised by loans of £100 to be secured by a mortgage of the whole estate; Johnson was one of those who responded to the appeal. Early in August, Johnson was present at a meeting at which it was stated that £3,300 was required to complete the building; a subscription was to be started 'for furnishing the public rooms, in order to their being opened at the ensuing races'. These measures appear to have been successful, as the new assembly room was used for the race ball on 17 September.[51]

Nichols provided a contemporary description of the building which 'may, from the grandeur of its windows, its statues, basso relievo, and other decorations, be justly considered as the first modern architectural adornment of the town' (*Illus. page 137*). The assembly room running the whole length of the first floor, as at Chelmsford, measured 75 by 33 feet and was 30 feet high.

> *The entrance is in the centre of the side wall, over which is a spacious orchestra, projecting a small way into the room. It is of a semi-circular plan, domed, and carried back over the landing of the stairs: the access to it is by a back staircase. The ceiling of the room is arched and formed into compartments; three of which are large circles, decorated with the allegorical paintings of Aurora, Urania, and Luna. At each end is a chimney, over which is a painting, in a compartment, of an aërial figure in a dazzling attitude; there are also two others in compartments, on a side wall. On each side of the chimney are niches, in which are beautiful figures, from the models of Bacon. Mr. Johnson employed Mr. Ramsey Reinagle [1775–1862] to execute the paintings . . . Beside the eight beautiful lustres, branches of lights are held by four statues from the designs of Bacon. Mr. Rossi, R.A., was employed . . . to execute the two figures in the front of the building (Comic and Lyric Muses) and the bas reliefs between the windows'.*

The latter are Coade stone, together with other details on the facade (*see Chapter 3*). Rossi did a great deal of work for the Coade factory, but, according to the late Rupert Gunnis, the statues were designed in terracotta in association with John Bingley. The building also included 'a coffee-room, handsomely furnished'. The venture, however, was not a success and in 1817 the Rooms were sold to the county for use as Judges' Lodgings. Alterations appear to have been made by Joshua Harrison to all the rooms except the ballroom. At this date the word 'Hotel' was obliterated over the porch and the stone on the parapet worded 'Assembly Rooms' turned round.[52]

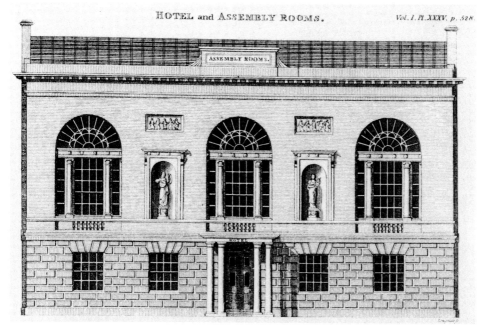

ASSEMBLY ROOMS.

Leicester, County Rooms (built as hotel and assembly rooms)

Johnson also built a small theatre, adjoining the hotel, in 1800; he was a shareholder. The town's first permanent theatre was described by Nichols as 'neatly and commodiously fitted up, nearly on the plan of the London houses', but proved to be poky and inconvenient and was replaced by the Theatre Royal in 1836.[53]

CHAPTER NINE

COUNTRY HOUSES II

BRADWELL LODGE

The Revd. Henry Bate, who assumed the name of Dudley in 1784, purchased the advowson of Bradwell-juxta-Mare in 1781. He acted as curate to the absentee rector until 1797, employing Johnson to add 'an elegant chateau', designed 'in a style clearly metropolitan' to the existing timber-framed rectory. John Cornforth has suggested that Bate Dudley's defence, as editor of the *Morning Post*, of John Strutt in 1779 suggests close personal contact; he refers to Strutt as residing 'in a magnificent seat built by himself within a few miles from Chelmsford' (*see Chapter 2*). The work at Bradwell is said to have taken place between 1781 and 1786, but it seems more likely that the main house was completed by 1783. In that year, Johnson exhibited 'the lawn front of a Lodge now building in Essex' and the diary of John Crosier of Beeleigh Mill referred to 'a very handsome house' as already erected. Although the house remained a rectory until 1938, when it was purchased by Tom Driberg, M.P., Wright referred to it as a lodge in 1833. Since 1938 it has been known as Bradwell Lodge. The entrance hall between the timber-framed and the Georgian parts may, however, have been an addition between 1783 and 1786 to the original plan.[1]

The exterior of the house is little changed from Angus' engraving of 1793 with the exception of the loss of a bold dentilled cornice, taken down after a storm in 1914 (*Illus. page 139*). The main front has a Venetian window between niches containing Coade urns, with an oval bay lighting the library on the garden front. The observatory or belvedere has Ionic columns at its four corners 'which have been ingeniously contrived to form the chimnies of the whole fabric'. The low entrance hall, joining the two parts of the house, has a dome and medallions similar to Johnson's work at Woolverstone Hall and Langford Grove. The rear entrance hall also has medallions in the pendentives with a short staircase with honeysuckle scroll balusters, which are repeated in the main staircase.

The drawing room has a ceiling incorporating seven *grisailles* by Robert Smirke the elder (1752–1845)[2] (*Illus. page 139*). The subjects reflect Bate Dudley's artistic interests: in the centre medallion Britannia is crowning a figure symbolising the Arts, which are depicted individually in oval medallions; the plasterwork between these has the lunettes with mermaid, dolphin and pillar motif used at 38 Grosvenor Square and Holcombe House. The end compartments have round grisaille paintings and oval panels with the bow and arrow and quiver and torch motifs. Two round-headed windows look out on the garden; opposite the Venetian window on the entrance front is a white marble chimneypiece with Siena inlay; the seven inset paintings are in the style of Angelica Kauffmann. Bate Dudley owned paintings by this artist, but, as she left

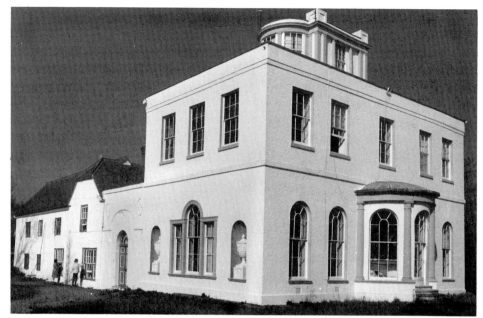

Bradwell Lodge

England in 1781, she may not have been responsible for the inset paintings. In the oval library, the shape of the three round-headed windows is echoed by the shallow recess containing the concealed door into the staircase hall and the four inset bookcases, below one of which is a cast-iron stove. The room has Johnson's characteristic bold acanthus frieze.

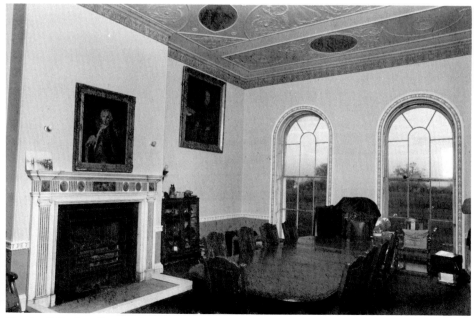

Bradwell Lodge, former drawing room

LANGFORD GROVE

Johnson's work for Nicholas Wescomb is undocumented, but is usually ascribed to 1782. The commission may, perhaps, be identified with the elevation and section 'of a Gentleman's seat now building in Essex', exhibited in 1783. Here, he attempted the full Palladian treatment, although on a smaller scale than at Woolverstone Hall; three-bay pedimented pavilions were linked to the main block by single-storeyed passages; white brick was used throughout. The entrance front had a tripartite doorway with a Coade keystone (*see Chapter 3*). The garden front, shown in Thomas Sandby's gouache, had a Venetian window on the first floor in a two-storeyed recessed arch (*Illus. page 140*). The interiors were recorded by the National Monuments Record prior to the demolition of the house in 1953. The groined entrance hall with medallions in the pendentives, typical of Johnson's work, led to an impressive geometric staircase, with honeysuckle scroll balusters, and a dome with a heavy metope frieze and bold acanthus and lotus cornice, identical with that at Woolverstone Hall; the dome was supported by columns and pilasters (*Illus. page 141*). The drawing room ceiling had a central painted medallion, which appears to depict the marriage of Cupid and Psyche, and four oval medallions in the end compartments, which may also have been painted by Smirke. The centre painting was surrounded by oval plaster medallions containing bow and arrow and quiver and torch motifs, as in the first floor ceiling at Woolverstone Hall.[4]

One of the pavilions escaped demolition in 1953, together with the coach house. This has a pedimented centre block, linked to pyramidal roofed two-storeyed wings; all have recessed arches, the centre one having a Coade bearded head keystone, possibly that originally on the main house. Bookcases from

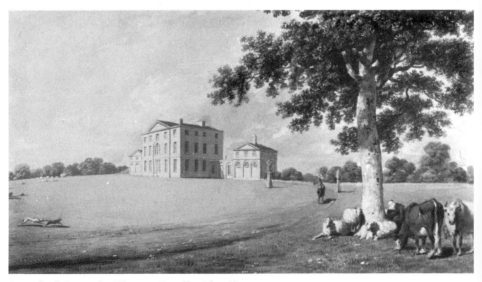

Langford Grove by Thomas Sandby (detail)

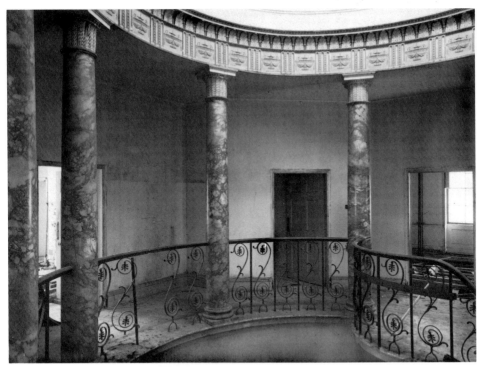

Langford Grove, staircase (demolished)

Langford Grove were used by Tom Driberg in the library in the 16th century part of Bradwell Lodge.[5] A second view by Sandby shows a pedimented temple in the grounds, which may also have been designed by Johnson.[6]

THORPE HALL, THORPE-LE-SOKEN

One of Johnson's few surviving finished designs, for the 'Embellishment to Front of Thorpe Hall', is dated 1782 (*Illus. page 141*).[7] Stephen Martin Leake, junior, Norfolk Herald Extraordinary, had agreed in June 1781 to purchase the remainder of his father's lease of Thorpe Hall from a bankrupt tenant; he seems to have been considering taking the whole house into his own use.[8] Johnson's design appears to be for the refronting of an existing house, which may account for its curious proportions. The string courses at first and second floor level are related to those shown on undated sketches of the side elevations of the three-storeyed front block of the old house. The design has affinities with the elevations of Hol-

Thorpe Hall, unexecuted design for refronting, 1782

combe House and Hatfield Place, apart from the treatment of the ground-floor windows and the use of single, rather than double, Corinthian pilasters; it is not known to have been executed. The house was rebuilt in 1822–24 to the designs of M. G. Thompson.[9]

WORK FOR THE RUSH FAMILY

Nichols' list of Johnson's work includes Benhall in Suffolk for Sir William (Beaumaris) Rush (1750–1833), who had inherited his estates from his kinsman, Samuel Rush, who died on 24 June 1783. Samuel is said by Manning and Bray to have built a house in Suffolk costing £36,000. Henry Davy, however, states that William Beaumaris Rush pulled down the old Benhall Lodge and built 'a large handsome and convenient mansion' on the same site which he sold to his cousin, George Rush, in 1790, who in turn sold it to Admiral Sir Hyde Parker. After the latter's death it was purchased by Edward Hollond in 1810, who is said to have demolished the house because it was 'badly situated'. However, Norman Scarfe has suggested that the red brick Old Lodge stables, recorded by the National Monuments Record prior to demolition in 1948, may be identified with the house designed by Johnson. The round-headed windows on the ground floor are linked by a stone string course, consistent with Johnson's style; the servants' quarters and brewhouse survive as Old Lodge Farmhouse.[10]

In view of their involvement with the restoration of Wimbledon church (*see Chapter 8*), it seems likely that Johnson also worked for William Beaumaris Rush at his property at Wimbledon, later known as Belvedere House. This house was designed by Colen Campbell for Sir Theodore Janssen, c.1720; the Rush family acquired it as a result of Janssen's financial difficulties after the South Sea Bubble burst. G. F. Prosser refers to W. B. Rush as having 'much enlarged and improved the residence', probably before 1793 when it is described as 'an elegant villa'. Comparison between Prosser's engraving (*Illus. page 142*), and an earlier

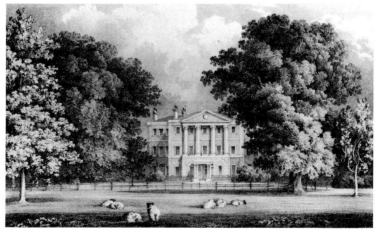

Belvedere House, Wimbledon, Surrey, 1828 (demolished)

drawing, of which a photograph is in the possession of the Wimbledon Society, suggests that the facade of the early Georgian house was remodelled with a pediment. The quoins on the five bay centre block were retained, the ground floor was rusticated, with Ionic pillars above, producing an elevation with affinities to the Shire Hall at Chelmsford. The portico may have been a slightly later addition. The garden front also had a pronounced string course above the second storey; the balustraded parapet is similar to that shown on the earlier elevation of the entrance front.[11] Sale particulars of 1834, after Rush's death, suggest that the house, described as 'of handsome uniform elevation', may have been recently redecorated, although the 'recesses for Figures' in the entrance hall and the 'enriched cornice' in the principal drawing room may well relate to the alterations attributed to Johnson.[12] The estate filled the area between St. Mary's church and the High Street, the house itself, demolished c.1900, standing opposite the church.

HATFIELD PLACE, HATFIELD PEVEREL

Hatfield Place, for Colonel John Tyrell who had married at the end of November 1791, is the best documented of Johnson's later houses. There is an account rendered by Johnson's son's firm (John Johnson, junior, Joseph Andrews and William Horsfall, late copartners) for work done in 1792–93, together with a notebook containing a complete account of Tyrell's expenditure, including the garden and plantations, 1792–95, amounting to £3,618 12s. 9½d.; in July 1794 Johnson received £180 commission.[13]

The original estimate for building a 'House with Kitchen Office adjoining' amounted to £2,533 10s. Additional works, bringing the total to £2,960 11s. 8½d., are listed in more detail. The 'Rusticated Stone work to the Entrance front' cost £90. Expenditure of 14s. on labourers filling in foundations

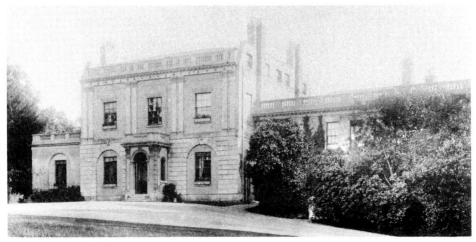

Hatfield Place, before 1905

and raising the ground for the portico and 15s. for painting its interior suggests that there may have been a semi-circular porch, similar to that at Holcombe House, preceding the existing Victorian portico. Coade keystones of Pomona and Flora were charged at £1 11s. 6d., although the other Coade features on the front elevation are not detailed (*see Chapter 3*). A reference in the accounts to paving 'as done at Mr. Anderson's house' makes it clear that the design was deliberately based on that for Holcombe House. The elevations of the main blocks are virtually identical, although the proportions at Hatfield Place are improved by the increased height of the windows. A photograph taken before the addition in 1905 of a small two-storeyed block on the right, designed by George Sherrin, shows the original relationship of the main house and kitchen wing (*Illus. page 143*); a single-storeyed ballroom was added for W. M. Tufnell between 1855 and 1874. The balustraded parapet of the main block conceals a slate roof.

The interior has a number of features in common with Holcombe House. The oval staircase hall, with geometric stair and honeysuckle scroll balusters (*see back cover*) leads into 'the Groin'd Passage' with its three small female medallions surrounded by scroll work. The main rooms on the garden front were the dining parlour, now the drawing room, and the drawing room, now used as a dining room. Unlike Holcombe House, there are no decorated ceilings, but the dining parlour has ' 3 large Medallions', costed with the three small ones at £9 3s. The two large female figures are identical in subject and treatment with those at Holcombe House; over the chimneypiece Apollo replaces Eros (*Illus. page 145*). The frieze with sphinx and urn and dolphin and pillar motifs is identical to that at Holcombe House (*Illus. page 40*); the marble chimneypiece in this room was supplied for £45. Upstairs, the oval plan of the staircase hall is reflected in the bedroom plans. The accounts also include detailed expenditure on two vaults under the kitchen and the 'Doomical Vault under the Principal Staircase'; the latter was originally used as a wine cellar.

THE LAWN, ROCHFORD

Nichols lists a house for Major Carr at Stroud Green. Major George Davis Carr inherited an interest in a property there called Hunters in October 1796, a date which fits with Benton's reference to the Carr family building a handsome suite of rooms in front of the old house. At some date before 1873, Arthur Tawke (d. 1884) pulled down the old part and rebuilt in corresponding style. The existing five bay centre block with balustraded parapet, Ionic porch and thin glazing bars may well be Johnson's elevation. A watercolour, in the possession of Mrs. Keddie in March 1965, shows this front without the existing pediment, which was probably added by Tawke as it corresponds to that on the rear elevation. In 1895 the house, described as having a dining room, sitting room, drawing room, library and kitchen, with ten bedrooms and two dressing rooms, was sold to James Tabor, who enlarged it the following year.[14]

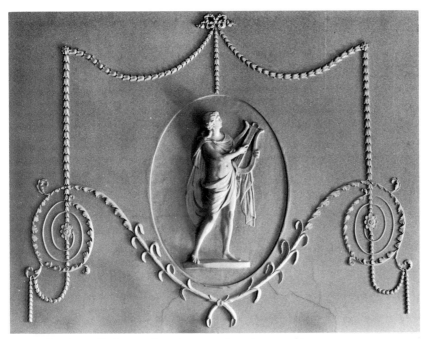

Hatfield Place, dining parlour (present drawing room)

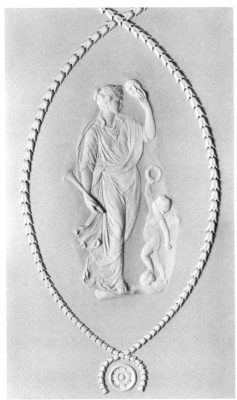

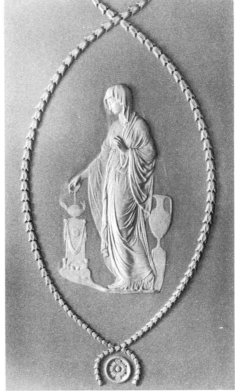

Hatfield Place, dining parlour (detail)

Hatfield Place, dining parlour (detail)

145

KNIGHTON HALL, LEICESTERSHIRE

The late Sir Albert Richardson suggested to Professor Jack Simmons that part of the front of this house, now the residence of the Vice-Chancellor of Leicester University, was added by Johnson to the early 18th century work, which conceals an earlier core. The two-storeyed range on the left of the early 18th century block consists of a narrow bay with a semi-circular Tuscan porch and a wider one with tripartite windows.[15] The drawing room in the wider bay has an oval plan with four niches, with a continuous reeded moulding, also found on the chimneypiece and door case; the frieze may have been inserted c.1890. The work is of sufficient quality to have been designed by Johnson.

Sir Edmund Cradock Hartopp announced his intention of forming a temporary residence at Knighton in May 1799, when he planned to have a survey made by Johnson. He was certainly in contact with Johnson at the end of the year over the scheme for the County Rooms, Leicester (*see Chapter 8*). Johnson's letter does not make it clear whether the drawings which are to be sent to Sir Edmund's residence near Sutton Coldfield relate to this scheme or to Knighton Hall. His remark that 'if you would leave me free from the responsibility of the Estimates it matters not to me what workmen are employed' could apply equally to either. Some work on the house, referred to as Knighton Lodge, and grounds, went on until May 1802. Johnson's account for £96 12s. was outstanding in 1803.[16]

ST. LEONARD'S LODGE, LOWER BEEDING, SUSSEX

This commission is listed by Nichols as the seat of Charles Beauclerk in Sussex. Charles George Beauclerk (1774–1846) was the son of Topham and Lady Diana Beauclerk. He bought the south portion of St. Leonard's Forest, near Horsham, c.1803, and 'built a competent mansion' of stone, known as St. Leonard's Lodge, before 1808; he was living there in 1830. The house was demolished in 1853 and replaced by the present mansion, known as Leonardslee by 1874.[17]

WHATTON HOUSE, LONG WHATTON, LEICESTERSHIRE

Whatton House was designed by Johnson, c.1802, for Edward Dawson, who had been one of the chief subscribers to the County Rooms at Leicester. The house was described in 1829 as 'constructed of fine stone with a rustic basement', the plan was 'nearly quadrangular', with a semi-circular projection forming the entrance on the south-east front (*Illus. page 147*). 'The architecture is pure and displays much taste'.[18]

The house was partly rebuilt and extended after a series of fires in the 1870s and 1880s. The original shape of the centre block was retained, a pedimented entrance with Tuscan porch replacing the full-height bow, which was left at basement level. The south front was extended by three bays and a tall one-storey addition made to the north front. The conservatory at the south-west angle, replaced by a colonnade in 1974, may possibly have been original. Chimney-

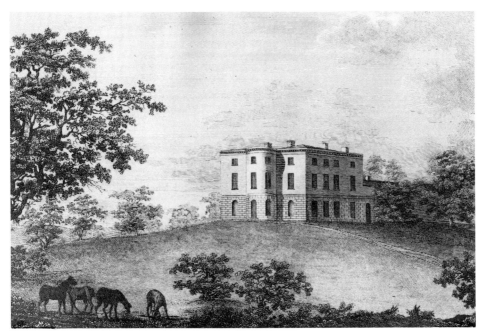

Whatton House, Leicestershire, c.1815

pieces and a plaster ceiling in a ground floor room are in the style of c.1800, but may be copies. Stables attached to the rear of the building are mainly original, the right bay having stable doors and windows in a characteristic seven-bay blind arcade. The Doric summer house, described in 1829 as 'made of oak bark', may be Johnson's work.[19]

MISCELLANEOUS ESSEX ALTERATIONS AND REPAIRS

During the summer of 1797, Johnson made a survey of the roof of Moulsham Hall, Chelmsford, for Sir Henry Mildmay and recommended the replacement of tiles by patent slating. The resultant shallower pitch of the roof would do away with the existing 'little separate divisions'. He pointed out that the slates 'being laid in Oil Cement, instead of Mortar' meant that gutters and pipes were less likely to be choked. The cost of the work would not exceed £500; Sir Henry was characteristically assured that 'it has never been My Practise to Lead My Employer into More Expence than is Needful'. He also suggested capping defective chimneys with a stone cornice, estimated at £30 7s. 8d. The work on the roof was executed, but, unfortunately, the architect to the Barrack Department pointed out in May 1804 that the patent slates 'continually let in the wet', presumably because the cement had perished.

John Tyrell, for whom Johnson had built Hatfield Place, moved to Boreham House in 1796 and employed him for alterations there between 1802 and 1803. The house had been built for Benjamin Hoare in 1727–28. Johnson's estimate for £1,220, dated 9 February 1802, included alterations to the roof and cornice, using patent slate, replacing the balustrade by a parapet, cutting down four

windows on the garden front to correspond with new ones; designs and plans for other alterations to the house are mentioned. Further details are given in John Kemshead's letter of 15 February, which refers to a new chimneypiece for the drawing room (£30), a new staircase in the hall with 'barr balusters and Mahogany Rail (but no Iron Ornament) as at Hatfield', and a new ceiling in the breakfast room. The total cost of the work, carried out by John Johnson, junior, amounted to £2,323 12s. Despite Hopper's extensive alterations in 1826–27, including the present wings and flanking gateways and the main staircase with an elaborate balustrade, some of Johnson's work can be identified. The present offices have features with reeded mouldings, including doorcases and a marble fireplace. The upper portion of the present back staircase has stick balusters, which may well be of this period. Boreham House is now used by the Ford New Holland International Training Centre.[21]

Braxted Lodge, Great Braxted, had been remodelled for Peter Du Cane I between 1753 and 1756, to the designs of Robert Taylor. When Du Cane died in March 1803, just before his 90th birthday, he was succeeded by his son, Peter Du Cane II (1741–1822). His accounts provide some evidence about his extensive alterations under Johnson's direction, amounting to £6,068 odd by August 1806. The work was carried out by local craftsmen, including the Chelmsford mason, George Wray. Du Cane wrote Johnson a stiff letter in December 1804 about the delay in measuring the brickwork, roof and slating.

As it is now a long time in a state to be measured, I thought that you would have had it done, knowing my wish to pay all the workmen before Xmas – The day bills can have nothing to do with the measured work, and I see no use in sending them prior to Measuring, or indeed at all.

As Johnson received a total of £373 1s. 2d., it seems that Du Cane paid a measuring charge of two and a half per cent as well as the usual architect's commission of five per cent for designs and supervision.

The work appears to have consisted of extending the house northwards. The arcading of the garden front on the ground floor is characteristic of Johnson's style; the thin glazing bars are of metal, possibly copper as used at Gnoll. Wray supplied a Portland stone cornice, probably round the whole house. A stone staircase cost £70 2s. 7d. in March 1806; this is almost certainly identifiable with the existing staircase with mahogany handrail. No other interior work by Johnson can be identified; the library on the north front, described in 1923 as having a decorated floral cornice and a statuary Adam white marble mantel inlaid with green marble surrounds, was redecorated c.1950. The house, known as Braxted Park from about 1850, was purchased by the Plessey Company after World War II, but has been used as a private residence since 1965.[22]

In 1807 Johnson was employed by John Archer Houblon for repairs to Hallingbury Place, which he had been occupying since 1802. The work, which cost £238, was carried out at the same time as repairs to the church (*see Chapter 8*), but no details are available.[23]

TORRELL'S HALL, WILLINGALE DOE

John Crabb acquired Torrell's Hall in September 1800 and was living there when he subscribed to Johnson's *Essex County Hall* in 1808.[24] Johnson added a gault brick two-storeyed front block to a house of late 16th century origins with numerous alterations and extensions. The elevation has tripartite windows with segmental heads, a stone band under the first floor windows and a central fluted Doric porch, leading into a barrel coved entrance passage. There are reeded architraves and cornices throughout this block, with a pair of Corinthian 'Palmyra' columns defining a recess in the dining room, and a typical staircase with stick balusters.[25]

WORK FOR THE REVD. JOHN BRAMSTON-STANE

Willingale Doe's rectory, which was sold by Chelmsford Diocese in 1982, is similar in style to the front block of Torrell's Hall. It has three storeys of gault brick, with a plain stone band at first floor height. The ground floor has a porch, with fluted Doric half and three-quarter columns, between tripartite windows with segmental heads. This building may well represent Johnson's work for the Revd. John Bramstone-Stane at Willingale, listed by Nichols. John Bramston, the son of T. B. Bramston, became rector in 1797. He assumed the name of Bramston-Stane in 1801 on inheriting Forest Hall in High Ongar. However, it has been suggested that the commission was for Forest Hall rather than the rectory. Forest Hall was rebuilt before 1812 on a site on higher ground 300 yards south of the existing house of c.1700. Alterations, including the casing of the windows in stone, were made after 1862; the interior did not have any features of distinction when the National Monuments Record recorded it prior to demolition in 1957.[26]

BROOMFIELD LODGE, BROOMFIELD

Broomfield Lodge, Johnson's last known country house, was built for John Judd shortly before his death in September 1808 and sold by his widow in 1813.[27] The two-storeyed gault brick elevation had a Doric porch and a stone band at first floor level. When advertised for sale in 1813, it was said to have 'lately undergone very considerable additions and improvements'. The entrance from Broomfield road was 'by massy wrought-iron gates, supported by piers, with figures of Italian lions'. The porch led into the entrance and staircase halls, the latter having Ionic columns. The original drawing room, used as a hotel dining-room prior to demolition of the house in 1964, retained a frieze and cornice, segmental over-doors with consoles and a white marble chimneypiece with fluted jambs, decorated frieze and tablet with a female figure, possibly representing Architecture. There were reeded doorcases elsewhere on the ground floor. The staircase, lit by a round-headed window, had wooden stick balusters alternating with a wrought iron balustrade of similar pattern to that at the Shire Hall and at Manydown Park, Hampshire.[28]

CHAPTER TEN

LAST YEARS

JOHNSON'S HEALTH MAY may have begun to fail in his seventieth year. He was not well in November 1801. Although he attended Quarter Sessions on 12 January 1802, he described himself as 'very unwell' four weeks later.[1] The following July, he was housebound for three days.[2] John Johnson, junior, mentioned his father's ill-health early in 1803.[3]

During one of these periods his third son, Dr Joseph Johnson, died suddenly of an apoplectic fit on 13 February 1802, at his house in Paddington.[4] Joseph, born on 3 March 1770, had been educated at Leicester and at Trinity College, Cambridge, where he matriculated in 1788 and proceeded M.B. in 1795; his

education cost his father £3,000.[5] In April 1790 Johnson settled property on him worth £8,000, with a further £2,000 in 1797. By 1795, when he became a trustee of the Consanguinitarium (*see below*), he had acquired a house in Upper Belgrave Place, Westminster; he had moved to Paddington by 1799.[6] His father erected a Coade monument in a niche on the south wall of St. Mary's church, Paddington Green (*Illus. page 150; see Chapter 3*).

On 5 May 1803 Johnson was declared bankrupt, as a result of the failure of Dorset, Johnson, Wilkinson, Berners and Tilson, a firm of London bankers in which he had been a partner since 1785. The original four partners had been headed by Sir Herbert Mackworth, Bt. (d. 1791). Johnson had contributed £4,000 towards the original joint stock of £15,000.[7]

Johnson's examination in bankruptcy throws interesting light on his financial position between 1785 and 1803. He estimated that his property in 1785 had been worth £47,164; by 1803 it had risen to £55,468, despite settling

St. Mary's church, Paddington Green, Coade monument to Dr. Joseph Johnson (d. 1802)

£24,000 on his three sons in 1790, with a further £6,000 in 1797; a redistribution of assets in 1802 between his two surviving sons and his grandchildren amounted to £15,000; there were also gifts of £1,600 to relatives and the endowment of the Consanguinitarium in Leicester (*see below*). Johnson put his banking income over the period at £29,835, but considered that his 'private business as a surveyor' was bringing in only £400 a year, which would not have covered his household expenses of £950 a year, including the cost of keeping a carriage up to c.1799. His income as county surveyor varied from year to year, amounting in 1802 to £105, made up of expenses and commission of £44; in 1803, the total was £219, of which £138 was commission. He described himself 'as a man of large property', estimating that he had acquired £83,640 since 1785, mainly as the result of accumulated savings, 'his income being large and his expenditure small.'[8] He had been engaged in speculative building for about forty years; properties in Newman Street had been sold to Mackworth in 1767 and 1768, whilst some houses in Paddington Street, Berners Street and Charles Street were retained as investments. He was also purchasing property, mainly in St. Marylebone, from at least 1779; some of it was transferred to his sons and grandchildren, but property still in his possession in 1803 included unlet freehold land in Leicester, valued at £2,350, and four houses there, probably in Southgate Street, estimated to be worth £1,512.[9] There were also mortgages and other loans. A mortgage of £3,000 on Mr. Colman's estate in Birmingham formed part of the Revd. Charles Johnson's marriage settlement in 1790. Johnson lent money to associates, and possibly to clients, such as Sir William Dolben (£800), Sir Patrick Blake (£800), his unfortunate young partner, William Berners (£500) and John Utterton (£4,000). Mr. Andrews, who was liable for a mortgage of £868 10s. in lieu of 4% consols and a note of hand for £822 18s., may have been Joseph Andrews, his former clerk and son's partner. There were a few outstanding clients' accounts at the time of Johnson's bankruptcy, including John English Dolben (balance of £300) and Sir Charles Bampfylde (£542 payable by instalments and possibly relating to earlier work at New Cavendish Street; *see Chapter 1*). An account for £200 delivered to Sir Stephen Lushington must represent work amounting to £4,000, possibly to be identified with a two-storeyed wing added to Wimbledon House on Parkside, not otherwise documented.[10]

Although Johnson was not an active partner in the bank, whose accounts he did 'not perfectly understand', he had £32,581 'employed in the Business', compared with £19,932 for George Dorset, £9,124 for John Wilkinson, and under £4,000 each for William Berners and James Tilson.[11] The banking house is said to have been 'deeply embarrassed' when Tilson became a partner in 1797, which may explain Cunningham's unsubstantiated story of John Bacon placing £40,000 at Johnson's disposal when a run on the bank was expected.[12] However, Johnson joined his partners in the parlour upstairs in the banking house at 68 New Bond Street on 4 May 1803, when they instructed their clerk to stop

payment and to refuse admittance to Thomas Bentley Buxton, the Leicester banker, who acted as petitioning creditor.[13] On 6 May, a warrant of seizure was executed at Johnson's house at 53 High Street, St. Marylebone, and his furniture valued at £898 18s.; the lease of the house had been assigned to his son, John, in September 1802.[14] The following week, Johnson vetoed Wilkinson's scheme for the Leicester bank to provide £19,000 in support.[15] The partners' examinations in bankruptcy were adjourned from August to November 1803; Johnson expressed his anxiety to the Strutts in September, but they had no objection to his collecting rents for them and may even have lent him money. Johnson's examination was held on 19 November. After giving up private property worth nearly £70,000 to the assignees, he passed his examination and by the end of January, his certificate had been signed by nearly 300 creditors. Unable to raise bail of £300,000, he was forced to go into hiding and suffered a stroke as the result of confinement.[16]

The main creditors of the house were other bankers. Apart from Bentley and Buxton of Leicester, involved to the extent of £37,698 and themselves subsequently declared bankrupt, country bankers drawing on Dorset, Johnson and Co. included William Roscoe of Liverpool, John Heath of Chippenham, Wiltshire, and Thomas Waters of Carmarthen.[17] Personal creditors included architects and surveyors, such as Robert Furze Brettingham, John Love, Richard Fleming, Thomas Rogers and Henry Hakewill, Johnson's associates like Thomas Collins, the younger Bacon and his sisters, a few Essex gentry, Robert Jones Adeane of Waltons and Dame Margaret Smith Burges of Havering, with Johnson's assistant, the Chelmsford innkeeper, Charles Murrell (*see Chapter 4*).[18]

Johnson ascribed the failure of the bank 'to the unwarrantable conduct of one or more of my late partners'.[19] William Seymour, the solicitor acting for the assignees, wrote to Wriothesly Digby, a trustee for the Mackworth family, in August 1803, that both Johnson and George Dorset 'were wholly ignorant of the frauds committed by Mr. Wilkinson', to which both Berners and Tilson were consenting parties, although the latter had remonstrated in writing.[20] Wilkinson appears to have been dealing fraudulently in consols and reduced Bank annuities, from at least March 1801, by selling stock without the holder's consent and continuing to credit the dividends, but not the capital, or by claiming to have purchased stock, from which no dividend was paid; the chief sufferers were the children of the late Sir Herbert Mackworth.[21] Johnson's old friend, John Heyrick of Leicester, was relieved to hear of Digby's conviction that Johnson 'was not privy to the fraudulent transactions of the house', describing him as 'the most honest and liberal minded man I ever knew'.[22]

James Tilson put forward another explanation in his examination, blaming the failure on the large advances made to the Gainsborough banking house of William Hornby and Joseph Esdaile, which also failed, and to Richard Parsons, trustees.[23] Whatever the cause, Johnson felt that he had been deprived 'of the property I had acquired by a life of Industry and care and reduced at the Eve of

it from a respectable state of affluence to one of disgrace and penury.' A dividend of 4s. in the pound was declared in the spring of 1804, with a larger one expected in June; Johnson was discharged from bankruptcy in May 1804.[24] He moved to Camden Town, writing to John Strutt on 17 August from White's House; the entries in the rates for Camden Street, September 1805 to September 1806, and for College Street from June 1807 may refer to the same property.[25]

With increasing age and failing health, Johnson probably became more dependent on his son's assistance in his work as county surveyor. John Johnson, junior, had been helping with the preparation of accounts as early as the autumn of 1799.[26] When his father was accused of being dilatory in settling accounts in July 1806, he was able to assure Lewis Majendie that Harvey, the Chelmsford bricklayer, had been paid £150 on account and that his accounts for the Chelmsford house of correction would be examined and liquidated before the Michaelmas sessions.[27] The following year, repairs to Halstead house of correction had to be deferred because of the county surveyor's health.[28] After attending sessions on 4 October 1808, Johnson does not seem to have carried out county business during the rest of the year, resulting in Sir Eliab Harvey's belief that he was dead.[29] The clerk of the peace remonstrated with Johnson for not attending sessions in May 1810, but his reply, perhaps surprisingly, refers to impending visits to Sussex and Berkshire.[30] After attending the auction of the old house of correction in Chelmsford on 12 December 1811, he was confined to the house by 'a Rheumatic pain at his Stomach', preventing his attendance at sessions in January and March 1812. John Johnson, junior, had to carry out the survey of White's bridge, Great Burstead, and report on its condition at the sessions on 7 April.[31] He sent a covering letter with the surveyor's bills to the July sessions at which his father announced his intention of resigning at Michaelmas (*see Chapter 4*).[32] The reports on White's and Dagenham Beam bridges to that session were signed by the younger Johnson.[33]

After his retirement at the age of eighty, Johnson moved from Camden Town to Leicester, where his health improved slightly. He was grateful for a subscription, amounting to £105, raised by the magistrates in January 1813. The subscribers included T. B. Bramston and his two sons, John Strutt and his son, John Crabb and G. D. Carr, together with Johnson's successor, Robert Lugar. A further £100 was acknowledged in March 1813 by his son, Charles, as tending 'in no small degree to alleviate him under the numerous vicissitudes he has had to encounter, added to the infirmities of declining nature'. By June he had difficulty in dictating to his housekeeper an acknowledgment of a further £115 5s.; 'the Subscription has done him the Highest Honour, and will be greatfully felt by him to the Last hour of his Life'.[34]

Before Johnson's accounts as county surveyor had been finally settled, his son, John, died on 26 February 1813. He had drawn up his will on 22 December 1812, so may have already been in failing health. He was buried on 4 March 1813 at Finchley, where his friend and relative, Captain John Richards, R.N.,

erected a tablet to him in the tower, with a long inscription commemorating his generosity, evidenced by a bequest to Richards of £1,000 in lieu of all debts owed to the testator. Unfortunately, as his affairs proved to be in disorder, his father never received the annuity of £200 mentioned in the will.[35]

John Johnson, junior, described himself variously as architect or surveyor from c.1790, but little is known of his professional activities, apart from his assistance to his father.[36] However, his work as a building contractor and speculative builder is documented from late in 1784, when he was already in partnership with Joseph Andrews and William Horsfall (see Chapters 5, 6).[37] They were involved in the development of Upper Newman Street before April 1788.[38] The partners supplied materials and carried out building work for the Essex justices from 1785, their major contract being that for the Shire Hall (see Chapter 6).[39] In London, they were employed by Sir Herbert Mackworth at 5 Cavendish Square from 1786, including the enlargement of the dining room in 1789; after his death in 1791, they carried out work for Lady Mackworth in Harley Street.[40] The partners were involved in a dispute over the cost of alterations to Garrett Green Farm in Wandsworth, Surrey, for Mrs Elizabeth Gower in 1787. Her brother, John Strutt, complained to John Johnson, senior, that his son had failed to call on him. The son's reply referred to Strutt's 'long friendship for my father'. Johnson put the blame on his son's partners 'with whom I am not upon the best terms, nor have been for some time past'.[41] The partnership finally broke up during 1791, while work was still in progress on the Shire Hall, the conduit and Hatfield Place (see Chapters 6, 9), although their affairs had not been finally settled by May 1796.[42]

The younger Johnson remained in business as a building contractor, based at Berners Street, referring in September 1799 to his 'people Going into the City Every day'.[43] He worked on the school house at Felsted (1799–1802), the restoration of Chelmsford church (1801–1803) and alterations to Boreham House (1802–1804). John Gittins, who had earlier worked for his father, may have acted as his clerk.[44]

Both father and son were involved in estate management in London on behalf of the Mackworth and Strutt families. Johnson collected Mackworth's rents from Newman Street and a house in Henrietta Street from 1786–91, when his son took over until 1809. The younger Johnson received two and a half per cent commission and also dealt with the renewal of leases and insurance.[45] His father acted as surveyor to Strutt's brother-in-law, the Revd. Charles Phillips (d. 1801) who owned an estate called King David's Fort, north of Ratcliff Highway in Stepney; after his death, Johnson worked for the trustees, John Strutt and his son, Col. J. H. Strutt. The withdrawal of compulsory purchase threatened by the London Wet Dock Company resulted in the decision to let the land on building leases. Between 1802 and 1808 Johnson was concerned with surveying and measuring the ground, setting it out, fixing the boundaries of streets, named after members of the Phillips and Spencer families, and making plans of the

houses in Union Street. Apart from commission on collecting rents, he charged £407 7s. 9d. for his services between October 1801 and July 1808.[46]

John Johnson died on 27 August 1814 at his house in Southgate Street, Leicester, one of the four he had erected 'on the spot where he was born', and which he had retained after his bankruptcy.[47] These four white brick houses, with a centre pediment, partly screened the Consanguinitarium, a group of five houses in Gothic style, which he had endowed in 1795 as homes for poor relatives. Each house had one room on the ground floor with a chamber upstairs; the windows were filled with stained glass (*Illus. page 135*). The original trustees were Johnson's three sons, his brother, William, brother-in-law Joseph Spring-thorpe and nephew, also Joseph Springthorpe. An estate at Lubbenham, Leicestershire, was charged with an annual rent of £70 to maintain the building and to provide each inhabitant with 4s. 6d. a week and a ton of coal annually. The rules stipulated that furniture should be provided by the first occupants. They were not allowed to keep pets, hens or rabbits and had to use the wash-house in rotation; there was also a communal kitchen. The women were expected to look after the sick. All had to live peaceably together and to 'attend public worship, at such place as is most congenial to their conscience, and give praise to the Great Author of the Universe, for enabling and permitting the Founder of these dwellings to have the pleasure of giving the comforts they afford to them'. The Consanguinitarium was rebuilt in Earl Howe Street by R. J. Goodacre, also a relative; the houses in Southgate Street were demolished c.1965.[48]

Johnson, who drew up his will on 12 January 1811, left the houses in Southgate Street to his nephews, William and Francis, sons of his brother, William (d. 1 November 1810), his niece, Elizabeth, wife of Robert Bond of Leicester, gent., and his housekeeper, Hannah Bunning, with remainder to John, eldest son of his nephew, Charles Johnson. The latter, who moved to Rochdale, Lancashire, seems to have acted as his uncle's clerk between 1808 and 1812. The houses were charged with an annual payment totalling £20 to augment the stipend payable to the residents in the Consanguinitarium. The residue, including any future proceeds from the banking house, was to be divided amongst his grandchildren and the children of his nephews and niece. After the move to Leicester, codicils made provision for Hannah Bunning, with his goods and chattels going after her death to William and Francis; William was to have his portrait. He wished to be interred in the chancel of St. Martin, Leicester, near his parents, and gave the wording of the inscription to be placed on his parents' monument:

In Memory of John Johnson Architect late of the Parish
of St. Mary-le-Bone London son of the above-named
John and Frances Johnson and Founder of the Consanguinitarium
in this Town . . .

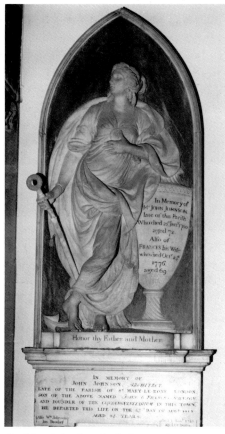

His executors, William Johnson and Robert Bond, carried out his wishes in this respect, William adding the date of his father's death (*Illus. page 156*).[49]

It is during these last years that John Johnson is most clearly seen as a family man, determined to endow his three sons equally and also to make provision for his nephews and niece and less fortunate kinsmen in Leicester. Johnson's second son, the Revd. Charles Johnson (1768–1841), was the only one to marry and to survive his father. He was educated at Exeter College, Oxford, taking his B.A. in December 1790, and became vicar of Berrow, near Burnham in Somerset, and of South Stoke, near Bath, where he resided, in 1792. He was also vicar of South Brent, near Berrow, from 1799, and prebendary of Wells from 1816.[50] On his marriage in 1790 his father settled property worth £8,000 on him, followed by £2,000 in cash c.1797, with further property for himself and in trust for his nine children in April 1802. He also inherited a life interest in the estate of his brother, John, including the family properties in Berners Street.[51] Through the marriage in 1822 of his second son, the Revd

St. Martin's church, Leicester (now Cathedral), monument to John and Frances Johnson, designed by their son, c.1780, with inscription to him, 1814

Francis Charles Johnson, vicar of White Lackington, near Ilminster, Somerset, to Emma, sister of Sir James Brooke, Rajah of Sarawak, Charles became the ancestor of the later Brooke Rajahs and of Henry Carslake Brooke Johnson, Treasurer of Sarawak.[52]

Johnson's wealth, destroyed by the bankruptcy, must have originated in the speculative building of his early years in London. During this period, like other contemporary architects, he may have begun to build up a team of his own workmen, although it is not possible to say how many of these were employed on a permanent basis or even how far he may have relied at first on a barter system with other craftsmen. Carpenters are most likely to have formed the nucleus of such a team. The London carpenters working at Sadborow may have been Johnson's employees. London craftsmen were employed more extensively at Kingsthorpe and Carlton Hall, with the exception of the locally-based masons

He had his own foremen from at least 1771. On the other hand, in the dispute over alterations to Springfield Place in 1780, Johnson claimed that the foreman and other workmen were independent of him; these workmen included the bricklayer, Starkey, whose wife in London was receiving part of his wages, and an apprentice named Watkins. By c.1785, Johnson's son and his former clerk and foreman were in partnership working on major contracts such as the Shire Hall and Hatfield Place, although the Wimbledon vestry insisted in 1787 on employing local workmen. After the dissolution of this partnership c.1791, John Johnson junior continued to work on his father's commissions until at least 1805, although his father displayed indifference as to the choice of workmen for a job in Leicester in 1799. Whilst employed at Chelmsford church in 1802, the younger Johnson estimated that at least eight or ten carpenters, plasterers and slaters were preparing materials, such as plasterers' moulds, in his London workshop. The role of John Kemshead of Berners Street, carpenter, at this period is less clear; during 1802 he was corresponding on Johnson's behalf over Boreham House, for which Johnson's son had the contract, but contracted on his own account for the carpenter's work at the Chelmsford house of correction. The elder Johnson must have derived part of his early income from profits made from supplying materials and joinery, made in his own workshop, as at Sadborow, Kingsthorpe and Carlton Hall, although his first clients considered him cheap and he himself claimed never to have led clients into unnecessary expense.

For the greater part of his career Johnson owed a great deal to the support and friendship of two patrons, Herbert Mackworth and John Strutt. Two of Mackworth's relatives were clients: his brother-in-law, the Revd. John Hotham and his cousin, Sir William Dolben. Mackworth may also have recommended him to Welsh gentry and to Sir Patrick Blake. Johnson also worked for relatives of John Strutt, especially the Revd. Charles Phillips, who was also on the Essex bench. Most of his Essex clients came from this circle: Henry Bate Dudley, Nicholas Wescomb, George Davis Carr, John Crabb, the Revd. John Bramston-Stane, Sir John Tyrell and John Archer Houblon. Thomas Berney Bramston, who had recommended Johnson to Strutt and, later, to his own son, served as Chairman of Quarter Sessions. Although Bramston, Strutt and Archer Houblon served as Tory members of parliament at various periods, this may not have been highly significant in Essex, where the county seats were divided between the parties from 1772 to 1810. However, Montagu Burgoyne, Johnson's chief opponent on the bench, was a Whig.

From his early work as a speculative builder, Johnson developed into a competent designer of country houses, perhaps at his peak during the period c.1772–78. This part of his work, not always well documented, was characterised more by consistency than originality. His exteriors display a fondness for Coade stone and for recessed arches. He excelled as a designer of staircases, often domed and with his favourite honeysuckle scroll balusters; those at Sadborow,

Holcombe House and Hatfield Place are amongst the most elegant and the lost example at Langford Grove must have had a certain grandeur. He made use of a limited number of Neo-classical motifs, favouring stucco panels on walls with figures such as Eros or Bacchus and Ariadne. Smaller classical medallions were used in entrance halls and elsewhere. His ceilings feature compartments, filled with female figures or putti, radiating from a central motif, the more elaborate examples containing a painting or a figure composition in stucco. Favourite motifs for the end compartments of ceilings were bow and arrow or quiver and torch, and mermaids with dolphins and a pillar arranged to suggest a lyre.

The proximity of Essex to London and the presence of two early patrons on the bench made it possible for an experienced architect based in the capital to be employed as county surveyor from 1782 to 1812. Documentary evidence abounds for this aspect of his career, throwing considerable light, in Jack Simmons' words, on 'the work of a forgotten class of public servants'.

APPENDIX ONE

WORKS (excluding bridges)

(N) = Listed by John Nichols, *History of Leicestershire*, i, 528. The list of buildings was almost certainly supplied by Johnson himself.

DEVON

(N) Killerton, Broadclyst, for Sir Thomas Dyke Acland, 7th Bt., 1778–79; altered, 1900

Mamhead, unexecuted schemes for alterations for Earl of Lisburne, c.1777

DORSET

(N) Sadborow, Thorncombe (transferred from Devon, 1842) for John Bragge, 1773–75; west wing added, 1843

ESSEX

Skreens, Roxwell, alterations including new stables for Thomas Berney Bramston, c.1769–71; remodelled c.1910; dem. c.1920

(N) Terling Place for John Strutt, 1772–78; exhib. 1778; alterations by Thomas Hopper, 1818–24

(N) Bradwell Lodge, Bradwell-juxta Mare, for Revd. (Sir) Henry Bate Dudley, 1781–86; ? exhib. 1783

(N) Langford Grove for Nicholas Wescomb, c.1782; ? exhib. 1783; dem., except for one pavilion, 1953

Halstead, House of Correction, rebuilt 1782–83, probably to design of William Hillyer; dem. early 1970s

(N) Chelmsford, County Gaol, alterations and additions, 1782–96; elevation exhib. 1783; dem. 1859

Thorpe Hall, Thorpe-le-Soken, unexecuted design for new front elevation for Stephen Martin Leake, 1782

Chelmsford, conduit with Coade stone naiad, 1787–91; dem. 1814; statue now in foyer of Shire Hall

Colchester, alterations to House of Correction in Castle, 1787–88

(N) Chelmsford, Shire Hall, 1789–91

Barking, House of Correction, 1791–93; dem. c.1834

(N) Hatfield Place, Hatfield Peverel, for Col. John Tyrell, 1791–95; additions, c.1860, 1905

(N) The Lawn, Stroud Green, Rochford, enlarged for Major George Davis Carr, after 1796; altered, late 19th century

Chelmsford, Grammar School House, alterations, 1797–99

Chelmsford, Moulsham Hall, alterations to roof for Sir Henry Mildmay, 1797; dem. 1809

(N) (?) Willingale Doe, rectory for Revd. John Bramston-Stane, after 1797

159

(N) (?) Forest Hall, High Ongar, for Revd. John Bramston-Stane, c.1801–12; altered after 1862; dem. 1957

Felsted School, new master's house (now Ingrams), 1799–1802

Chelmsford, St. Mary's church (now Cathedral), nave rebuilt, 1800–1803

(N) Torrell's Hall, Willingale Doe, new front block for John Crabb after 1800

Boreham House, alterations for Sir John Tyrell, Bt., 1802–1803

Chelmsford, House of Correction, 1802–1807; dem. 1859

Hornchurch, church restoration, 1802

Braxted Lodge, Gt. Braxted, north front and staircase for Peter Du Cane, 1804–1806

Hallingbury Place, Gt. Hallingbury, repairs for John Archer Houblon, 1807; dem. 1924

Gt. Hallingbury, repairs to church, 1807

Thaxted, repairs to church spire, 1807

(N) Broomfield Lodge, for John Judd, c.1808; dem. 1964

HERTFORDSHIRE

Bishop's Stortford, church restoration, c.1803

HUNTINGDONSHIRE

Stilton church, rebuilding of chancel, c.1808

LEICESTERSHIRE

Leicester, Brunswick Square, unexecuted design, 1792

Leicester, four houses and Consanguinitarium, Southgate St., 1792–93; dem.

(N) Leicester, Borough Gaol, Highcross St., 1792–93; dem. 1837

(N) Leicester, Hotel (now County Rooms), 1799–1800

Leicester, Theatre, 1800; dem. 1836

Knighton Hall, addition for Sir Edmund Cradock Hartopp, 1799–1802

(N) Whatton Hall, Long Whatton, for Edward Dawson, c.1802; partly rebuilt and extended, late 19th cent.

LONDON

Paddington St., St. Marylebone, house, 1762

Berners estate, St. Marylebone, 1769–71

49–66 Newman St.; 28–36 Berners St.; 31–35 Charles (later Mortimer) St.

(N) Harley St., house, no. 27 (later no. 48), for Revd. Sir John Hotham, Bt., later Bishop of Ossory, c.1773; dem.

(N) Harley St., house, no. 43 (later no. 63) for John Pybus, c.1773, dem.

(N) Charles St., St. James' Square, no. 19, for 7th Earl of Galloway, 1775–76; exhib. 1778; dem. 1912

(N) New Cavendish St., no. 9 (now no. 63) for Sir Charles Bampfylde, Bt., c.1775–77; exhib. 1775, 1778

(N) New Cavendish St., no. 10 (now no. 61), for John Udney, c.1775–77; exhib. 1775

Grosvenor Square, no. 38, alterations for 3rd Duke of Dorset, c. 1776

(N) Portman Square, no. 10 (later no. 13), for Hon. Henry Willoughby, later 5th Lord Middleton, 1777; ? exhib. 1778; dem. c.1965

(N) Portman Square, no. 9 (later no. 12), for Hon. Charles Greville, 1778; ? exhib. 1778; dem. c.1965

(N) Pall Mall, house on N. side reconstructed for Sir Hugh Palliser, Bt., c.1779; dem. 1866

Portland Place, no. 22, for Sir Patrick Blake, Bt., c.1781; dem.

Attributed
Bedford Square, nos. 9 (c.1777), 19, 21 (c.1782), 30 (c.1776)

MIDDLESEX
(N) Holcombe House, Mill Hill, Hendon, for Sir John Anderson, Bt., c.1775–78; exhib. 1778

NORTHAMPTONSHIRE
Castle Ashby, rebuilding of great hall for 8th Earl of Northampton, 1771–74; altered, 1884

(N) Kingsthorpe Hall, for James Fremeaux, 1773–75

Lamport Hall, unexecuted plan for drawing room for Sir Justinian Isham, c.1773

(N) Pitsford Hall, for Col. James Money, c.1775; altered in later 19th and 20th centuries

(N) Carlton Hall, East Carlton, for Sir John Palmer, Bt., 1776–81; exhib. 1778; enlarged c.1820; rebuilt 1870

Finedon, alterations for Sir William Dolben, Bt., 1780–81; altered after 1835; dem. 1980

Attributed
East Haddon Hall, for Henry Sawbridge, 1780–83

RUTLAND
Burley-on-the-Hill, dining parlour for 8th Earl of Winchilsea, c.1778; design for capital exhib. 1778

Attributed
Burley-on-the-Hill, design for grotesque temple exhib. 1778

SOMERSET
Halswell, temple of Pan for Sir Charles Kemeys Tynte exhib. 1778

SUFFOLK
Newmarket, stables for Lord March, c.1770

(N) Newmarket, New Rooms (now Jockey Club), 1771–72; refronted 1933

(N) Woolverstone Hall, for William Berners, 1776, exhib. 1777
(N) Benhall Lodge, for Rush family, n.d.; dem.
 Langham Hall, design for hermitage for Sir Patrick Blake, Bt., exhib. 1783

SURREY

Design for lawn front of gentleman's house (unidentified), exhib. 1783
(N) Wimbledon church, rebuilt 1787–88; rebuilt 1843

Attributed

Wimbledon (later Belvedere) House, enlarged for Sir William Beaumaris Rush, after 1783; dem. c.1900
Wimbledon House, Parkside, addition for Sir Stephen Lushington, c.1803; dem. c.1900

SUSSEX

(N) St. Leonard's Lodge, Lower Beeding, for Charles George Beauclerk, c.1803–1808; dem. 1853
 Lewes, County Hall, 1808–12

WALES

(N) Clasmont, near Morriston, Glamorgan, for Sir John Morris, c.1775; dem. 1819
(N) Gnoll Castle, Neath, Glamorgan, west wing added and Ivy Tower remodelled for Sir Herbert Mackworth, Bt., c.1776–78; house dem. c.1956
 Design for gentleman's seat (unidentified), Carmarthenshire, exhib. 1783

APPENDIX TWO

COUNTY BRIDGES, 1813

This list is based on that dated 12 May 1813 at the end of the volume containing the county surveyor's quarterly abstract of payments (Q/FAc 6/3/2). Entries in square brackets relate to other bridges for which documentary evidence is available for the period 1782–1812. Information in italics relates to work carried out before Johnson was appointed.

1 Abridge	Lambourne/Theydon Bois	*Built, 1777*	Additional arch, 1980–81
2 Ackingford	Bobbingworth/Chipping Ongar	Rebuilt (timber), 1806	Rebuilt (concrete), 1913
3 Ballingdon	Ballingdon/Sudbury, Suffolk	Rebuilt (timber), 1805	Transferred to Suffolk, 1905; rebuilt (concrete), 1912
4 Bardfield	Gt. Bardfield	*Built, 1763*	Extant

5	Battlesbridge	Rawreth/Rettendon	Rebuilt (timber), 1795–6	Rebuilt (iron), 1855, 1872
6	Baythorn	Birdbrook	Repaired, 1795	Extant
7	Blackwater	Bradwell-juxta-Coggeshall	Rebuilt (timber), 1788	Rebuilt (iron), 1852, 1862
8	Blue Mills [Marchants]	Witham	Culverts, 1799	Extant
9	Cattawade	Lawford	Rebuilt (timber), 1790	Rebuilt (concrete), 1911
10	Causeway	Aveley and West Thurrock	—	Rebuilt (brick), 1816; (iron) 1862 and c.1930
11	[Chain]	Mountnessing	Rebuilt (brick), 1792	Abutments and parapets (concrete); superstructure (steel)
12	Chelmsford [Moulsham]		Rebuilt (stone), 1787	Extant
	Chigwell	*Recte* Loughton (q.v.)		Not listed, 1857
13	Dagenham		Repaired, 1804	Rebuilt, 1899
14	Dedham	Dedham/Stratford St. Mary, Suffolk	Rebuilt (brick), 1786; (timber), 1795–96	Rebuilt (iron), 1875; (concrete), 1928
15	Fingringhoe	Fingringhoe/East Donyland	—	Rebuilt (timber), 1814; (concrete), 1923
16	Half Mile	Ingatestone	Rebuilt (brick), 1796	Rebuilt, c.1920
17	Hallsford	Stondon Massey	*Built 1775*	Rebuilt (concrete), 1934
18	[Heybridge]	Ingatestone/Mountnessing	Widened, 1788	Steel superstructure
19	Ilford		Repaired, 1801	Large bridge rebuilt, 1904; small bridge demolished
20	Langford	Kelvedon Hatch	Rebuilt (timber), 1808–1809	Rebuilt (concrete), 1914
21	Laver, High	High Laver/Moreton	—	Reconstructed (concrete), 1976
22	Leaden Wash	Leaden Roothing	Subscription bridge, 1810	Rebuilt, 1843
23	Loughton		Small bridge rebuilt (timber), 1809–10	Large bridge altered, 1824
24	Margaretting			Not listed, 1857
25	Moreton	Moreton/Bobbingworth	Rebuilt (brick), c.1784	Partly rebuilt, 1870
26	Nayland	Gt. Horkesley/Nayland, Suffolk	*Built, 1775–76*	Rebuilt, 1959
27	Ongar, Chipping		Rebuilt (brick), 1797	Widened, c.1956
28	Ongar, High	High Ongar/Chipping Ongar	Rebuilt (brick), 1787	Rebuilt (concrete), 1913

29 Paine's	Romford (Noak Hill)	—	Transferred to L.B. Havering, 1965; rebuilt, 1980–81
30 Passingford	Stapleford Abbots/ Stapleford Tawney	Rebuilt (brick), 1785	Demolished, c.1968
31 Peet	West Mersea/Peldon	Rebuilt (brick), c.1803–1805	Extant
32 Pentlow	Pentlow/Cavendish, Suffolk	Rebuilt (timber), 1793–94	Rebuilt (brick), 1885
33 Ramsey		Rebuilt (timber), 1808	Rebuilt (brick), 1874
34 Rod	Foxearth/Long Melford, Suffolk	Rebuilt (timber), 1808	Rebuilt (concrete), 1912
35 Roxwell		*Rebuilt, c.1779*	Rebuilt (iron), 1870
36 [Roydon]	Roydon/Stanstead Abbots, Hertfordshire	Rebuilt, 1802	Transferred to Hertfordshire, 1802
37 Salt	Eastwood/Rochford	*Built, 1772*	Rebuilt, 1900
38 Sandon		*Built, 1767*	Rebuilt (iron), 1857–58
39 Shellow	Beauchamp Roothing/ Willingale Doe	Rebuilt (timber), 1812	Rebuilt (concrete), c.1957
40 Shonks Mill	Navestock/Stanford Rivers	Rebuilt (timber), 1810	Abutment (concrete), temporary decking, 1943
41 Small Lea	Waltham Holy Cross/ Cheshunt, Hertfordshire	Rebuilt and widened (brick with stone piers), 1810–11	Rebuilt (iron), c.1858
42 Stifford		Rebuilt (brick), 1800	Rebuilt (iron), 1868; c.1925
43 Stone	Hatfield Broad Oak	—	Rebuilt, c.1936
44 Sutton Ford		Rebuilt (brick), 1784	Rebuilt, 1902
45 Theydon [Mason's]	Theydon Garnon	—	Rebuilt, c.1868
46 [Two Mile]	Writtle	Widened, c.1794	Rebuilt, 1937
47 Uttlesford	Wendens Ambo	*Widened (brick), 1765*	Extant
48 Weald	North Weald Bassett	Rebuilt (brick), 1785–86	Extant
49 Whites	Gt. Burstead	Rebuilt (brick), 1812	Structure modified (concrete)
50 Whites	Margaretting	*Built, 1770*	Extant
51 [Wickford]		*Built, c.1773–75*	Rebuilt, 1933–34
52 Wickham Mill	Wickham Bishops	Culverts, 1799	Arches widened, 1923
53 Widford		Rebuilt (timber), 1805	Rebuilt (iron), 1845
54 Woodford		*Built, 1771*	Rebuilt, 1962

APPENDIX THREE

PORTRAITS

Johnson is known to have had at least two portraits painted by his great friend, the pastellist, John Russell, R.A. (1744–1806). Two identical portraits, measuring 24 by 18 inches, are listed in 1894 by G. C. Williamson, *John Russell* (pp. 146–148), as in the possession of John Harley, Esq., Millfield, Lincoln Road, Peterborough, and of Miss Horobin, 79, The Market Place, Leicester. The Harley portrait is described as of Mrs. Harley's great-uncle. One of these was exhibited at the Royal Academy in 1787 as the portrait of a gentleman; Russell was then living near Johnson at 7 Mortimer Street, St. Marylebone. Johnson left a portrait, probably to be identified with one of these entries, to his nephew, William Johnson of Leicester.

Two surviving portraits by Russell can be identified with those described by Williamson. The one in the Chelmsford and Essex Museum (Acc. 1978: 318) was presented by Mrs. Dorothy A. Ainsley of Quenby, Hillside Court Road, Cheltenham, Gloucestershire, in 1978; she was a descendant of Johnson and was then 'nearly 90'. The portrait is signed and dated 1786; it measures 23 by 17½ inches (*see Frontispiece*). The other portrait in a private collection, which is identical, has been recorded by the Paul Mellon Centre for Studies in British Art (PMC B0936 1971) and measures 24 by 18 inches.

A third portrait was in the possession of Mrs. Brooke-Johnson of Richmond, Surrey, in 1974. No details of this work are available, but it is likely to have descended in the family of the Revd. Charles Johnson (*see Chapter 10*). A miniature of Johnson was formerly in the County Rooms at Leicester.

APPENDIX FOUR

GLOSSARY OF ARCHITECTURAL TERMS

For further information, see John Harris and Jill Lever, *Illustrated Glossary of Architecture*, 1966

Acanthus	ornament based on broad scalloped leaf of this plant
Aedicule	opening framed by columns and pediment
Alto relievo	sculpture in high relief
Anthemion	honeysuckle
Arabesque	flowing interlaced type of ornament, derived from Raphael's version of Greco-Roman work

Architrave	moulded frame of door or window; *see also* Entablature
Ashlar	large blocks of squared hewn stone
Bandcourse	*see* String course
Basso relievo	sculpture in low relief
Belvedere	turret or lantern on a house, to afford a view
Blocking course	a course of bricks or masonry above a cornice
Bucranium	ox skull used decoratively in friezes
Cable	rod placed in the recess of a flute (*q.v.*)
Centre	temporary framework, usually of timber, to support an arch or vault during construction
Channelling	the use of square-section joints in rustication (*q.v.*)
Chiaro o(b)scuro	treatment of light and shade in painting
Clerestory	upper storey of nave above aisle roofs, pierced with windows
Console	a scrolled bracket; truss
Coving	large concave moulding, especially between ceiling and cornice
Dentil	small square block used in series in classical cornices
Diocletian window	semi-circular window divided by two upright mullions
Entablature	collective name for horizontal members (architrave, frieze and cornice), carried by a wall or column
Etruscan style	decoration inspired by colouring and motifs of so-called Etruscan vases and urns
Fa(s)cia	band, usually plain, e.g. horizontal division of an architrave (*q.v.*)
Flute	one of series of concave grooves
Foliated	surface covered with leaf ornament
Grisaille	monochrome painting
Grotesque	decoration with foliage scrolls incorporating ornaments and fantastic figures; *cf.* Arabesque
Guilloche	continuous band of interlaced spirals
Imperial staircase	single flight leading to double flight
Impost	horizontal moulding at the springing of an arch
Keystone	central wedge-shaped block of an arch; also used as ornament on head of door or window
Loggia	covered colonnade or arcade open to the air on at least one side
Lunette	semi-circular window or panel
Metope	plain or decorated space between triglyphs (*q.v.*) in a Doric frieze
Mezzanine	low intermediate storey between two floors
Modillion	small console (*q.v.*) at regular intervals along the underside of a cornice

Necking	lowest part of capital
Nosing	rounded edge of a tread, projecting above the riser
Ovolo	convex moulding
Palladian window	*see* Venetian window
Patera	round or oval ornament in low relief
Pendentive	spandrel (*q.v.*) formed as part of a hemisphere between arches meeting at an angle, supporting a dome
Piazza	open space surrounded by buildings; arcaded ground floor (18th cent.)
Pilaster	flat representation of classical column in low relief against a wall
Plinth	projecting courses at foot of wall or column
Quoin	dressed stone at angle of a building
Raffle leaf	development of acanthus (*q.v.*) into a freely flowing, asymmetrically curving leaf, used in scrolling foliage
Rustic	basement storey (18th cent.); rustication (*q.v.*)
Rustication	exaggerated treatment of masonry with deeply recessed joints
Scantling	size to which stone or timber is to be cut
Soffit	undersurface of architectural feature, e.g. of arch
Spandrel	roughly triangular space between an arch and its containing rectangle, or between adjacent arches
String course	moulding or projecting band running horizontally across a facade
Thyrsus	pine-cone tipped staff, associated with Bacchus and used in dining room ornament
Tongue	motif used in convex mouldings, e.g. egg and tongue
Torus	wide, convex moulding
Triglyph	rectangular grooved block between metopes (*q.v.*) in a Doric frieze
Tympanum	triangular or segmental space between the enclosing mouldings of a pediment
Venetian window	tripartite window with arched central opening and narrower side openings with flat heads
Vermiculated	rustication (*q.v.*), with stylized texture giving effect of worm-casts
Vesica	pointed oval shape
Vitruvian scroll	classical running ornament of curly waves
Volute	spiral scroll, the distinctive feature of the Ionic capital; also used in consoles (*q.v.*) and brackets
Voussoirs	wedge-shaped stones or bricks used to form an arch

REFERENCES

CHAPTER 1 Early Career in London (pp. 1–19)

1 Simmons, 128–129; Nichols, i, 528.

2 Parish registers; information from Richard Higginbottom; H. Hartopp (ed.), *Register of the Freemen of Leicester, 1196–1770*, Leicester, 1927, 241.

3 Nichols, i., 604, pl. xliv.

4 Hartopp, *op. cit.*, 315; Simmons, 129; *Gent. Mag.*, lxxxiv (2), 296.

5 G.L.R.O., P.89/MRY 1/4; an entry in the same register for Eleanor Johnson, bap. 22 April 1760, may relate to the same family.

6 G.L.R.O., MDR 1763/4/444; 1766/5/547, 548; 1767/2/130; 1767/5/231; 1767/6/248; 1767/9/118; 1768/3/227; Marylebone Library, DD 1449, 1516, 1522, 1544, 1630, 1642, 1645; J. Slater, *A short history of the Berners estate, St. Marylebone*, 1918, 5, 39; Briggs, *Woolverstone*, 59.

7 Marylebone Lib., DD 1504, 1506, 1522, 1612, 1614, 1646; G.L.R.O., MDR 1766/6/162, 163, 508.

8 G.L.R.O., MDR 1767/6/477; 1768/5/504; Lloyds Bank Archives, A19d/41.

9 Marylebone Lib., DD 1520, 1524, 1544, 1547, 1630, 1644; J. Harris, *Sir William Chambers*, 1970, 229; Victoria Lib., 90/8/10.

10 Marylebone Lib. DD 1520; rates; G.L.R.O., P89/MRY 1/5.

11 Marylebone Lib., DD 1500, 1601.

12 Somerset R.O., DD/PLE Box 14; G.L.R.O., MDR 1768/5/505.

13 Marylebone Lib., DD 1469.

14 T/B 181/1/1.

15 G.L.R.O., P89/MRY 1/5.

16 Strutt MSS.

17 Marylebone Lib., minutes of trustees for building new church, 1770–97, pp. 3, 5–6; R. M. Robbins, 'Some designs for St. Marylebone church . . .', *London Topographical Record*, xxiii, 1972, 97–100; B. F. L. Clarke, *The building of the 18th century church*, 1963, 13–14; Harris, *op. cit.*, 91–94, pls. 144–147.

18 G.L.R.O., MDR 1771/1/373; 1771/3/2, 6–8; MR/B/C2/82.

19 Marylebone Lib., rates.

20 P. Jackson, ed., *John Tallis's London Street Views 1838–1840*, London Topographical Soc. Pub. No. 100, 1969, 167, 237.

21 A. Cox-Johnson, *John Bacon, R.A.*, St. Marylebone Soc. Pub. No. 4, 1961, 17, pl. ii, quoting A. Cunningham, *Lives of the most eminent British Painters, Sculptors . . .*, iii, 1830, 210–211; G.L.R.O., E/BN/36, 44.

22 G.L.R.O., MJ/SP 1778; M. Cosh, *An historical walk through Clerkenwell*, Islington Libraries, 1980, 25.

23 Graves, 1907, 130; Colvin, 464.

24 G.L.R.O., MDR 1774/3/110, 111; Nichols, i, 528; Colvin, 464; A. Saunders, *The art and architecture of London*, 2nd edn. 1988, 423.

25 J. Summerson, *Georgian London*, 1945, 149; W. Harrison, *Memorable London Houses*, 1889 (reprinted 1971), 99–101.

26 G.L.R.O., MDR 1777/2/638.

27 G.L.R.O., MDR 1775/4/41.

28 Reproduced A. T. Bolton, *Architecture of R. and J. Adam*, ii, 102.

29 Nichols, *loc. cit.*; Graves, *loc. cit.*; Colvin, 464; *Survey of London*, xxix, 288–289.

30 *Survey of London*, xxxix, 122, 123 (plan); xl, 149–150, citing P.R.O., C12/1346/22; Kent Archives Office, Sackville MSS., U269/E146/3.

31 Greater London Photograph Library, 75/14311, 14309.

32 Kent Archives Office U263 E146/3.

33 *C.L.*, 13 May 1982, 1360-1361; D. Stillman, *The decorative work of Robert Adam*, 1973, 93, pls. 107–108.

34 *Survey of London*, xxxix, pl. 16c; G.L. Photo. Lib., 57/00963 (New Cavendish St.); Briggs, *Woolverstone*, pl. vi b.

35 *Survey of London*, xl, pl. 42d; G.L. Photo. Lib., 75/14911, 14914.

36 *Survey of London*, xl, pls. 42b, c, e; G.L. Photo. Lib., 75/14305, 14306.

37 *Survey of London*, xl, 150.

38 G.L.R.O., MDR 1779/3/592; Marylebone Lib., rates; British Library, Crace Collection.

39 *C.L.*, 13 and 20 Oct. 1917; typescript Proof of Evidence in The County of London Nos. 16–20 and 5–15 Mansfield Street, 61, 63 and 82 New Cavendish Street, St. Marylebone Building Preservation Order 1964 (copy in author's possession).

40 M. Jourdain, *English Interiors in Smaller Houses, 1660–1830*, 1923 (reissued 1933), 75–80, figs. 65–73; D. Stroud in *Report of the Institute of Psycho-Analysis*, 1953, 69–72, cf. typescript notes, St. Marylebone Lib., and *The Architecture of Sir John Soane*, 1961, 157.

41 *C.L.*, 20 Oct. 1917, 6* (restored elevation); A. Kelly, 'Coade Stone in Georgian Architecture', *Arch. Hist.*, 28 (1985), 81–82, pl. 3c; A. Byrne, *London's Georgian Houses*, 1986, fig. 63.

42 Jourdain, *op. cit.*, fig. 71; G.L. Photo. Lib., 58/00622, 00623.

43 Jourdain, *op. cit.*, figs. 65 (plan, elevation and details), 66, 68, 69; G.L. Photo. Lib., 58/00625.

44 G.L. Photo. Lib., 67/00474, 58/00626.

45 Jourdain, *op. cit.*, figs. 67, 70; G.L. Photo. Lib., 58/00630.

46 Jourdain, *op. cit.*, fig. 72; G.L. Photo. Lib., 58/00632.

47 Jourdain, *op. cit.*, 75, fig. 73.

48 G.L. Photo. Lib., 75/14310.

49 G.L. Photo. Lib., 57/00963.

50 Graves, *loc. cit.*

51 G.L. Photo. Lib., 65/00406, 00410.

52 G.L.R.O., MDR 1778/1/360; Marylebone Lib., DD510; A. T. Bolton, *Architecture of R. and J. Adam*, ii, 1922, 81, 91; Nichols, *loc. cit.*

53 Marylebone Lib., Ashbridge Coll., 1363 (reproduced, G. Mackenzie, *Marylebone*, 1972, pl. 14), 1362 (Nattes), cf. T138 (33), photo c.1910; G.L. Photo. Lib., F2682, 1945; P.R.O., C12/1346/22; J. M. Robinson, *The Wyatts*, 1979, 243.

54 G.L.R.O., MR/B/R3, 479, 480 (affidavits missing); Marylebone Lib., rates; *Post Office London Directories*, 1961–1966.

55 G.L. Photo. Lib., 59/401, 2871/8, 10, 11; Graves, *op. cit.*, 130.

56 G.L.R.O. MDR 1781/1/284, 285, 459; 1782/2/323; J. H. Busby, *Thomas Collins of Woodhouse, Finchley, and Berners Street*, unpublished typescript, 1965; A. T. Bolton, *Architecture of R. and J. Adam*, ii, 102, 107; *Bury Post*, 8 July 1784 (reference kindly supplied by Nesta Evans); N.M.R., exteriors by H. Clunn, c.1930, and Kersting N 879.

57 *Survey of London*, xxix, 326–327.

58 Marylebone Lib., St. Marylebone Association: minutes; list of associates for No. 4 Berners St. District.

59 Marylebone Lib., rates; *Universal British Directory*, 1793, Supplement; Holden, *London Directory*, 1802, 1805–1807; T/A 384/1/29, 36, 39, 62; Q/SBb 428/17; Tallis, *op. cit.*, 166, 237.

60 Marylebone Lib., rates; T132 (38); T138 (9, 10, 11); Holden, *London Directory*, 1802; W. Mankowitz, *Dickens of London*, 1976, 88.

61 W. Harrison, *op. cit.*, 114–115; St. Marylebone Society Christmas card (sketch by Norman Smith, 1955).

62 A. Byrne, *Bedford Square: an architectural study*, 1990, 42, 104, 118, 132; F. Kelsall, *Georgian Group visit to Bedford Square, 21 April 1983* (typescript).

63 Marylebone Lib., rates; Byrne, *op. cit.*, 93–94, pl. 9 (baluster); *Survey of London*, v, 1914, pls. 72, 73.

64 Byrne, *op. cit.*, 84, 118, pl. 67; *Survey*, pl. 87.

65 Byrne, *op. cit.*, 107–109, pls. 34, 95–98.

66 Leics., R.O., DG4/601; Northants. R.O., Th. 2466; E.R.O., D/DRa F28; T/A 384/1/29, 40, 52.

67 *An Appeal to the Public on the Right of using Oil-Cement or composition for Stucco . . .*, 1778, 62–63; *Reply to Observations on two Trials at Law*, 1778, 8–10, 20; P.R.O., C12/1346/22.

68 D/DRa F28.

69 Castle Ashby MSS., F D 1053.

70 Leics. R.O., DG4/598.

71 D/DRa F28.

72 Castle Ashby MSS., F D 1053.

73 Dorset R.O., D.1/8871A, e.g. p. 82.

74 D/DRa F28.

75 P.R.O., C12/1346/22; G.L.R.O., MDR 1768/5/505, 1790/5/11; Somerset R.O., DD/PLE Box 14.

76 Strutt MSS., Accounts of Joseph Strutt and John Strutt, M.P., 1759–1869, p. 65; Northants. R.O., Th. 2466, 2420a, 2421–2442.

77 Leics., R.O., DG4/598, 601; P.R.O., C12/1346/22.

78 G.L.R.O., MDR 1767/6/477, 1771/1/373; Northants. R.O., Th. 2466, 2454, 2458, 2459, 2467.

79 Leics. R.O., DG 4/601.

CHAPTER 2 Country Houses I
(pp. 20–46)

1 C. R. Strutt, *The Strutt family of Terling, 1650–1873*, 1939, 15–16.

2 T/B 251/7; T/B 181/5/6; T/B 181/2/1, 2; British Library, Add. MS. 41133, f.6v; J. Harris, *Sir William Chambers*, 249 (136); T/B 181/3/1, 181/1/1. For Richmond, see D. Jacques, *Georgian Gardens*, 1983, 85, 112, 113f, 134.

3 Strutt MSS., accounts of Joseph Strutt and John Strutt, M.P., 1759–1869, p. 66; T/B 181/3/2.

4 T/B 181/1/2.

5 T/B 181/1/3; Strutt MSS., Bramston to Strutt, 28 July 1771; T/B 181/5/2, 181/4/1, 181/11, 13–15; Strutt, *op. cit.*, 16.

6 Strutt, *loc. cit.*

7 Strutt MSS., accounts, pp. 64–65; A. Clifton-Taylor, *The Pattern of English Building*, 1973, 172; Strutt, *loc. cit.*

8 Strutt MSS., accounts, pp. 63–65; *Survey of London*, v, pl. 73; T/B 181/4/1, T/B 181/14, 15; Briggs, *Woolverstone*, pl. Vb; cf. R. Gunnis, *Dictionary of British Sculptors*, 1953, 375.

9 Strutt MSS., accounts, p. 63; T/B 181/1/3.

10 Graves, 130; T/B 181/13.

11 Strutt, *op. cit.*, 16, 37.

12 D/DRa E89; T/B 181/9/1.

13 Strutt, *op. cit.*, 57.

14 Strutt MSS., letter from Hon. Mrs. Drummond, 4 Sept. 1873 (kindly transcribed, 1974, by the late Hon. C. R. Strutt); R. Gunnis, *Dictionary of British Sculptors, 1660–1851*, 1953, 197.

15 D/DRa E25.

16 Cf. T/B 181/11, 13.

17 Cf. *History of Essex by a Gentleman*, i, 1770, 297 and lithograph by Day and Haghe (Sage Collection 1612); T. Wright, *History of Essex*, i, 1836, 181; T/B 181/3/1, 2; Strutt MSS.: letters to John Strutt; accounts, p. 63.

18 Sale Catalogue B177A; Spalding Coll., Roxwell; *Burke's and Savill's Guide to Country Houses*, iii, 1981, 72; R. Strong, M. Binney, J. Harris, *The Destruction of the Country House*, 1974, pl. 56.

19 W. B. Compton, *History of the Comptons of Compton Wynyates*, 1930, 201–202; Castle Ashby MSS., FD 1053, 1364 (photograph), notebook of Lady Alwyne Compton, 1860–76; N. Pevsner and B. Cherry, *The Buildings of England: Northamptonshire*, 2nd edn., 1973, 138 (plan), 143–144; E.R.O. T/B 181/4/1; Leics. R.O., DG4/601; *C.L.*, 6 Feb., 1986, 312–313; information from Peter McKay.

20 R.C.H.M., *Dorset*, i, West, 1952, 246–247; A. Oswald, *Country Houses of Dorset*, 2nd edn., 1959, 169–170.

21 R.C.H.M., *Dorset*, i, pl. 751; Dorset R.O. (Dorset Natural Hist. and Archaeol. Soc. collection), D.1/LL10; D.1/8871A, pp. 13–26.

22 R.C.H.M., *op. cit.*, pl. 120.

23 Dorset R.O., D.1/8871A., pp. 1–12.

24 Dorset R.O., D83/6, 7, 8 (W. J. Langdon collection); D.1/8871A, pp. 13–26.

25 Dorset R.O., D.1/8871A, pp. 1–12, 91.

26 Dorset R.O., D.1/8871A, pp. 82, 91.

27 R. M. Serjeantson, *History of the church of St. Peter, Northampton*, 1904, 185, 210, 214; J. A. Gotch, *Squires' Homes . . . of Northamptonshire*, 1939, 33, figs. 84–86.

28 Northants. R.O., Th. 2466, 2326.

29 N.R.O., Th. 2331, 2471, 2324–2327; G. Baker, *History . . . of the County of Northampton*, i, 1822–1830, 41.

30 N.R.O., Th. 2340, 2388, 2329.

31 N.R.O., NAS 50, p. 147, reproduced Gotch, *op. cit.*, fig. 84.

32 N.R.O., Th. 2478.

33 N.R.O., Th. 2473.

34 N.R.O., Th. 2420.

35 N.R.O., Th. 2466.

36 N.R.O., Th. 2473, 2478.

37 N.R.O., Th. 2420.

38 N.R.O., Th. 2476, 2385, 2415.

39 N.R.O., Th. 2473; M. Girouard, *Life in the English Country House*, 1978, 256.

40 N.R.O., Th. 2342, 2354.

41 N.R.O., Th. 2466, 2056.

42 Serjeantson, *loc. cit.*; Gotch, *loc. cit.*

43 Leics. R.O., DG 4/601.

44 Leics. R.O., DG 4/597/1.

45 Leics. R.O., DG 4/597/12, 4/598; J. D. Williams, *Audley End: the restoration of 1762–1797*, E.R.O. Pub., no. 45, 1966, 20; D/DBy A42; Colvin, 448.

46 Leics. R.O., DG 4/598, 601.

47 J. Bridges, *History and Antiquities of Northamptonshire*, ii, 1791, opp. p. 292; J. P. Neale, *Views of Seats*, iii, 1820 (engraving, 1823); Northants. R.O., NAS 51, p. 107.

48 Leics. R.O., DG 4/598; 4/597/2, 9; 4/601.

49 Leics. R.O., DG 4/601.

50 Leics. R.O., DG 4/597/3.

51 Leics. R.O., DG 4/601.

52 Leics. R.O., DG 4/597/9.

53 J. P. Neale, *Views of Seats*, iii, 1820.

54 Leics. R.O., DG 4/601.

55 E.R.O., D/DKe F4.

56 Leics. R.O., DG 4/601.

57 Graves, *loc. cit.*

58 Leics. R.O., DG 4/598.

59 Leics. R.O., DG 4/601.

60 Neale, *op. cit.*

61 N. Pevsner and B. Cherry, *The Buildings of England: Northamptonshire*, 2nd edn., 1973, 197.

62 Nichols, *loc. cit.*; Baker, *op. cit.*, i, 62; Colvin, 463; Northants. R.O., NAS 50, p. 158.

63 Baker, *loc. cit.*; *Post Office Directory*, 1847.

64 Northants. R.O., Law and Harris, Box 23, Pitsford Hall.

65 Northants. R.O., FS 4/4; NMR, photograph by E. Dockree.

66 Ex inf. the late Sir Gyles Isham.

67 Pevsner and Cherry, *op. cit.*, 374.

68 *Daily Telegraph*, 25 May 1989; *Today*, 23 Jan. 1990; information from Dr. Malcolm Tozer, Headmaster.

69 Ex inf. Martin Scott of Fitch Benoy, Newark.

70 P.R.O., C12/1346/22.

71 Graves, *loc. cit.*; this account is based on Briggs, *Woolverstone* and Woolverstone Hall Estate sale particulars, Savills, 1990; photographs of plans in Suffolk R.O., P 415.

72 Briggs, *Woolverstone*, pl. Vb.

73 Briggs, *Woolverstone*, pl. VId.

74 Nichols, *loc. cit.*; T. Lloyd, *The Lost Houses of Wales*, 1986, 74–75, 77.

75 D/DRa F28.

76 Strutt MSS., engraving of bridge, n.d.

77 Royal Commission on . . . Monuments in Wales, *Glamorgan*, iv, pt. i, 1981, 335; Norman Lewis Thomas, *Story of Swansea's Districts and Villages*, 190 (reproduces Rothwell's engraving).

78 Lloyd, *op. cit.*, 74–75, 83.

79 Graves, *loc. cit.*

80 J. P. Neale, *Views of Seats*, v, 1822; Lloyd, *op. cit.*, 77; *Glamorgan*, iv, pt. i, 338–339; *Cardiff Times and South Wales Weekly News*, 21 Jan. 1911 (Welsh Country Homes lix); 25″ O.S. 1st edn., Glamorgan XVI/9 (surveyed 1877).

81 Lloyds Bank Archives, A 19d/41.

82 Glamorgan R.O., D/D Gn/E/172, 186.

83 B. J. Malkin, *Scenery, Antiquities and Biography of South Wales*, 1st edn., 1804, 597–598; S. Lewis, *Topographical Dictionary of Wales*, ii, 1847; D. Rhys Phillips, *History of the Vale of Neath*, 1925, 379–381; Lloyd, *loc. cit.*

84 Graves, *loc. cit.*; R. Haslam, *The Buildings of Wales: Powys*, 1979.

85 Graves, *loc. cit.*; *V.C.H. Middlesex*, v, 1976, 7–8; Burke, *Extinct and Dormant Baronetcies*, 1841, 10.

86 Illus., A. Saunders, *The Art and Architecture of London*, 2nd edn., 1988, 201.

87 G.L. Photo. Lib., BB 67/529.

88 G.L. Photo. Lib., BB 67/532, 538.

89 G.L. Photo. Lib., A 45/3466, BB 67/535–537, 540.

90 Graves, *loc. cit.*; P. Finch, *History of Burley-on-the-Hill . . .*, i, 1901, 335; C.

Hussey, 'Burley-on-the-Hill II', *C.L.*, liii, 17 Feb. 1923, 210–217, fig. 7; Miss E. K. Stokes, *Burley-on-the-Hill*, English Life Publications, Derby, [1960], *passim*, pls. 7, 8, 10; N. Pevsner (revised E. Williamson) *Buildings of England: Leicester and Rutland*, 2nd edn., 1984, 460, pl. 112; J. Wright, *History of Rutland*, revised W. Harrod, 1788.

91 Nichols, *loc. cit.*; R.I.B.A. Collection, Wyatt drawings; A. Acland, *A Devon Family: the story of the Aclands*, 1981, 21–25; A. Acland, *Killerton, Devon*, National Trust, 1978, 2nd edn., 1983; B. Cherry and N. Pevsner, *The Buildings of England: Devon*, 2nd edn., 1989, 518–519. This account owes much to discussion with Lady Acland.

92 W. Courthope (ed.), *Debrett's Baronetage*, 1837, 154; *Burke's Peerage*, 1892, 902.

93 Northants. R.O., D(F) 51.

94 Leics. R.O., DG 4/601.

95 Pevsner and Cherry, *Northamptonshire*, 217–218; N.M.R.

96 N. Briggs, *Georgian Essex*, E.R.O. Pub. No. 102, 1989, 32; D/P 211/1/6 (Springfield M.I.); D/DRa F28.

97 D/DRa F28, F10; *C.L.*, lxxx, 21 Nov. 1936, 540.

98 Northants., R.O., I (L)3079, Folder D, No. 1 (Trustees of Lamport Hall); G. Isham, 'The Architectural History of Lamport', *Northants Architectural and Archaeological Soc. Reports*, lvii (1951), 13–28.

99 Graves, *loc. cit.*

100 A. Rowan, *Robert Adam: Catalogues of Architectural Drawings in the Victoria and Albert Museum*, 1988, 86, 88, 94–96; V.A.M. D.2192–1896 (ground-floor plan).

101 V.A.M. D.2188 – 1896.

102 V.A.M. D.2189 – 2192 – 1896.

103 Isham, 'John Wagstaff (Two Northamptonshire Builders)', *Reports and Papers of Northants Antiq. Soc.*, lxiv (1962–1963), 33–43.

104 Information from the late Sir Gyles Isham, Howard Colvin and Martin Scott.

105 Graves, *loc. cit.*

106 G. Jackson-Stops, 'Arcadia under the plough', *C.L.*, 9 Feb. 1989, 82–87, figs. 13, 17, 18; Escott MS. in the possession of James Stevens Cox (reference kindly supplied by Dr. R. Dunning).

107 J. Abel Smith, *Pavilions in Peril*, 1987, 20–21; W. Linnard, 'Where Nature has intervened: the Gnoll cascade', *C.L.*, 5 March 1981, 579–580.

108 *V.C.H. Middx.*, v, 7–8; N.M.R.

109 Graves, *loc. cit.*; Lloyds Bank Archives, A19d/94.

110 Ex inf. Nesta Evans and Philip Aitkens.

CHAPTER 3 Coade and Stucco (pp. 47–55)

1 Patent No. 1234, 1779.

2 A. Kelly, 'Coade Stone in Georgian Architecture', *Arch. Hist.*, 28 (1985), 81–82; *Mrs. Coade's Stone*, 1990, 19, 81–83, 323.

3 *Mrs. Coade's Stone*, 23, 56, 58–59.

4 Graves, 60.

5 *Mrs. Coade's Stone*, 83, 397; Graves, 130.

6 *Arch. Hist.*, 28, 82; *Mrs. Coade's Stone*, 82, 149–150, 153, 167, 169, 195, 375.

7 G.L. Photo Lib., 73/35/59A/11, 12.

8 *Arch. Hist.*, 28, 82; *Mrs. Coade's Stone*, 83.

9 Leics. R.O., DG 4/601.

10 *Mrs. Coade's Stone*, 346; T. Driberg, *Bradwell Lodge*, n.d. (illus.).

11 *Mrs. Coade's Stone*, 159; N.M.R., AA53/202, 211, 212.

12 A. Byrne, *Bedford Square*, 109, pls. 34, 98.

13 Q/FAb 52/1, no. 25; *Mrs. Coade's Stone*, 82, 165.

14 Q/FAc 6/2/1; *Coade's lithodipyra*; *Arch. Hist.*, 28, 81.

15 *Mrs. Coade's Stone*, 40–41, 43–44, 172; Q/FAc 6/2/1; Q/AS 2/5/2.

16 Q/AS 2/3/2.

17 R. Gunnis, *Dictionary of British Sculptors, 1660–1851*, 1953, 108; Q/AS 2/4/6; Q/SBb 348/7.

18 Q/AS 2/6, no. 56.

19 D. Lysons, *Environs of London*, i, 1792, 529.

20 *Mrs. Coade's Stone*, 425.

21 D/P 94/25/24; measurements by Hilda Grieve, 1975; *Mrs. Coade's Stone*, 127–129, 133.

22 D/DKe F4; *Mrs. Coade's Stone*, 348.

23 D/DHf T92/76.

24 *Mrs. Coade's Stone*, 400.

25 *Mrs. Coade's Stone*, 82–83, 96.

26 Revd. J. F. Williams, 'The re-building of Chelmsford church, 1800 to 1803', *E.R.*, xl (1931), 97–104; *Mrs. Coade's Stone*, 109–110.

27 D/P 94/6/13/80; T/A 384/1/16.

28 T/A 384/1/20 (printed *E.R.*, xl, 100–101); D/P 94/6/13/80; *Mrs. Coade's Stone*, 216–217.

29 D/P 94/6/13/80; T/A 384/1/16; D/P 94/6/2.

30 D/P 94/6/13/185, 262; D/P 94/6/5, pp. 67, 69, 75; T/A 384/1/60.

31 D/P 94/6/5, p. 44; T/A 384/1/45; Mint Portfolio, Debden.

32 T/A 384/1/58, 60; D/P 94/6/5, pp. 66, 118; D/P 94/6/13/262.

33 W. Chancellor, *A short history of the Cathedral church . . . Chelmsford*, revised edn., 1953, 19; A. W. Caton, *St. Peter's Chelmsford, 1892–1942*; J. C. Cox, *The cathedral church and see of Essex*, 1908, 51–52, and inf. from Mrs. C. M. Parkins; D/P 94/6/13/265.

34 D/P 94/6/5, p. 44; Q/FAc 6/2/2.

35 R. F. Dell, 'The building of the County Hall, Lewes, 1808–1812', *Sussex Archaeological Collections*, 100 (1962), 9; J. Catchpole, 'The restoration and repairs to the front elevation of County Hall, Lewes, 1958', *S.A.C.*, 100, 21, Pls. II, VB; E. Sussex R.O., QAH/1/8/E3 (295); Johnson, *Plans . . .*, pl. xiii.

36 Dell, 10; QAH/1/8/E3 (295).

37 Catchpole, 20, Pl. V A.

38 Dell, 9; Catchpole, Pl. II; QAH/1/7/E3 (27).

39 QAH/1/E1; cf. *Arch. Hist.*, 28, 82.

40 *Ch. Ch.*, 19 Feb. 1802; T/A 384/1/29; *Mrs. Coade's Stone*, 248 (illus. incorrectly captioned).

41 F. Kelsall, 'Liardet versus Adam', *Arch. Hist.*, 27 (1984), 118–126; Kelsall, 'Stucco', *Good and proper materials: the fabric of London since the Great Fire*, London Topographical Society, Pub. No. 140, 1989, 18–24.

42 J. N. Adams and G. Averley, 'The Patent Specification: the Role of Liardet v. Johnson', *Journal of Legal History*, 7 (1986), 156–177.

43 Patent No. 1150, 1777.

44 Adams and Averley, *op. cit.*, 171–172; *Reply to Observations on Two Trials at Law*, 1778, 11.

45 P.R.O., C12/1346/22.

46 P.R.O., C12/1346/22; *An Appeal to the Public on the Right of using Oil-Cement or Composition for Stucco . . .*, 1778; *Observations on Two Trials at Law respecting Messieurs Adams's new-invented Stucco*, 1778; *Reply to Observations on Two Trials at Law*, 1778.

47 P.R.O., C12/1346/22 (replies by Johnson and Downes); S. H. Widdicombe, *A Chat about Barnet . . .*, 1912, 23; J. E. Cussans, *History of Herts*. (Pybus pedigree in grangerized copy in Herts. R.O.).

48 *An Appeal . . .*, 66–67; Colvin, 669.

49 P.R.O., C12/1346/22; Colvin, 672; *An Appeal . . .*, 59–61; *Reply . . .*, 16–18.

50 P.R.O., C12/1346/22.

51 *Reply . . .*, 8–10, 20; *Appeal . . .*, 62–63.

52 *Good and proper materials*, 21; A. Byrne, *Bedford Square*, 1990, 68, 132.

53 P.R.O., C12/1346/22; G.L.R.O., MDR 1779/3/592; *Good and proper materials*, 21.

54 *Observations . . .*, 6.

55 Leics. R.O., DG 4/601.

56 *Good and proper materials, loc. cit.*

57 *Gent. Mag.*, xl, pt. 2 (1853), 29 (review of W. Gardiner, *Music and Friends . . .*, iii (1853); reference kindly supplied by John Booker).

CHAPTER 4 County Surveyor
(pp. 56–62)

1 Q/SO 13, pp. 263, 328–329, 370; Briggs, *County Surveyor*, 297–307. For brief summaries of Johnson's official career, see J. Simmons, *Parish and Empire*, 1952, 124–136, and Colvin, 462–464.

2 C. R. Strutt, *The Strutt family of Terling, 1650–1873*, 1939, 15–16; T/B 181/1/1; Bramston to Strutt, 28 July 1771 (Strutt MSS.); see Chapter 2.

3 Q/SO 13, p. 510; Q/FAb 30/1, no. 7.

4 Q/SO 14, pp. 116, 161–162; Q/SO 20, pp. 345, 388, 442.

5 Q/SO 13, p. 159.

6 Q/SO 13, p. 452.

7 Q/SO 17, pp. 307, 427; Q/SBb 379/15.

8 Q/FAc 6/2/1; Q/SO 17, p. 160; Q/AGb 1/1/1; Q/AGp 4.

9 Q/SBb 405/15; Q/SO 19, p. 465.

10 Q/SO 19, pp. 606–607; Q/SO 20, p. 77; Q/FAc 6/2/3; Q/SBb 426/20.

11 Q/SBb 416/7/8; Q/FAc 6/2/4; Q/SO 20, pp. 206–207, 345–346, 388–391; M. Burgoyne, *An Account of the Proceedings in the late Election in Essex*, 1810, 104–107.

12 Q/SO 20, pp. 504–509, 544, 598–599; Q/SBb 419/78; Q/SO 21, pp. 111, 189, 264, 376–377, 433–434; Q/SBb 426/20.

13 Q/SO 19, pp. 168, 233, 280, 291; Q/SBb 401/39, 401/40/1.

14 Q/FAc 6/2/3.

15 Q/SBb 418/66.

16 Q/SO 20, p. 436.

17 Q/FAc 6/2/3.

18 Briggs, *op. cit.*, 297, 303–304; Q/AGp 2/3.

19 Q/SO 14, p. 433.

20 Q/SO 16, p. 482.

21 Q/FAc 6/3/1, 2; Q/FAc 6/2/1–4.

22 Q/FAc 6/2/3.

23 Q/FAc 6/2/1, 3.

24 Q/SO 17, pp. 97, 410.

25 Q/SO 17, pp. 251–252.

26 Q/FAc 6/2/1; Q/SO 16, pp. 578–579.

27 Q/FAc 6/2/1.

28 Q/FAc 6/2/1.

29 Q/FAc 6/2/2.

30 D/DRa F28; cf. P.R.O., B3/1272.

31 Q/FAc 6/2/4.

32 Q/FAc 6/2/2.

33 Q/FAc 6/2/4.

34 Q/FAc 6/2/4.

35 Q/FAc 6/2/2.

36 Q/FAc 6/2/3.

37 Q/FAc 6/2/4; Q/SBb 426/20/1.

38 Q/FAc 6/2/2.

39 Q/FAc 6/2/4.

40 Q/SO 18, p. 615; Briggs, *op. cit.*, 301.

41 Q/SO 19, pp. 72–73.

42 Q/SBb 405/23.

43 Q/SBb 407/13; Q/SO 20, pp. 18–24; Colvin, *op. cit.*, 63.

44 See p. 118

45 Q/SO 19, p. 615; Q/FAc 6/2/1.

46 Q/SO 21, p. 92.

47 Q/SBb 426/17.

48 Q/SBb 428/7; Q/SO 21, p. 588; Simmons, *op. cit.*, 136.

CHAPTER 5 County Bridges
(pp. 63–90)

1 Briggs, *County Surveyor*, 297–307.

2 22 Henry VIII, c. 5.

3 C. Chalklin, 'Bridge Building in Kent, 1700–1850 . . .'. *Studies in Modern Kentish History presented to Felix Hull and Elizabeth Melling*, 1983, 51; J. Booker, *Essex and the Industrial Revolution* (E.R.O. Pub. No. 66, 1974), 122; S. and B. Webb, *English Local Government: the story of the King's Highway*, 1913, 90–103.

4 Q/FAc 6/3/2 (at end), dated 12 May 1813; cf. Q/ABz 2/1 (dated by watermark, c.1820).

5 G. Montagu Benton, 'Fingringhoe Bridge', *E.A.T.*, n.s., xx, 262–269.

6 Chapman and André, *Map of Essex* (1777) pl. xxiii, marks the ford; Q/SO 13, pp. 425–427; Q/SBb 315/34 (petition); illus., Ellis, *Book of sixty views [of] Southend-on-Sea . . . and neighbourhood*, c.1910, p. 89.

7 Q/ABp 2.

8 Q/SO 19, p. 398; Q/SBb 402/22.

9 Q/SBb 361/19; A. F. J. Brown, *Essex at Work* (E.R.O. Pub. No. 49, 1969), 80, 121.

10 Q/SO 17, pp. 170, 210; Q/FAc 6/2/1.

11 Q/SO 19, p. 616; Q/ABz 2/1; Q/ABz 3/1.

12 Q/SO 16, pp. 83, 127; Q/SBb 360/12; Q/SBb 361/24, 24A, 27; Chapman and André, *Map of Essex* (1777) pl. xiii, marks site of horse bridge; Q/FAc 6/2/4; Q/SO 20, pp. 398–399, 428, 451, 607; Q/ABp 7; Q/ABz 3/1.

13 Q/SO 15, pp. 11, 38, 92; Q/SBb 347/13; D/DP 020; Briggs, *op. cit.*, 303.

14 Q/SO 16, pp., 190, 194, 257; Q/SBb 362/19; Q/FAc 6/2/1; Q/ABz 3/1.

15 Q/SO 16, p. 219; Q/SO 17, p. 437; Q/ABz 3/1.

16 Q/SO 20, pp. 552, 575–576, 583; Q/FAc 6/2/4; Q/ABz 3/1.

17 Q/FAc 6/2/4; Q/SBb 420/9, 24–34; Q/SO 20, pp. 608, 639–640; Q/SO 21, pp. 19, 143, 145; Q/SBb 421/60; Q/ABz 3/1.

18 Chalklin, *op. cit.*, 51, 53; Q/AGp 2/3; 12 Geo. II c. 29, s. 13; Webb, *op. cit.*, 96.

19 Q/SO 17, p. 250.

20 Q/SO 15, pp. 335, 365; Q/SBb 352/19; Briggs, *op. cit.*, 303–304.

21 Q/SBb 337/13.

22 Q/FAc 6/2/4; Q/SO 21, pp. 597–598; Q/SBb 428/23.

23 Q/FAb 50/1, 3, 4–8; 52/1, 2; Q/AGp 2/3.

24 Q/ABp 2.

25 Q/FAc 6/3/1.

26 Q/SO 16, p. 436; Q/SBb 367/21.

27 Q/SO 14, p. 105; Q/AGp 2/3.

28 Q/SO 18, pp. 445–446; Q/SBb 389/25; Q/SO 19, pp. 234, 247; Q/SBb 399/16; Q/ABz 3/1.

29 Q/SO 19, pp. 343–344.

30 Q/SO 20, p. 133.

31 Q/SO 16, pp. 81, 152, 218, 256; Q/FAc 6/3/1.

32 Q/SO 14, p. 432; Q/ABz 3/1.

33 Q/SO 16, pp. 254–255; Q/SBb 364/26.

34 Q/SO 20, pp. 245, 252, 271; Q/SBb 412/15; Q/ABz 3/1.

35 Q/SO 21, pp. 19–20; Q/SBb 420/36.

36 Q/SO 20, pp. 87–88, 133–134, 171; Q/SBb 412/14; Q/FAc 6/2/3.

37 Q/SO 19, pp. 449, 473.

38 Q/SBb 332/24; Q/SO 14, p. 205; Q/AGp 2/3.

39 Q/SO 14, p. 182; Q/AGp 2/3.

40 Chapman and André, *Map of Essex* (1777), pl. xii, shows the narrow roadway; Q/SO 15, p. 334; Q/SBb 353/20; Q/ABz 3/1.

41 Q/SO 16, pp. 54, 82, 257; Q/SBb 359/15; Q/SBb 364/26.

42 Q/SO 16, pp. 22, 27, 81, 125; D/TX 5/6.

43 Q/SO 19, pp. 22, 50, 147; Q/SBb 395/39; Q/FAc 6/3/1.

44 Q/SO 17, pp. 170, 209; Q/SBb 376/21; Q/FAc 6/3/1.

45 Q/SO 17, pp. 170, 210; Q/FAc 6/3/1.

46 Q/SO 14, p. 359; Q/SBb 337/13; Q/FAb 55/4; Q/SO 20, pp. 133, 308.

47 H. Grieve, *The Sleepers and the Shadows* (E.R.O. Pub. No. 100, 1988), i, 34, 62 (map).

48 Q/SO 13, pp. 473, 488; Q/SO 6, p. 593; Q/SO 10, pp. 241, 287; Q/ABz 3/1.

49 Q/SO 13, p. 509.

50 Q/SO 13, pp. 527–528; Q/FAa 4/2; Q/FAb 49/7, no. 9; 49/8, nos. 22, 23.

51 D. W. Coller, *The people's history of Essex*, 1861, 199; Grieve, *op. cit.*, 169, 179 (map; see nos. 40–41 for King's Head).

52 Q/FAb 50/3, nos. 9, 10.

53 Q/FAb 50/1, no. 16; 50/3, no. 9; 50/5, no. 12; 50/8, no. 21; 52/1, no. 23; 52/2, no. 16.

54 Q/FAb 50/1, no. 7; 50/4, no. 8; 52/6, no. 25; D/DRa F28; *Ch. Ch.* 21 April 1786.

55 Q/FAb 50/4, nos. 19, 22; 50/8, no. 24; 52/1, no. 25.

56 Q/FAb 50/6, no. 22; 50/1, no. 16.

57 Q/FAb 52/1, no. 25; T/P 171/1, 2.

58 Q/FAa 4/2; Q/SBb 329/8.

59 Coller, *op. cit.*, 199.

60 Q/SO 14, pp. 393, 516, 548.

61 Q/SBb 477/18/1, 2, 5; Q/SBb 452/9; D/DOp E8; T/P 171/1, 2; Colvin, 819–821.

62 Briggs, *op. cit.*, 302; D. M. M. Shorrocks, 'John Abell's Bridge, Nayland', *E.R.*, lxi (1952), 225–232; P. Benton, *History of the Rochford Hundred*, 854; Q/SBb 272; Booker, *op. cit.*, 124; Q/SO 13, p. 159; Q/SBb 415/23/2.

63 Q/ABb 3.

64 Q/ABz 3/1.

65 Q/FAb 50/1, no. 7.

66 Booker, *op. cit.*, 208.

67 Q/ABz 3/1; Q/SO 16, p. 436.

68 Q/SBb 327/63; Q/SO 14, p. 84.

69 *V.C.H. Essex*, viii, 25; Q/SO 17, pp. 210, 247–248 (printed D. Dean and P.

Studd, *Stifford Saga*, 1980, 129), 316–317; Q/SBb 377/20; Q/ABz 3/1.

70 Q/SO 21, pp. 441–442, 469, 491, 516–517, 597–598; Q/FAc 6/2/4; Q/SBb 429/20; Q/ABz 3/1.

71 Q/SO 13, pp. 551–552, 609; Q/ABp 2.

72 Q/SBb 329/14; Q/SO 14, p. 137.

73 Q/SO 13, pp. 587–588; Q/ABp 2; Q/FAb 50/6, no. 25; Q/SO 14, pp. 35–37

74 Q/SO 13, p. 510; Q/FAb 50/1, no. 7.

75 H. J. M. Stratton and B. F. J. Pardoe, 'The history of Chertsey Bridge', *Surrey Arch. Soc.*, lxxiii (1982), 120.

76 Q/ABp 2; Q/FAc 6/2/1; Q/SBb 342/11.

77 Q/SO 20, p. 245; Q/SBb 412/18; Q/ABz 3/1.

78 L. T. Newman, 'The history of Battlesbridge', *E.J.*, viii, no. 1 (1973) 16–18, quoting Q/ABb 9.

79 Q/SO 20, p. 85; Q/SO 14, p. 432; Q/ABz 3/1.

80 See below, pp. 84–85

81 Q/SO 20, pp. 374, 399, 340; Q/SBb 415/21, 415/23/1, 2; Q/FAc 6/2/4.

82 *V.C.H. Essex*, iv, 64–65; Q/SO 16. p. 372; Q/SBb 366/14, 367/20; Q/FAc 6/2/1; Q/FAc 6/3/1.

83 Q/SO 20, pp. 245, 252, 271; Q/SBb 412/15; Q/FAc 6/2/3.

84 Q/ABz 3/1; *V.C.H. Essex*, iv, 64–65.

85 Q/SO 16, p. 81.

86 Q/ABb 9; Q/ABp 33; Q/FAb 55/4, no. 18.

87 Q/SO 20, pp. 34–35.

88 Q/SBb 337/13.

89 Q/ABb 3, 4; Q/SBb 412/15/2; Q/SBb 420/6.

90 Q/ABb 3; Q/FAc 6/2/2.

91 See below, pp. 84–85.

92 Q/SO 18, pp. 266, 326–327, 357–358, 385; Q/SBb 387/24, 25; 388/23, 24.

93 Q/SO 18, pp. 502–503, 536.

94 Q/FAc 6/3/1; Q/SO 18, p. 565

95 Q/SO 18, p. 596; Q/FAc 6/2/2; Q/ABb 3.

96 Q/SO 18, pp. 616–618; Q/SBb 392/16; Q/FAc 6/2/2; Q/ABp 47.

97 Q/AS 2/4/5; Q/FAc 6/3/1 (e.g. Stifford bridge, April 1801).

98 See below, pp. 150–152.

99 Q/FAc 6/2/2; Q/SO 19, p. 80.

100 D/P 211/1/2.

101 Q/SBb 405/23; Q/FAc 6/2/2.

102 Q/FAc 6/2/2; Q/SO 18, p. 428; Q/FAc 6/2/3.

103 Q/FAc 6/2/2; Q/SO 19, pp. 234, 320; Q/SBb 399/16.

104 M. Burgoyne, *An account of the proceedings in the late election in Essex . . .*, 1810, 106–107; Q/SBb 407/13/1.

105 25 Geo. III, c.124; Q/ABp 1; *V.C.H. Essex*, v, 186–187; vi, 342; E. J. Erith, *Woodford . . . 1600–1836*, 1950, 98–100.

106 Q/SO 14, pp. 393–394, 423; Q/SBb 338/23.

107 Q/SO 18, p. 11; Q/FAc 6/2/2; Q/FAc 6/3/1.

108 Q/SO 20, pp. 90, 136–137; Q/SBb 408/10/1; Q/FAc 6/2/3.

109 Q/FAc 6/2/1.

110 Q/SO 17, p. 249.

111 Q/FAc 6/2/2.

112 See above; Q/SO 14, pp. 137, 159, 182.

113 Q/ABp 26.

114 Q/ABb 43; Q/SBb 387/24; D/TX 5/6; Chelmsford and Essex Museum, Bamford Collection (M28039, 28040); E.R.O., Bamford Collection (Chelmsford); *E.R.*, xl, 99–100.

115 D/TX 5/21.

116 Booker, *op. cit.*, 128; H. Grieve, *op. cit.*, i, 62(m), 115; ii (forthcoming).

117 M. L. Smith, *Witham River Bridges* (duplicated typescript), 1972, 7, 10; Q/ABp 9; Q/SBb 387/24.

118 J. M. L. Booker, 'The Essex Turnpike Trusts', M.Litt. Durham, 1979, 136–137.

119 D/TX 5/3, 5/5.

120 D/TX 5/5.

121 Simmons, 1952, 132–133; Q/ABp 2.

122 Q/SO 13, pp. 488–489.

123 Suffolk Record Office, B105/2/47; Q/ABp 2.

124 Briggs, *County Surveyor*, 301, quoting S. & B. Webb, *Parish and County*,

518–519; S.R.O. B105/2/47 (8 April, 13, 28 July, 6 Aug. 1785); Colvin, 324; N. Scarfe, *Suffolk: a Shell Guide*, 1960, 29; N. Pevsner, *Buildings of England: Suffolk*, 1961, 107. Fulcher is listed in directories as a deal merchant, 1784 (Bailey's *British Directory*, i.v. 833) and as a surveyor and builder, 1794 (*Universal British Directory*). T. Fulcher and Son, timber merchants, Ipswich, produced *Hints for a plan of the intended improvement of the River Orwell*, 1803 (Ipswich Borough Museum Committee, *The Story of the Orwell*, 1959, 13, no. 84).

125 Q/SO 13, p. 508.

126 Q/SO 13, p. 529.

127 S.R.O., B105/2/47.

128 S.R.O., B105/2/47.

129 Q/ABp 2; Q/SO 13, pp. 607–609.

130 S.R.O., B105/2/48, f. 4; Q/ABp 2.

131 S.R.O., B105/2/48, ff. 33, 44, 55, 56, 66; B105/2/49, f. 7.

132 Q/SO 14, pp. 39, 84, 135, 137, 159, 183, 206, 232; Q/FAb 52/1, 53/1, 53/5, 54/1, 6; Q/SBb 331/25. For Palmer Firmin's ownership of Chapel Hill, part of which was taken into the highway to make the descent of Gun Hill less dangerous, see L. C. Sier, 'Dedham Gun Hill and Vicinity', *E.R.*, xlvi (1937), 135–137; cf. P. Morant, *History of Essex*, ii, 247.

133 Q/ABp 2; Q/FAb 54/6, no. 21; cf. F. Sheppard, 'Henley Bridge and its architect [1782–1786]', *Arch. Hist.*, 27, (1984), 327.

134 Q/ABp 2; Q/SO 13, p. 508.

135 Q/ABp 2; Q/FAc 6/2/1; S.R.O., B105/2/49, ff. 42, 175; J. Doughty, surveyor, Ipswich, subscribed to Richard Elsam, *An Essay on Rural Architecture*, 1803 (cf. pl. 14) and is listed as a surveyor in St. Nicholas Street by J. Pigot and Co., *New Commercial Directory*, 1823–1824; see also G. R. Clerke, *History of Ipswich*, 1830, 351. For Cattawade bridge, see E. Jervoise, *The ancient bridges of mid and eastern England*, 1932, 128–129, fig. 69.

136 Q/ABp 2; Q/SO 16, pp. 16–22, 24.

137 S.R.O., B105/2/50, p. 71.

138 Q/ABp 2; Q/FAc 6/2/1.

139 Q/ABp 2.

140 S.R.O., B105/2/50, p. 91.

141 S.R.O., B105/2/50, pp. 102–103; Q/ABp 2; Q/SBb 360/111.

142 S.R.O., B105/2/50, p. 104; Q/ABp 2; Q/FAc 6/2/1.

143 Q/SO 16, pp. 104–105.

144 Q/ABp 2; Q/FAc 6/2/1.

145 S.R.O., B105/2/50, p. 114; Q/ABp 2.

146 Q/SO 16, p. 217; Q/FAc 6/2/1.

147 Q/SO 16, pp. 254–255; Q/SBb 364/26; Q/FAc 6/2/1 (vol. of bridge accounts kept by William Jeffries, 20 Feb. 1795–4 July 1796).

148 S.R.O., B105/2/50, pp. 111, 160.

149 V. & A., R. 63; A. Smart and A. Brooks, *Constable and his Country*, 1976, figs. 72, 73 (aerial photograph showing site of bridge), pp. 121, 139–140. The ex-Fison collection painting was sold at Sotheby's on 17 June 1981; for reproductions see R. Gadney, *John Constable . . . a catalogue of drawings and watercolours . . . in the Fitzwilliam Museum, Cambridge*, Arts Council, 1976, pl. 3, and L. Parris, *The Tate Gallery Constable Collection*, 1981, fig. 2, pp. 51, 53.

150 Q/ABb 22; Simmons, 133.

151 S.R.O., B105/2/49, f. 102.

152 Q/SO 15, pp. 159, 190, 298.

153 S.R.O., B105/2/49, f. 132; Q/SO 15, p. 312.

154 Q/SO 18, p. 27.

155 Q/SO 18, pp. 83, 446.

156 Q/SO 18, pp. 441, 501–502; Q/SBb 392/35, 394/21/1; Q/SO 19, pp. 78–79.

157 Q/SO 19, p. 614.

158 Q/SO 20, p. 85; S.R.O., B105/2/53, f. 150.

159 Q/SO 20, p. 113.

160 S.R.O., B105/2/53, ff. 160, 161.

161 Q/SO 20, pp. 133, 308.

162 (Ed.) W. le Hardy, *Hertfordshire County Records: Calendar to the Sessions Books . . .*, viii, 230.

163 Q/SO 17, p. 248; Q/SBb 377/59.

164 *V.C.H. Essex*, v, 143, viii, 229.

165 Q/SO 17, pp. 546–547, 590–592, 593–594; Q/SBb 382/22, 23, 25.

166 Q/SO 18, p. 82.

167 Q/SO 18, pp. 384–385; *Herts. County Records . . .*, ix, 27, 28, 40–41.

168 Q/SO 18, pp. 412–415; Q/SBb 388/27.

169 Q/SO 18, pp. 438–441, 500–501, 723; Q/SBb 389/24; Q/SBb 394/16; *Herts. County Records . . .*, ix, 40–41, 46, 49.

170 Q/SO 15, pp. 298, 312; Q/SO 18, pp. 412–415; Q/SO 21, pp. 92–93.

171 Q/SO 14, p. 359; Q/SBb 337/13.

172 S.R.O., B105/2/49, f. 7.

173 W. le Hardy, *Herts. County Records . . .*, viii, pp. xxviii, 399, 428; Le Hardy and G. L. L. Reckitt, *Herts. County Records . . .*, ix, pp. xx, 4, 17, 40–41.

174 *Herts. County Records . . .*, ix, 74, 81–82.

175 *Herts. County Records . . .*, ix, 81.

176 *Herts. County Records . . .*, ix, 101; Q/SO 20, pp. 429, 453; Q/SBb 415/22; Q/FAc 6/2/4.

177 Q/SO 20, p. 522; Q/SBb 418/75; Q/FAc 6/2/4.

178 Q/SO 20, p. 606; Q/FAc 6/2/4.

179 Q/SO 15, pp. 298, 312; Q/SBb 350/11; S.R.O., B105/2/49, ff. 132, 149.

180 S.R.O., B105/2/48, f. 80; Q/SO 14, p. 359; Q/SBb 337/13; Q/FAb 55/4, no. 18.

181 Q/RLv 44–48, 50–66; cf. will of William Jeffries, carpenter and victualler, Manningtree, 1813, D/ABR 31/66.

182 Q/ABp 2; Q/FAb 54/6, No. 22; Q/SO 14, p. 432; Q/SBb 342/11; Q/ABz 3/1.

183 Q/SO 14, p. 549.

184 Q/FAc 6/2/1.

185 Q/ABp 2.

186 Q/SO 16, pp. 254–255.

187 Q/SO 19, p. 615.

188 Q/FAc 6/2/1.

189 Q/SO 20, pp. 133–134; Q/SBb 409/6, 19, 20/1; Q/FAc 6/2/4.

190 Q/SO 18, pp. 387, 441, 501–502; S.R.O., B105/2/52. 1, f. 70.

191 S.R.O., B105/2/52. 1, f. 24; Q/ABp 6.

192 Q/SO 18, pp. 615-616.

193 Q/SBb 392/35.

194 Q/FAc 6/2/2; Q/SBb 394/21.

195 Q/SO 19, pp. 343–344; Q/ABz 3/1; W. W. Hodson, 'Ballingdon Bridge', *Proc. Suff. Inst. Arch.*, viii, 21–30;

E.A.T. n.s., xx, 262.

196 See above, pp. 86–87; *V.C.H. Essex*, viii, 229.

CHAPTER 6 Shire Hall (pp. 91–112)

1 Briggs, *County Surveyor*, 299–301; H. Grieve, *The Sleepers and the Shadows*, ii (to be published); Q/FAa 1/1.

2 Briggs, *op. cit.*, 300–301; Q/SO 12, pp. 4–7, 53; Q/AS 1/3; *The several Petitions and Evidence laid before Parliament for and against obtaining a Bill to remove Chelmsford Gaol*, [1771], 7–12, 109, 123 (copy in E.R.O., D/DBe O1); Colvin, 84–85, 418; A. T. Bolton, 'The Shire Hall, Hertford', *Architectural Review*, vol. 43, 1 April 1918, 68–73.

3 Q/AS 2/4/1, 2; Q/SO 14, p. 230.

4 Q/AS 2/4/1.

5 Q/AS 2/4/2.

6 Q/AS 2/4/2; Q/SO 14, pp. 262–263.

7 Q/AS 1/1.

8 Q/AS 2/4/2.

9 Q/SO 14, pp. 287–288; Q/AS 2/4/3.

10 29 Geo. III, c. viii (copy in E.R.O. Library); Q/SO 14, pp. 116, 161–162.

11 Q/SO 14, pp. 287–288; *Ch. Ch.*, 1 May 1789.

12 Q/SO 14, pp. 312–317.

13 Q/AS 2/4/6, 2/5/1/7, 2/6, nos. 11, 23; D/DU 182/55; T/R 5/1/4; Grieve, *op. cit.*, i, 174 (Corn Exchange site).

14 Q/AS 2/7.

15 Q/AS 2/4/6, 2/5/1/7, 2/5/2.

16 Q/AS 2/7.

17 Q/AS 2/4/6, 2/6 no. 29, 2/7, 2/5/2; Q/SO 14, p. 438; C. Hussey, *English Country Houses: Mid Georgian*, 210.

18 E/AS 2/7, 2/5/1/4.

19 Q/AS 2/4/6, 2/6 no. 14.

20 Q/AS 2/4/5, 6, 2/5/2.

21 Q/AS 2/7, 2/4/6; Grieve, *op. cit.*, i, 174 (91 Duke St., site of White Lion), 176 (passage way between 87 and 88 Duke St.).

22 Q/AS 2/6, no. 2.

23 Q/AS 2/5/2.

24 Q/SO 14, p. 324; Q/AS 2/7, 2/5/2, 2/4/5.

25 D/P 211/11/2, 3; D/P 211/1/2; Q/SO

15, pp. 61–63; Q/AS 2/4/6; cf. baptism of children of John and Susannah Funnell, St. Marylebone, 16 Nov. 1788.

26 Q/AS 2/4/6, 2/5/1/4, 12, 15; 2/5/2.

27 Q/SO 15, pp. 34, 61–63; Q/AS 2/4/5, 6, 2/5/2.

28 Q/SO 15, pp. 61–63.

29 Q/AS 2/4/6 (another copy, Q/FAa 4/3); Q/AS 2/5/1, 2/6; Q/AS 2/5/2; Q/AS 2/5/3.

30 Coller, *op. cit.*, 171–172 (giving date as 14 Aug.); Q/AS 2/6, no. 25; Q/AS 2/5/1/11; *Ch. Ch.*, 4 Sept., 11 Sept., 1789, 15 July 1791, 13 Jan. 1792, 13 July 1792; Q/SO 14, pp. 330, 360; Q/SO 15, pp. 61–63; Simmons, 134–135; Q/AS 2/4/6, 2/6, no. 68; 'View of the County Hall . . .' 30 Dec. 1794 (E.R.O., Pictorial Collection, Mint O/S, Chelmsford).

31 Q/SO 14, p. 360.

32 J. B. Britton and E. W. Brayley, *Beauties of England and Wales*, v, opp. p. 256; T. Wright, *History of Essex*, 1836, i, opp. p. 72; S. Jarvis, *Chelmsford in old picture postcards*, 1988, no. 31; Q/AS 2/4/6, 2/5/1/16.

33 Q/AS 1/4/9; Jarvis, *op. cit.*, no. 40.

34 Q/AS 2/5/3, 1/1 (west front).

35 *Plans . . .*, pl. xiv; R. Gunnis, *Dictionary of British Sculptors, 1660–1851*, 1953, 24, 108; Q/FAc 6/2/1.

36 Q/AS 2/5/2.

37 Pl. lxxix; J. Fleming, 'Balavil House', *The Country Seat: Studies in the History of the British Country House presented to Sir John Summerson* (ed. H. Colvin and J. Harris) 1970, 178–180.

38 29 Geo. III, c. viii.

39 *Plans . . .*, pl. ii; A. T. Bolton, *op. cit.*, 69.

40 *Plans . . .*, pl. x; Q/FAb 60/1, no. 22; Spalding Collection, Chelmsford: Public Buildings, Crown and Nisi Prius courts, 1936.

41 *Plans . . .*, pl. ix; Spalding Collection, *loc. cit.*, Crown court, 1936.

42 *Plans . . .*, pl. i; Q/AS 2/4/2.

43 Q/AS 1/1, N. front; Spalding 0720255; *Plans . . .*, pls, ix, xi; Spalding Collection, Chelmsford: Public Buildings,

Nisi Prius court, 1936; Q/AS 2/4/4, 2/6, no. 62; A. Heal, *The London Furniture Makers, 1660–1840*, 1953, 53.

44 Q/AS 2/6, no. 56; Q/AS 2/5/2; Spalding Collection, *loc. cit.*

45 *Plans . . .*, pl. iii.

46 *Plans . . .*, pl. v.

47 *Plans . . .*, pl. ii.

48 *Plans . . .*, pls. ii–vi, x; Q/AS 2/5/2, 3; Q/AS 2/6, no. 56.

49 Bolton, *op. cit.*, 69; C. J. Totton, 'Three 18th century Shire Halls', Thames Polytechnic School of Architecture dissertation, 1972 (copy in E.R.O. Library).

50 Q/AS 2/5/3; *Plans . . .*, pls. vii, viii, xi, xii.

51 *Plans . . .*, pls. vi (marked A), vii; Q/AS 2/5/2, 2/4/6.

52 Q/AS 2/5/2, 2/5/1/11; *Plans. . .*, pl. viii; Simmons, *op. cit.*, 135; Gunnis, *op. cit.*, 326–329.

53 *Plans . . .*, pl. vii; Q/AS 2/5/2; J. Fowler and J. Cornforth, *English Decoration in the 18th century*, 1974, 204–205.

54 Q/AS 2/5/2; Q/AS 2/6, no. 67; *Plans . .*, pls. vii, viii.

55 *The Chelmsford Guide*, c.1807, 8–9; Britton and Brayley, *op. cit.*, v, 257; T. K. Cromwell, *Excursions in the County of Essex*, i, 1818, 9.

56 *Ch. Ch.*, 23 Sept. 1791.

57 M. Girouard, 'Spreading the Nash Gospel: Assembly Rooms III', *C.L.*, 2 Oct. 1986, 1057–1059, figs. 4 and 5; Staffordshire Record Office, Q/AS/1.

58 Bolton, *op. cit.*, 72; W. le Hardy, *Hertfordshire County Records*, viii, 150–151, 160.

59 *Ch. Ch.*, 20, 27 May, 3, 10, 25 June, 1, 8, 15, 22, 29 July 1791, 6 Jan. 1792; Coller, *op. cit.*, 207; Simmons, 140; Simmons, *Leicester past and present*, i, 1974, 140; cf. le Hardy, *op. cit.*, 200–201, for Hertford subscription.

60 Q/AS 2/6, no. 67; Q/AS 2/9.

61 Wright, *op. cit.*, i, 72–73; Q/AS 2/9.

62 Q/AS 2/9; Fowler and Cornforth, *op. cit.*, 136.

63 Q/SO 18, pp. 423, 486, 551–552; Q/FAc 6/2/3.

64 Q/SO 19, pp. 125–126.

65 Q/SO 29, pp. 249, 309: Q/SBb 481/18.

66 Q/SO 29, pp. 313, 335–336, 368, 428–429; Q/SBb 481/32.

67 Q/AS 2/3; Q/SO 34, p. 25; Wright, i, 72; Negus, 7.

68 Q/SO 34, pp. 94–95, 154, 249, 294, 327–328, 389; Q/AS 1/4/1; 1/4/11; 1/4/14; 1/5; Spalding Collection, Chelmsford: Public Buildings, entrance hall, 1936.

69 Q/SO 37, pp. 507, 581; *Essex Standard*, 1 July 1842.

70 D/F 32, introductory note; Jarvis, *op. cit.*, 38, 39.

71 Q/ACm 6, pp. 101, 112; Q/AS 2/8/1.

72 Q/SO 41, pp. 72, 376; Q/ACm 6, p. 72; Q/AS 1/4/3.

73 Q/SO 40, pp. 241, 407–408, 462; Q/ACm 6, pp. 104, 105, 107–108; Q/AS 1/4/8, 2/8/1; Spalding Collection, Chelmsford: Public Buildings, courts before alteration, 1936.

74 Q/SO 41, pp. 28, 72, 434; Q/ACm 6, pp. 131, 136–137, 139–140, 143, 148–149, 153, 155; Q/AS 1/4/9, 2/10; Jarvis, *op. cit.*, 40.

75 Q/SO 42, pp. 491–492; Q/ACm 6, pp. 194–197; *Essex Standard*, 29 Feb. 1856; *Builder*, 8, 15 March 1856; Colvin, 305.

76 Q/ACm 6, pp. 197–198; J. Harris, *Sir William Chambers*, 1970, 106 (n.53); H. M. Colvin, *The King's Works*, v, 1976, 374.

77 Q/AS 1/4/1; Jarvis, *op. cit.*, 36.

78 Q/ACm 7, pp. 11, 23–24, 26–27, 29–31; Q/AS 1/4/13, 1/5; Jarvis, *op. cit.*, 31.

79 Q/ACm 7, pp. 64–65, 72–75, 93–96.

80 Q/ACm 7, pp. 273–275.

81 D/HCh 10, pp. 164, 251-252; Durrant's *Handbook for Essex*, Chelmsford (1887), 64.

82 C/MSj 2/1, pp. 165–166, 171–172; Jarvis, *op. cit.*, 41.

83 C/MSj 2/1, pp. 190, 245–246; 2/2, p. 27; 2/3, pp. 11–12; Totton, *op. cit.*, 2:11.

84 C/MSj 2/2, pp. 28, 41, 45.

85 C/MSj 2/2, p. 37.

86 C/MSj 2/2, p. 93; C/MSj 2/1, p. 106.

87 C/MSj 2/3, pp. 21–22, 26; for photographs of the county room prior to the stencilling of the panels and pilasters, see Spalding Collection, Chelmsford: Public Buildings.

88 C/MSj 2/4, p. 25.

89 C/MSj 2/4, pp. 40, 46, 53, 57, 62–63, 68–71, 78; 2/5, p. 28; *Essex Weekly News*, 22, 29 Jan. 1937; Spalding Collection, Chelmsford: Public Buildings; Spalding 4156.

90 C/MSj 2/5, pp. 163, 170–171, 180.

91 *Ch. Ch.*, 3 June 1791.

92 D/P 94/25/24; *Ch. Ch.*, 4 Feb., 9 Dec. 1791: *Universal British Directory*, 513; Chelmsford and Essex Museum, M28333.

93 D/P 94/25/24.

94 D/P 94/21/2.

95 *Excursions*, i, 9; Jarvis, *op. cit.*, 33.

96 G. L. Gomme (ed.), *Gentleman's Magazine Library: Durham, Essex, and Gloucestershire* (1893), 88–89; *Essex Countryside*, vol. 11, no. 71 (Dec. 1962), 62–63; vol. 12, no. 93 (Oct. 1964), 604–606; Chelmsford Borough Council, *Annual report of Borough Librarian and Curator, 1964–1965*; *Essex Weekly News*, 13 Sept. 1963, 30 Oct. 1964, 31 May 1979, 31 Jan. 1980; *Essex Chronicle*, 9 Jan. 1976 (reproduces sketch in 68), 22 Sept., 13 Oct. 1978; 25 May 1979, 10 July 1981; discussion with Hilda Grieve.

97 Unless otherwise stated, this account is based on R. F. Dell, 'The building of the County Hall, Lewes, 1808–1812', *Sussex Archaeological Collections* 100 (1962), 1–11, and J. Catchpole, 'The restoration and repairs to the front elevation of County Hall, Lewes, 1958', *S.A.C.*, 100, 12–23.

98 East Sussex R.O., QAH/1/8/E3 (294); QAH/1/E1; Colvin, 237.

99 E.S.R.O., QAH/1/E1 (30 June 1810); QAH/1/7/E1, pp. 51, 82.

100 E.S.R.O., QAH/1/7/E1, p. 58; QAH/1/7/E3 (16).

101 E.S.R.O., QAH/1/7/E1.

102 E.S.R.O., QAH/1/8/E3 (295).

103 E.R.O., Q/AS 2/8/1.

104 E.S.R.O., QAH/1/8/E3 (295).

105 E.S.R.O., QAH/1/8/E3 (293).

CHAPTER 7 County Gaol and
Houses of Correction (pp. 113–120)

1 Briggs, *County Surveyor*, 303; Q/SO 15, pp. 154–156; Q/SO 16, pp. 249–250, 474; Q/SBb 342/21, 21A; Q/AGp 4; Q/AGb 7.

2 Q/SBb 304/2.

3 Q/SO 13, p. 206; Q/FAc 5/1/1.

4 Q/SO 13, pp. 284–285.

5 Q/SO 13, pp. 299–300.

6 Q/SO 20, pp. 267–268; Q/AGp 16.

7 Q/SO 13, pp. 367–368, 403–404; Q/SBb 314/8.

8 Q/AGp 2/3.

9 Q/SO 14, pp. 369, 388; Q/SBb 357/25; Q/AGp 4; Q/AGb 6.

10 Q/AGb 6; cf. Q/AGp 16.

11 Q/AGp 16; *White's Dir. Essex* (1848), 691; *Kelly's Dir. Essex* (1866), 155; W. H. Evans, *Old and New Halstead*, 1886, 62; *Industries of the Eastern Counties*, 1888–1890, 199; J. Booker, *Essex and the Industrial Revolution*, 89; Halstead and District Local History Soc., *A Pictorial History of Halstead and District*, 1979, 7, 32; Doreen Potts, *Halstead's Heritage*, Halstead and District Local History Soc., 1989, 2 (map), 25 (photo).

12 Colvin, 418; Briggs, *op. cit.*, 301; J. Howard, *State of the Prisons*, 1784, 259–260.

13 Q/SO 13, p. 263.

14 Q/SO 13, pp. 284, 346; Q/FAc 5/1/1.

15 Graves, 130.

16 24 Geo. III, c. 54.

17 Q/SO 13, p. 425; Q/SO 14, pp. 38, 57–58, 80; Q/AGp 2/3.

18 Q/SO 14, p. 205; Q/AGp 2/2; *Ch. Ch.*, 18 July 1788.

19 Q/AGp 2/5.

20 Q/SO 14, p. 362.

21 Negus, 'The jurisdiction of judges of assize to fine a county', *E.R.*, xlvii, 57–67; Q/AGp 2/5.

22 31 Geo. III, c. 46.

23 Q/SO 15, pp. 151–152, 182; Q/SBb 350/11; *Gent. Mag.*, lxxiv, Part 2, Aug. 1804, 703.

24 Q/SO 15, pp. 383–387, 420–424; Q/FAb 59/6, no. 26, 59/8, no. 13; J. S. Scott, *A Dictionary of Building*, Penguin, 1964, 265.

25 Q/SO 15, pp. 420–424; Q/SO 16, pp. 13, 55–56.

26 Q/SO 16, pp. 287–288.

27 J. C. Loudon, *Encyclopaedia of Architecture and Furniture*, 1833, 1132; Colvin, 936, 956; D/DMy 15 M 50/84/17; Q/FAb 60/1, no. 22; 60/4, no. 13.

28 Q/FAa 4/3; Q/FAb 59/8, no. 18; *Bailey's Brit. Dir.*, 1784, 791–793; *Universal Br. Dir.*

29 Q/FAb 59/8, no. 19; Q/SBb 369/19; Q/SO 16, pp. 533–534.

30 Burgoyne, *A Letter . . . to the Freeholders of . . . Essex*, 2nd edn., 1808, 35–36.

31 *Gent. Mag.*, lxxiv, Part 2, Aug. 1804, 703–704; Q/AGb 1/3/1; Q/AGp 4; cf. Q/AGp 19 (*Report from the Committee of Aldermen . . .*, 1816, 52–54).

32 Q/SBb 407/9/7 (sketch plan); 407/10/6; 407/10/11.

33 Q/SBb 386/10.

34 Q/AGp 4; Western, *op. cit.*, 91–94.

35 Coller, *op. cit.*, 209; White, 1848; White, 1863, 415, 418; J. White, 'Chelmsford Gaol in the 19th century', *E.J.*, xi, No. 4 (Winter 1976/77), 83–94.

36 H. Grieve, *The Sleepers and the Shadows*, i, 179 (nos. 63–64); sale particulars 1811 (Q/SBb 426/20/1).

37 Q/SO 14, p. 475.

38 Q/SO 15, pp. 152–153.

39 Q/SO 15, pp. 426–427; D/DXd 1; Q/SO 16, p. 15; Q/FAa 4/3, Mids. 1795.

40 Q/SO 17, pp. 16, 55, 135.

41 Q/SO 17, pp. 359–360, 425–426, 484–485; Q/SO 18, pp. 2–7, 95, 103, 233, 237–238.

42 Q/SO 18, pp. 103, 254–256.

43 Q/AGb 2; Q/SO 18, pp. 302–304, 416.

44 Q/SO 18, p. 376; Q/AGb 2.

45 D/DKe A 3; Marylebone Library, DD. 1642; Q/FAc 6/2/2.

46 R. Elsam, *Essay on Rural Architecture*, 1803, list of subscribers; Colvin, 486; D/DKe F10; Q/SO 24, p. 194.

47 Q/FAc 6/2/3.

48 Q/AGb 2.

49 Q/AGp 4; Q/AGb 1/3/1, no. 2; Q/FAc 6/2/3.

50 Q/FAc 6/2/3.

51 Q/SO 19, p. 21.

52 Q/FAc 6/2/2.

53 Q/SO 18, pp. 655–656; Q/SO 19, pp. 172–173, 240; cf. D/NC 22/2, D/NC 22/3, pp. 10, 42.

54 Q/SO 19, p. 568.

55 Q/FAc 6/2/3.

56 Q/SO 20, pp. 18–24; Q/SBb 407/13/1; Colvin, 63.

57 Q/SBb 407/13.

58 Q/SO 20, p. 24; M. Burgoyne, *A Letter . . . to the Freeholders of . . . Essex*, 2nd edn., 1808, 35–36.

59 C. C. Western, *Remarks on Prison Discipline*, 1821, 91–94.

60 Q/SO 14, pp. 475–477; Q/SBb 340/62 (plan of existing house).

61 Q/SO 14, pp. 545, 583; *V.C.H Essex*, v, 244.

62 Q/SO 15, pp. 11, 39, 189–190, 297, 330, 393; for craftsmen, see J. E. Oxley, *Barking Vestry Minutes*, 1955, 138, 221.

63 Q/SO 15, pp. 431, 458.

64 Q/AGb 5; Q/AGp 4.

65 Q/AGb 8; Q/SO 31, pp. 64, 269; *E.R.*, 1, 163.

66 Q/SO 32, pp. 362, 448, 525–526; *V.C.H. Essex*, v, 244.

67 Q/SO 14, pp. 137, 159, 183, 233; J. Howard, *State of the Prisons*, 1784, 261; B.L., Add. MS., 29927; Q/AGp 4; Q/AGb 3 (cf. plan in *R.C.H.M. Essex*, iii, 52). This section owes much to discussion with Dr Janet Cooper, Editor, *V.C.H. Essex*, and Dr. Paul Sealey, Assistant Keeper of Antiquities, Colchester and Essex Museum.

68 *Gent. Mag.*, lxxiv, Pt. 2, Aug. 1804, 705; [J. H. Round], *The History and Antiquities of Colchester Castle*, Colchester, 1882, quoting *Gent. Mag.*, lxxiv, 1096–1098.

69 Q/SO 16, pp. 409–412; Q/SO 17, pp. 362–363, 489, 527–528; Q/FAc 6/3/1; E.R.O. Colchester, D/DU 888/17, pp. 20, 21 (photograph).

70 Round, *op. cit.*, 132; P. J. Drury,

'Aspects of the Origins and Development of Colchester Castle', *Archaeological Journal*, cxxxix (1982), 408; Q/AGb 4/2.

CHAPTER 8 Churches and other public buildings (pp. 121–137)

1 D/P 198/5, 198/3/2; R.C.H.M., *Essex*, iv, 1923, 172.

2 C. C. Lee, *St. Pancras Church and Parish*, 1955, 32–33, 133.

3 Unless otherwise stated, this account is based on F. M. Cowe (ed.), *Wimbledon Vestry Minutes, 1736, 1743–1788*, Surrey Record Society, xxv, 1964, 77–88; see also *Ambulator*, 1794, 300; J. Harvey, *history of the parish church of St. Mary the Virgin, Wimbledon*, 5–9.

4 Reproduced by Harvey, *op. cit.*, 6.

5 W. A. Bartlett, *The history and antiquities of the parish of Wimbledon, Surrey*, 1865 (reprinted 1971), 73.

6 Surrey Record Office, P5/3/479, pp. 7–8, 10, 12, 17, 25, 34.

7 Bartlett, *loc. cit.*; D. Lysons, *Environs of London*, i, 1792, 509; Victoria Library, 90/8/20.

8 Bartlett, *op. cit.*, 73–74; Harvey, *op. cit.*, 7; Surrey R.O., P5/2/22, p. 88.

9 Bartlett, *op. cit.*, 74; Harvey, *loc. cit.*; Surrey R.O., P5/2/126, 127, 132, 137, 152.

10 Bartlett, *loc. cit.*; Harvey, *op. cit.*, 7–9, plan (inside back cover); Surrey R.O., P5/2/93.

11 D/P 94/11/2.

12 D/P 94/5/3, 4.

13 Q/SO 15, pp. 93, 114; D/P 94/5/4.

14 D/P 94/6/2, 3, 5, 12, 13; T/A 384/1/1–81; see also J. F. Williams, 'The re-building of Chelmsford church, 1800 to 1803', *E.R.*, xl (1931), 96–104.

15 T/A 384/1/53.

16 G. L. Gomme, ed., *The Gentleman's Mazazine Library: Durham, Essex and Gloucestershire*, 88; *E.R.*, xl, 97.

17 D/P 94/5/4; *E.R.*, xl, 98–99.

18 D/P 94/6/2, pp. 5–6.

19 T/A 384/1/5 (printed, *E.R.*, xl, 99–100).

20 D/P 94/6/13/6, 15, 85, 93, 144, 155, 169,

268, 269, 312; D/P 94/6/12; T/A 384/1/10, 15, 81.

21 T/A 384/1/21; D/P 94/6/13/30, 36, 43, 47, 52, 57, 60, 68.

22 D/P 94/6/2, pp. 14, 16.

23 T/A 384/1/10; D/P 94/6/2, pp. 22, 26; D/P 94/6/13/80.

24 D/P 94/6/2; T/A 384/1/26, 81; cf. A. Kelly, *Mrs. Coade's Stone*, 109.

25 D/P 94/6/2; T/A 384/1/81.

26 D/P 94/6/5, pp. 29–30; T/A 384/1/36, 81; D/P 94/6/3, 12; D/CF 7/1.

27 D/P 94/6/2; T/A 384/1/52, 53.

28 D/P 94/6/2; D/P 94/6/13/93, 210.

29 D/P 94/6/2, 3; D/P 94/6/13/312; T/A 384/1/78, 81.

30 D/P 94/6/3; D/P 94/6/12; D/P 94/6/13/ 277; T/A 384/1/81.

31 D/P 94/6/12; D/P 94/12/14; D/P 94/8/3.

32 D/CF 7/1.

33 D/CF 12/1.

34 W. Chancellor, *A Short History of the Cathedral Church . . . Chelmsford*, revised edn., 1953, 21, 30.

35 D/P 306/1/1; Q/SO 17, pp. 421–422; Guildhall Lib., MS. 9532/10, ff. 114– 117; *V.C.H. Essex*, iv, 207.

36 E. Ogborne, *History of Essex*, 1814, 148; *V.C.H. Essex*, vii, 48; A. V. Worsley, *Hornchurch Parish Church*, 1964, 24; *Gent. Mag.*, lxxviii (2), 974 (1808).

37 D/P 16/5/9.

38 Colvin, 463; H. M. E. M. Cocks, *The Great House of Hallingbury*, 1988, 30; Lady Alice Archer-Houblon, *The Houblon Family*, ii, 1907, 283.

39 *Gent. Mag.*, lxxviii (2), 974 (1808); P.R.O., B3/1272.

40 *Gent. Mag., loc. cit.*; Venn, *Alumni Cantabrigienses*, Pt. ii, vol. vi, 258; St. Deiniol's Library, Hawarden, Church notes of Sir Stephen Glynne, i, f. 68; Huntingdon C.R.O.: Stilton Heritage compiled by Stilton W.I. (from B.L., Add. MS. 18479, f. 67); PH 77/1; Acc. 22471; 2696/6/1; 2696/5/3; Colvin, 151; *V.C.H. Hunts.*, iii, 225.

41 E.R.O., T/B 181/1/2.

42 G.E.C., *Complete Peerage*, x, 1945, 701–702.

43 *C.L.*, 1 Oct. 1932, 378–384; N. Scarfe,

Suffolk: a Shell Guide, 1960, 81; R. Gunnis, *Dictionary of British Sculptors*, 1953, 220.

44 D/DBe O4.

45 D/Q 12/3; J. C. Buckler, *Sixty Views of Endowed Grammar Schools*, 1827; 1st edn. 120″ O.S. Chelmsford, Sheet 10 (surveyed 1874).

46 M. Craze, *History of Felsted School*, 1955, 123–127, pl. ix; D/Q 11/59.

47 Nichols, i, 1815, 527; J. Simmons, *Leicester Past and Present*, i, 1974, 124.

48 Nichols, *op. cit.*, 531; Simmons, *op. cit.*, 139–140; (ed.) G. A. Chinnery, *Records of the Borough of Leicester*, v, 1965, 282–283, 393.

49 *Records . . .*, v, 279–280, 283, 286; Nichols, *loc. cit.*; J D. Bennett, *Leicestershire Architects, 1700–1850*, Leicester Museums, 1968; N. Pevsner (revised E. Williamson), *Buildings of England: Leicester and Rutland*, 2nd edn., 1984, 231.

50 Nichols, *op. cit.*, 528; R. Gill, *The Book of Leicester*, 1985, 36; Bennett, *op. cit.*

51 J. Thompson, *History of Leicester in the 18th Century*, 1871, 229–230; J. Simmons, *Parish and Empire*, 139–142; Leics. R.O., 10D72/470, 486, 487; P.R.O., B3/1272.

52 Nichols, *op. cit.*, 533–534; A. Kelly, *Mrs. Coade's Stone*, 77–78, *passim*; R. Gunnis, *Dictionary of British Sculptors*, 326; N. Pevsner (revised E. Williamson), *The Buildings of England: Leicestershire and Rutland*, 2nd edn., 1984, 222; *Trans. Leics. Arch. Soc.*, xxv, 1949 (illus. opp. p. 156).

53 Nichols, *op. cit.*, 534; Simmons, *Leicester Past and Present*, i, 139; P.R.O., B3/1272.

CHAPTER 9 Country Houses II (pp. 138–149)

1 J. Cornforth, 'Bradwell Lodge, Essex', *C.L.*, 7 July 1966, 15–19; W. Angus, *Seats of the Nobility*, pl. 35, text printed *E.R.*, xlv, (1936), 189; T/A 604 (microfilm), printed A. F. J. Brown, *Essex People*, E.R.O. Pub. 59, 1972, 25; Graves, 130; T. Wright, *Hist. Essex*, ii, 696.

2 E. Croft-Murray, *Decorative painting in*

England, ii, 1970, 280.

3 Nichols, i, 528; Graves, 130.

4 N.M.R., AA53/201–207, 209–214.

5 *C.L.*, 7 July 1966, 19.

6 Photograph, E.R.O., Pictorial Collections.

7 D/DHf T92/76.

8 D/DHf T92/83.

9 D/DHf T92/77/1, 2, T92/88; E. A. Wood, 'Three Georgian houses: the rebuilding of Thorpe Hall . . .', *E.A.T.*, 3rd series, ii, 1967, 123–129.

10 Nichols, *loc. cit.*; O. Manning and W. Bray, *History and antiquities of the county of Surrey*, iii, 1814, 367, 590; Burke, *Landed Gentry*, ii, 1847, 1160; H. Davy, *Views of the seats of noblemen and gentlemen in Suffolk*, 1827; N.M.R., AA48/7342, 7344.

11 G. F. Prosser, *Select illustrations of the county of Surrey*, 1828; *Ambulator*, 7th edn., 1794, 299; Wimbledon Soc., P. 22 (reproduced, Wimbledon Soc. Newsletter, Dec. 1985); Colvin, 464; R. Milward, *Wimbledon's Manor Houses*, John Evelyn Soc., Wimbledon, 1982, 5–6.

12 Wimbledon Soc., Eph. XI. 2/5/1 (kindly transcribed by Dr. G. R. C. Davis).

13 W. Courthope (ed.), *Debrett's Baronetage*, 1837, 350; D/DKe F4.

14 Nichols, *loc. cit.*; P. Benton, *History of Rochford Hundred*, c.1884, 848–850; L. R. Cryer, *A history of Rochford*, 1978, 139–140; T/P 181/9/14; D/CT 291; 1st edn. 25″ O.S., Sheet 70/14 (surveyed, 1873).

15 Simmons, 244; N. Pevsner (revised E. Williamson), *Buildings of England: Leicestershire and Rutland*, 2nd edn., 1984, 273–274.

16 Leics. R.O., 10D72/470, 683, 691, 693/1, 698; D. Paterson, *A new and accurate description of Roads in England and Wales*, 15th edn., 1811, 136; P.R.O., B3/1272.

17 Nichols, *loc. cit.*; *Burke's Peerage*, 103rd edn., 1963, 2130; E. Cartwright, *The Parochial Topography of the Rape of Bramber . . . Sussex*, ii, pt. ii, 1830, 365; J. Foster, *Alumni Oxonienses*, i, 1887, 83; Colvin, 468; C. and J. Greenwood, *Survey of Sussex*, 1825; *V.C.H. Sussex*, vi, 18.

18 Nichols, *loc. cit.*, iii, 1105 (illus.); Jones, *Views of seats*, i, 1829; Leics. R.O., 10D72/487.

19 N. Pevsner (revised E. Williamson), *Buildings of England: Leicestershire and Rutland*, 2nd edn., 1984, 279; Department of Environment, *Statutory list*, 1989.

20 D/DMy 15M50/84/17, 18; D/DRa Z8.

21 D/DJg T1, T8; D/DKe A3; Colvin, 311, 435, 464, 732; N. Briggs, *Georgian Essex*, 1989, 27.

22 N. Briggs, 'Braxted Lodge', *E.J.*, v (1970), 97–102; D/DDc F6; D/DDc A28, ff. 63, 72, 85, 113, 116; Sale Particulars A62.

23 Colvin, 464 (cost kindly supplied by Howard Colvin); Lady Alice Archer-Houblon, *The Houblon Family*, ii, 1907, 283.

24 D/DYq 22.

25 Department of Environment, *Statutory List*, 1984.

26 Department of Environment, *Statutory List*, 1984; Sale Particulars C885; Nichols, *loc. cit.*; Colvin, 464; J. A. Rush, *Seats in Essex*, 1897, 85–86 (illus.); ed. M. Binney and E. Milne, *Vanishing Houses of England*, 1982, 23 (illus.); *V.C.H. Essex*, iv, 180; *Burke and Savill's Guide to Country Houses*, iii, 1981, 52; D/DC 27/1115; D/DCw P19.

27 Nichols, *loc. cit.*; *Chelmsford Guide*, n.d., 17; D/P 248/11/1,2; D/DE T79/1, T93.

28 *Ch. Ch.*, 12 March 1813; Spalding Collection; E.R.O., Pictorial Coll. (Domestic Architecture); *Kelly's Directory of Chelmsford*, 1943–1964; N.M.R., BB65/98 (Manydown Park).

CHAPTER 10 Last Years (pp. 150–158)

1 T/A 384/1/26; Q/FAc 6/2/2; D/DKe A3.

2 T/A 384/1/43A.

3 T/A 384/1/57.

4 *Ch. Ch.*, 19 Feb. 1802; T/A 384/1/29.

5 G.L.R.O., P89/MRY 1/5; J. A. Venn, *Alumni Cantabrigienses*, Pt. ii, vol. iii, 1947, 581; P.R.O., B3/1272.

6 P.R.O., B3/1272; Simmons, 137; Victoria Lib., C443; Somerset R.O., DD/PLE Box 14; Marylebone Library, Paddington rates.

7 P.R.O., B3/1268 (2, 5); *London Gazette*, 3–7 May 1803, pp. 535, 1697; Lloyds Bank Archives, A19d/3.

8 P.R.O., B3/1272; Q/FAc 6/2/2.

9 P.R.O., B3/1272; G.L.R.O., MDR 1790/5/11; Somerset R.O., DD/PLE Box 14.

10 P.R.O., B3/1272; R. Milward, *A new short history of Wimbledon*, Wimbledon Soc., 1989, 12–13; information from Dr G. R. C. Davis.

11 P.R.O., B3/1272.

12 Lloyds Bank Archives, A19d/3; A. Cunningham, *Lives of the most eminent British . . . Sculptors . . .*, iii, 1830, 210–211.

13 P.R.O., B3/1268 (2, 5).

4 P.R.O., B3/1269, 1272; Somerset R.O., DD/PLE Box 14.

15 D/DRa F31/4.

16 P.R.O., B3/1272; D/DRa F31/9; Lloyds Bank Archives, A19d/3, 41; Strutt MSS., accounts, p. 64.

17 P.R.O., B3/1268 (1), B3/1270 (97, 102, 122), B3/1271 (231, 248), B3/1272 (329, 338).

18 P.R.O., B3/1268 (2, 5, 9, 15, 23), B3/1269 (175), B3/1270 (75, 81, 89, 112, 119), B3/1271 (261, 265); Colvin, 139, 376.

19 P.R.O., B3/1272.

20 Lloyds Bank Archives, A19d/3.

21 P.R.O., B3/1269 (149, 209), B3/1270 (105, 106), B3/1271 (310, 322).

22 Lloyds Bank Archives, A19d/3.

23 P.R.O., B3/1270, 1272; *Universal British Directory*, 1794, iii, 140.

24 P.R.O., B3/1272, 1273 (52A); Lloyds Bank Archives, A19d/3.

25 D/DRa F31/9; Swiss Cottage Library, St. Pancras poor rates (North).

26 Q/SBb 377/46.

27 Q/SBb 405/23.

28 Q/SO 20, p. 29.

29 Q/FAc 6/2/4; Q/SBb 415/23.

30 Q/SBb 419/81, 420/34.

31 Q/SO 21, pp. 429, 491, 516; D/P 94/6/12; Q/SBb 426/16; Q/SBb 427/16.

32 Q/SBb 428/7, 15–17.

33 Q/SBb 429/20.

34 D/DKe F10.

35 D/DKe F10; P.R.O., PROB 11/1542; transcript of burial register and M.I. by J. H. Busby.

36 G.L.R.O., MDR 1790/5/11; Holden, *London Directory*, 1802; P.R.O., PROB 11/1542.

37 Somerset R.O., DD/PLE Box 14.

38 St. Marylebone Lib., DD 1254, 1323, 1624, 1625; G.L.R.O., MDR 1790/10/218–222, 1791/8/414–417.

39 Q/FAb 50/1, 4, 60/1, 4; Q/SO 14, pp. 260, 324.

40 Lloyds Bank Archives, A19d/41.

41 D/DRa F10.

42 D/P 94/5/24, 94/21/2; D/DKe F4; Lloyds Bank Archives, A19d/41.

43 Q/SBb 377/46.

44 D/Q 11/59; T/A 384/1/81; D/DKe A3; Q/SBb 337/13; Marylebone Lib., DD. 1254.

45 Lloyds Bank Archives, A19d/35, 41.

46 D/DRa F31/4, 7, 9, 10; W. Faden, *A New Pocket Plan of the Cities of London and Westminster . . .*, 1815.

47 Simmons, 144; *Ch. Ch.*, 23 Sept. 1814; Nichols, i, 528; P.R.O., B3/1272; *Gent. Mag.*, lxxxiv (2), 296.

48 Nichols, *loc. cit.*; Simmons, 137–139; *32nd Report of the Commissioners to enquire into Charities: Leicester* (1839), 100–102; J. D. Bennett, *Leicestershire Architects, 1700–1850*; R. Gill, *The Book of Leicester*, 1985, 36.

49 P.R.O., PROB 11/1579; *Charity Commissioners' Report, loc. cit.*; D/DRa F31/7, 9; Q/SO 21, p. 491; East Sussex Record Office, QAH/1/7/E3 (16, 24).

50 C. W. Boase, *Registrum Collegii Exoniensis*, ii, Oxford, 1894, 176; C. and J. Greenwood, *Somersetshire Delineated*, 1822, 23, 29.

51 P.R.O., B3/1272; PROB. 11/1542; Somerset R.O., DD/PLE Box 14.

52 Somerset R.O., DD/PLE Box 14; *Dictionary of National Biography, 1912–1921*, 66; *Burke's Landed Gentry*, 18th edn., iii, 1972, 120–121.

MANUSCRIPT SOURCES

ESSEX RECORD OFFICE

Main classes used: Q/Court of Quarter Sessions; D/D Estate and Family Archives; D/P Parish Records

Q/SO	Sessions order books
Q/SBb	Sessions bundles
Q/ABb 3	Widford bridge, plans, 1803
Q/ABb 4	Ackingford bridge, elevation, 1806
Q/ABb 9	Battlesbridge, contract and plans for iron bridge, 1854–55
Q/ABb 22	Dedham bridge, contract for iron bridge, 1875
Q/ABp 2	Dedham bridge, reports and correspondence, 1786–95
Q/ABp 3	Ballingdon bridge, papers, 1802
Q/ABp 7	Langford bridge, case and counsel's opinion, 1809
Q/ABp 26	Tan Office (Heybridge), memorandum, 1845
Q/ABp 33	Battlesbridge, reports and papers, 1854–71
Q/ABp 43	Springfield bridge, extracts and correspondence, 1867
Q/ABp 47	Bridges on turnpike roads, extracts, 1796–1868
Q/ABz 2/1	List of county bridges, c.1820
Q/ABz 3/1	County surveyor's annual reports, 1858–72
Q/AGb 1/1	New county gaol at Moulsham, contract and specification, 1773
Q/AGb 1/2	Proposed gaol on White Horse inn site, Chelmsford, engraved plans, 1770
Q/AGb1/3/1	Moulsham gaol and house of correction, plans for alterations, 1819
Q/AGb 1/5, 6	Do., 1820, 1823
Q/AGb 1/7	Moulsham gaol, plans for installation of gas, post 1819
Q/AGb 1/8	Moulsham gaol and clerk of peace office, site plan, 1831
Q/AGb 4/2	New house of correction, Colchester, contract, 1832
Q/AGb 5	Barking house of correction, ground plan, 1819
Q/AGp 2/3	Fine on county, affidavits and answers to questions by county surveyor, c.1789
Q/AGp 2/5	Fine on county, committee report giving history of case, 1789–93
Q/AGp 4	Proposed alterations to gaol, committee reports, 1817–19
Q/AGp 16	Halstead house of correction, sale particulars (plan), 1850
Q/AGp 19	Committee of London aldermen appointed to visit county gaols, printed report, 1816
Q/AS 1/1	New Shire Hall, plans and elevations, 1788
Q/AS 1/3	'Assize House', engraved plans, c.1770
Q/AS 1/4/1	Corn market in Shire Hall, plans for improvement, 1834
Q/AS 1/4/3	Judges' rooms, plan, 1846
Q/AS 1/4/8	Alterations to courts, plans, 1849
Q/AS 1/4/9	Clerk of peace office and record room, plans, 1850–51
Q/AS 1/4/11	Sebastopol gun, plans for positioning in front of Shire Hall, 1858
Q/AS 1/4/13	Surveyor's report on enclosing market area, 1864
Q/AS 1/4/14	Proposed illuminated clock on Shire Hall, plan, 1868
Q/AS 1/5	Proposal to enlarge market area, plan, 1864
Q/AS 2/3	Corn market facilities, petition and orders, 1834
Q/AS 2/4/1–4	Shire Hall rebuilding, papers, 1788–91
Q/AS 2/4/5	Contractors' losses, correspondence, 1791–92
Q/AS 2/4/6	Abstract of accounts, 1788–93 (another copy, Q/FAa 4/3)

Q/AS 2/5/1, 2/6	Vouchers, 1789–93
Q/AS 2/5/2	Contractors' accounts, 1789–91
Q/AS 2/5/3	Surveyor's report on expenditure to 1790
Q/AS 2/7	Contracts, 1789–90
Q/AS 2/9	Shire Hall furniture, inventories, 1808, 1816, 1842
Q/AS 2/10	Alterations to west wing, plans, 1849
Q/ACm 6, 7	General committee minute books, 1842–75
Q/FAb	General bills and vouchers
Q/FAc 5/1/1	Accounts for rebuilding gaol, 1767–83
Q/FAc 6/2/1–4	Surveyor's bills and vouchers, 1790, 1796–1813
Q/FAc 6/3/1, 2	Surveyor's quarterly accounts, 1796–1824
D/DBe 01	Removal or enlargement of gaol, papers, 1770–72
D/DBe 04	Chelmsford grammar school, papers, 1773–96
D/DDc F6	Letter from Peter Du Cane to Johnson, 1804
D/DDc A28	Cash book kept by Du Cane, 1803–1807
D/DHf T92/76	Design for elevation, Thorpe Hall, Thorpe-le-Soken, 1782
D/DHf T92/77/1, 2	Plan and elevation, Thorpe Hall, c.1825
D/DKe F4	Building accounts, Hatfield Place, Hatfield Peverel, 1792–94
D/DKe F10	Magistrates' subscription for Johnson, papers, 1813
D/DKe A3	Boreham House repairs, estimate and accounts, 1802–1805
D/DMy 15M50/84/17, 18	Letters from Johnson re Moulsham Hall roof and chimneys, 1797
D/DOp E8	Moulsham bridge papers, 1818–24
D/DP 020	Chain bridge, Mountnessing, papers, 1791
D/DRa F10	Garrett Green Farm, Wandsworth, Surrey, correspondence with John Strutt re alterations, 1787
D/DRa F28	Dispute over alterations to Springfield Place, papers, 1780–81
D/DRa F31/4, 7, 9, 10	Trustees of Revd. Charles Phillips' estate in Stepney and Whitechapel, papers, 1795–1809
D/DRa E25	Terling Place, proposals for alterations, 1821
T/B 181/1–15	Terling Place, correspondence and plans, (copies), 1769–73
T/B 251/7	Letters from Bamber Gascoyne to Strutt, 1759–84 (typed copy)
D/CF 7/1, 12/1	Chelmsford church, faculties for restoration, 1867, 1873
D/HCh 10	Chelmsford Board of Health minutes, 1886–88
D/P 16/5/9	Thaxted churchwardens' accounts and vestry minutes, 1767–1821
D/P 94/5/3–4	Chelmsford churchwardens' accounts and vestry minutes, 1757–1811
D/P 93/6/1	*Coade's Gallery* (printed catalogue), 1799
D/P 94/6/2, 3	Trustees for repairing Chelmsford church, minutes, 1800–15
D/P 94/6/5	Letter book of do., 1800–12
D/P 94/6/8	Bill for repair of church (40 Geo. III) 1800 (cf. Act, Q/CM 4/20)
D/P 94/6/12	Trustees' correspondence and misc. papers, 1804–27
D/P 94/6/13	Bills and vouchers for repairs, 1800–35
D/P 94/8/3	Chelmsford vestry minutes, 1817–21
D/P 94/11/2	Chelmsford overseers' rates and vestry minutes, 1784–93
D/P 94/21/2	Chelmsford surveyors' accounts and minutes re new drain from Burgess Well to conduit, 1797
D/P 94/25/24	Sir W. Mildmay's Charity (Burgess Well), accounts, 1777–1818
T/A 384/1/1–81	Chelmsford church, correspondence and accounts re rebuilding (microfilm), 1800–1804
D/P 198/3/2	Woodham Ferrers, faculty, 1793

D/P 198/5	Woodham Ferrers, churchwardens' accounts, 1715–1829
D/P 306/1/1	Shelley parish register, 1687–1812, inc. notes on demolition, 1800, and re-erection of church, 1811
D/Q 11/59	Felsted School, papers re building of master's house, 1796–1803
D/Q 12/3	Chelmsford grammar school accounts, 1773–1831
D/TX 5/3, 5, 6	Essex Turnpike Trust, treasurer's records, 1795–1801
D/TX 5/21	Do., 1813
C/MSj 2/1–5	Standing Joint Committee, Shire Hall sub-committee, minutes, 1889–1937
Sale Particulars A62	Braxted Park, 1923
Sale Particulars A277A	Skreens Park, 1915
Sale Particulars C885	Willingale Doe rectory, 1982

OTHER REPOSITORIES

DORSET RECORD OFFICE

D.1/8871A	Sadborow, building accounts, 1773–76
D.1/LL10	Sadborow, site plan, c.1800
D.83/6–9	Accounts kept by John Bragge, 1773–76

GLAMORGAN RECORD OFFICE

D/D Gn/E/5/1	Gnoll estate plan, 1812
D/D Gn/E172	Gnoll estate accounts, 1856, inc. inventory, 1853
D/D Gn/E186	Gnoll Castle, sale particulars, 1856

HAWARDEN, ST. DEINIOL'S LIBRARY

Church notes of Sir Stephen Glynne, vol. i	Stilton, Huntingdon (f. 68)

HUNTINGDON COUNTY RECORD OFFICE

2696/5/3	Stilton church restoration, vouchers, 1856–57
2696/6/1	Do., citation for faculty, 1857
22471	Typescript history of Stilton by Leonard Hutton, n.d.

LEICESTERSHIRE RECORD OFFICE

DG 4/597	Carlton Hall, Northants, building accounts, 1776–80
DG 4/598	Do., weekly accounts (wages and materials), 1777–80
DG 4/601	Do., accounts for labour and materials supplied by Johnson, 1778–82
10D72/470	Letter, Johnson to Sir Edmund Cradock Hartopp, Bt., 1799
10D372/486, 487	Hotel and Assembly Rooms, Leicester, letter and subscription list, 1800
10D72/683, 691, 698	Knighton Hall, correspondence re alterations, 1799–1802

LONDON: BOROUGH OF CAMDEN (SWISS COTTAGE LIBRARY)

St. Pancras poor rates (North), 1805–12

LONDON: LLOYDS BANK ARCHIVES

A19d/3	Co-partnership articles, Mackworth, Dorset, Johnson and Wilkinson, bankers, 1784; papers re bankruptcy of firm, 1803

A19d/35	Bank passbooks, Sir H. Mackworth (d. 1791) and his executors, 1785–1803
A19d/41	Papers re work by J. Johnson, sen. and jun., for Mackworth estate, 1786–1810, inc. letter re Johnson's examination in bankruptcy, 1804
A19d/94	Will of Sir Patrick Blake, Bt., 1784

LONDON: CORPORATION OF LONDON, GREATER LONDON RECORD OFFICE

MJ/SP 1778	Middlesex Sessions papers, 1778
MDR	Middlesex Deeds Registry, registers of memorials (abbreviated copies of deeds)
MR/B/R2, 3	District surveyors' registers of affidavits, 1770–1784
MR/B/C2/82	District surveyor's affidavit, houses in Charles St., 1771
E/BN/36	Particulars of repairs, 17 Newman St. (Bacon family), 1841
E/BN/44	Case for counsel's opinion, inc. sketch plan of 17 Newman St., 1855

LONDON: PUBLIC RECORD OFFICE (CHANCERY LANE)

C12/1346/22	Petition of James Liardet, re infringement of stucco patent, with Johnson's reply, 1777
B3/1268–1273	Bankruptcy papers, Dorset, Johnson and Co., 1803–1805
PROB. 11/1542	Will of John Johnson, junior, 1812 (proved 1813)
PROB. 11/1579	Will of John Johnson, senior, 1811 (proved 1816)

LONDON: VICTORIA AND ALBERT MUSEUM, DEPT. OF PRINTS AND DRAWINGS

D.2188-D.2192-1896	Unexecuted designs for alterations to Mamhead, Devon, n.d., c.1777

LONDON: WESTMINSTER CITY ARCHIVES (MARYLEBONE LIBRARY)

	St. Marylebone, rates, 1769–1805
	Trustees for building new church, minutes, 1770–97
	St. Marylebone Association: minutes; list of associates, No. 4 (Berners St.) District, 1780
	Paddington, rates, 1799, 1803
Acc. 449/3–5	Portland estate, rentals, 1778, 1782–83, 1813
DD 1469, 1500, 1516, 1520, 1601, 1642, 1645	Berners St., deeds, 1767–71
DD 1449	Charles St., deed, 1771
DD 1504, 1506, 1520, 1522, 1524, 1544, 1547, 1612, 1614, 1630, 1644, 1646	Newman St., deeds, 1766–68
DD 1254, 1323, 1624, 1625	Upper Newman St., deeds, 1788–94
DD 510	Portman Sq., deed, 1778
DD 1611	Norfolk St., deed, 1803

LONDON: WESTMINSTER CITY ARCHIVES (VICTORIA LIBRARY)

C 443	St. George, Hanover Sq., rates (Out Ward), 1795
Acc. 90/8/10	Lutheran Chapel of the Savoy, carpenter's bill, 1766
Acc. 90/8/20	Do., plasterer's bill

NORTHAMPTONSHIRE RECORD OFFICE

D(F) 51	Finedon, letter re alterations, 1780
F.S. 4/4	Brochure advertising lease of Pitsford Hall, 1914
I (L) 3079, Folder D, No. 1	Lamport Hall, plan for alteration of drawing room, n.d., c.1775
Law and Harris, Box 23	Pitsford Hall, plans, 1887–98
NAS 50, 51	Drawings by Geo. Clarke, c.1840
Th. 2056	Ledger of James Fremeaux, 1790–99
Th. 2324–2497	Kingsthorpe Hall, building accounts, 1773–75

SOMERSET RECORD OFFICE

DD/PLE Box 14	Deeds and papers of Revd. Charles Johnson and his descendants, c.1790–1894, incl. abstract of London leases

SUFFOLK RECORD OFFICE (IPSWICH BRANCH)

B105/2/47	Quarter Sessions minutes, 1781–86
B105/2/48–53	Quarter Sessions order books, 1786–1809
P415	Woolverstone Hall, photograph of plans, c.1776

SURREY RECORD OFFICE

P5/2/22	Wimbledon churchwardens' accounts, 1792–1871
P5/2/93	Wimbledon church, faculty for restoration, 1841
P5/2/126–157	Do., papers re alterations, 1818–20
P5/3/479	Wimbledon vestry minutes, 1788–1906

EAST SUSSEX RECORD OFFICE

QAH/1/E1	County Hall building committee, minutes, 1808–1814
QAH/1/7/E1	Do., building accounts (fair copy), 1808–1814
QAH/1/7/E3 (16, 24, 27)	Do., correspondence and accounts, 1809, 1812
QAH/1/8/E3 (293–295)	Do., accounts rendered by clerk of the peace and architect, 1808–1814

PRIVATE POSSESSION

CASTLE ASHBY MSS.

F.D. 1053	Estate accounts, 1771–75
F.D. 1364	Photograph, Great Hall, prior to alteration in 1884
	Notebook of Lady Alwyne Compton, 1860–76

JAMES STEVENS COX

Escott MS.	Memorandum book kept by Richard Escott as steward to Sir Charles Kemeys Tynte of Halswell, Somerset, 1753–80

STRUTT MSS.

Accounts of Joseph Strutt and John Strutt, M.P., 1759–1869

Correspondence of John Strutt, 1770–71

Engraving of bridge at Pont-y-Pridd, Glamorganshire, n.d.

WIMBLEDON SOCIETY

Eph. XI/2/5/1	Sale particulars, estate of late Sir W. B. Rush, 1834

SOURCES OF ILLUSTRATIONS

Chelmsford and Essex Museum: frontispiece, pp. x, 97, 129, 130

Country Life: p. 41

Essex County Council Planning Department: p. 21

Glamorgan Archives: p. 38 (lower)

Greater London Photograph Library: pp. 5–13, 15, 17, 34

Leicestershire Museums, Arts and Record Service, Leicestershire Record Office: pp. 134, 135, 137, 147

Leicester Cathedral, Provost and Chapter: p. 156

National Museum of Wales: p. 38 (upper)

National Monuments Record (Crown copyright: Royal Commission on the Historical Monuments of England): pp. 16, 26, 39, 40, 111, 141 (upper), 150

National Monuments Record for Wales (Crown copyright: Royal Commission on Ancient and Historical Monuments in Wales): p. 46

National Trust: pp. 42, 43

Northampton Borough Council: p. 27

Northampton Library: p. 28

Northamptonshire Record Office: pp. 30, 33

Suffolk Institute of Archaeology: p. 76

Suffolk Record Office: pp. 35, 37

Surrey Record Office: pp. 123, 142

Victoria and Albert Museum, Board of Trustees: p. 73 (lower)

Wimbledon Society: p. 124

All other photographs were taken by Nelson Hammond, photographer to the Essex Record Office, from original documents or on location.

SELECT BIBLIOGRAPHY

Works are published in England, except where stated. Newspapers, directories, biographical reference works and Ordnance Survey maps have been excluded.

Acland, A., *A Devon family, the story of the Aclands*, 1981.

Acland, A., *Killerton, Devon*, National Trust, 1978, 2nd edn., 1983.

Adams, J. N. and Averley, G., 'The Patent Specification: the role of Liardet v. Johnson', *Journal of Legal History*, 7 (1986), 145–177.

Angus, W., *Seats of the Nobility*, 1787–1815.

An Appeal to the Public on the Right of using Oil-Cement or composition for Stucco . . ., 1778.

Baker, G., *History . . . of the county of Northampton*, i, 1822–1830.

Bartlett, W. A., *The history and antiquities of . . . Wimbledon*, 1865 (reprinted 1971).

Bennett, J. D., *Leicestershire Architects, 1700–1850*, Leicester Museums, 1968.

Benton, G. M., 'Fingringhoe bridge', *E.A.T.*, n.s., xx, 262–269.

Benton, P., *History of Rochford Hundred*, 2 vols., 1867–1888.

Binney, M. and Milne, E., *Vanishing houses of England*, Save Britain's Heritage, 1982.

Bolton, A. T., *Architecture of R. and J. Adam*, 2 vols., 1922.

Bolton, A. T., 'The Shire Hall, Hertford', *Architectural Review*, 43 (1918), 68–73.

Bolton, A. T., 'Town houses of the 18th century Nos. 18–20 New Cavendish Street', *C.L.*, 13, 20 Oct. 1917.

Booker, J., *Essex and the Industrial Revolution*, E.R.O. Pub. No. 66, 1977.

Booker, J. M. L., 'The Essex Turnpike Trusts', Durham M.Litt. thesis, 1979.

Bridges, J., *History and antiquities of Northamptonshire*, 2 vols., 1791.

Briggs, N., 'The evolution of the office of county surveyor in Essex, 1700–1816', *Arch. Hist.*, 27 (1984), 297–307.

Briggs, N., 'Braxted Lodge', *E.J.*, v (1970), 97–102.

Briggs, N., *Georgian Essex*, E.R.O. Pub. No. 102, 1989.

Briggs, N., 'Woolverstone Hall: some reflections on the domestic architecture of John Johnson . . .', *Proc. Suffolk Institute of Archaeology*, xxxiv (1977), 59–64.

Brown, A. F. J., *Essex at Work*, E.R.O. Pub. No. 49, 1969.

Brown, A. F. J., *Essex People, 1750–1900*, E.R.O. Pub. No. 59, 1972.

Buckler, J. C., *Sixty views of endowed Grammar Schools*, 1827.

Burgoyne, M., *An account of the proceedings in the late Election in Essex*, 1810.

Burgoyne, M., *A letter . . . to the Freeholders of Essex*, 2nd edn., 1808.

Busby, J. H., *Thomas Collins of Woodhouse, Finchley, and Berners Street*, unpublished typescript, 1965.

Byrne, A., *Bedford Square: an architectural study*, 1990.

Byrne, A., *London's Georgian Houses*, 1986.

Catchpole, J., 'The restoration and repairs to the front elevation of County Hall, Lewes, 1958', *Sussex Archaeological Collections*, 100 (1962), 12–33.

Chalklin, C., 'Bridge building in Kent, 1700–1850 . . .' *Studies in modern Kentish history presented to Felix Hull and Elizabeth Melling*, ed. A. Detsicas and N. Yates, Kent Archaeological Soc., 1983.

Chancellor, W., *A short history of the Cathedral church . . . Chelmsford*, revised edn., 1953.

Charity Commissioners, *32nd Report, Leicester*, 1839.

Chelmsford Guide [c.1807].

Cherry, B. and Pevsner, N., *The Buildings of England: Devon*, 2nd edn., 1989.

Chinnery, G. A. (ed.), *Records of the Borough of Leicester*, v, 1965.

Clarke, B. F. L., *The building of the 18th century church*, 1963.

Coade's lithodipyra [bound etchings in Guildhall Library] [c.1785].

Cocks, H. M. E. M., *The Great House of Hallingbury*, Gt. Hallingbury Local Hist. Soc., 1988.

Coller, D. W., *The people's history of Essex*, 1861.

Colvin, H., *A biographical dictionary of British Architects, 1600–1840*, 1978.

Compton, W. B., *History of the Comptons of Compton Wynyates*, 1930.

Cornforth, J., 'Bradwell Lodge, Essex', *C.L.*, 7 July 1966, 15–19.

Cowe, F. M. (ed.), *Wimbledon vestry minutes, 1736, 1743–1788*, Surrey Record Soc., xxv, 1964.

Cox-Johnson, A. (comp.), *Handlist of painters, sculptors and architects associated with St. Marylebone, 1760–1960*, 1963.

Cox-Johnson, A., *John Bacon, R.A.*, St. Marylebone Soc. Pub. No. 4, 1961.

Cracklow, C. T., *Views of all the churches . . . Surrey*, 1823 (illus. repr. for Surrey Local History Council, 1979).

Craze, M., *History of Felsted School*, 1955.

Croft-Murray, E., *Decorative painting in England*, ii, 1970.

Cryer, L. R., *A history of Rochford*, 1978.

Davy, H., *Views of the seats of noblemen and gentlemen in Suffolk*, 1827.

Dean, D. and Studd, P., *Stifford Saga*, 1980.

Dell, R. F., 'The building of the County Hall, Lewes, 1808–12', *Sussex Archaeological Collections*, 100 (1962), 1–11.

Driberg, T., *Bradwell Lodge*, n.d.

Erith, E. J., *Woodford . . . 1600–1836*, Woodford and District Hist. Soc. Proc., x, 1950.

Evans, W. H., *Old and new Halstead*, 1886.

Finch, P., *History of Burley-on-the-Hill . . .*, i, 1901.

Gerson, M. B., 'A glossary of Robert Adam's neo-Classical ornament', *Arch. Hist.*, 24 (1981), 59–82.

Gomme, G. L. (ed.), *The Gentleman's Magazine Library: Durham, Essex and Gloucestershire*, 1893.

Gotch, J. A., *Squires' homes . . . of Northamptonshire*, 1939.

Graves, A., *The Society of Artists of Great Britain, 1760–1791, and the Free Society of Artists*, 1907.

Grieve, H., *The Sleepers and the Shadows*, i, E.R.O., Pub. No. 100, 1988; ii, to be published.

Gunnis, R., *Dictionary of British Sculptors, 1660–1851*, 1953.

Hardy, W. le (ed.), *Hertfordshire County Records: Calendar to the Sessions Books, 1752–1799*, viii, 1935.

Hardy, W. le and Reckitt, G. L. (eds.), *Hertfordshire County Records: Calendar to the Sessions Books, 1799–1833*, ix, 1939.

Harris, J., *Sir William Chambers*, 1970.

Hartopp, H. (ed.), *Register of the Freemen of Leicester, 1196–1770*, 1927.

Harvey, J., *A history of the parish church of . . . Wimbledon* [c.1972].

Hodson, W. W., 'Ballingdon bridge', *Proc. Suffolk Institute of Archaeology*, viii, 21–30.

Howard, J., *State of the Prisons*, 1784.

Hussey, C., 'Burley-on-the-Hill II', *C.L.*, liii, 17 Feb. 1923, 210–217.

Isham, G., 'John Wagstaff (Two Northamptonshire Builders)', *Reports and Papers of Northants. Antiq. Soc.*, lxiv (1962–63), 33–43.

Jackson, P. (ed.), *John Tallis's London Street Views 1838–1840*, London Topographical Soc. Pub. No. 110, 1969.

Jackson-Stops, G., 'Arcadia under the Plough,' *C.L.*, 9 Feb. 1989, 82–87.

Jackson-Stops, G., 'Castle Ashby, Northamptonshire II', *C.L.*, 6 Feb. 1986, 310–315.

Jarvis, S., *Chelmsford in old picture postcards*, Zaltbommel, Netherlands, 1988.

'The Jockey Club Rooms at Newmarket', *C.L.*, 1 Oct. 1932, 378–384.

Johnson, J., *Plans, sections and perspective elevation of Essex County Hall . . .* [1808].

Jones and Co., *Views of seats*, i, 1829.

Jourdain, M., *English interiors in smaller houses*, 1923 (reissued 1933).

Kelsall, F., 'Liardet versus Adam', *Arch. Hist.*, 27 (1984), 118–126.

Kelsall, F., 'Stucco', *Good and proper materials: the fabric of London since the Great Fire*, London Topographical Soc. Pub. No. 140, 1989, 18–24.

Kelly, A., 'Coade stone in Georgian architecture', *Arch. Hist.*, 28 (1985), 71–101.

Kelly, A., *Mrs. Coade's Stone*, 1990.

Kenworthy-Browne, J., Reid, P., Sayer, M. and Watkin, D. (eds.), *Burke's and Savill's Guide to Country Houses*, iii, 1981.

Lee, C. C., *St. Pancras church and parish*, St. Pancras P.C.C., 1955.

Lloyd, T., *The Lost Houses of Wales*, Save Britain's Heritage, 1986.

Malkin, B. J., *Scenery, antiquities . . . of South Wales*, 1st edn., 1804.

Manning, O. and Bray, W., *History . . . of Surrey*, iii, 1814.

Milward, R., *A new short history of Wimbledon*, Wimbledon Soc., 1989.

Milward, R., *Wimbledon's manor houses*, John Evelyn Soc., Wimbledon, 1982.

Neale, J. P., *Views of seats . . .*, iii (1820), v (1822).

Negus, R. E., 'The jurisdiction of judges of assize to fine a county', *E.R.*, xlvii (1938), 57–67.

Negus, R. E., *A short history of the Shire Houses of Essex*, 1937.

Newman, L. T., 'The history of Battlesbridge', *E.J.*, viii (1973), 16–18.

Nichols, J., *History of Leicestershire*, 2 vols., 1815.

Observations on two Trials at Law respecting Messieurs Adams's new-invented Stucco, 1778.

Ogborne, E., *History of Essex*, 1814.

Oswald, A., *Country houses of Dorset*, 2nd edn., 1959.

Pevsner, N. (revised, Williamson, E.), *Buildings of England: Leicester and Rutland*, 2nd edn., 1984.

Pevsner, N. and Cherry, B., *Buildings of England: Northamptonshire*, 2nd edn., 1973.

Phillips, D. Rhys, *History of the Vale of Neath*, 1925.

Potts, D., *Halstead's Heritage*, Halstead and District Local Hist. Soc., 1989.

Prosser, G. F., *Select illustrations of the county of Surrey*, 1828.

Reply to Observations on two Trials at Law, 1778.

Robbins, R. M., 'Some designs for St. Marylebone church . . .', *London Topographical Record*, xxiii (1972), 97–100.

Robinson, J. M., *The Wyatts*, 1979.

[Round, J. H.], *The history and antiquities of Colchester Castle*, 1882.

Rowan, A., *Robert Adam: Catalogues of architectural drawings in the Victoria and Albert Museum*, 1988.

Royal Commission on Historical Monuments, *Dorset*, i, West, 1952.

Royal Commission on Historical Monuments in Wales, *Glamorgan*, iv (1), 1986.

Rush, J. A., *Seats in Essex*, 1897.

Scarfe, N., *Suffolk: a Shell Guide*, 1960.

The several Petitions and Evidence laid before Parliament for and against obtaining a Bill to remove Chelmsford Gaol [1771].

Shorrocks, D. M. M., 'John Abell's Bridge, Nayland', *E.R.*, lxi (1952), 225–232.

Simmons, J., *Leicester past and present*, i, 1974.

Simmons, J., *Parish and Empire*, 1952 (article on Johnson (pp. 128–145, 242–245) reprinted from *Trans. Leics. Arch. Soc.*, xxv (1949), 144–158).

Slater, J., *A short history of the Berners estate*, St. Marylebone, 1918.

Smart, A. and Brooks, A., *Constable and his country*, 1976.

Smith, J. Abel, *Pavilions in peril*, Save Britain's Heritage, 1987.

Smith, M. L., *Witham River Bridges*, duplicated typescript, 1972.

Stieglitz, C. L., *Plans at Dessins Tirés de la Belle Architecture*, Leipzig and Moscow, 1800.

Stillman, D., *The decorative work of Robert Adam*, 1973.

Stokes, E. K., *Burley-on-the-Hill* [1960].

Stroud, D., 'Notes on No. 63 New Cavendish Street', *Report of the Institute of Psycho-Analysis*, 1953, 69–72.

Stroud, D., *The architecture of Sir John Soane*, 1961.

Strutt, C. R., *The Strutt family of Terling, 1650–1873*, privately printed, 1939.

Summerson, J., *Georgian London*, 1945.

Survey of London, v (1914), xxix (1960), xxxix (1977), xl (1980).

Talbot, W., 'Bradwell Lodge . . .', 1793', *E.R.*, xlv (1936), 189.

Thompson, J., *History of Leicester in the 18th century*, 1871.

Victoria History of the County of Essex, iv (1956), v (1966), vi (1973), vii (1979), viii (1983).

Victoria History of the County of Huntingdon, iii (1936).

Victoria History of the County of Middlesex, v (1976).

Victoria History of the County of Sussex, vi (3) (1987).

Webb, S. and B., *English Local Government: the story of the King's Highway*, 1913.

'Welsh country homes lix', *Cardiff Times and South Wales Weekly News*, 21 Jan. 1911.

Western, C. C., *Remarks on prison discipline*, 1821.

White, J., 'Chelmsford Gaol in the 19th century', *E.J.*, xi (1976/77), 83–94.

Williams, J. F., 'The re-building of Chelmsford church, 1800 to 1803', *E.R.*, xl (1931), 97–104.

Williamson, G. C., *John Russell*, 1894.

Wood, E. A., 'Three Georgian houses: the re-building of Thorpe Hall . . .', *E.A.T.*, 3rd series, ii (1967), 123–129.

Woodcroft, B., *Alphabetical index of Patentees of Inventions, 1617–1852*, 1969.

Worsley, A. V., *Hornchurch parish church*, 1964.

Wright, T., *The history and topography of . . . Essex*, 2 vols., 1836.

INDEX

N.B. Except where otherwise noted, and with obvious exceptions, place-names are in the ancient geographical county of Essex. Italic indicates plan or illustration.